Getting Your Sh*t Together

A Professional Practices Manual

for Artists

Getting Your Sh*t Together
GYST Ink Press
4223 Russell Ave
Los Angeles, CA 90027-4511

Find us online at www.gyst-ink.com.
Email us at info@gyst-ink.com.

GYST makes software for artists available for Mac and PC. Try it for free by visiting the GYST
website at www.gyst-ink.com/buy, or email us at info@gyst-ink.com

Writers: Karen Atkinson, Tucker Neel, Monica Hicks, Michael Grodsky, Christine Leahey, Caitlin
Strokosch, and Calvin Lee

Editors: Karen Atkinson, Tucker Neel, and Monica Hicks
Production: Karen Atkinson and Tucker Neel
Design: Rebecca Edwards

SPECIAL THANKS
Special thanks goes to the Emily Hall Tremaine Foundation for support of previous classes
taught at California Institute of the Arts, Side Street Projects, the New York Foundation for the
Arts (especially Penny Dannenberg), to all the artists who have taken the GYST (Getting Your
Sh*t Together) classes and workshops, and those who have purchased or used the software
of the same name. To the GYST staff both previous and current, thank you for your support
and tenacity. And to Joe Luttrell who puts up with all this stuff, Karen thanks him for his
support of her many long hours at work.

GYST Ink produces a professional practices blog at www.gyst-ink.com/blog.

This book is dedicated to artists everywhere.

Getting Your Sh*t Together
A Professional Practices Manual For Artists

Contents

Introduction to GYST

This Getting Your Sh*t Together manual came from years of experience in teaching at the college level as well as working with artists in a variety of situations as a nonprofit director, a curator, editor, and public artist. Having diverse experiences in the art world gave me insight into a lot of things artists either never experience, or only glimpse at. While founding and running Side Street Projects, an artist run organization, I developed ways of educating artists for successful careers. Whether they are aspiring gallery stars, or independently producing artists, there are things that artists need to know.

I began formally teaching these workshops and classes both at CalArts and in the city of Los Angeles and soon I was presenting around the country. The class was a way to make available important information as a part of a comprehensive curriculum, not separate workshops that seemed less important.

When I got out of graduate school in the early 80's, there was little support for emerging artists, women, people of color and those making public and more conceptually based work, but in the last 20 plus years, the art world has changed drastically. Students are now grabbed out of school before they graduate in order to begin working with a gallery. Graduate students often have shows outside of school. Collectors are concentrating on emerging artists because the work is cheap and easy to purchase. Artists who have just graduated rarely have time to develop their work, let alone to develop professional practices as an artist. Today artists of all kinds need to be less naive about how the art world works in order to avoid being railroaded into doing things they don't wan to do, and, of course, getting screwed by unscrupulous folks in power.

So, GYST, or Getting Your Sh*t Together, was born. After many years of teaching and sharing my syllabus with countless institutions and teachers, I created software for visual artists to keep track of everything in their art lives, which I use to teach my classes. Much of the information written for the software is included in this artist manual, which has been created as a response to requests for information as well as for a "how to" manual for artists.

Teaching this class "out in the world" has been a great experience, and quite different than teaching it at the University level where the range in age can be as great as the range in the kinds of artists who take the class. The goal? Make artists aware of how to do everything themselves so they don't need to pay good money for someone else to do it, so they can be a vital part of their own careers. I want to make sure they understand how things work so they can educate their dealers and other arts administrators.

If you have further questions, don't hesitate to contact me at info@gyst-ink.com. I look forward to any feedback you have regarding this publication as well as any suggestions or additions you may have. Otherwise, good luck.

Karen Atkinson , Copyright 2008
Founder, GYST Ink (Getting Your Sh*t Together)

Using This Artist Manual

Every artists' situation is different. Schools vary widely as to what you may have learned or been exposed to. Nonprofit organizations, too, range from the conservative to the conceptual and address a wide range of ages and issues.

This manual is divided into versatile modules that can be used in the order that you feel best serves you. You don't need to use every module. Some of these ideas are for beginning artists, or for those who have little or no experience talking about their work. Other modules work for more artists. For example, your practice/institution/situation may already include a lot of time talking about and critiquing work, so you won't necessarily need to schedule time to present your work to your class/friends as part of the Presenting Yourself module.

You can use this manual by itself, or you can buy the GYST software which has a large database of files that includes an artwork inventory, a place for your artist statements, resumes, exhibition forms, etc. This is the best way to get all of this information and saves the environment and on copying costs. For more information see our website at www.gyst-ink.com, or email info@gyst-ink.com. A demo version of the software is now available online and you can try it FREE for 30 days before purchasing it.

Since not everyone is alone in this artist journey, it is highly recommended that you actively engage your artist peers to discuss those things with which you may not be familiar, like legal issues, accounting, or curating. Different perspectives and experiences can be very valuable to hear. Participating in a visiting lecture or other workshops for artists could be invaluable. Other voices are always a good idea, as artists like to hear from a variety of people.

gyst

An artist run company
for artists

You can now download a free copy of the GYST software
by going to our website at
www.gyst-ink.com/buy/buyonline.php

1: Artist Manual Overview

 Objectives

Introduce yourself to a variety of options for artists within your artistic practices and your life choices.

Become aware of a set of tools and resources to enable you, the artist, to do things for yourself with a DIY approach.

Prepare yourself for issues that may come up as you develop your practice, and learn the business skills necessary to have a productive career.

 Goals

To create an understanding that artists are responsible for their own careers and choices.

To understand the basic tools and resources an artist needs to maintain their practice.

To impart the importance of how to conduct yourself as an artist in all social and professional situations.

To provide clear and accurate information, develop research skills, and create a life plan for the future.

To come away with valuable skills and a portfolio which can be used to begin or further an art career.

To expand the perception of the "art world universe" to understand opportunities and choices that determine the track of your life and career.

✳ Things to Consider

1. Write down a few words about the kind of work you make.

2. Write down a few questions you want to know the answer to, and write down the answers as they come to you in this manual.

3. Generate a list of the myths and your fears of the art world.

4. Fill out the GYST survey.

5. Keep a journal or notebook with ideas, questions and notes. This will help you formulate insight into the kind of professional practice you are seeking and what it may take to achieve it.

2. GYST Personal Survey

 ## Objectives

Get an idea of how much you know, or think you know.

Give yourself an idea of the kinds of things you need to know as a working artist.

Give the yourself a way to evaluate what you have learned by taking the survey again at the end of the manual.

Things to Consider

It's so hard to measure success in the art world. For some artists success is a solo show at the Met, for others it's just making a living off of one's work. No matter what your long-term goals are, you might want to start thinking about your practice as a barometer for success. Throughout your art career you should amass a set of indispensable skills. This survey will help you see how much you have learned and key you into what you need to improve upon. This is a good tool for self evaluation and an intro to what artists need to know. Be brutally honest with yourself.

If you use the GYST software, this survey can be completed within the software, and can be taken multiple times. The software will automatically archive old surveys add up your scores.

✳ GYST Personal Survey

1. The Usual Sh*t

Name

Date you took this survey

What kind of art do you make?

Occupation / Day Job:

Education Level:

I have been a practicing artist for years.

2. Introspective Sh*t

On a scale of 1 to 10, with **10** being "I <u>really</u> got my sh*t together," and **1** being "I don't got my sh*t together, like, at ALL," please rate how well you think you've got your sh*t together

1 2 3 4 5 6 7 8 9 10 NA

3. The Sh*t You Need to Figure Out

On a scale of 1 to 10, with **10** being "Dude, I got that sh*t ALL figured out ," and **1** being "Duh, what?," please rate your level of expertise on the following topics.

Finding an appropriate space to produce your work

1 2 3 4 5 6 7 8 9 10 NA

Creating an effective artist's resume

1 2 3 4 5 6 7 8 9 10 NA

Writing a compelling artist's statement

1 2 3 4 5 6 7 8 9 10 NA

Writing a grant

1 2 3 4 5 6 7 8 9 10 NA

Applying for funding from governmental agencies (city, county, state, & national)

1 2 3 4 5 6 7 8 9 10 NA

Applying for funding from corporations

1 2 3 4 5 6 7 8 9 10 NA

Applying for funding from private foundations

1 2 3 4 5 6 7 8 9 10 NA

Approaching individual donors for project support

1 2 3 4 5 6 7 8 9 10 NA

Collaborating with nonprofits to secure project funding (fiscal sponsor)

1 2 3 4 5 6 7 8 9 10 NA

Writing an project proposal

1 2 3 4 5 6 7 8 9 10 NA

Creating a detailed project budget

1 2 3 4 5 6 7 8 9 10 NA

Writing cover letters, "thank you" letters & other forms of business correspondence

1 2 3 4 5 6 7 8 9 10 NA

Finding an exhibition/project venue

1 2 3 4 5 6 7 8 9 10 NA

Approaching small venues with your project proposal

1 2 3 4 5 6 7 8 9 10 NA

Approaching large venues with your project proposal

1 2 3 4 5 6 7 8 9 10 NA

Producing independent projects at alternative or artist run spaces

1 2 3 4 5 6 7 8 9 10 NA

Submitting your work to exhibitions/group shows

1 2 3 4 5 6 7 8 9 10 NA

Responding to general "requests for proposals" and/or "requests for qualifications"

1 2 3 4 5 6 7 8 9 10 NA

Submitting your work to festivals

1 2 3 4 5 6 7 8 9 10 NA

Etiquette and tactics for business meetings

1 2 3 4 5 6 7 8 9 10 NA

Organizing and facilitating effective meetings

1 2 3 4 5 6 7 8 9 10 NA

Developing an Exhibition or Performance Checklist

1 2 3 4 5 6 7 8 9 10 NA

Knowing the expectations of exhibition/performance venues

1 2 3 4 5 6 7 8 9 10 NA

Managing your time and meeting deadlines

1 2 3 4 5 6 7 8 9 10 NA

Strategies for effective "networking"

1 2 3 4 5 6 7 8 9 10 NA

Creating and maintaining effective mailing lists

1 2 3 4 5 6 7 8 9 10 NA

The basics of contracts and negotiation

1 2 3 4 5 6 7 8 9 10 NA

Writing press releases and promoting your work/project

1 2 3 4 5 6 7 8 9 10 NA

Archiving/documenting your work

1 2 3 4 5 6 7 8 9 10 NA

Now that you have taken the survey, what kinds of things do you notice? Did you discover anything about yourself?

3: Assumptions, Myths, & Fears About the Art World

✳ Objectives

Compare conceptions and realities, understandings of who has power and who does not, and how artists are perceived.

Think about and evaluate these options and brainstorm possibilities within them.

Think about and evaluate how participation in this arena can affect positive change.

Understand what choices you have and how you make decisions.

✳ Things to Consider

1. Grab a piece of paper and a writing utensil. Draw a diagram of the "Art World" based on your perceptions of how it is constructed. For example, you may have a circle with you in the center, and stemming from it are galleries, art dealers, or collectors, and from them may be museums, or more collectors....

2. Brainstorm myths and beliefs of the art world and whether they are "true" or not. This may work best when you can discuss them with a group of your peers. Everyone has a different perception and this could help you see where you fit on this issue.

3. What kinds of information would help clarify these assumptions?

4. Think about and write down the perceptions of you, the artist. Both within the "Art World" and outside of it.

5. Choose three ideas you have written down and answer the following questions:

• How did I form this idea?
• How firmly do I believe it?
• Why do I maintain this idea?
• What would make me change my belief?
• Which of these beliefs inspire the strongest emotions?
• If I don't like this idea, can it be changed?

Some Common Myths (to get started):

• The myth of the starving artist.
• There is a grant for everything.
• I have to live in New York City.
• My gallery or dealer will take care of me.
• There is an "art mafia".
• When I make it big, my troubles will be over.
• Artists can make a living selling their work.
• Art is not my job, my job is ...
• Artists can't write.
• Artists are not good at math, bookkeeping or business skills.
• An artist should be able to get grants to survive.
• Artists should live a nomadic lifestyle.
• It is impossible to have kids and be a good artist.
• Those who can, do, those who can't, teach.
• If you are talented, you will be recognized.
• Art is not a business.
• Taking care of business will undermine my art.
• Selling my work, is "selling out".

Other Questions For Individual Evaluation

1. Do you have an artist statement?

2. Do you have an artist statement that you like?
3. Do you have a resume?
4. Do you have an up to date portfolio of your work?
5. Have you applied for a grant? Have you received one?
6. Are you interested in gallery representation?
7. Do you have a website?
8. Did you file a tax return last year? Will you need to do one this year?
9. Have you sold any of your artwork?
10. Have you ever approached an institution to show or sell your work?
11. Have you ever signed a contract in relation to your artwork?
12. Have you ever copyrighted any of your work?
13. Do you know how to price your artwork?
14. Have you ever been commissioned to do artwork?
15. Where do you make your work? Where will you make your work when you graduate?

✳ Things To Do

Fill out the Self-Assessment Questionnaire. This project will give you a series of questions in order for you to begin to make plans for the future, and determine just what kinds of things you want to do.

 Self-Assessment Questions

The questions in this survey will help you determine who you are as an artist, and how you fit into the big picture. Feel free to answer more questions than are provided here. These questions will help you identify who you are and how you might contribute to the field of art.

Your Artistic Identity

1. What words would you use to describe your work as an artist?

2. What sources are you aware of that guide or influence your work? Include physical, intellectual, emotional, conceptual, relational, etc.

3. What materials do you enjoy working with? What do you hate to work with and why? What materials do you want to try working with in the future?

4. Whose work do you admire (contemporary as well as historical)? Why?

5. Whose work do you dislike and why?

6. Who do you compare yourself to? What kind of comparisons do you draw?

Your Relationship to the "marketplace" or gallery system?
1. If you had a choice, whose career would you emulate?

2. Where or in what kind of context would you most like to exhibit your work?

3. Who do you think your work is for? Do you have a sense of who your audience is and who you would like to see your work?

4. What critics do you read. Do you relate to them?

The World At Large
1. What kinds of things do you read outside of your discipline?

2. Where do you come from? Community, geography, ethnicity, economic background, family structure, peers, mentors, antagonists? How would you describe your background and how has it influenced you?

Your Skills and Work Related Values and Preferences

1. What skills (including, but also in addition to those you use in your artwork) do you have? What do you value most? What do you most enjoy doing?

2. What sort of tasks do you find difficult or unpleasant to do?

3. What kind of work environment do you prefer? Under what circumstances are you most productive?

4. What kind of living arrangement do you need to feel comfortable and supported in your life and work?

5. What kind of social contacts do you require? What kind of social interactions do you enjoy? Dislike? Handle well? Find difficult?

6. What accomplishments of yours make you feel the most pride? For each accomplishment what skills, relationships and environments informed your experience?

Your Financial Picture

1. What does it currently cost you to make your work? (materials, travel, equipment, overhead)

2. What must you have in order to live and take care of yourself? (weekly or monthly?) Are school loans a part of this picture?

3. What if anything would you be willing to do without?

Your Community Network

1. Who do you know? Friends, family, fans, acquaintances, mentors, contacts? Who supports you? Who do you need or want to get to know? Who do you want to recognize you for the work you do?

4: Life Planning & Goal Setting

 Objectives

Clarify your goals as an artist, and determine how to get there.

Create a life mission statement.

Create short term and long-term goals.

Understand the various career choices and expand options.

Things to Consider

1. Think about and write down why planning and goal setting are important. Try to separate your short term and long-term goals.

2. Use the planning sheets and fill out what you think you can handle. It can be overwhelming to a) be asked what you really want to do and b) to commit to writing it down. Take your time and think about it.

3. What do you think about the idea of a mission statement for your life? Try writing one down. It doesn't matter how long it is. Make it a proclamation of what you are doing, will be doing, and will accomplish with your life.

 Things To Do

Fill out the goal sheets. You can do this through the GYST software, or print out the sheets.

Obituary

Write your own obituary. You can be as creative as you want about how you die and when, but make sure the accomplishments are true to your desires. This is an exercise in visualizing a complete life, since it is hypothetically over, and doing this enables you to think about what it is you are accomplishing and focusing your energy on, in the here and now.

 Why Plan?

"A plan is nothing. Planning is everything."
- Dwight Eisenhower

"Successful artists as well as businessmen use creative thinking to get from point A to point B."
- James Rosenquist

"Basically you could say that artists I have known who have had rewarding and successful careers are those who have been able to make very clear choices about their priorities and expectations. Once these priorities were selected, they wasted no emotion on the other things they gave up. I want to make it clear that when I refer to a successful artist I do not necessarily mean financially successful. To me a successful artist is one who continues to make art, and is not more than 50% bitter about the rest of life."
- Bruce Beasley

Whether you are planning ahead in order to make money or to have the career you want, setting realistic goals can get you organized, motivated and on track. Writing down your short and long-term goals makes your aspirations more concrete. A flexible plan of action can also help you deal with the challenges of the present and visualize what you want in the future.

Goal setting keeps you motivated because when you accomplish a goal, even if it's starting your mailing list with just one contact, you can see progress and improvement. It's a good reminder about what priorities you have chosen, and gives you a good way to check back and see how you are doing.

The key to setting goals is to be realistic, flexible, and diligent. It's helpful to remember that you won't get everything done in a day, a month, or maybe even a year. Planning does not have to be overwhelming. Start small and work up to the big stuff. Get organized first, and things will fall into place more easily.

Plan ahead. If you keep accurate records of your work, and have a list of all your past exhibitions, artist statements, resumes, and an inventory of where your work is and who has purchased it, when you have that retrospective or mid-career survey, you will know what you have made, when you made it and what you were thinking about while you were making it. The curators tasked with organizing and writing about your work will be thrilled because they will be more knowledgeable about your ideas and finding old work from collectors will be so much easier.

A great idea for keeping yourself on track and managing your goals effectively is to schedule a short business meeting with yourself once a week. Use this time to reflect on what you accomplished during the last week and what needs to get done this week, then adjust your goals accordingly.

Remember, the reason this manual is part of GETTING Your Sh*t Together is because you never really GET Your Sh*t Together because an art practice is never really finished. You always have to keep updating your mailing list, archiving your work, applying for exhibitions, and revisiting your goals. So keep in mind that planning is a fluid process. Plans are made, and plans are changed and an effective plan is adaptable, shifting according to your good or bad fortune. So you didn't secure a solo show at The Guggenheim by your thirtieth birthday. No problem, just shift that goal to a few years in the future and be happy you've set up your website. The trick is to always keep working towards goals and to keep the larger picture in mind. An art practice goes through hills and valleys over the course of an artist's lifetime, so be prepared for a wonderful and challenging ride.

 ## Goal Suggestions

These exercises are a great way to clarify your own goals and determine just how to get to where you want to go. Once your goals are set, you can then create an action plan. This is not just a plan for your art career, but for your life.

Remember:

• There are no right or wrong answers
• There is no "one way" to create an art career
• You, and only you, can judge your own success.
• Knowing where you're going and how to get there is a key to success

Questions to Consider When Setting Goals

1. What is your artistic practice?
- What words would you use to describe yourself as an artist? (not the artwork)
- What words would you use to describe your artwork?
- What influences can you discern?
- What materials do you favor?
- What materials do you avoid?
- What materials have you always wanted to try, yet have not?
- Whose work do you like? (art or otherwise)
- What kind of style would you say describes your work?
- What kind of artwork do you like?
- What kind of artwork do you dislike?

2. Where do you want your work to be seen or exhibited?

- Do you have someone whose career you would like to emulate?
- In what kind of space or context would you like to show your work?
- Who is your audience? For whom is the work intended?
- What critics do you read?
- What critics do you like?
- What critics do you dislike?
- What art publications do you read?
- What art publications do you like?
- What art publications do you dislike?

3. What other kinds of things do you enjoy that are not art related?

- What else do you read?
- What kinds of movies do you like?
- What kind of music do you like?
- Do you have hobbies or other pursuits?
- Where do you come from?
- Who is your community?

- How do you describe your background and what has influenced you?
- If you could not be an artist, what profession would you choose?

4. What kind of skills and work values do you have?

- What skills do you have now?
- What skills would you like to have in the future?
- What skills do you like using the most?
- What kinds of tasks do you not like to do?
- What kind of work environment do you prefer?
- What kind of environment makes you the most productive?
- What kind of living arrangements do you need to feel comfortable?
- Do you need a workspace separate from your living space?
- What kind of social contacts do you require?
- What kinds of social activities are your favorite?
- What kinds of social activities make you uncomfortable?
- What accomplishments are you the most proud of?
- What skills, relationships, or environments contributed to those experiences?

5. Your financial picture.

- What does it currently cost you to live the life you live?
- What does it cost to produce your work?
- Where does your money currently come from?
- Do you know your weekly or monthly expenses?
- Do you have school loans or debts to consider?
- What would you be willing to do without?
- For how long could you do without it?

6. Your community.

- Do you have people who can write you a letter of recommendation?
- Who would you like to know and why?

- Who do you want to have champion your art in the future?
- Who do you know that supports you personally, professionally or financially? (This can be friends, teachers, mentors, family, fans, acquaintances, etc.)

Optional Assignment: A Hundred Questions

From Michael Gelb, <u>How to Think Like Leonardo da Vinci</u>. (NY: Delacorte Press, 1998., p 59)

In your notebook or journal, make a list of a hundred questions that are important to you. Your list can include any kind of question as long as it's something you deem significant. List anything from "how can I save more money?" to "how can I have more fun?" to "what is the meaning and purpose of my existence?" and "how can I best serve the Creator?"

Do the entire list in one sitting. Write quickly; don't worry about spelling, grammar, or repeating the same question in different words (recurring questions will alert you to emerging themes.) Why a hundred questions? The first twenty or so will be "off the top of your head." In the next thirty or forty, themes often begin to emerge. In the later part of the second half of the list you are likely to discover unexpected but profound material.

When you have finished, read through your list and highlight the themes that emerge. Consider emerging themes without judging them. Are most of your questions about relationships? What about business, fun, money or the meaning of life?

 Three-Month Goals

Fill out this form with short-term goals you would like to accomplish in three months. They don't all have to be art related. Be as detailed as possible. If your goal has too many steps, break it down and include the steps it takes to get there as a goal. Be very realistic. Now is the time to be honest about your goals and what you can achieve in three months.

X	Goals

 One-Year Goals

Fill out this form with short-term goals you would like to accomplish in one year. If your goal has too many steps, break it down and include the steps it takes to get there as a goal. Remember a year is a long time to get some things done, like creating a mailing list, and a very short amount of time to do something like securing a solo show. Be realistic about what you can accomplish in this period of time.

X	Goals

 Five-Year Goals

Fill out this form with goals you would like to accomplish in five years. They don't all have to be art related. Be as detailed as possible. If your goal has too many steps, break it down and include the steps it takes to get there as a goal. Take time to think ahead about where you want to be professionally, financially, and personally.

X	Goals

 # Ten-Year Goals

Fill out this form with goals you would like to accomplish in ten years. If your goal has too many steps, break it down and include the steps it takes to get there as a goal. A lot can change in a decade. Use these goals to visualize your practice in ten years. Where do you want to live, work, and play? What do you want to make and how much do you want to get paid for it? Who do you want in your life?

X	Goals

 Life Goals

Fill out this form with goals you would like to accomplish in your lifetime. They don't all have to be art related. Be as detailed as possible. If your goal has too many steps, break it down and include the steps it takes to get there as a goal.

X	Goals

 # One-Year Priorities/Action Plans

Prioritize your One Year Goals and list the ones that are the most important. Include your action plans to accomplish the goal. You can do the same with each of your goal sheets.

X	Goal # 1 (List first goal)
	1. (step one)
	2.
	3.
	Goal # 2
	1.
	2.
	3.
	Goal # 3
	1.
	2.
	3.

✳ Goal Suggestions

Set up an Artwork Inventory

Create my portfolio

Create a brochure of work

Put together proposal packets

Get into Grad School

Meet X art critic

Write thank you letter to X

Create a Website

Get into a group exhibition

Do a solo show

Get a review of my show

Get a teaching job

Apply for a public art project

Create a mailing list

Create a mission statement

Sell a painting

Read X book

Schedule a studio visit

Curate a show

Apply to artist's residencies

Visit the Venice Biennale

Write a review

Get an art dealer

Earn $40,000 a year

Produce a catalog of my work

Show in (Europe, New York, Los Angeles)

Make a living with my artwork

Find a studio

Do three performances this year

Research artist funding

Meet with a nonprofit for fiscal receivership

Research materials for donation

Paint the studio

Order new lighting

Get insurance

Do two shows this year

Hire an artist's assistant

Hire a studio manager

Apply for a business license

Organize the office

Get a museum show

Make 10 paintings for a new series

Fill out planning sheets

Call your mother

Apply for a DBA (Doing Business As) business name

Get a professional photographer to document your work

5: Artist Statements

 ## Objectives

Understand why an artist statement is important.

Understand what makes a great artist statement.

Create a clear and effective one-page artist statement- a key to an artist's success.

Things to Consider

1. Where are artist statements used and why do we have to write one?

Most everyone you ask for anything will require an artist statement, including galleries, grants, applications, arts related jobs, press releases, exhibitions, critics, reviewers etc.

A clear and concise artist statement will operate as a stand-in for your own voice during those times you can't be there to share or talk about your work in person, such as when you send a portfolio to an institution, or your dealer needs to talk to buyers about your work, or a reviewer needs some information about your work.

2. What goes into an artist statement?

See Section on Writing an Artist Statement.

 ## Things To Do

Write a one page, single-spaced draft of your artist statement. Use the writer's block ideas to get started. You may want to get someone else to read it and then continue drafting after that. Writing an artist statement is an ongoing process.

 # Writing an Artist Statement

An artist statement is an invaluable tool the artist uses to better understand how and why they do what they do. It is an ever-changing document that is revisited, often after a new body of work or project is completed, concisely outlining the artist's practice, ideas, intent, materials and methods. Almost every institution, gallery, critic, curator, funding resource, and collector will ask for, or require an artist statement at some point, so it's good to have an updated artist statement ready at all times.

A clear and concise artist statement will operate as a stand-in for you when you can't talk about your work in person, like when you send a portfolio to an institution, or your dealer needs to talk to buyers about your work.

Keep in mind that while everyone can read your statement, most people won't, or they will just scan it. The people who HAVE TO read your statement do so because it's part of their job. These people are curators, gallery workers, critics, people on grant panels (which can be almost anyone), historians, teachers, employers, colleagues, and students. Remember, you should always consider your audience when writing your statements, as a statement for a gallery show might be very different from a statement to a grant panel or a tenure committee.

Here are some common questions artists have when it comes to artist statements:

Why should I write an artist statement?

• Writing an artist's statement can be a good way to clarify your own ideas about your work.

• A gallery dealer, curator, docent, or the public can have access to your description of your work, in your own words. This can be good for a reviewer as well.

• A statement can be useful when writing a proposal for an exhibition or project.

• It is often required when applying for funding.

• It is often required when applying to graduate school.

• It is good to refer to when you are preparing a visiting artist lecture.

• It is often required when you are applying for a teaching position. It can also help you write a Teaching Philosophy, which is different from an artist statement (see Teaching in the Resources section).

• It can help you or someone else write an effective press release.

• It can help in writing a bio for a program brochure.

• It can help reviewers and critics write more informed pieces about your work.

• It is a good way to introduce your work to a buying public. Often the more a buyer knows about your work the more they become interested in what you do, which can lead them to purchase your work.

• A collection of artist statements over the course of an artist's career can be one of the only written keys to understanding how an artist's ideas about their practice have changed over time.

Will one statement do, or will I need different kinds of statements?

You will have to write all kinds of artist statements during the course of your career. Your statement should change as your practice matures and you gain perspective on older work. Usually you rework your statement after finishing a new body of work. If you make many different kinds of works you might find it helpful to have a separate statement to correspond with each kind of work. That said, here are a few statements you will certainly need handy:

• Full-Page Statement

This is the statement you will use most often. It speaks generally about your work, your intent, the methods you have used, the history of your work, and where you see your work going. It may also include specific examples of your current work or project.

• Short Statement

A shorter statement includes the most important aspects of your practice, often using only a sentence or two to talk about the specific project at hand.

• Short Project Statement

This is a very short statement about the specific project you are presenting.

•Bio

A bio is a short description of your career as an artist and your major accomplishments. It includes a sentence about you and where you base your practice, a sentence about your general interests or what your work investigates, a sentence listing your academic background, a sentence about where you have exhibited work and in what publications reviews of your work have appeared. You can also use a sentence to list important awards, fellowships and residencies you have secured. Make sure to include your artist website. Basically, it is a short version of your resume or cv.

How should I structure my statement?

The first paragraph should be a general introduction to your work, a body of work, or a specific project. It should open with the work's basic ideas in an overview of two or three sentences or a short paragraph.

The following paragraphs should go into detail about how issues or ideas are presented in the work. If writing a full-page statement, you can include some of the following points:

- Why you have created the work and its history.
- Your overall vision.
- What you expect from your audience and how they will react.
- How your current work relates to your previous work.
- Where your work fits in with current contemporary art.
- How your work fits in with the history of art.
- How your work fits into a group exhibition, or a series of projects you have done.
- Sources and inspiration for your images or texts.
- Artists you have been influenced by, or how your work relates to other artists' work. Be careful how you include these references because you don't want to appear derivative.
- How this work fits into a series or larger body of work.
- How a certain technique is important to the work.
- Your philosophy of art making or of the work's origin.

The final paragraph should recapitulate the most important points in the statement and leave the reader wanting to experience the work and learn more. This is also where you might want to talk about any long-term goals you have with your practice.

What shouldn't go in an artist statement?

Pompous or arrogant language, exclaiming your artistic genius. Leave that up to other people.

Empty and cliché expressions about your work. The phrase "feast for the eyes" is trite and unimaginative. Use your own words and make them count. Remember, if you think you've heard it said before, it probably has been, so take it out.

Technical jargon. You want to keep them reading so find a way to connect without sounding like a robot.

A long dissertation or explanation. Short and sweet is the key. Don't linger on one thought for too long. Leave your reader room to form their own opinions.

Discourses on the materials and techniques you have employed. Ok, if you're using the nectar of a rare Siberian orchid to make drawings on endangered palm fronds, then mention that, but don't bore the reader with your inventive use of materials. If you paint, mention if its in oils, acrylics, etc, but don't go on and on about your masterful glazing techniques. As always, get to what the work is actually about.

Poems or prosy writing.
Great artist statements
Are not cute haikus.
Write about your art.

Folksy anecdotes, autobiographies, or stories about your life. Don't include anything about your childhood or family life. Leave these stories out unless they are directly related to the work, integral to the content and meaning of the work, in a way anyone reading will understand.

Bragging language, a list of accomplishments, or something like a boring press release. Don't mention where you've shown, awards you've won, or pieces you've sold in your statement.

Indecipherable text. Now, if it's for an exhibition and it conceptually relates to the work, you might have cause to use this sort of a statement. But in general, obtuse, rambling statements, statements consisting of one sentence, or statements that are artworks themselves, may risk coming off as condescending, disingenuous, or just plain stupid.

How should I write my statement?

This most often depends on the context where it will appear. The most important thing to keep in mind is who will read your statement and where they will be when they read it. What assumptions can you make about your reader's knowledge of your work, art and art history, and any references or theory you mention?

Depending on your reader you might want to alter your:

• Emotional tone. Some readers will respond to the urgency of your ideas and convictions in different ways. A grant panel may want to know about your emotional investment in your work, while some critics might dismiss it. The choice is up to you.

• Theoretical context and academic tone. There's nothing wrong with being able to

situate yourself within a theoretical context. But some readers may not want to read about or begin to understand your desire to create "works that speak to the subaltern impulse as informed by Deleuze's relationship to Derridian archiving impulses prevalent in post-industrial American hegemonic centers of cultural production." There are publications where this kind of writing is appropriate, but only write this way for these publications.

• Analytic approach. Some people might want you to write about your work from a formal standpoint. Others may want you to discuss how your work functions socially. There are readers who are interested in how a work operates politically. Some readers may want to know how a work navigates the marketplace. How you analyze your work can say a lot about your stance as an artist, and can help readers understand how you want your work to function.

• Humor. Two artists walk into a bar. There. That's the end of the joke. Get it? A poorly written, pushy joke can ruin any statement. If your work is humorous it might be a good idea to let it stand on its own. Use your statement to speak about the ideas that inform the work. If you want to be funny, then try this: Have five people you don't know, who don't know your work, read your statement. If four out of five of them laugh, out loud, where they should when reading it, then you're probably safe. Remember, you can try to be John Stewart, but you risk coming off like Carrot Top. (See, bad jokes can ruin writing!)

• Antagonistic approach. "I dare you to even try to understand my work." Thanks, but no thanks. You want your statement to be readable, understandable, and written out of a genuine desire to connect.

• Political assertiveness. There is nothing wrong with having political beliefs and there is nothing wrong with making work that attests to these beliefs. However, you don't want your statement to get in the way of your reader coming to their own conclusions about the work.

• Professional appearance. A statement for a job review will demand a certain level of professionalism that you might not have to employ in a statement for a publication or exhibition or lecture. Picture how other artists, colleagues, and superiors will read your statement, not just now, but in the future.

• Ask yourself "What are you trying to say in the work?" "What influences my work?" "How do my methods of working (techniques, style, formal decisions) support the content of my work?" "What are specific examples of this in my work" "Does this statement conjure up any images?" Answer these questions using specific examples in the work itself.

• Make sure the statement matches up with the work. There is nothing worse than a statement that seems completely contrary to an artist's work. If you say your work addresses questions of environmental destruction, then this should be backed up in the work. Some artists create many bodies of work and find synthesizing this pluralistic practice into one statement to be difficult. Don't worry. Just find the common themes that unite these projects and write about them. When presenting each project you can have a totally different statement.

• Be honest. Don't try and force some external set of ideas on the work if that's not what the work is about. Don't try and construct a false narrative for the work or lie about its origins. Don't linger on what the work is not. Stay positive and used an informed voice.

• Try to capture your own speaking voice. One way to do this is to talk to a friend about your work and record the conversation. Sometimes we are much better at communicating our ideas when we speak vs. when we write. Another way to ensure your statement reads well is to actually read it aloud. Doing this will help you to see the hiccups and confusions in your writing.

• Use descriptive language so that the reader can better "see" the work. One way to do this is to start by just describing the work, "it's X big, made with X materials, it's X color, it sits in X place in relation to the floor, etc." Really get down to details. Don't include this long description in your statement, but use key sections as descriptive elements in your statement.

• Avoid using passive voice. Don't use phrases like "I hope to…" or "I am aiming at…"

• Write your statement on a word processor so that you can make changes and update it often. Consider using a program where other people can make edits you can see and approve or reject. You should keep older copies so that you can refer to them if you should need to write or talk about your older work or if you have a retrospective.

• Refer to yourself in the first person, not as "the artist". Write it like "In my work I explore …. " This way, there is no doubt the ideas are yours.

• Make it clear and direct, concise and to the point. Go over your statement and see if you have repeated yourself. Look out for redundant words and sloppy grammar. In general, each sentence should take up no more than three lines and be very easy to read. The length of a sentence should relate to the complexity of the idea it intends to convey.

• Your statement should not be longer than one page.

• Use no smaller than 10 – 12 point type. Some people have trouble reading very small type.

• Artist's statements are usually single-spaced.

• Do not use fancy fonts or tricky formatting. The information, not the graphic design, should wow your reader.

• Make sure to include your name at the top as well as the date. This will help people know whose artist statement it is and when it was written.

• Always keep copies of all your artist statements. Don't write over a previous one. You might have a retrospective one day and you may be asked to talk about what you were thinking a long time ago.

 Writer's Block

Writing can be difficult, especially for artists who have not had to write about their work before. It's best to keep things in perspective and realize that it will take many, many rewrites before you've come up with an effective, well-written statement. So don't panic if your first attempts are wrought with false starts and half-constructed ideas. Remember, you have to start somewhere. The most important thing is to start writing! Once the momentum kicks in things tend to fall into place.

Warm up with short writing exercises. Find a place where you will not be interrupted for about two hours. Start by setting a timer for three minutes, and then, without worrying about punctuation, spelling, or grammar, begin writing down words and short phrases that describe your work and your process. Work fast and do not edit or erase anything. When the timer goes off, put this piece of paper aside, or save your work on the computer. Writing in short spurts gets you past the overly self-critical hump, reduces stress, and cuts to the chase.

Without looking at what you have previously written, set the timer again for three minutes and begin by writing about your work in the way you would tell your aunt Florence or a friend about your work. Do not do any editing at this point. Silence your inner critic and let it ride.

If you are having trouble with writing anything at all, write down why you should NOT write an artist statement, and what is getting in the way. Do you fear your writing style or the fact that you never learned the rules of grammar? Do you have lousy spelling? Are you unsure that you can write what you know about your work? Give yourself three minutes, then set this aside.

Then, write down every reason that you should and will write an artist's statement. Again, you have three minutes. Set this aside. Go back to the three-minute writing exercise about your work.

Only when you have collected a pile of three-minute quotations and jottings should you then begin to put them into some kind of order and start to edit.

Sometimes you can find great inspiration in past notes you have taken in your sketchbook. Or you may want to refer to pieces others have written about your work. Think back to critiques and conversations you have had and consider using those ideas if they are relevant.

Still stuck? Record a conversation with a friend about your work. Chose someone you trust who is knowledgeable about your history and your larger body of work. It's best if this person isn't a spouse or family member, as they will probably not give you the critical feedback you need. Find someone who knows a little about art but is also willing to give visceral, gut-instinct feedback. Record the conversation, then go back and transcribe the parts you find most relevant to your work.

You should always be keeping notes and references about other artists making work similar to yours or dealing with similar ideas. Research articles written about these artists. How have critics, curators, and writers described their work? What key phrases keep cropping up? Think about borrowing some of this descriptive language when describing your own work. Just remember not to plagiarize.

Listen to how other artist describe their work, and go to a number of visiting artist lectures. Read interviews in art magazines and consider how these writers and artists talk about work.

6: Résumés

Objectives

Understand what an artist résumé is, and the difference between various kinds of resumes.

Create a resume of your exhibitions, projects, jobs etc.

Things to Consider

Think about and write down a few things that recipients of a resume are looking for. Then write down what they probably do not want to see.

Things To Do

Write a resume or update the one you have already.

Resume Hints

Writing a Resume

The artist resume provides a selected overview of your artistic and professional accomplishments, education, affiliations, and hints at future aspirations. It usually accompanies your artist statement for exhibitions, proposals, and portfolios. While many employers like to receive a one-page resume, the artist resume does not need to follow this convention. Just like artist statements and portfolios, artist resumes should be customized to meet the needs and expectations of each circumstance in which they are needed.

An artist resume is not the same thing as a curriculum vitae or CV, which is primarily used as an academic document.

Always keep a full version of your resume detailing every single accomplishment, exhibition, from the beginning of your art career up to the present. You can then cut and paste sections for a new version as needed.

Formatting Your Resume

Your resume should be clear, concise, and easy to read. Select fonts that are easy to read, and never use less than 10 point type. Use white spaces, and don't try to make it look longer by using fancy graphics, or too much blank space.

Always list your most recent accomplishments first, and go back in time listing past accomplishments.

Always date your resume, so you will know when it is from.

As your career progresses, you will want to add new categories to your resume, such as residencies, catalogs, lectures, etc. How you format your resume says a lot about how you prioritize your practice. Usually artists put their most important info first on a resume. So, if you put your education first, that says something about you. Realize that it is OK to rework your resume for each opportunity or submission.

 # Artist Résumé Structure

The following is a way to format your resume according to guidelines set forth by the College Art Association.

1. Name

Preferred mailing address:
Phone Number(s):
Work:
Studio:
Home:
Fax:
Email:
Personal Web Site: (if appropriate)

Always make sure that you contact information is up to date, and there are a number of ways to contact you. Sometimes galleries will ask that you remove your personal contact info from your resume if you have a sole representation contract with the gallery.

2. Education

Degree	Graduation Date	School, Major or Area of Concentration
M.F.A.	1984	California Institute of the Arts (say: "pending" if you are still in school)
B.A.	1981	California Fresno State University
A.A.	1979	Reedley College

You can list your area of study (i.e. Sculpture, Painting etc.) if your academic institution has these categories. You may also want to list any honors, (i.e. cum laude). It is not uncommon for artists to have studied at a number of institutions without a degree. You can list these periods of study after the degrees.

3. Grants/Awards (Grants/Fellowships, Awards/Honors) You can customize this title to fit your accomplishments

Date	Name of Grant, Name of granting Institution if a applicable.
2003	Tremaine Foundation Grant
1998	California Arts Council Artist Fellowship

4. Solo Exhibitions (One-Person Shows, One and Two-Person Shows, Solo Shows)

Date	Title of Show, Gallery, Curator (if applicable), City, State, (Award for show, if applicable)
2004	Prisoner of Love, Barnsdall Municipal Art Gallery, Los Angeles, CA
1999	M.F.A. Thesis Exhibition, University California San Diego, San Diego, CA

Once you have many shows under your belt, you might want to change the heading to Selected Solo Exhibitions. You can then pick and choose shows that reflect your career best.

If you are a media-based artist, you might want to title this section with Exhibitions and Screenings. If you are a performance artist, then consider Exhibitions and Performances, etc. Use the heading that makes the most sense to you.

Some artists list one or two-person shows in this section, as many spaces have more than one artist doing solo shows at a time.

Make sure you give credit to collaborative projects, and include the names of your collaborators.

If you don't want to separate Solo and Group shows, then demarcate the solo shows in some way. For example, the title might include (*one and two-person shows). In this case you would simply list all of your exhibitions and put a * next to the one and two-person shows.

5. Group Exhibitions

Date	Title of Show, Gallery, Curator if applicable), City, State (Award for show, if applicable)
2004	Prisoner of Love, Municipal Art Gallery, Los Angeles, CA (COLA Award)
	For the Time Being, Side Street Projects, Los Angeles, CA
2003	Tough Terrain, Banff Centre for the Arts, Banff, Canada

If you work on multiple projects of different kinds, you might want to consider the following categories for your resume. Structure these in the same way as you would an exhibition as listed above:

• Public Art Projects
• Commissions
• Curatorial Projects
• Screenings
• Performances
• Lectures and Panels
• Published Projects and Articles
• Books Published
• Software or CD Titles, Videos
• Artist Books
• Membership Activities

6. Bibliography (Selected Bibliography)

Name of Writer. "Title of Article." Title of Publication. Date or issue number: Page number, URL (if applicable).

Christopher Knight. "Portrait of the Artist Abroad." The Los Angeles Times 11 April 2003: D 13

Johnathan Writesalot. "Art As Life" Essays on Art and Everyday Existence: Being There. Ed. Mario Editorio. Toronto: York Publishers, 1991. 56-59.

Some people list the writer first, and then the title of the article. List inclusions in books, magazines and newspaper articles. You might also list radio and TV interviews, and can include that in the heading as Bibliography/Radio/TV. For proper formatting see The MLA Style Guide.

7. Employment (or Current Employment)

Years of Employment	Position, Hiring Institution, City, State
1988-2004	Faculty, California Institute of the Arts, Valencia, CA
1991-2002	Director, Side Street Projects, Los Angeles, CA

Typically, artists list their employment history if their jobs are related to the arts. If you use the heading Current Employment, you can list your current job. However, if you have a history of teaching at well known Universities, or other impressive jobs, you may want to list them here as well.

8. Collections (Public, Private, Corporate)

Peter Norton, Norton Family Foundation, Santa Monica, CA
Museum of Contemporary Art, Los Angeles, CA

This section is for listing notable collections only. Do not list your friends and family here, unless of course they are notable collectors. Be sure to ask private collectors if you can list their names. Sometimes they require privacy for security or other reasons.

9. Current Gallery Representation (if applicable)

Terrain Gallery, San Francisco, CA,
Asher/Faure, Santa Monica, CA
Tom Fisher Gallery, Chicago, IL

✱ Sample Resume

June 2025

Arty McArtist

1234 Resume Ave
Suite 95
Springfield, CA 90000
Cell (555) 000-0000
Studio (555) 000-0000
art@artymcartist.com
www.artymcartist.com

Education

M.F.A. 2020 University of Everywhere, Studio Art, Springfield, CA

B.A. 2010 University of Somewhere, Fine Art & Art History, Springfield, MA

Grants/Awards/Fellowships

2025 The General Grant Imaginary Grant Foundation of American Grantsters and
 Fun Funders

2023 Art Practices Award for Getting Your Shit Together, GYST Art Awards

2013 Fine Fellowship, The Superfly Fellowship Foundation

One and Two-Person Exhibitions

2025 Making My Way, Main Gallery, University of Everywhere, Springfield, CA

2024 The Space Between You & Me, University of Somewhere, Springfield, TN

2019 It's my show and I can cry if I want to., Gallery in Yo' Head, Tel Aviv, Israel

2015 The Show Must Go On, Gallery of the World, Springfield, NY

Group Exhibitions

2025 Summer Group Show, Springfield Community Arts Gallery, Springfield, GA

Art for Arts Sake, Gallery 1234, Springfield, MA

Doing It For Ourselves, The Woods of Springfield, curator: Linda Likesomeart, Springfield, MO

2023 Summer Group Show, Springfield Community Arts Gallery, Springfield, GA

Our Shit is Together, Temporary Project Space, The corner of Spring and Main, Springfield, CO

Artists We Like, Gallery of The World, curator: Madame McBrush, Springfield, NY

2020 Summer Group Show, Springfield Community Arts Gallery, Springfield, GA

This Is Our Show And We're Keeping It That Way, OK?, Red White and Blue Gallery, curator: Cura McSelecto, Springfield, MD

Public Art Projects

2021 Artist Draw The World: Take That Mr. Obelisk, Temporary mural on the Washington Monument, Part of the DC Public Art Fund, Washington, DC

Commissions

2022 Private Mural, The Oscar Wilde Foundation, Springfield, OK

2015 Private Mural, The Mellon Family, Springfield, MN

Curatorial Projects

2016 Everyone Loves Playtime, 1234 Gallery, Springfield, SD

2014 It's All In Our Heads, Performances along 6th Ave., Springfield, ND

Screenings

2024 This is What I Want, The Springfield Film Festival, Springfield, TN

This is What I Want, The Michigan Film Festival, Springfield, MI

Performances

2016 Hey Look At Me: A Corporeal Biography of Masculinity and American Ultimate Frisbee, part of Everyone's Gonna Laugh At Joe, Got It?, October's Space For Innovative Culture, organized by Liz L'Organizer, Springfield, WA

2015 Hey Look At Me: A Corporeal Biography of Masculinity and American Ultimate Frisbee, part of Spring Performances At The Wisconsin Theater, organized by Sally Someone, Springfield, WI

Lectures, Workshops, and Panels

2021 Getting Your Sh*t Together, Ten-week workshop, Space for Artists, Springfield, WY

How I Learned To Stop Worrying And Learned To Love Getting My Sh*t Together, Presentation in coilaboration with Tyler Teacher, University of Alabama, Springfield, AL

Published Projects and Articles

2025 "Don't Stop Believing: How Fortune Telling Will Change The Art World." Introvert Magazine Issue No. 12, Fall, 2005. P.23-26

2023 "Artist Loves Resume, Changes World." The Los Angeles Times September 25, 2023: A1-2

Books Published

2025 My Book Likes It When You Touch: A Book For Your Hands. New York: Generous Publishers.

Membership Activities

2024 – Present The College Art Association (Member)

Bibliography

2025 Reba Reporter. "This Art is Cool." The Springfield Examiner 21 May 2025: D 13.

Donald Drudge. "Artists With Resumes." The Springfield Word 9 March 2025: A14-15.

2020 Walter Writer. "Art Worth Thinking About" <u>Art Monthly</u> Jan-Feb. 2005: 123-28.

2015 On Onlinika. "Art That Moves You" The Artminded Bloggie Blogger. 23 Oct. 2015.12
 Apr. 2015 <http://www.artmindedblogieblog.com/thisisthearticlehtm>.

Employment

2025-Present Assistant Professor of Studio Art, Springfield University, Springfield, HI

2015-25 Registrar, Gallery of Cool Art, Springfield, HI

Collections

AT&T Corporate Collection
The Michelle And Barack Obama Family Collection

Current Gallery Representation

A Very Understanding Gallery, 1234 Gallery Drive, Springfield, OR

7: Time Management & Organization

Objectives

Review time management skills to estimate
how time is spent.

Make appropriate changes to activities to
increase productivity and eliminate wasted time.

Schedule a staff meeting with yourself each week.

Schedule both creative time and down time in
order to balance a work week.

Things to Consider

Think about and write down strategies for
creating a time management system. You
might include setting aside a day or evening
for studio work, and an evening for business of
art activities. Keep the schedule consistent.

Once a week go over your goals and lists to see
what you need to re-prioritize.

Time Management

Time is an important resource which needs to be managed in order for things to be accomplished. Below are some steps to take in order to evaluate how you spend your time, understand how long it takes you to do activities , and develop an overall picture of how you spend your time.

1. First, every business or company that is successful has staff meetings. Since you are a business of one, you should also consider having staff meetings with yourself. Make lists of those items that are the most important to get done, and schedule what you think you can accomplish in one week. Prioritize those items.

At every staff meeting with yourself, go over your list and take what you did not accomplish this week, and roll it over to the current week, perhaps making those items a priority.

Be sure to schedule time for unexpected items and issues that may arise, as they always do.

2. A good way to figure out how you spend your time is to track it for 2 weeks. Evaluate how you spent your time and how you might do similar tasks together, instead of jumping from item to item. You might put everything you have to do outside your studio on one day, so you are not running around every day. You might decide that you would rather work at night, instead of during the day.

3. Evaluate how rewarding an activity may have been versus the time you spent doing it. How much did you accomplish and was it productive? Can you make any changes to make things go smoother? Did you under-schedule enough hours to complete the items required?

4. You may need to make a long term schedule, such as work in your studio every Saturday and Tuesday and Thursday nights. Maybe Wednesday nights are for doing all the arts business issues such as updating your mailing list or sending out invoices, or doing the books. This way you won't be so behind should you need pertinent information for a grant or a project proposal.

5. You may need to schedule time to relax in addition to creative time. Being overworked doesn't always help creativity. You may need to create a balance for yourself.

8: Presentation Venues

 ## Objectives

Understand why an artist would want to show their work in a public venue.

Understand a variety of presentation venues for artists, what their strengths and weaknesses are, and how they might or might not be good for your work.

Understand the context of how work is presented and how that work may change according to its presentation site.

 ## Things To Do

Fill out the 10 Venues Sheet.

 ## Presentation Venues

Museums

ABOUT: There are many different types of museums. Some museums are encyclopedic, meaning they strive to collect works which represent a good cross section of art history. Some contemporary art museums are dedicated to only exhibiting and collecting the work of living artists. Each museum has a specific mission so it's important to do your research to understand what they are likely to showcase. Depending on the institution, museums offer one-person, group, thematic, invitational and juried exhibitions. Most do not accept proposals for review, but some do. Most have their own curatorial staff, who invite artists to exhibit work. Most museums do not accept unsolicited donations of artwork.

EXPECTATIONS: Most museums now have Web sites, which will usually let you know their policies for submissions or studio visits. If not, be sure to call the staff before sending information. Many museums schedule their exhibitions 2 – 4 years in advance.

PROS: Museums are prestigious venues. The level of professionalism and assistance to the artist is high. Additionally, if the museum buys your work it is likely that the prices and demand for the rest of your work will increase.

CONS: Most museums will not consider unsolicited proposals. Many museums still do not provide an artist fee.

RESEARCH: Research online or call museums to find out their selection process, or if they have open call exhibitions. Most will publicize applications and information. Be sure to find out their policies for a requesting a studio visit.

RESOURCES: AAM is the Association of American Museums. Also, the summer issue of Art in America lists most all museums in the U.S.

Commercial Galleries

ABOUT: Galleries are for-profit businesses that select artists either by open call or private selection. Gallery dealers make their money from sales of the artwork. The commission the dealer takes from the sale of this work can range from 40 – 90%. Most sales should be about 50% to the dealer and 50% to the artist. No two galleries are alike, so research is a must! Artists are treated very differently from gallery to gallery. For more information see the Galleries section in this manual.

EXPECTATIONS: A working relationship between the artist and the dealer should result in the promotion of the artist's work. A good gallery will cover the costs of exhibitions and shipping. This requires trust, good communication, and up-to-date consignment agreements. Artists represented exclusively by a gallery usually have at least one solo exhibition at that gallery every three years. Most galleries deal with a small number of artists on a regular basis.

PROS: Good galleries are active in the promotion and marketing of their artists. An artist can build a long-term relationship with a good gallery. Regular sales through a gallery can provide a steady income to an artist. Having a good gallery on your side can lead to more visible shows in museums and other galleries in other cities.

CONS: Galleries that are run poorly do not actively sell work, can renege on contracts, and be slow to pay artists. Some galleries do not sign contracts. This should make you suspicious. Some galleries expect the artist to cover gallery costs. Some take a large commission, using excuses such as the high costs of promoting emerging artists, which require more work. Never accept less than a 50-50% split. Always have good contracts and never pay to show your work.

RESEARCH: Make sure you find out which galleries show the kind of work you make. Not all galleries review work, so make sure you call first, or check their Web site. Often galleries like to receive an email with an image of your work, and a way to contact you or see more images. Be sure to find out how they operate. Thoroughly investigate their business practices and their relationship with their current and past artists.

RESOURCES: Most large cities have gallery guides that list galleries and who they represent. Art in America has an annual issue that lists most galleries in the US. The Gallery Guide National and Regional Editions is a good place to look, as well as calendar listings in your local newspaper or weeklies.

Nonprofit and Artist Run Spaces

ABOUT: Traditionally called alternative spaces, these organizations began in the 1970s to expand exhibition opportunities for artists. These exhibition spaces are supported through public and private funding. They often have many opportunities for artists and do educational programming as well.

EXPECTATIONS: These spaces generally work with a range of artists from emerging to established. They often will show work that is

risky, or experimental. Many support local and regional artists and usually pay an artist fee for showing work. Some take a small percentage of the price of work sold. They are usually a good place for emerging artists to begin showing work, as the staff is often supportive of artists.

PROS: Nonprofits are usually accessible to emerging artists, often pay an artist fee, and often present programming that reflects community concerns. Many do group exhibitions that allow an artist to get started showing work. Most spaces encourage the submission of proposals from artists and curators. They often have an exhibition committee of artist peers who make decisions.

CONS: Often these spaces are financially challenged, and will sometimes request that the artist help fund the exhibition.

RESEARCH: Be sure to understand the mission of the organization and see if your work fits their mandate. Contact the organization or visit the Web site to find out about submission guidelines.

RESOURCES: Art in America's Annual Guide lists many nonprofits. National and regional gallery guides, and Web sites are good places to find out about these spaces. Also, you may contact your state's arts council or commission. Check out your city's Cultural Affairs Department for information.

Alternative Venues

ABOUT: These are exhibition sites that don't fit into any of the rest of the categories listed here. They include banks, bookstores and other commercial venues, corporate and city government lobbies, restaurants, schools etc.

EXPECTATIONS: Work is hung in a public space. Often the responsibilities for labor and expenses fall onto the artist.

PROS: A good way to introduce your work to new audiences, and/or create an important context for the work. If you are working with a business or corporate setting, sometimes they don't schedule work far in advance, so you can get a show within a year. This is good for calendar-specific subject matter. Also some critics and curators are very interested in seeing work in unconventional settings.

CONS: The artist may have to work out their own insurance, the exhibition space might be less than ideal, and the majority of the work on the project falls to the artist. It can also be difficult to get people to visit out-of-the-way venues or venues where they are expected to pay money to see the work.

RESEARCH: Make contacts by visiting local venues and talking with the manager or owner. Search out venues where artists have already shown their work.

RESOURCES: There are no listings of sites, but talking to your peers for ideas is helpful. For context-specific sites, check out the web and the local yellow pages.

College and University Galleries

ABOUT: Many colleges and universities have galleries supported by the institution. Many are open to proposals from the field. Some have a dedicated curator on staff, others are student-run or managed by faculty. Some college galleries often have a built-in audience of students and faculty.

EXPECTATIONS: Many of these spaces function like museums or nonprofit spaces. Contact them to find out submission guidelines.

PROS: Colleges and universities provide good opportunities to exhibit work. Many have substantial staff, and most will support financial aspects of the exhibition or project. Many fund a brochure or a catalog and some pay artist fees.

CONS: Some exhibition spaces are less than desirable, or hard to get to for the general public. Some have parking issues. Security can be an issue at some sites.

RESEARCH: Visit the Web site or call to find out if they accept proposals. Many of these galleries are scheduled 2 – 3 years in advance.

RESOURCES: Art in America's Annual Guide, local listings in publications, and Web sites.

Private Art Dealers and Art Consultants

ABOUT: Many private dealers and consultants work from their home or a small office. Most do not organize public exhibitions. Some work with a specific genre or media, others choose artists on a project-to-project basis. Some make their money from the sale of an artist's work, and others don't.

EXPECTATIONS: Private art dealers and consultants generally work with a wide range of artists. A corporate art consultant works on a project basis with a client to build a collection. Most consultants take a commission from sales.

PROS: Working with private art dealers and consultants can be a good source of income. An artist may work with several consultants at one time.

CONS: Work is sold without being publicly exhibited. Some consultants or dealers may not have the best interests of artists in mind. They may take advantage of artists they work with.

RESEARCH: Contact individual consultants to find out how to submit work samples. Many consultants hold on to images of an artist's work in order to make presentations. Some consultants will consign work.

RESOURCES: Art in America's Annual Guide and local web listings. Other artists are a good resource.

Rental Galleries

ABOUT: Rental Galleries are often associated with museums or decorating services. They show the work of artists and rent the work by the month or year.

EXPECTATIONS: Rental galleries generally work with a wide range of artists. They expect artists to consign work to them for varying periods of time.

PROS: Rental galleries can be a good way to generate income from your work. Also some curators and collectors periodically visit rental galleries to find new artists' work.

CONS: Many of these works are hung in private places, so are not open to viewing by the public. Also some rental galleries rent work to decorators and designers who can damage work. Make sure your work is insured.

RESEARCH: Check the Web for information, or consult other artists.

RESOURCES: Web listings are probably the best place to start. You might also want to contact your local arts organizations.

Corporate Art Collections

ABOUT: Corporate art collections range from Fortune 500 corporations, to hospitals, to local restaurants. Art is purchased for investment, office furnishing, prestige, and employee morale. Some corporations have in-house curators on staff.

EXPECTATIONS: Corporations generally purchase non-controversial work, usually through independent arts consultants or in-house staff. They seldom purchase directly from artists. Some collections specialize in a particular media, region or theme.

PROS: Corporate art collections can be a good resume booster, and a good source of income. Often they commission work for particular spaces. If an employee admires an artist's work in the collection, they may purchase some for their home. Also people on corporate boards of directors who collect work sometimes donate work to museums, so your work may be more appealing to them if your work is in their company's corporate collection.

CONS: Often if your work is in a corporate collection it won't be seen by the general public. If the corporation goes bankrupt, your work may not be protected. Sometimes it is hard for the artist to borrow the work back from a corporate collection for a show or retrospective.

RESEARCH: Contact the curator of the corporate collection to get protocols for submission, or work with an art advisor.

RESOURCES: Corporate Web sites and philanthropy publications.

Registries (Formerly Known as Slide Registries)

ABOUT: Slide registries can be actual archives for physical slides or virtual databases for digital images. Many slide registries are sponsored by local arts organizations, museums, libraries, and public art agencies. Many are curated and made available to the public, curators, collectors, critics and historians for exhibition opportunities, articles, and research.

EXPECTATIONS: Some slide libraries open to the public, some are curated, or open only to invited members. Registries will also collect other information such as resumes, catalogs, exhibition announcements, prints etc. in a file folder to be viewed upon request. Each slide library has its own requirements.

PROS: Slide registries and libraries are a great opportunity to get your work seen by curators and collectors. Some registries have an online database that can be accessed worldwide. A good registry will ask for periodic updates.

CONS: Poorly maintained registries can get little traffic and often contain mainly out of date materials. Remember to update any slide registry that you are in, even if not requested, at least once a year, especially if contact information changes.

RESEARCH: Research online or call to find out if the organization has a slide registry. An application form with necessary materials is usually available

RESOURCES: Web sites with registry listings.

Open Studios

ABOUT: An open studio consists of an artist or group of artists hosting an event for viewing,

celebration, and selling of artwork. This can be at their actual studio spaces, or artists can come together to show work in one studio space.

EXPECTATIONS: Open studios can happen in many ways. Expectations are based on the organizer of the event. If the open studio takes place at an individual artist's studio, the artist does all the work.

PROS: Open studios are a great way to introduce new work to the curious public. Sales and contracts can result from open studios. Connections with other artists can be made, as well as with curators and galleries.

CONS: Usually all expenses for an open studio are paid by the artist. The artist has to be available for all hours of the event, which can be exhausting.

RESEARCH: Artists should have open studios for two consecutive days, also offer hours by appointment. Develop and share good mailing lists. A great idea is to team up with other artists for group open studios.

RESOURCES: Talk to other artists and organizations that have put on open studio events.

Online Galleries and Sales Sites

ABOUT: There are both for-profit and nonprofit online galleries. The best ones are curated and put up a selection of artists' works for sale or visibility. They can be small online databases or massive digital warehouses of work.

EXPECTATIONS: Some online galleries require members to pay monthly or yearly fees. Some membership organizations allow members to post work on their Web site. Other Web sites are exclusively for showing or sales, and artists are

curated into the online collection. Commercial online galleries take a commission on sales.

PROS: Online galleries are a good way to direct people to your work, plus they provide visibility to an expanded audience.

CONS: Your work will be seen in the context of other artists' work. If you are concerned, make sure you check out the submission policies and the artists currently on the site. Not all sites have good sales records. Many charge a fee for each work displayed. Not all work looks good online. If someone buys your work online, has it shipped to them, and they don't like it or it doesn't correspond to the image online, they have the right to return it, which can be a financial and mental battle.

RESEARCH: Conduct online searches for information. Talk to other artists who use these services.

RESOURCES: Some Web sites have listings of online galleries.

Vanity Galleries

ABOUT: Vanity galleries are for-profit galleries that require artists to pay for exhibition of their work as well as many other related expenses. They may also require an additional commission on work sold.

EXPECTATIONS: Vanity galleries generally charge for all associated expenses of the exhibition, including publicity, rental of the space, shipping etc.

PROS: A chance to show your work.

CONS: A vanity gallery has little incentive to sell or promote your work because they are getting

money from you up front anyway. Vanity galleries usually represent poor quality artists. They usually give the artist a bad name because the artist had to buy a place to exhibit work. Vanity galleries don't look good on your resume.

RESEARCH: Find online.

Juried Exhibitions

ABOUT: Juried exhibitions are offered worldwide, through galleries, museums, organizations and arts councils. They usually consist of a call for entries, where artists are asked to submit their works for review by a guest curator or jury panel.

EXPECTATIONS: Sometimes artists are required to pay to submit their work for review, sometimes they are not. Often juried exhibitions are fundraising campaigns for nonprofits or commercial spaces, where they make money off of artists paying to submit work. Usually artists pay to ship their work to and from the venue. Some juried exhibitions offer prizes to select artists and sometimes publish a catalog to accompany the show.

PROS: Juried exhibitions are one way to get visibility for your work. This can be good for emerging artists because their work can get in front of important jurors or panels.

CONS: Applying to multiple juried shows can be expensive. A good juror does not ensure high quality of work chosen or visibility for the artist. You may not like the context your work is placed in or the other artists chosen alongside you. The artist is most often responsible for shipping, framing and packing of work.

RESEARCH: Art classifieds, Web sites and local listings.

RESOURCES: Art Calendar's Web site, nyfa.org, art calendars, Artweek, Afterimage and other sites.

CO-OP Galleries

ABOUT: Co-op galleries are based on artist participation and membership, in which the artists share the expenses and business responsibilities of the gallery.

EXPECTATIONS: Usually artists who participate in co-op galleries have to pay a monthly or yearly fee in return for a guaranteed show of their work. Artists must apply for membership. And sometimes have to put in time or labor, like sitting in the gallery or managing accounts, etc.

PROS: A co-op gallery is a guaranteed venue. Some of the older ones are well respected and reviewed regularly. Sometimes a co-op gallery is the only local exhibition opportunity available to artists in rural or overlooked locations.

CONS: Sometimes, participating in a co-op, having to deal with group dynamics, can get political and lead to in-fighting. Some co-ops have a bad reputation because some people consider them a venue where an artist pays to exhibit their work.

RESEARCH: Take the same procedures as most commercial galleries. Inquire about a co-op's financial standing. Do your homework.

RESOURCES: Online research and Art in America Annual Guide.

Public Art Programs

ABOUT: Public art programs consist of commission and sale opportunities to artists sponsored by federal, state, municipal agencies and independent organizations for work in a

public context. They can entail both large and small-scale projects.

EXPECTATIONS: Art councils often administer these programs. Artists are selected by panel process and are then asked to submit a proposal. They are often curated from slide registries.

PROS: Public art programs provide a good opportunity to have work seen by many, which can lead to other opportunities. They also provide a chance to execute projects on a scale that you can't otherwise afford.

CONS: Working in public can require the artist to adapt their intent, and work within strict budgets and guidelines. Many programs want artists with previous public art experience. Work can be vandalized.

RESEARCH: Contact your local arts council and consult with public art program directories. Conduct online searches.

RESOURCES: Americans for the Arts, Public Art Directories.

Art Fairs and Festivals

ABOUT: Art festivals can come in many forms. Mostly, festivals consist of environments where artists sell their work directly to buyers in rented space or at rented tables. Generally art festivals take place yearly and on a state or regional level. Art Fairs on the other hand are held for galleries to sell their inventory to dealers and collectors, often on an international scale.

EXPECTATIONS: For festivals, artists and/or dealers are expected to pay for the space. At an art fair, usually the gallery owner or dealer pays for the space rental. In both situations, the gallery, artist, or one of the gallery's

representatives must be on hand to sell work to the public.

PROS: Sales are directly to the public. This can be a good way to make money in a small amount of time. Also these exhibition opportunities usually come with high foot traffic. Also festivals and fairs can be an excellent way to network with other artists, galleries, curators, and collectors and can be a good way to introduce the work of an artist outside of the context of a gallery show.

CONS: Fairs and Festivals can be expensive to enter. The artist or dealer must be on-site at all times. Also these exhibition opportunities can be inadequate spaces to view work.

RESEARCH: Before you commit carefully research the venue and the quality of work displayed there in the past.

RESOURCES: Art in America Annual Guide, local guides and listings and the Web.

Auctions and Benefits

ABOUT: Donating work to an auction is a great way to help out a nonprofit organization or a good cause, and gain exposure for your artwork. Auctions come in many different forms. Some auctions are silent, where the host institution has a party and invites guests to silently outbid on bid sheets. Some auctions are open forums where people bid for work out loud. Some auctions are curated by the host institution, others involve more submissions or work from a larger, more nebulous pool of artists.

EXPECTATIONS: Artist donates the work, and the organization takes care of the sales. Artists usually pay for framing costs and sometimes shipping. Sometimes an artist needs to set the minimum bid for their work.

PROS: Sales are directly to the public, and there can be high foot traffic. The artist sometimes receives a percentage of the sale. Auctions can provide great exposure for emerging artists because collectors, curators, and other artists often attend these auctions.

CONS: It costs money to create the artwork and usually the artists does not recoup this money when the work sells.

RESEARCH: Carefully research the venue and the quality of work displayed in the past before you commit.

RESOURCES: Many museums and artist run spaces hold auctions of artists' work.

Alternate Presentation Sites

If you are going to engage in exhibiting your work in these alternative venues, be sure to get the required permits or permission if needed. If you have more suggestions to add to this list, email info@gyst-ink.com

City Hall or Government Buildings

Houses, apartments, garages, living rooms (both commercial and alternative spaces)

Empty stores in malls (e.g. Beverly Naidus' installation project)

Restaurants

Storefronts of existing businesses, (e.g. flower market, architect's office, etc.)

Public schools, especially their theater spaces

Abandoned buildings

Theaters on their "dark" days

Fences and sidewalks

Walls of concert halls, theaters, or other performance venues

Movie theaters (e.g. "Projections", Karen Atkinson and Sylvia Bowyer)

Buses (they sell advertising space)

Subway or metro

Billboards (some companies give discounts to artists) or alter an existing one

Signage (can go anywhere)

Front lawns of business or suburban neighborhoods Parks

Public spaces in front of a business

Parking lots (project a movie, project slide work, or do a performance)

Loft spaces

Rent a space at the swap meet for exhibition or performance

Newspaper space (ads, classifieds, personals, e.g. Group Material)

Check out a local rag or magazine, especially if they are just getting started

Storage space in a storage building

Posters

Mail art

Postcards

Park your car (installation or sculpture) on the side of the road, and feed the meter (e.g. Foundation for Art Resources)

Paint the side of a truck or semi

Install a show in a truck, and park at another gallery opening

Performance in a truck

Banners

Flags

Public libraries (e.g. ,"6 Degrees" exhibition by
 Side Street Projects)

Coffee houses

Use a taxi, drive a taxi

Slip posters or printouts inside newspapers
 (buy a paper and insert your work into the
 rest of the papers)

Calendars

Birthday cards

Hair salons

Furniture store

Laundromat

Rooftops of buildings

The beach

Local celebrations and festivals

Enter a parade (e.g. the Doo-Dah Parade in
 Pasadena, California)

Dentist or doctor's office

Model homes

The front door of your house or apartment

Bookstores

Block parties

Empty fields

Parking structures

Infiltrate parties as caterer/server

Student unions at universities

Churches, especially progressive ones (e.g., Tim
 Miller's performance with a Minister)

Gridlock Shows, when traffic is stopped, hand
 out your artwork

Sandwich billboards (walking art performance)

Slip art into books in the public library or
 magazine rack

Sky writing

The Internet

Safe deposit boxes in a bank

Alter store bought goods and return to shelves
 (e.g. Barbie Liberation Movement)

Digital projections can be projected almost
 anywhere (statues, monuments, buildings,
 from inside your car)

For a public art reception, put reception goods
 in trunk of car and serve from there

Riverbeds

Hiking trails (e.g. New Town's events)

Overpasses

View master (e.g. Karen Atkinson and Sylvia
 Bowyer for "Projections" catalog)

Parking meters (e.g. Karen Atkinson)

Audio can be broadcast almost anywhere (e.g.
 Terry Allen's trees at UCSD)

Stages built in public sites

Used or new car lot

Republican or Democratic Convention's
alternative stage area (e.g. Side Street Projects)

Exhibitions and installations in Motel and
 Hotels

Short weekend shows in all sorts of places (e.g.
 Dave Muller's Three Day Weekends)

10 Venues

Venue	Contact Person	Venue Interests	Artists they Exhibit	Submission Requirements

9: Artwork Inventory

 Objectives

Understand why keeping track of what you make as an artist is important.

Understanding what you should keep track of.

Create a system for tracking your work and knowing where it is at all times.

 Things to Consider

Think about and write down why you should keep track of your work. Why you should keep track of your work even if your gallery does it for you. (What if the gallery goes out of business and you don't get the information?)

✳ Things To Do

Fill out at least 5 forms for 5 works.

 Artwork Inventory

Inventory Number ⎯⎯⎯⎯⎯⎯⎯⎯⎯⎯⎯⎯⎯⎯⎯⎯

Title of Work ⎯⎯⎯⎯⎯⎯⎯⎯⎯⎯⎯⎯⎯⎯⎯⎯⎯⎯⎯⎯

Mediums ⎯⎯⎯⎯⎯⎯⎯⎯⎯⎯⎯⎯⎯⎯⎯⎯⎯⎯⎯⎯⎯⎯

Size (framed) ⎯⎯⎯⎯⎯⎯⎯⎯⎯⎯⎯ Size (unframed) ⎯⎯⎯⎯⎯⎯⎯⎯⎯

Category ⎯⎯⎯⎯⎯⎯⎯⎯⎯⎯⎯⎯⎯⎯⎯⎯⎯⎯⎯⎯⎯⎯

Date Created ⎯⎯⎯⎯⎯⎯⎯⎯⎯⎯⎯⎯⎯⎯⎯⎯⎯⎯⎯⎯

Edition of ⎯⎯⎯⎯⎯⎯⎯⎯⎯⎯⎯ Where signed ⎯⎯⎯⎯⎯⎯⎯⎯⎯⎯

Status ⎯⎯⎯⎯⎯⎯⎯⎯⎯⎯⎯⎯⎯⎯⎯⎯⎯⎯⎯⎯⎯⎯⎯

Image File Name ⎯⎯⎯⎯⎯⎯⎯⎯⎯⎯⎯⎯⎯⎯⎯⎯⎯⎯⎯

Kind of image ⎯⎯⎯⎯⎯⎯⎯⎯⎯⎯⎯ Where Stored? ⎯⎯⎯⎯⎯⎯⎯⎯⎯

Work Location ⎯⎯⎯⎯⎯⎯⎯⎯⎯⎯⎯⎯⎯⎯⎯⎯⎯⎯⎯⎯

Work Description ⎯⎯⎯⎯⎯⎯⎯⎯⎯⎯⎯⎯⎯⎯⎯⎯⎯⎯⎯

⎯⎯⎯⎯⎯⎯⎯⎯⎯⎯⎯⎯⎯⎯⎯⎯⎯⎯⎯⎯⎯⎯⎯⎯⎯⎯⎯⎯

⎯⎯⎯⎯⎯⎯⎯⎯⎯⎯⎯⎯⎯⎯⎯⎯⎯⎯⎯⎯⎯⎯⎯⎯⎯⎯⎯⎯

Expenses Total ⎯⎯⎯⎯⎯⎯⎯⎯⎯⎯⎯⎯⎯⎯⎯⎯⎯⎯⎯⎯

Collected by ⎯⎯⎯⎯⎯⎯⎯⎯⎯⎯⎯⎯⎯⎯⎯⎯⎯⎯⎯⎯⎯

Sold by ⎯⎯⎯⎯⎯⎯⎯⎯⎯⎯⎯⎯⎯⎯⎯⎯⎯⎯⎯⎯⎯⎯⎯

Date Sold ⎯⎯⎯⎯⎯⎯⎯⎯⎯⎯⎯⎯⎯⎯⎯⎯⎯⎯⎯⎯⎯⎯

Wholesale Price ⎯⎯⎯⎯⎯⎯⎯⎯⎯⎯⎯ Artist Received ⎯⎯⎯⎯⎯⎯⎯⎯⎯

 # Information for Artwork Inventory

Information for Artwork Inventory

Inventory #:
• You can devise your own tracking number system. Here is a suggestion.

The first number should be the last two digits of the year the work is completed. 03 for 2003, or use the full year. The next letter should define a category. For example:

P = Painting S = Sculpture E =Edition
V = Video F=Photo M = Media
D = Drawing I - Installation

Then a number for each item. A painting might be numbered, 03P-023. This would be the 23rd painting done in 2003.

If you have an edition, you can add yet another set of numbers. For instance, it might be labeled 03E-002-21. This would be the 2nd print done in 2003, and the edition number is 21.

Title:
• This should include the title of the artwork.

Category:
• List the medium or other descriptive title. This is very useful for doing searches for all your paintings for instance.

Date Created:
• This can be the exact date the work is finished, or just the month and year.

Medium(s):
• Add the various mediums that you used to create the work. Details can be useful if you need to sort by this category.

Dimensions:
• This should include the height, width, depth of the work (in that order). Or variable, for an installation, or the length of a video work.

Use separate areas for framed and unframed dimensions.

Edition:
• Include the number of editions of this work. Details can be included in the description section.

Status:
• Keep track of what work is sold, what is available, or who you have given work to as a gift.

Description:
• Describe the artwork visually for added tracking, and for archival purposes.

Expenses:
• You can keep track of your expenses for each artwork so you know you are not losing money when you set the price.

Collection:
• Keep track of who owns your work. If it is resold to another buyer you can track who owns it (if anyone tells you they sold it). See Resale Royalties Act in CA.

Prices:
• Keep track of who sold the work and when it was sold. Include how much you received for the work, and when you were paid.

10: Condition Reports

 ## Objectives

Understand what condition reports are for and how to fill out a condition report

 ## Things To Do

Fill out a condition report for each of your works.

 ## About Condition Reports

Condition reports are a tool artists, curators, conservators, insurance companies, appraisers, and museum professionals use to keep track of the changing physical condition of artworks and their attendant structures (like frames, pedestals, hanging equipment, etc.). Condition reports help to keep tabs on the physical health of art and are very important when it comes to appraising the value of work. Serious arts institutions will ask that you submit a signed condition report for each work you leave in their care. This condition report will be reviewed by the institution and will be updated before the work is returned to its owner. Condition reports are a safeguard against future destruction of the work and help to cover liability for damaged work.

Each institution has its own special way of constructing and writing condition reports, but each report has some basic features. You will find each of these fields in the condition report included in this software:

• Date of report
• Name person conducting report
• Address

• Phone
• Email
• Art reference number
• Title of work
• Date work was created
• Medium
• Dimensions

If you can, remember to use white gloves when evaluating the condition of work. White gloves allow you to notice when work is dirty and they also protect the work from destructive oils on your hands. An actual evaluation never uses terms like "good, bad, or fair"; it sticks to specifics and is only concerned with physical changes to the work.

The condition report is divided into two sections: Recto, meaning front; and verso, meaning back. There is usually a space to make a rough drawing of the work divided into a grid. The person conducting the report usually makes notes on this drawing indicating where there is damage to the work. This can be done by giving each instance of damage its own letter that corresponds to a written report adjacent to the drawing. For example, if there is a tear in a painting, the tear will be indicated on the drawing and given the letter A. On the description side the letter A appears alongside the note "2.5 in. tear in canvas. Tear has punctured varnish, paint, and has gone clear to verso." If the tear has caused the paint around the opening to flake, you would note this too. The more detailed the analysis, the better. A detailed photo of the damage can be very useful on the report, or attached.
If you are evaluating the condition of a sculpture, choose which side will be the front,

and which the back, and use your drawing to show this delineation. For media, or time based work, you will have to make notes as to when damage occurs, perhaps using the time code of a DVD, or a frame of a film.

Here is some terminology for creating or reading a condition report:

• Abrasion– An alteration of the surface of a work caused by friction with another object.

• Accretion– A build up of material on the surface of the work. Make notes as to what this substance is, because it's not always dust or dirt.

• Blanching– numerous tiny white dots or specs occurring on a painted or treated surface. This usually results from poor handling and puncturing.

• Bleeding– The spread of pigment after the work has been created. Usually related to water damage.

• Bloom– Less serious than blanching, but also containing numerous small white dots marring the clarity of a painted surface. Usually located in the varnish of a painting.

• Blush– Damage similar to a bloom occurring in lacquer.

• Check– the opening of a piece of wood occurring along the grain. It is smaller than a split in the wood but usually precludes to a larger split.

• Chip– a broken piece of material on the work, usually fully or partially separated from the work.

• Cleavage– an area of small cracks in the work separating the underlying material of the work.

• Cockling– two or more parallel waves on a piece of un-creased paper

• Corrosion– loss to a portion of the work where a foreign agent has caused a chemical reaction.

• Crack- a linear or planar fault in a surface. This can also be a break in the surface of the work that does not involve loss of material.

• Crackle- an area of perpendicular cracks that does not involve Cleavage.

• Craquelure– an intricate accumulation of Crackle often caused by climate changes.

• Crevice- a narrow but deep type of Crackle

• Dent- A concave distortion in the surface that does not include Loss.

• Dig- a Dent that includes Loss or Displacement.

• Discoloration- any change in color.

• Dishing (aka Draw)– A warping or disruption of the surface of a canvas caused by unequal tension along the canvas' stretcher.

• Disjoin- a separation of elements or portions of an object, in which the separation can be complete or incomplete.

• Dust- the accumulation of fine, particle-like ambient dirt.

• Embrittlement- self-explanatory, the process by which a work becomes more brittle, usually because of exposure to heat or extremely arid climates.

• Erosion- a loss of material, usually due to Abrasion or Embrittlement.

• Fading– Discoloration resulting in the loss of saturation or value of pigment.

• Fingerprint- This is obvious. But make sure to note which digit of the hand it is if possible.

• Foxing - Corrosion of paper, often resulting from mold spores or rusting iron in the paper's pulp.

• Gouge– An area where material has been lost due to a scooping abrasion.

• Grime– Where dust or other foreign powdery matter sticks to the surface of the work, usually bonding with an oily medium.

• Lacuna (aka Loss)– Where a portion of the material of a work has gone missing.

• Rift– Like Crackle, but wider.

• Run– Where foreign viscous matter has dried on the work.

• Smear– Grime that has spread over the work, usually due to human intervention.

• Spatter– Dried foreign matter splattered on the surface of a work.

• Split- a Check that runs the entire length of a wood's grain.

• Stain- Discoloration resulting in both fading and darkening of the surface of a work.

• Stretcher Crease– A fold or crease with attendant fine cracks along an edge of a painting's stretcher.

• Tear- self-explanatory, usually applied to cloth or paper.

Condition Report

Name:

Business:

Address:

City, State, Zip:

Phone:

Email:

Date of Condition Report:

Person Creating Report:

Title:

Tracking Number:

Date Work Created:

Medium(s):

Dimensions:

Mark below where there is a condition issue on the work.

Recto (Front) Diagram Description:

Mark below where there is a condition issue on the work.

Verso (Back) Diagram Description:

11: Exhibition Forms

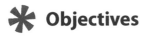 **Objectives**

Understand why it is important to keep track of exhibitions and reminders of those things you need to remember to do for each show.

Create a checklist for historical purposes and a reminder to update your resume

Develop reliable organizational skills

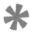 **Things to Consider**

Ask yourself why having this info organized is important. Write down your main reasons.

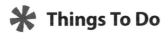 **Things To Do**

Fill out a form for each exhibition you have done, and for exhibitions you are working on now.

 Exhibition Form

Exhibition Title _____

Exhibition Dates _____ Exhibition Type solo or group _____

Contact Person _____

Contact E-mail _____

Contact Phone _____ Where _____

Address _____

Contract Signed? _____

Artist Fee _____ Insurance _____

Shipping Requirements _____

Who pays for shipping? _____

Announcement Information: _____

Any installation support? _____

Delivery of Artwork Due _____

Artwork Pick Up Date _____

Exhibition Checklist Delivered _____

Gallery Commission _____

Press Release Information Deadline _____

Catalog Information Deadline _____

Opening Reception Date _____

Other exhibition participants _____

12: Portfolios

 Objectives

Create a portfolio in order to present your work in a professional way

Understand what a portfolio is for and ways to use it to further your career

Understand the various options for creating a portfolio and resources for help

 Things to Consider

Your portfolio should include:

- Cover Letter
- Artist Statement
- Resume
- Work Samples
- Work Samples description sheet
- Written proposal for what you would like to present
- Budget for the project you want to do

1. Consider asking your artist peers or friends to come in and review your portfolio with you. It may even be fun to have them bring their portfolios as well.

2. Have each of them fill out a portfolio evaluation sheet for you and one another if they want to participate.

 Things To Do

Write down why a portfolio is important, and where it will get used. Think about why you should have a portfolio ready at all times. Now go grab that portfolio, if you have one, and look at it.

 Your Portfolio

Your portfolio is what speaks for you, whether or not you are there when it is presented. It is a visual representation of your work and your degree of professionalism, as well as a record of your accomplishments. It is essential in working with clients, applying for a job, applying for graduate school or requesting an exhibition. You should have a portfolio by the time you graduate from art school or when you feel you are ready to go after a job or exhibition. A portfolio is similar whether you are an artist, a graphic designer or in another arts related field. It displays examples of your work, and can either be hand carried, mailed, or presented digitally. (See Digital Portfolios section)

Documentation of your work is vital. Not only does your work need to look good in its original form, but also it has to look good in slide or digital form. Pay careful attention to documenting your work, as it can make or break your chances of getting what you want. Bad reproductions of your work are like presenting bad work. Many artists have been eliminated from grant applications for having bad photographs of their work in their portfolio. (See Documentation section)

Proofread your portfolio before sending it out. Have someone else proof it to be sure. It is a good idea to have others look at it, so you can see if they have any questions.

Presentation

Exterior

Your portfolio can range from conventional black to something more inventive. A handmade cover, or something made out of materials that catches the eye, is ok, as long as it does not hamper the use of the portfolio. You can also use a box, a binder or loose examples that can be passed around. It must be easy to carry, and durable if it needs to be shipped. It must open easily, and not have parts falling off when being viewed. A simple three ring binder often makes the best portfolio container.

Dimensions

Your portfolio should be easy to handle, and not so large as to make it impractical for the viewer. Usually you will present your portfolio work in the form of photographs, and then set up a studio visit so your reviewer can see originals. DO NOT send your original work in a portfolio to a gallery or other venue.

Inside

The inside of the portfolio should be easy to add and delete pages, and rearrange. The pages should be durable; high quality page protectors work quite well. There are archival page protectors that can be ordered from an archival quality distributor of photo supplies, or an art store. These fit into a binder or can fit into a box or case.

Number of Pages

The number of pages you use should be enough to show your best work to its full advantage. If your work is better seen with detail shots, be sure to include them. Do not leave empty pages in the back of the portfolio. Quality is the most important. Do not show everything you have ever made. Show your most recent work and make sure that there is a good reason to include what you do.

Layout of Pages and Backgrounds

Do not use bright colors or distracting backgrounds behind your images. Choose pages where you can change the background if your work looks better on gray, black or white. Do not use fancy graphics or an illegible typeface to label images. Always label your images so the viewer does not have to flip back and forth to see a title or other information. Labels should include: title of piece, year produced, medium, edition size and dimensions. If printing digital images for your portfolio, use matte photo paper to make your images stand out against the page. Never print your images on regular lightweight computer paper.

Contents

Your portfolio may include a combination of presentation materials including a videotape, a CD Rom or DVD. Make sure the case you choose allows room for all of these mediums. A laptop is an excellent way to present your work, as it makes you self-reliant. If you need to use someone else's equipment when sharing your portfolio, make sure you have called ahead to make arrangements and fix technical issues. Always do a run through of your presentation to make sure everything is working and know how to use the equipment before you present your work.

If you cannot be there, make sure you include detailed instructions about how to view the items you have included.

If you have included slides, it is a good idea to have some color prints that your reviewer can see easily without a projector. This will entice them to look further.

A good portfolio will include your artist statement, your resume, and some copies of reviews if you have them. An annotated slide sheet, or work description sheet is important. This means a list of your work, with a sentence or two about the work. Adding this to your portfolio may enhance the information on your work for the viewer, in addition to your artist statement. The more information the better.

Whenever you get the chance, see other artists' portfolios.

Portfolio Organization

By Chronology or Category

If you lay out your portfolio pieces according to chronology, it is probably a good idea to put the most recent work first, since it is probably more skilled, and will create a good first impression.

If you make multiple kinds of work, such as video as well as paintings, you might want to make separate categories by media. Usually the most recent work goes first and progresses chronologically in the portfolio. You will have to use your best judgment.

Business Cards & Nonreturnable Work Samples

Another good use for pockets and plastic sleeves is to hold loose samples and business cards. You want the person reviewing the portfolio to be able to keep something as a reminder of who you are.

Tailor to What You Are Seeking

Organize your portfolio with elements that prove you are good at what you have solicited. Never use filler or lesser works. Know the required skills for the position you are seeking, and highlight those skills.

Building Your Portfolio

Everyone starts somewhere. If you are lacking work for a portfolio, then make it! Engage with other artists, volunteer to work with nonprofit arts organizations, or just get into the studio.

Your Digital Portfolio

This is a general guide for creating a basic digital portfolio. Feel free to customize your portfolio to meet any criteria, viewing circumstances, or guidelines that may come up.

A digital portfolio is a document containing all the necessary aspects of a portfolio that can be emailed to an interested party using a basic email server. This means that it has to be a small file (preferably less than 2 megabytes). Make sure whomever receives your digital portfolio can print it out on standard 8.5 x 11 inch paper without images bleeding off the page.

You should assemble your digital portfolio in the same way you would your physical portfolio. Make sure you number each page in your portfolio and, if possible, include your name and contact information in small font at the top or bottom of each page. You will want to structure your digital portfolio in the following order:

• A Cover page with your name, your title (artist, or painter, or art activist, writer –whatever you want), contact info, and the date you assembled the portfolio.

• Your artist statement

• Your resume

• A page introducing your Work Samples

• 8 - 20 examples of your work. Use only 72 dpi images and make sure your images don't bleed off the page. Make sure you label each work using the format:

Title, year
size, medium
And a description of the work if necessary.

• Scanned copies of articles written about your work. If information about your work is buried inside the article, highlight this information so it pops out at the reader.

You can use a number of graphics programs to assemble your portfolio, including Photoshop, InDesign, Scribus (a freeware like InDesign), and Gimp (a freeware like Photoshop). If you have trouble using graphics programs like this you can always design your digital portfolio using a word-processing program like Microsoft Word or Google Docs, but it may be harder to format it the way you want.

Once you have assembled your portfolio you will want to save it as a PDF so that it opens as one file using a image reader program like Adobe Acrobat or Mac Preview. Make sure you set the size of the PDF to 2 MB or less so that it can be easily emailed and downloaded.

Always ask an email recipient if they would like to see your digital portfolio before you send it to them. Some email services block emails with large attachments as spam, so you will want to give your recipient a heads-up that your portfolio is coming their way.

Remember to save old copies of your digital portfolio and update your digital portfolio often, so that it keeps up with the progress of your art practice.

 ## Portfolio Checklist

• Business Cards
• Take-away work samples
• Cover Letter (if applicable)
• Project Proposal (if applicable)
• Your artist statement
• Your resume
• Work Samples (Anywhere from 8 – 20 works, depending on the situation)
• Copies of Reviews or articles written about you
• An annotated work description sheet listing all the works in the portfolio. This means a list of your work, with a sentence or two about the work they are seeing. Adding this to your portfolio may enhance the information on your work for the viewer, in addition to your artist statement. The more information you include the better.
• DVD or VHS (if applicable) labeled with your name and pertinent work info.
• A Self Addressed Stamped Envelope if you are mailing your portfolio.

Audio / Video Portfolio

Audio

As with any portfolio review scenario, you need to research what equipment is available for presentation.

Audio Cassettes

Use high quality tapes, type 1 (normal bias) or type 2 (chrome high bias).

Break out the corner of the tape so that it cannot be overwritten.

Label both the cassette and cassette box with your name.

Cue tapes up to the section you wish to be reviewed.

Put 5 to 8 seconds of silence between selections.

Identify and explain your specific role in the creation of the piece. It is very important that you convey this information to the listeners because they may not be able to infer it. Without this information, they will not be able to respond properly to your work.

Compact Discs (CDs)

Use a name brand CD, such as Memorex.

Only use a CD-R so that it cannot be overwritten. (CD-RWs are rewritable.)

Label both the CD and CD case with your name.

Put between 5 to 8 seconds between selections.

Make sure to indicate which tracks you wish to

be reviewed. Provide the cues for each track on the Work Description Sheet.

Identify and explain your specific role in the creation of the piece. It is very important that you convey this information to the listeners because they may not be able to infer it. Without this information, they will not be able to respond properly to your work.

MP3s

Make sure you have converted the audio file using the highest possible quality. Review the audio file on multiple computers to make sure it plays correctly and is not corrupted. If you are planning on emailing the audio file, make sure it's not too big and can be opened on the recipient's computer.

Choosing Your Work Samples

Choose a selection that will make your listeners curious about your music and make them want to hear more. Reviewing audiences are different than any other listening audience. For example, when you edit your audio work sample, keep in mind that the reviewer may take approximately two minutes to review your music.

Make sure that the first music selection is your best and most appropriate work sample.

Always submit more than one sample.

Get listeners' feedback by trying your audio sample out on musicians or friends who might be familiar with your work.

Video

Be sure to find out what type of viewing equipment the reviewer has at their disposal. If

you are sending video overseas, you will need to convert it to a PAL system, which can be done using Final Cut or through most professional dubbing services.

You will need to cue your tape. Most reviewers will specify the duration of their viewing. This may not be the beginning of the work, but a place in the middle. You should always include a paragraph describing the context of what they are looking at, as well as an explanation of the content.

Things You Should NOT Do

Do not use recycled tapes, as the deterioration can be noticeable to the viewer. Try to keep the documentation simple, not overwhelmed with special effects.

Do not include any parts on the tape (at all) that you do not want seen by the viewer.

Do not include anything that is not requested.

Don't waste the ten-minute review on color bars at the front, or on credits, unless this is the most important part of the work.

 Portfolio Evaluation

Artist's Name _____

Reviewer's Name _____

Your written evaluation of this portfolio is vital. Please pay attention to detail. Imagine you are on the receiving end of whomever the portfolio is addressed to, and you have just received it in the mail.

Did they include:

_____ Cover Letter _____ Project Proposal
_____ Artist Statement _____ Resume
_____ Annotated slide (or other visuals) list _____ Visual Presentation
_____ Budget

1. What is your first impression?

2. Does the cover letter clearly state what they are asking for? Does it include contact information? Any suggestions for changes?

3. How effective is the visual information?

A. What visual materials were included?

B. Were the images effective?

C. Do you think you understand the work from the visuals? Do they raise any questions? List them.

D. Can you understand the information on the labels? Is it helpful?

E. Would you make any changes to the visual materials?

4. How effective is the written information?

A. What are your impressions of the artist statement?

B. Does it give you an overall picture of the artist's practice?

C. Does it address the work in the portfolio?

D. If you have questions, list them here.

5. What is your overall impression of the artist's resume?

A. Is it easy to read?

B. What information do you notice on the resume?

C. Is the resume well organized?

6. What could be included to make the presentation stronger?

7. What could be eliminated from the presentation?

8. Would you have accepted this artist's application for whatever they are asking for?

9. Any final comments?

13: Work Samples

 ## Objectives

Understand the variety of work samples that can be submitted as a portfolio

Create a portfolio or good work samples

 ## Things to Consider

Think about and write down what makes a good work sample and how samples should be presented in a portfolio.

Look online for artists who have posted a portfolio and see the techniques they use.

Work Samples

1. Always check with whom you are submitting your work samples to and find out what formats and ways they are able to see your work. Not all institutions have the latest equipment, and formats change rapidly.

2. Examples of submissions might include slides, photographs, video, film, digital files of all kinds, and presentation via your computer.

3. Always include the following information about each work sample given:

• Title of Work
• Mediums of Work
• Size of Work
• Date of Work
• If site specific, where work is shown
• Any collaborators

• A short sentence or description of the work (if allowed or necessary)

4. Make sure your digital portfolio conforms to the guidelines stipulated required for your presentation.

5. Always know to whom you are sending your work. Never address a letter "Dear Sir,".

6. See the Portfolio Checklist for what should be included in your portfolio besides work samples.

14: Art School

Objectives

Understand why one would want to go to art school.

Understand what goes into a good art school application.

Things To Do

Research art schools you are considering and start requesting applications

Art School

Going to art school is a big exciting step in the life of an artist. Preparing ahead of time, researching your options will help make the transition from "the real world" to art school and back again a painless and extremely rewarding experience. This section is not about naming the best art schools or what schools will turn you into an art star. As you will learn, art schools change all the time, so it's best to look for the school that's right for you and not rely on the promises and opinions of others unless they have direct experience.

People decide to go to art school at many different times in their lives. Some go right out of high school, some wait one, two, or even twenty years before they enroll in an art program. Some people put lucrative careers on hold to go to art school. And some artists never go to school at all. Wherever you are on your road to an academic art education, know that there is no right or wrong time to start school. In the end, it's up to you.

Going to art school for a Bachelors of Fine Arts (BFA) degree is very different from going for a Masters of Fine Arts (MFA) degree. The financial, emotional, and academic requirements vary drastically from program to program, and so there is no hard and fast way to describe every school.

A Bachelors degree program usually lasts four years. Most BFA programs require a high school degree for entry and, depending on their status as a public or private institution, might not require you to take the SATs. Some schools may also look favorably on students coming from the community college level, specifically because many of the teachers at these schools are also adjunct teachers at art schools.

During the course of a Bachelors of Fine Arts education, students usually study many different kinds of art, taking a variety of studio, art history and writing courses before they decide on a concentrated field of artistic inquiry. The rigidity of this medium-specific course of study can vary from school-to-school. Some schools require you decide if you want to only major in a very specific media, like photography; others are content to let you work in many different media. Depending on the type of school you enroll, in, you might have to take courses in subjects unrelated to art, like Math or Science. And yes, you will have to write papers in art school. Usually a BFA degree culminates in a Senior thesis show where student's exhibit their work in either a group or solo exhibition. Some BFA programs also require that you write a thesis paper before graduation.

A Masters of Fine Arts Degree usually last two to three years and is achieved after one has received a Bachelor's degree. Most MFA programs don't require you take the GRE. You don't have to have an undergraduate degree in art in order to enroll in a Masters program. In fact, some Masters programs look favorably on applicants specifically because they don't have an Art BFA, because these students bring ideas from outside of the art world to the classroom. Some schools may request that applicants with little to no art background enroll in a Post-Baccalaureate program, which is like a program just after undergrad and before grad school.

An artist decides to go to a Masters program for a number of reasons, most typically:

• To receive a MFA so they can teach at the collegiate level.

• To focus their artistic practice, how they make work, in order to better understand what they want their art to do.

• Form a network of supportive artists, mentors, and professional contacts.

• Learn more about how to operate as an artist in the world.

• Study with and under the instruction of accomplished working artists.

Masters programs differ tremendously from school to school, but generally classes in masters programs include many individual and group critiques, where students and teachers get together to discuss work in depth. Additionally, Masters candidates will usually take a mixture of Art History and Studio classes pertinent to their focused area of study. Since MFA programs are much more student-driven, time is given to individual study and research so that the student can develop a well researched and executed body of work. A Masters program usually culminates in a thesis exhibition where a student exhibits their work in a solo or small group show. Additionally, many MFA programs require students to write a lengthy thesis paper about their practice and artistic influences.

After you have decided that you want to be an artist, and you want to go to school, there are few very important things to consider:

• Is this the right tome to go to school? Can you devote two to four years of your life completely to school? Being able to go to school and not work full time will make your studies and artwork more focused. Some MFA programs insist that you not work while in school.

• Are you financially prepared to go to school? Do you have savings to pay for school? Are you going to rely on scholarships, loans, or work-study programs? Getting a degree is rewarding, but leaving school with tens, sometimes almost one-hundred thousand dollars worth of debt can be suffocating. Make sure you have your financial situation in order before beginning the application process.

• What geographic locations appeal to you? Do you need to be in an urban environment? Can you learn in an out-of-the-way rural environment? Are there loved ones you need to be near? Can you afford to move to a different city? A different country?

• Are you committed to teaching? An MFA is required to teach in most schools across the country, but you should not apply to a program for that reason alone.

Answers to these questions will help you better understand what schools are right for you. No matter what, prepare yourself for about a year of research into finding, applying, and deciding on the perfect school.

Starting the Search:

It takes time and lots of research to pick just the right school for you. You don't just wake up one day, decide to go to art school, and the next month you're in. The more time and consideration that goes into your grad school search, the happier and more professionally and academically satisfied you'll be when you matriculate and graduate.

Begin by looking at the goals section of this manual. Think ahead. Where do you want to be in three, five, ten years? What are your life goals? These goals may not be set in stone but they will help you keep track of your priorities and conceptualize which school will help you fulfill your goals.

After this, think about your answers to the questions above. If you don't want to move to another state or country, if you can't afford to spend a certain amount, and if you only want to go to school for a specific amount of time, then you're choices will narrow down a bit.

If you are in high school, start your college search by visiting your guidance/college counselor. He or she will advise you on what schools are in your price/location range. Additionally he or she will be able to put you in touch with admissions representatives from your top school choices. At the same time you should be compiling research on your own. Visit websites like http://www.edref.com/college-degrees/performing-and-visual-arts/fine-arts, to find schools, their contact info, prices, and statistics.

Cast your net far and wide at first. Look at school websites. There, you will be able to find a list of full time faculty, curriculum, admissions policies, and more. Start a research file on your computer and give each school it's own sub file. Start compiling lists of pertinent info on each school and take meticulous notes. If the school has a website link to student work, check out the quality of the work. If the student's have personal websites, check those out too. Do you think your work will mesh with this work? This does not mean decide if your work looks like their work, or is even in the same media. You want to see if you can find comrades in the program. Are the students dealing with issues that also concern you? You want to find a place that will not only teach you how to develop a thriving practice, but also a place where you will have an extensive and supportive network of students and professors.

When you find a school that interests you, request that they send you an application packet. This will come with college brochures, an application, and a few other fancy things like pencils or stickers designed to spark your interest. Pour over these materials with a fine-toothed comb. Pay close attention to information like curriculums, resources, and alumni statistics. While all these promotional materials can give you a general idea of what the school will be like, especially things like courses offered/required. Keep in mind that these are ads, promo material, designed to convince you to apply and enroll. So take claims, photos, and superlative phrases with a grain of salt.

The next step is to ask teachers, mentors, anyone whose opinion you trust and respect, about schools they think you should consider. When asking around try to find people who know about how the school functions now, as opposed to five to ten years ago. Schools

change, so their opinions of the school could be out of date. Most importantly, ask around and see if your contacts know people who currently teach at schools you are considering. These contacts will be vital when you want to visit schools and ask more specific questions. Find recent alumni from schools you're considering and ask them questions about their experience. Here are a few questions you might want to ask your contacts:

- What schools do you consider the best for establishing my career as an artist?
- Who do you know who teaches at these schools?
- What schools will be receptive to my specific art practice?
- What schools will put me in a good position to find a teaching job/gallery show/ professional position?
- What schools support their students after they graduate?
- What is the culture like at the school? Do students get along and socialize outside of the classroom?
- How successful are the alumni from these schools?

For MFA programs, an excellent place to start your school search is to consider who your teachers will be. Your mentors and professors in grad school will be the greatest asset you have after graduation to get teaching positions, gallery connections, and more. So start thinking about artists you admire and see if they teach. But beware, some schools will highlight their most well-known faculty on their website, but in reality these famous faculty are rarely available to students. It would be a shame if you enrolled in an MFA program to learn from a certain artist, only to find that they rarely meet with students, do two studio visits a year and little more.

Additionally, if you are considering a university for an undergrad BFA program, you might find yourself only learning from teaching assistants instead of professors. If you really want to study with a particular professor, call their department and ask if they are scheduled to go on sabbatical in the next few years. You don't want to arrive at school and find out that your favorite professor will be away for a year or two. Most importantly, remember that just because an artist is a great artist, doesn't mean they are a good teacher. There are ways to find out if a professor is effective. If you can, ask their students how they perform in the classroom. Websites like ratemyprofessors.com let students grade their professors and provide comments about their teaching. Take these ratings with a grain of salt, but in general, you can learn about which professors are student favorites. Overall, when considering professors and programs, make sure you are getting what you pay for.

Additionally, try and answer the following questions during your research:

- What housing options are available to students?
- Does the school offer teaching assistant positions?
- Does the school have a work-study program?
- What financial aid options are available?
- How much does it cost to live on campus? Off campus?
- Does the curriculum include professional practice classes on the business of being an artist?
- What is the career track for alumni?
- What is the school's endowment?
- What is the turnaround for the school's faculty?
- Is the faculty made up of full-time professors or part-time adjuncts?
- Does the school routinely invite visiting artists to give lectures and hold individual critiques?

After you have met with your contacts, done extensive online research, and talked with college counselors, you'll be ready to start filling out applications.

Your Application

Every school looks for different things in a portfolio, and it is smart to know how they tailor their admissions. Some skill-focused art schools, based in what is known as the Beaux Arts, will look for a wide range of traditional drawings that show you can draw, and expect you to focus on developing craftsmanship while in school. Other schools, schools dedicated more to conceptual development, will concentrate more on work you have done outside of class in order to assess your inventiveness, independent thinking skills, and conceptual rigor. They also look for skill sets, but are more interested in creative potential.

If you are applying to a BFA degree program you should have a history of taking art classes and creating work for a while. If you have been producing work outside of classes, then you may have developed a way of working that is less about assignments and more about your own creative expression. Know what kind of school you are applying to and understand how your application will or won't link up with the school's pedagogical outlook.

When approaching the application the most important thing is to FOLLOW INSTRUCTIONS. Read the application twice before you even begin to answer questions. Consider the application as an opportunity to better understand you, your work, and what you want to do as an artist. Your application essays will usually ask you why you want to be an artist, what you expect to get out of art school, and perhaps what artists you admire. As you work

your way along the application process, you'll learn more about your art than you would have ever expected, and you might whittle down your college choices as well.

The Application Portfolio

Your portfolio should concentrate on your personal voice as an artist and include a variety of media and style. Read application requirements very carefully. Make sure to only include what the school asks for. Don't submit more than the maximum amount of work samples, or less than the minimum. Although it is rare, some schools still require slides, while most others will accept digital submissions. If you are submitting video work, make sure the school can view your portfolio on their equipment. Check out the Portfolio section for more information.

The most important thing about your portfolio, other than having good work, is having excellent quality reproductions of work. Bad documentation, out of focus shots, poor lighting, awkward framing, can make even the best work look amateurish. Getting a good portfolio together requires some planning ahead. If you don't have a high quality camera to document your work, consider hiring a photographer to do it for you. See the Documenting Your Work section for info on how to properly document your work.

For Undergraduate applications, many art schools like to have the following in a portfolio (but not all, so check the guidelines!):

• Drawings from Observation. This means still-life studies, figure drawings, self-portraits and other drawings, which show off your skills, and how you make choices.

• Work in Color to demonstrate your color sensibility and your ability to create palettes.

• Design work to convey your ability to think conceptually and incorporate graphic elements in your work. These can be 2-D or 3-D works.

• A range of media in the rest of the works can be helpful. Photography, printmaking, sculpture, installation or public projects are good choices. Some schools like to see jewelry, ceramics or fiber art.

• Theme-based work to show your interests in subject matter and form.

• Some schools require a specific assignment. They may ask you to make a drawing inspired by a theme. Be sure to read the instructions carefully. This assignment might give you a good idea of what the school finds important.

• Other schools do not want to see any assignment-based work at all. They are looking for your own creativity, and the work you make outside of a classroom. These schools are looking for your ideas as much as your talent for painting or printmaking.

Unless specifically requested, do not send original works with your portfolio. Always include a self-addressed stamped envelope (SASE) if you want the school to return your portfolio. If the application doesn't explicitly state who will review your portfolio, ask the admissions department who will review your application. Will it be only full-time staff? Some schools have current students review portfolios to ensure that incoming students will mesh with the program.

If you are unsure with whether or not your portfolio exhibits the skill and conceptual rigor necessary to get into your choice schools,

you may consider seeking outside advice and training. Enroll in extra art classes, take a class at a community college or a summer course. The added training will look good on your applications and the extra work will enhance your portfolio.

If you ever have questions about your portfolio, what to include or not include, don't hesitate to contact the school. The admissions staff will take note of your inquisitiveness and follow-though.

National Portfolio Days

Schools from across the country participate in National Portfolio Day, where representatives from admissions departments gather in accessible locations and review prospective students' portfolios. Portfolio day provides an excellent opportunity to get multiple opinions about your work from an array of schools. Additionally, reps can answer questions about their programs of study. For more information visit http://www.portfolioday.net.

Prospective students may be asked if there is anything that their teacher told them not to put in their portfolio and if they have slides or documentation of work not included. It is a good idea to take these images with you in case a more progressive school wants to see non school-based work. Some high school teachers are very conservative and use the same assignments everyone else in the country does, so most of the work looks the same. This kind of work is hard to judge for individuality, so make your portfolio distinctive if they don't ask for specifics.

Follow-Up Interviews

After looking through initial applications, some schools narrow down their choices to a second

tier group. They will then ask this group to interview with faculty or representatives or alumni from the school. If you are called back for an interview the school may ask you to visit the campus, or if you can't travel, they will have someone come to you. The interview should be laid back. The interviewer is just trying to get a feel for your dedication to the arts, to art school, and make sure you are a right fit for the school's program. Be relaxed and prepared. Know enough about the program to be informed and come with educated questions about the school. The interviewer will appreciate your thought-out questions.

Visit the campus

So you've sent out applications, received acceptance and rejection letters, and now you have to decide on a school. First of all, if you got rejected from your top choice, consider applying again. You can call the school and ask how you can improve your portfolio. When you apply again you will be in a better position to get accepted.

If you get accepted by one or more schools, you should seriously consider visiting the schools to get a first-hand experience, meet professors and students. Schedule your visit with the admissions office. Ask for a tour and an interview with an admissions staff member. Sit in on a critique to see if you can get along with other students. When you sit in on the critique ask yourself a few questions:

• How long is the critique?
• Does the critique give enough time for adequate review of the work?
• Is the crit environment respectful? Do people talk over each other?
• Do the students seem knowledgeable about each others' work?

• Are students using academic terms and vocabulary appropriate for the discussion of professional work?
• Does everyone talk, or is the critique dominated by one or two people?
• How effective are the professors at moderating the critique?
• How receptive is the critique to diverse viewpoints?
• Does discussion of the work address multiple viewpoints, such as cultural specificity, political standpoint, race, gender, sexuality, formal and conceptual ideas?

While on campus, take note of the following issues:
• Are students talking with each other? Does it seem like a sociable environment?
• What are the campus galleries like? Will they be the right size to properly exhibit your work?
• Is the campus easy to navigate?
• Is there a place where you can buy last-minute supplies?
• Are the facilities clean?
• How big are the studios? Will you have enough room to make your work?
• Does the school have the technology you need to create your work? Are the computers up to date?
• Are they operating with current software?
• Is the shop well maintained and stocked with the tools you will need to create your work?
• Do students have 24-hour access to studios and other facilities?
• Where will you eat while on campus?
• Does the school provide adequate storage for your work when it's not in your studio?
• What is the library like? Will you be able to conduct research?
• Does the school have professional practices classes where students learn about the business of being an artist?

- Are professors easily accessible? Do they socialize with students outside of class?
- Do students regularly attend gallery openings?
- Does the school invite guest lecturers to campus? Is there a guest lecturer series?

Have fun during your visit. Check out the surrounding town/city/neighborhood. Remember, you'll be spending a lot of time at school but you'll also need to get away from time to time. Are there places to have fun? See movies? Study with a cup of coffee? Get a drink? Meet new people?

For some people, a school's location is the most important factor of all. If a school is in an urban environment, close to well-known galleries, nonprofits, and museums, its easier to make connections with these institutions. On the flip side, working in an isolated rural environment might be best for other artists, who enjoy the time to be alone and focus on work.

Preparing for School

You've visited the campuses, talked to students, sat in on classes, and weighed the pluses and minuses of each school and finally decided where you're going to go. You need to make sure you have your finances in order and loans in place before registration. This might mean meeting with the Financial Aid office beforehand.

Before school starts, decide what classes you want to take by thoroughly reading the school's course schedule. For beginning undergraduate students, some classes, like Foundation, or Design I, etc. will be mandatory. For all other elective classes, it's good to have an idea of the classes you want to take before registration day. If possible, before registration, let the professors teaching the classes you want to take know you want to take their class.

This might help should the class reach capacity early. Beginning students often are at the bottom rung when it comes to registration, so expressing interest ahead of time will put you in a better position to get the classes you want.

If at all possible, see if you can get a copy of the syllabi for the classes you will take ahead of time. It never hurts to read ahead and get an understanding of the books and articles routinely assigned for the class. This won't replace reading these texts when they are assigned, but it will give you a jump-start on the class.

Remember that your time in school will be best spent if you continually work to develop a professional practice. This means establishing good organization, documentation, and business skills as early as possible. If your school doesn't teach professional practices, ask if you can bring in guest lectures to talk about the business of art.

Resources:

http://www.artschools.com/articles/admission/best/

http://www.artschools.com/articles/admission/schoenberg/

http://www.edref.com/college-degrees/performing-and-visual-arts/fine-arts

15: Signing & Dating Your Work

 Objectives

Understand how to sign and date your work properly.

 Things To Do

Go through your art inventory to make sure you have signed and dated your work in the proper manner.

 Signing And Dating Your Work

• Many contemporary artists don't sign their work on the piece itself. The signature may be concealed behind the work, on the back of the canvas, or the back of the mounting for a photograph. For some conceptual work, a signature comes in the form of a certificate of authenticity. Think about what kind of signature is right for your work. If you are confused, consult an art professor, namely a curator of contemporary art or a contemporary art historian.

• Make and sign your art in the same medium (except for prints and graphics, which are generally signed in pencil). For example, sign a watercolor in watercolor, an acrylic in acrylic, and an oil painting in oil paint. When you sign in a different medium, you increase the chances of someone eventually questioning whether or not the art was actually done by you.

• Always put the edition size on limited edition graphics.

• Sign all of your art in more or less the same way. Signatures should be consistent in size, coloration, location, style (written or printed), and other particulars. That way, people who do not know your art will have an easier time recognizing your work. Also, signing your name in many different ways or locations eventually makes it easier for forgers to sign art in various ways and claim that it is by you.

• Dating your art minimizes any guesswork as to when something was completed. You may not think this is important now, but after you have been making art for several decades, you will understand why you need to date work. If you do not want to date your art on the front, date it inconspicuously on the back. The better known you become, the more important dates are for anyone interested in your evolution as an artist.

• Do not sign on top of a varnished painting or glazed sculpture because the signature then looks like it was added later, more as an afterthought than a declaration.

• Your signature should not be so bold or obvious that it interferes with or detracts from the composition. It should blend rather than contrast with its surroundings and look like it belongs in the art.

• Do not scratch your signature into dried paint, ceramic, or similar media unless this is how you normally sign your art. Scratched signatures rarely blend with their art and their authenticity can easily be questioned.

• Remember, you are not always going to know where every piece of your art is or where its journeys will end. Those who buy your art today will not necessarily own it tomorrow. Regardless of where your art ends up or who eventually owns it, make sure that it will be handled with care and never relegated to the "I do not know" pile. Treat your signature with respect and maximize the chances that people will know and remember you through your art for all time.

16: Cover Letters

Objectives

Understand the purpose of cover letters.

Understand what goes into a cover letter.

Create a cover letter.

Things To Do

Write a cover letter for your portfolio. Address the cover letter to someone you will really be sending the proposal/portfolio to. Ask yourself, "Would I be interested in this proposal?"

Cover Letters

You should always include a cover letter whenever you send a grant, proposal or a portfolio. A cover letter is a general letter of introduction that identifies what you are asking for and what is included in the packet you are sending. If you are asking for money, it should state clearly in the first or second sentence exactly what you are asking for. Never bury this request deep in the letter or the request, as it should be easy to find. A cover letter can be short, as its job is to describe what materials are enclosed and why. A cover letter can set a pleasant tone or introduction to the reader as well as introduce the project and what you are asking for. Generally a cover letter has three parts.

The Opening

This should get the reader's attention. "Dear Sir" will probably get you a low score, while if you use the correct person's name, you will score high points. Use it to introduce your work, bring attention to a third party, or to follow up any previous communication.

The Middle

This should include a more detailed description of the project or information on the work. You could have a summary of your artist statement here, or something important about your request. Listing goals and accomplishments of the work may work here as well as any pertinent information you think would help you "sell" the project.

The Closing

Always suggest further contact, whether an appointment, a phone call or a studio visit. Always mention how the materials can be returned (include an self addressed stamped envelope). This could also be where you mention how they can see more of your work, or more details.

17: Galleries, Dealers, Agents & Consultants

 Objectives

Understand the difference between galleries, dealers, agents and consultants.

Understand how each of these institutions will influence student's art careers.

 Things to Consider

What are the conceptions about galleries, dealers, agents and consultants? How are they different and what does each one provide? What are the pros and cons of working with these sellers of work?

Understanding Representation

Although most artists do not have personal managers or agents, the trend has begun. Increasingly, people are calling themselves art agents or consultants with little or no experience in the arts. You need to understand the pros and cons of doing business with agents like this. Most consultants charge by the hour, and will tell you things you could have learned for free, or by reading the GYST materials and information in this manual. Agents tend to be more complicated.

Many artists have dealers or full time managers who represent them either through an art gallery or as consultants. Some dealers work out of their home instead of having a commercial gallery open to the public. Most of their clients are fairly well established and can afford these services. If you have multiple galleries, or are overwhelmed by managing your career, engaging in the services of a manager might be a good way to go. If you are an emerging artist and you just want someone to make you famous, think twice about how feasible this is.

If you decide to work with a private dealer or agent or consultant, make sure that you check out their references and reputations. Agents have been known to resort to unethical practices, like buying out the shows of their artists, without the artist knowing. Such market manipulation can kill your career. So do your homework, and ask yourself if you really need to be paying for an agent.

If you are only showing in one or two galleries at a time, a single dealer is usually adequate to handle the detail work. A good dealer will act as an informal agent for the artists they represent by giving them advice, organizing future shows and commissions, and publicizing their work. Many artists who develop a long-term relationship with a gallery or dealer usually have specific agreements that allow agents or representatives to act for the artists on a limited basis. Be sure to notify your dealer if you become interested in adding an agent or consultant.

If you are an emerging artist, getting involved in the art scene, developing relationships and networking is probably a much better bet than going with an agent. If no one knows who you are, the agent will not get very far either, and you will have paid a lot of money that could have gone into making your work.

Commercial Galleries

Private commercial galleries are in the business of selling artwork. They can offer artists a one-person exhibition, the possibility of reviews, public exposure, publicity, an opening reception, etc. Galleries generally take 50% of sales for the privilege of representing you on an exclusive basis. Exclusivity is usually defined in one of two ways: by the geographical area to be covered by the gallery or by the length of time it will remain in effect. Galleries make money by selling work, so your work must be sellable in order to maintain a long-term relationship.

Art Consultants

Private art consultants usually specialize in selling artwork to corporate collectors, such as banks, law offices, and hotels—but they also work with collectors and public art projects. They generally do not offer exclusive representation or an exhibition, but they can sell work in large quantities. They usually work out of their home or a small office, so there is no public exposure. At the same time, consultants usually take a smaller percentage because they do not have the operating expenses of a regular gallery. You might think of commissions to galleries and private consultants a "fee for service." Consultants' degree of professionalism and experience varies, so check them out carefully and get references.

Agents

Companies and individuals are increasingly targeting the art market to turn a quick profit. They offer a wide range of services as well as fees. Ask yourself if you really need an agent and do lots of research before you engage in a contract. Like everything else, there are good and bad agents. Agents are usually interested in the sale of your work because they can make more money that way. Be sure to understand the agent's back room policies and make sure that their contract stipulates both what they will and will not do.

Noncommercial Galleries

Noncommercial galleries are in the business of educating the public and are usually nonprofit. In most cases they may be less concerned with selling the work and more interested in the work itself. They usually offer good exposure for an artist if the space is reputable; examples are museums, college and university galleries, cultural centers, community centers or artist-run spaces. The best way to approach these galleries is to submit proposals for review. If you know of three or four other artists whose work seems compatible with your own, gather all the work samples and bios to propose a group exhibition, particularly if you are an emerging artist. Most of the staff is open to chatting with artists, but the same etiquette applies. Give them a call or check out their web site to find out the submission guidelines policy. The great thing about these organizations is that a committee of your peers usually views proposals. They are often good at giving feedback, should your proposal be rejected.

Working out Representation

Once a gallery has decided to represent you, make sure you are prepared with a contract that has your best interests in mind. Read through the GYST contracts and compile a list of issues and questions you need to talk with the gallery about before signing anything.

You will also want to talk with other artists represented with the gallery before deciding on representation. Ask them what it's like working with the gallery, if they are paid on time, if they

are happy with how the gallery represents them. If you can talk with artists who have worked with the gallery in the past you might want to ask them the same questions.

When dealing with a gallery always try to get agreements in writing. You can use the GYST's sample contracts as a way to develop your own contract with the gallery. Some galleries will not work with a contract, and it is important to know why this is the case. If nothing else, be sure to write down the agreements and information offered by the gallery. Then, send it back with a request to correct any miss-information. This is a good business practice.

Make sure you ask every question necessary. You might use the exhibition checklist to remind you of things you need to know. For example, who pays for shipping? When do you get paid? Do they pay on time? What are your responsibilities as an artist, and what will the gallery do for you?

Referring to the Gallery Representation Contract, you will need to decide on the scope of the gallery's representation. Will they represent you only in your city or nationwide? How many shows will they offer you and how frequently? What will the commission be?

It is a good idea to ask about the issues for all opportunities, not just commercial gallery representation.

Working on a Stipend with a Gallery

Although less common, working with a gallery that offers a stipend can be a good way to spread out your income.

When money is being exchanged over a period of time, a contract is crucial. In order to avoid miscommunication about stipend agreements,

create a contract ahead of time and do not rely on a verbal agreement. To create a productive business relationship, both parties must be clear, honest and forthcoming about their needs, expectations, and requirements. A good contract includes payment schedules, penalties for late payments, what types and amounts of art are to be produced and delivered within what periods of time, penalties for late art deliveries, the time period during which the contract is enforceable, and all other specifics that both parties agree upon.

Both parties should address the definition of the stipend, which will ideally be designed to finance artistic exploration. One of the reasons that dealers may offer artists a stipend is to acquire art that can be sold to cover expenses, or to spread out the payments to an artist instead of giving a lump sum. Remember that a commercial gallery is there to sell work. Beware of dealers who ask you to make replicas of previous works unless you are amenable to this. Dealers should not place restrictions on artists, but expect critical feedback from the dealer. Understand the "give and take" dynamics of the relationship.

 ## How Galleries Work

Many artists want to show their work at art galleries for various reasons like the desire for fame, money, or stability. It is important to remember that galleries and art consultants only work with artists whose work they can sell. They may take you on because they think your work will sell, but if it does not, they may reconsider the relationship. Galleries are in the business of selling art, and making a living selling art. They are not there to make you feel good. You should be an active partner in determining how to sell your work, and who the buyers may be. The gallery is not in a position to do all of that for you.

Basically a conventional art gallery works like a regular brick-and-mortar store, with inventories (art), suppliers (artists), sales launches (openings), regular clients (collectors), and discounts. Additionally, good galleries participate in active PR and marketing campaigns, just like any other business. Like most boutiques, the majority of galleries work on a consignment system, where you consign your work to the gallery and they do the work of selling it. If the works sells, you split the sales figure with the gallery (usually a 50/50% split). If the work doesn't sell the gallery can either keep it in their inventory, or will return it to you. This basic relationship has infinite variations from gallery to gallery.

Remember: Selling art is a hard job.

Making a living by the sale of your work is even harder due to fluctuations in the market and buyers' desires. If you want to make a living selling art, you have to be an equal part of the process. Never assume that the gallery will take care of everything for you.

Artists are notoriously unaware of how the business end of the art world works. Most art schools do not provide this information, as school is generally about learning to make good art. Art schools do not traditionally function to get you a career and a degree, even an MFA from the most prestigious institutions do not guarantee financial success. Still, if you do experience a dramatic bump in sales make sure you don't quit your day job until you are sure you can make it on your own. Markets go up and down all the time, and when the market is down people spend less money. It is not always your dealer's fault if your work does not sell.

Never underestimate the importance of being a savvy business collaborator. Be proactive and productive so your gallery won't have to be on your back all of the time to get things done. If you expect your dealer to take care of everything, you are in trouble.

You don't need to go to art school or have any credentials whatsoever to be an art dealer. Some dealers are great and know what they are doing, and others are as green as can be. You may need to train your dealer on how to function professionally. If they are really clueless, you might want to refer them to the GYST software and this manual. Who knows, they may thank you for alerting them to software that can help them run their business more efficiently.

It is very important to keep track of all of your own records and finances with the gallery. If your gallery closes without telling you, and all the paperwork is in the office, you may not get access to the records without a fight. Keeping your own records is crucial. Make sure you know who bought your work, when, for how much, and where the work is at all times.

Never forget your job as an artist. Even while working with the gallery remember to focus on art making by getting into the studio and having studio swaps with colleagues and peers. While you are making work and talking about it with other artists, you need to keep developing professionally. Volunteer at a local nonprofit, go to art openings, read art publications, go to local lectures/symposiums that are of interest… basically engage with the community. Along the way, you will meet plenty of people, make connections, and open the doors to many opportunities. This is a tried and true way to get galleries, sales, teaching referrals and all kinds of other good stuff to happen for your career. The art business works on connections and referrals. So be on your toes, be generous, and above all, be a professional.

Approaching Galleries

Preparation

Do your research!!! Before approaching a gallery, see if they have a website where you can find a list of the artists they represent and images of past, and current, shows. While browsing their site, ask yourself:

• Does the website project a certain feel? Is it restrained or colorful? Is it stylistically designed or is it poorly constructed?

• What kind of work does the gallery typically show? Is the galleries' roster of artists mainly abstract, figurative or conceptual?

• Stylistically or formally, how does the your work fit into the gallerys' focus?

• Are the represented artists in the same general career range as you? Does this gallery show just emerging artists, mid-career artists, or established artists? An artist's biography will show you their career track record.

• If the gallery lists their past shows, how often does it exhibit group shows, shows organized by outside curators?

Once you've visited their website the next step is to obviously visit the space.

While there ask yourself:

• Is the gallery located in an accessible place? What is the neighborhood like and are there other galleries in the vicinity?

• Is this gallery large enough to accommodate my work? Is it small enough to achieve a sense of intimacy?

• Is the artwork shown at the gallery in the same general price range of your work? Ask to see price list for price comparison.

• Is there proper lighting and wall space? How has the gallery been maintained? Nail holes? Floors? Wall paint?

• Does anyone greet guests or offer to talk about the work? What is the reception area like?

If, after visiting the space you are still interested in being part of the gallery, the next step is to attend an opening at the gallery.

At the opening you should ask:

• Are the openings well attended?

• Has the gallery scheduled the opening to coincide with other gallery openings in the neighborhood?

• What is the atmosphere at the opening like? Is it a party scene, a networking scene?

• What kind of people are at the opening? Artists, collectors, dealers, writers, curators, hangers-on?

• Are people having fun?

• Is the gallery and featured artist/s director accessible?

• How do people talk about the work at the opening? What kind of language do they use?

Once you've experienced the gallery first-hand you will want to do a little more research. Ask yourself:

• Does the gallery take unsolicited portfolios? Is the gallery taking on any new artists?

• How often is the gallery reviewed in local and national publications? Are the reviews more often positive or negative?

• What is the reputation of the gallery?

• How far in advance is the gallery's exhibition schedule filled? Why pine after a gallery that is booked three years in advance when you are ready NOW?

Making Connections

If you continue to go to the gallery's openings, and visit the gallery during office hours, you may have a chance to meet the gallery director. One of the best ways to get in good with the gallery is not to be too pushy. Start by complimenting the show. Obviously only do this if you actually like the work on the walls. State clearly and intelligently why you like the work. The director will appreciate your honesty and interest. Make sure to introduce yourself and leave your business card. Follow up with a short email stating you enjoyed your conversation about the gallery.

No gallery owner, director, assistant director, or intern will do a bunch of busy work for you for free, including critiquing your art, web site, making suggestions about how to have an art career and connecting you with their collectors/clients/curators. A dealer will only do the above after representing you as an artist in their roster and after a business relationship is established. Otherwise, why would a dealer suggest someone to their business clients without knowing who you are, what you are capable of producing, how you are to work with, how you handle deadlines and what your reputation is? Regardless of what a dealer thinks of your art, they will not jeopardize their existing business relationships and reputation by referring a complete stranger.

Listen to the advice of collectors, curators, critics, and artists. So, if you are interested in showing with a particular gallery you will want to make these connections first. Remember that it is improper to ask an artist for an endorsement if they are unfamiliar with your work and if you are unfamiliar with their gallery. Maintaining an excellent and organized practice is the best way to ensure a good gallery relationship.

Applying

Once you have done your research, and talked briefly with the gallery director, you might want to send an introductory letter expressing your interest in the gallery and your desire to learn more about their program. Again don't be pushy. This is not a letter requesting a show, representation or even a studio visit. Never send out boilerplate letters or requests for representation. Always address correspondence using the persons' full name and title—never use Dear Sir or Madam. As always, double-check your letter for typos. Graciously inquire about the gallery's current portfolio review policies. Often, review procedures can be found on a gallery's website. If the gallery says they are not accepting submissions, respect that and don't ask to submit your work.

If, and only if, the gallery says they are looking at submissions, make sure to follow the application instructions very carefully. Make sure to include a self-addressed stamp envelope for the return of any submission materials. If you don't send a SASE, galleries will throw away your materials, especially if the submission was unsolicited. Methods of review vary and some galleries only review slides or CDs.

Timing Your Portfolio Review

Depending on the review procedures, call or write several weeks ahead of time to request a

portfolio review. If writing, be sure to include a self-addressed envelope with a reply card. Always address your request to the decision maker. If you are not sure who that is, call the gallery and find out. Form letters are frequently sent to galleries and typically are not well received.

Never expect anyone to stop what she or he is doing to review your portfolio. If you are only in town for one or two days, have the courtesy to schedule an appointment ahead of time. Galleries are busy with the artists they represent, and you will want the same consideration when you gain representation.

It is a good idea to call and confirm a meeting time. After all, you want their full attention.

Be on time! If a scheduling conflict arises, cancel and reschedule as soon as possible. If you are running late, call ahead and let them know. If they are in the middle of installing a show or another event, they might not have time for your meeting to run over. Timing is very important for a successful meeting with any professional arts administrator.

Common Sense

Being late should not be an issue. If you are new to a city, leave early, look up the directions, and know where you are going.

Be polite and considerate. You are asking for something from them, and their time is valuable.

If at all possible, visit the gallery beforehand. Go early and look at the work on display. Show an interest in the other artists in the gallery. Know about their programs and the history of the exhibition space. If you care about them, they may just care about you.

Follow-Up

Send a thank you card to the person(s) you meet. A postcard with one of your images may remind them of your work. Follow-up in four to six months or when you have new work or images to show, especially if they asked you to keep them informed.

Keep track of correspondences with galleries who you have had studio visits with. Keep track of what transpired. You should include the name of the reviewer, the name and address of the gallery, phone number, email address, when you met with them, what work you presented and any comments or suggestions you want to remember in the future. Write down how you will follow up and then do so.

Patience is a Virtue!

Developing a relationship with a gallery takes time and is like developing a relationship with anyone. Be patient, as hounding people is not professional and chances are it will completely disinterest gallerists. Remember they are busy with the artists that they currently represent.

A gallery might not have a slot for you at the moment, but they may be interested enough in your work to ask you to keep them posted. By all means follow up, but be nice about it. Don't hound them. Wait a few months, or until you have a new body of work, to schedule a new studio visit.

It takes more than just good artwork to become a successful artist. You must understand how the business works, create a good portfolio and master your presentation. Although timing and luck are part of building a successful career, your business and personal relationships will always make a big impact. This is the part you can control, so be really good at it.

 ## Objectives

Use a series of checklists for various artist activities like exhibitions, performances, lectures and events.

Understand the things an artist needs to know and keep track of when presenting work

 ## Things To Do

Fill out a checklist to determine if you know what goes into planning an event.

 ## Exhibition Checklist

Once you have secured a venue for your exhibition, make sure you understand the following: (Choose the questions that are applicable to your project and the venue)

Name of Exhibition:
Venue:
Dates for the exhibition:
Date and time of the opening reception:
Who is the main contact person for the venue?
When can you sign the contract, or loan form?
If work is sold, what is the commission for the venue?
What is the honorarium or artist's fee?
Who pays for shipping, insurance, reception costs?
What are the responsibilities of the venue or gallery?
What are your responsibilities as the artist?
Who pays for shipping, insurance, reception costs and invitations?
Is there a floor plan for the space? If so, where is it located?

When are the installation dates?
What are the installation procedures?
Who installs the work?
What tools are available for installation?
Who designs and mails the announcement?
If the gallery designs and mails announcement, what is the deadline for information from the artist?
Who pays for the announcements and the mailing?
What is the deadline for information needed for the press release and other publicity?
Does the venue have an emailing list for announcements?
How many invitations will you receive as the artist?
What equipment and technical support is available?
Are there issues with electrical outlets and extension cord routes?

 ## Exhibition Timeline

3 months before the show opens

• Sign agreement with exhibition venue detailing dates, commissions, and any relevant information listed above.
• Write up a budget for your project.
• Plan any new work that needs to be made.
• Make sure your mailing list is updated and ready to go.
• Do a layout of the installation of your show, using a map if helpful.
• Make sure you have a contract if possible.
• Photograph any works that are finished.
• Send publicity to magazines.

- Check the press release for accurate information or write it yourself.
- Organize publicity packets and Include a copy of the announcement if available. Images can be included, or make sure to state that images are available in 8x10 black and white, color transparencies, or digital.

6 weeks before the show opens

- Design your announcements or work with a graphic designer.
- Check all spelling and use the announcement checklist to make sure you have included all of the necessary information. Be sure that the reader will understand the difference between when the show opens, and when the opening reception is.
- Get bids from printers.
- Print announcement.

Announcement Contents Checklist

- Title of show.
- Dates of show.
- Hours the show will be open to the public.
- Date and time of opening reception.
- Venue and address, phone number, email and Web site information.
- Directions if needed.
- Parking info if needed.
- Acknowledgments.
- If the space is wheelchair accessible, note this on the invite.
- List of artists in the show, or your name.
- Be sure there is room for the label or address, and the stamp or nonprofit indicia.

4 weeks before the show opens

- Recruit people to help with the reception: bartenders, parking attendants, ticket takers, and gallery sitters, etc. if needed.

- Distribute publicity (announcements, flyers etc.).
- Mail announcements if using bulk mail.
- Mail press releases to newspapers, weekly publications, reviewers and radio stations.
- Make a checklist of those things you need to do to finish the work. (framing, installation hardware, painting walls in gallery, etc.).
- Send a save-the-date invite to your email list.

3 weeks before the show opens

- Make sure your artwork is ready to install.
- Go over any special requirements with the venue to make sure you are in agreement with the site management.
- Design and order any exhibition signage you will need.
- Arrange for photographer or videographer to document the work or performance at the exhibition site.
- Mail announcements if using first class mail.
- Send press releases to broadcast media.
- Assemble and mail press packets to special writers and publications. (see press section)

2 weeks before the show opens

- Make calls to calendar listings managers to make sure your event will be listed.
- Make phone calls to arts writers and invite them to the show or event.
- Create Facebook / Myspace Event invitation and invite your friends.
- Schedule installation and/or performance rehearsals.
- Design and print any handouts, exhibition checklist, price lists, artist's statements, programs etc.
- Email announcement to your emailing list. (Be sure to put your email addresses in the BCC area of your Email so your reader does not have to scroll through all those Email

addresses to read your information and private Emails are not made public)
- If you send an image as an attachment or inclusion, make sure it is the smallest size (both in size and resolution), which you think you can get away with.
- Including the information in the email, instead of requiring the reader to click a link, will ensure that they read it more often than having to go to a link.

1 week before the show opens

- Make sure all supplementary materials are printed or in a binder.
- Make sure your resume, artist's statement, price lists, reviews, guest sign in sheets, etc. are ready.
- Make sure the venue is ready for you to install the work, and do so if needed.
- Print, mount and install any labels needed.
- Install exhibition signage.

2 days before the show opens

- Set or adjust lighting.
- Patch and paint any walls or surfaces.
- Set up guest book and supplementary information.
- Get your reception supplies that don't require refrigeration.
- Test all equipment and do any rehearsals necessary.
- Send a very brief reminder email to your email list about the opening.
- Take any clothes you plan to wear to the opening to the dry cleaners if necessary.

Opening day of the show

- Buy any reception supplies requiring refrigeration. Don't forget the ice.

- Check to make sure everything is installed and working.
- Show up on time to the reception.
- Call any special friends or writers to remind them about the show.

During the run of the show

- Document the show with slides, video, or digital images early, in case you need to re-shoot the images.
- Make any appointments with curators or writers at the venue.

Week before closing

- If you plan a closing reception send reminder emails.
- Send reminder emails about the last chance to see the show.

After the show

- Send any thank-you notes to those who volunteered.
- Send letters to those who donated money or in-kind services to your show, including a 501(c)(3) letter if needed for a tax deduction.
- De-install the show, making sure that the space is returned to its original condition if required.
- Make sure your show is taken down in time for the next person to install.

✳ Performance Checklist

Once you have secured a venue for your performance, make sure you understand the following: (Choose the questions that are applicable to your project and the venue.)

- Name of Exhibition:
- Venue:
- Dates for the performance(s):

- Date and time of the opening reception:
- Who is the main contact person for the venue:
- When can you sign the contract?
- What is the honorarium or artist's fee?
- Will you receive a share of the gate, and how much?
- Who pays for shipping, insurance, reception costs and invitations?
- What are the responsibilities of the venue or gallery?
- What are your responsibilities as the artist?
- Is there a floor plan for the space or stage? If so, where is it?
- What changes can you make to the performance area?
- And what can't you change?
- When will you have access to the space?
- When are the rehearsal dates?
- What are the rehearsal procedures?
- Who installs the stage elements and sets lighting?
- Is there enough seating at the venue?
- Who designs and mails the announcement?
- Does the venue have an emailing list for announcements?
- If the gallery designs and mails announcement, what is the deadline for information from the artist?
- Who pays for the announcements and the mailing?
- What is the deadline for information needed for the press release and other publicity?
- Does the venue have an emailing list for announcements?
- How many invitations will you receive as the artist?
- What equipment and technical support is available?
- Is there back-up equipment?
- What tools are available on-site?
- Are there issues with electrical outlets and extension cord routes?
- Are there lighting issues, if so what?

- How many invitations will you receive as the artist?
- Who will document the event?

 Performance Timeline

3 months before the performance

- Sign agreement with exhibition venue detailing dates, commissions, and any relevant information listed above (also see contracts section).
- Write up a budget for your project.
- Make sure your mailing list is updated and ready to go.
- Do a layout of the installation of your performance elements and props, using a map if helpful.
- Plan any new work that needs to be made.
- Make sure you have a contract if possible.
- Photograph any performance out takes if possible.
- Send publicity to magazines. Check the press release for accurate information or write it yourself. Include a copy of the announcement if available. Images can be included, or make sure to state that images are available in 8x10 black and white, color transparencies, or digital.

Announcement Contents Checklist

- Title of performance.
- Dates of performance.
- Hours the performance will be open to the public.
- Venue and address, phone number, email and Web site information.
- Directions if needed.
- Parking info if needed.
- Acknowledgments.
- If the space is wheelchair accessible, note this on the invite.

- List of artists in the performance, or your name.
- Be sure there is room for the label or address, and the stamp or nonprofit indicia.

6 weeks before the performance

- Design your announcements or work with a graphic designer. Check all spelling and use the announcement checklist to make sure you have included all the necessary information. Be sure that the reader will understand the difference between when the show opens, and when the opening reception is.
- Get bids from printers.
- Print announcement.
- Recruit people to help with the performance: bartenders, parking attendants, ticket takers, prop managers, etc. if needed.
- Send a save-the-date invite to your emailing list.
- Distribute publicity (announcements, flyers etc.)
- Mail announcements if using bulk mail.
- Mail press releases to newspapers, weekly publications, reviewers and radio stations.
- Make a checklist of those things you need to do to finish the work.

3 weeks before the performance

- Make sure your performance props are ready to install.
- Go over any special requirements with the venue to make sure you are in agreement with the site management.
- Arrange for photographer or videographer to document the performance.
- Design and order any performance signage you will need.
- Assemble and mail press packets to special writers and publications. (See press section)
- Send press releases to broadcast media.
- Mail announcements if using first class mail.

2 weeks before the performance

- Make calls to calendar listings managers to make sure your event will be listed.
- Make phone calls to arts writers and invite them to the show or event.
- Schedule final performance rehearsals.
- Create Facebook / Myspace Event invitation and invite your friends.
- Design and print any handouts, artist's statements, programs etc.
- Email announcement to your emailing list. Be sure to put your email addresses in the BCC area of your email so your reader does not have to scroll through all those email addresses to read your information and private emails are not made public
- If you send an image as an attachment or inclusion, make sure it is the smallest size (both in size and resolution), which you think you can get away with.
- Including the information in the email, instead of requiring the reader to click a link, will ensure that they read it more often than having to go to a link.

1 week before the performance

- Make sure all supplementary materials are printed or in a binder. Resume, artist's statement,reviews, guest sign in sheets etc.
- Make sure the venue is ready for you to install and check the performance area.
- Install performance signage.
- Put together your comp list for the person who will take tickets at the door.

2 days before the performance

- Set or adjust lighting.
- Patch and paint any walls or surfaces.
- Set up guest book and supplementary info.

- Get your reception supplies that don't require refrigeration.
- Test all equipment and do any rehearsals necessary.
- Take any clothes you plan to wear to the opening to the dry cleaners if necessary. Opening day of the performance
- Check to make sure everything is installed and working.
- Show up on time to the final rehearsal or event.
- Call any special friends or writers to remind them.
- Buy any reception supplies requiring refrigeration. Don't forget the ice.

During the performance

- Document the show with slides, video or digital images.

After the performance

- Send any thank-you notes to those who volunteered.
- Send letters to those who donated money or in-kind services to your event, including a 501(c)(3) letter if needed for a tax deduction.
- De-install the performance props, making sure that the space is returned to its original condition if required.
- Make sure your props are taken down in time for the next person to install.

✳ Screening Checklist

Once you have secured a venue for your screening, make sure you understand the following:
(Choose the questions that are applicable to your project and the venue)

- Name of Screening:
- Venue:

- Dates and times for the Screening:
- Who is the main contact person for the venue:
- When can you sign the contract, or loan form?
- If work is sold, what is the commission for the venue?
- What is the honorarium or artist's fee?
- Who pays for shipping, insurance, reception costs?
- What are the responsibilities of the venue or gallery?
- What are your responsibilities as the artist?
- Who pays for shipping, insurance, reception costs and invitations?
- Is there a floor plan for the space? If so where is it?
- When are the installation dates?
- What are the installation procedures?
- Who sets up the screening?
- What tools are available for screening?
- Who designs and mails the announcement?
- If the host venue designs and mails announcement, what is the deadline for information from the artist?
- Who pays for the announcements and the mailing?
- What is the deadline for information needed for the press release and other publicity?
- Does the venue have an emailing list for announcements?
- How many invitations will you receive as the artist?
- What equipment and technical support is available?
- Are there issues with electrical outlets and extension cord routes?

Screening Timeline

3 months before the screening

- Write up a budget for your project.
- Make sure your mailing list is updated and ready to go.

- Make sure you have a contract if possible.
- Photograph any screening out takes if possible.
- Send publicity to magazines.
- Check the press release for accurate information or write it yourself.
- Organize publicity packets and Include a copy of the announcement if available. Images can be included, or make sure to state that images are available in 8x10 black and white, color transparencies, or digital.

6 weeks before the screening

- Design your announcements or work with a graphic designer. Check all spelling and use the announcement checklist to make sure you have included all the necessary information. Be sure that the reader will understand the difference between when the show opens, and when the opening reception is.
- Get bids from printers.
- Print announcement.

Announcement Contents Checklist

- Title of screening.
- Dates of screening.
- Hours the screening will be open to the public.
- Venue and address, phone number, email and Web site information.
- Directions if needed.
- Parking info if needed.
- Acknowledgments.
- Your name.
- Be sure there is room for the label or address, and the stamp or nonprofit indicia.
- If the space is wheelchair accessible, note this on the invite.

4 weeks before the screening

- Recruit people to help with the reception: bartenders, parking attendants, ticket takers, and gallery sitters, etc. if needed.
- Distribute publicity (announcements, flyers etc.)
- Mail announcements if using bulk mail.
- Mail press releases to newspapers, weekly publications, reviewers and radio stations.
- Make a checklist of those things you need to do to finish the work. (framing, installation hardware, painting walls in gallery, etc.).
- Send a save-the-date invite to your email list.

3 weeks before the screening

- Make sure your screening material is ready to install.
- Go over any special requirements with the venue to make sure you are in agreement with the site management.
- Design and order any screening signage you will need.
- Mail announcements if using first class mail.
- Send press releases to broadcast media.
- Assemble and mail press packets to special writers and publications. (see press section)

2 weeks before the screening

- Make calls to calendar listings managers to make sure your event will be listed.
- Create Facebook / Myspace Event invitation and invite your friends.
- Make phone calls to arts writers and invite them to the screening.
- Design and print any handouts, artist's statements, programs etc.
- If you send an image as an attachment or inclusion, make sure it is the smallest size (both in size and resolution), which you think you can get away with.
- Email announcement to your emailing list.

Be sure to put your email addresses in the BCC area of your email so your reader does not have to scroll through all those email addresses to read your information and private emails are not made public.
- Including the information in the email, instead of requiring the reader to click a link, will ensure that they read it more often than having to go to a link.

1 week before the screening

- Make sure all supplementary materials are printed or in a binder. Resume, artist's statement, reviews, guest sign in sheets etc.
- Make sure the venue is ready.
- Create a comp list for the person taking tickets at the door.

2 days before the screening

- Set or adjust lighting.
- Set up guest book and supplementary info.
- Get your reception supplies that don't require refrigeration.
- Test all equipment and do any rehearsals necessary.
- Take any clothes you plan to wear to the opening to the dry cleaners if necessary.

Opening day of the screening

- Buy any reception supplies requiring refrigeration. Don't forget the ice.
- Check to make sure everything is installed and working.
- Show up on time to the event.
- Call any special friends or writers to remind them.

After the screening

- Send any thank-you notes to those who volunteered.

- Send letters to those who donated money or in-kind services to your event, including a 501(c)(3) letter if needed for a tax deduction.

 ## Visiting Artist Lecture Checklist

Once you have secured a venue for your lecture, make sure you understand the following: (Choose the questions that are applicable to your project and the venue)

- Date and time for the lecture:
- Venue Location:
- Who is the main contact person for the venue:
- What is the honorarium or artist's fee:
- When can you sign the contract:
- Who is your audience?
- How long are you expected to talk?
- Is the venue set up for questions from the audience?
- What are the responsibilities of the venue or gallery?
- What are your responsibilities as the artist?
- What are the particular issues the venue expects you to address?
- Is there a stage or lectern?
- Microphone or amplification?
- Does the venue have an emailing list for announcements?
- Who designs and mails the announcement?
- If the venue does, what is the deadline for information from the artist?
- How many invitations will you receive as the artist?
- What is the deadline for information needed for the press release and other publicity?
- What equipment and technical support is available?
- Is there back-up equipment?

Things to Consider When Giving a Lecture

Talking Points:

- Your background, including any pertinent information that has influenced your work.
- Your influences, such as other artists, events, elements of popular culture, etc.
- The materials you use, and any special techniques. How do the materials lend to the content of the work?
- The content of the work, where your ideas come from, and sources of imagery.
- Describe the evolution of your work, and the history of your ideas.
- Who the audience for your work is, and how you would like your audience to respond to the work.
- Do NOT face the screen when describing your work, face your audience.
- Be enthusiastic and enjoy the presentation.
- Connect with your full audience by making eye contact throughout the room, including those sitting in the back.
- Project your voice. If you have a quiet voice, request a microphone.
- When presenting the work, the audience likes to know what they are looking at, so include the title, date made, materials and other pertinent information.

Preparation:

- Consider making an outline for your talk. You can set it up in various ways, such as chronologically, thematically, or as a narrative.
- Be selective about the amount of work you will show. If you are showing slides, one slide tray is a pretty good guide, which is a maximum of 50 images.
- You should probably keep the talk down to an hour and a half at the most, and make sure this includes time for questions.

- If you are new to this, it may be a good idea to do a practice session, and run through your presentation materials.
- If you are showing slides, check that all your slides by projecting them if at all possible. It is embarrassing when you have upside down slides during your talk. (see information on slide labeling).
- If you are projecting a PowerPoint presentation make sure you have a backup burned on a CD and/or a flash drive.
- Make sure you have all the necessary cords needed to connect your computer to the host institution's projector (if applicable).
- Print two copies of your talking points and bring them to the venue.
- Make sure the presentation will work on the host institution's computer.
- Make sure you prepare for a wide range of questions, including those that you find difficult to answer.

Other tips:

- Be yourself, and talk with an authentic tone of voice.
- You know your work best, so be truthful and enthusiastic.
- Sometimes it is useful to mingle with your audience before the talk. It sets the tone, and makes you accessible to your audience. Making connections with your audience is important.
- If you are nervous, don't let it get to you. You might admit your nervousness to the audience, as it tends to make them very sympathetic and generous.
- Be sure to allow your audience to ask questions, during and/or after your talk.
- Create an atmosphere where there is an exchange with your audience.
- Thank the audience for coming, and thank the hosts.

Day of the lecture

• Check to make sure the equipment is working.
• Make sure your media is in working order, and your slides are loaded correctly.
• Having your own slide tray pre-loaded is important.
• Show up on time to the event. Allow plenty of time for set up and equipment and media check.
• Make sure you have two copies of your talking points printed out.
• Call any special friends or writers to remind them.

After the lecture

• Send any thank-you notes to the venue.
• Make sure to add your lecture to your resume.

19: Proposals & Grants

 Objectives

Understand the basics of proposal and grant writing

Understand how to find and research information

Understand things you should know about proposals in general

 Things to Consider

Read through the basic outline of proposals to understand why and where you would use them.

 Things To Do

Practice writing a project or exhibition proposal as part of your practical growth as an artist. This does not have to be done immediately, or perfectly, simply make it formulated and thought through. Take your time and realize that you are just practicing.

 Types of Funding

Here is a very bare-bones list of the different kinds of funding available to artists from different regional and national organizations and institutions

Public
Arts Councils and Agencies
 National
 National Endowment for the Arts
 National Endowment for the Humanities

State
 State Arts Councils (like the California Arts Council)
Local
 Local Arts Councils or Cultural Affairs Departments (like the Los Angeles Cultural Affairs Department)

Private
 Foundations
 Art Service Organizations
 Art Centers and Workshops
 Corporate Sponsorship
 Museums and Galleries

Cash Grants And Awards
 Unrestricted
 Fellowships and General Support
 Competitions and Awards
 Restricted
 Project Grants and Support
 Commissions
 Public Art Projects
 Special Opportunity Grants
 Emergency Funds and Assistance

Time And Space
 Artists' Residencies
 Artists' Colonies and Communities
 Artists' Retreats
 Facilities and Technical Support
 Gallery or Museum Residencies or Awards
 University or Education Awards
 Arts-in-Education Awards
 Scholarly Awards
 Space Awards

In-Kind

> Equipment Access
> Materials and Supplies
> Specialty Services (like Graphic
> Designers, Fabricators, etc.)
> Professional Development

 Research

Finding the right funder is crucial to your efforts, so take time to do the research. It is a waste of time to apply to funders who do not fund what you are asking for. It is also not a good idea to make up a project or change your project in a way that does not satisfy your ideas.

Read each application's guidelines very carefully. Many grants are lost because the applicant did not follow instructions. If you are unsure of the guidelines, make sure you do further research either by checking their Web site, or calling directly. Take careful note of the language used by the funder, and use some of that language to communicate back to them.

The web has increasingly become an important and indispensable resource when looking for funders. Most foundations and funders have a website, or a listing on a site that will at least give you basic information. You may need to write or call for additional information. There are also research centers in most cities, where you can make an appointment to search their library or grants database.

As with all endeavors it's best to start local. Research funders in your neighborhood, then city, then state, then country, then International funders. Starting from the closest funder to you will open more opportunities as you expand the scope of your research. Even if you use the Internet to find funding sources, make sure not to neglect the person-to-person connections crucial to building a relationship between you

and the funder. Pick up the phone and call a funding organization. Your interest will often set you apart from the rest of the application pool. If you can get access, read other successful proposals dealing with projects similar to yours. Finding out what has been previously funded can give you an idea of what funders are interested in.

While looking for funding sources try and answer these questions, which will not only help you find the right funder for your project, but will also assist in you writing a more effective grant:

• How will funding sources relating to your project change in the next few months, year, three years, decade?

• What funders routinely give money to projects like yours?

What organizations create, manage or develop projects similar to yours? Can you collaborate with these organizations?

• Has your project been created in a different form, community, or context and if so what sets your project apart from this past work?

Many artists cannot afford grant writers, but there are workshops and support groups that may be helpful ask your local arts nonprofit what sorts of grants writing workshops are available in your community.

 Planning

Use this section to sketch out a plan. Start with the big picture. Go nuts and write down all the things you want to do with your project. Determine the overall scope of your project then break it up into manageable sections. You might start to realize that you may be getting in over your head. Or, you might sit back and realize that you need to expand the scope of your project. Whatever you decide to do, take some time to plan ahead and revisit this section periodically.

Have your materials handy and updated, such as your resume, artist statement, labeled work samples and work descriptions. A proposal will need to be created for each application. Each funder usually has very specific questions that you will need to answer. Never send out a bunch of generic proposals, as they are usually rejected. Be specific to each funder in your application.

Before you begin, read the guidelines for the grant or call for entry you are applying to. Make sure you answer any lingering questions the application brings up. Next, write out a timeline. This timeline will change as your project progresses, but decide which benchmarks are very important and stick to them. Most funders have very specific deadlines, so you will have to make sure to meet them. Make sure you know if the deadline is a postmark deadline, or a delivery deadline. Some granters specify a time of day the grant must be in their hands.

 Summary

A proposal summary is a short one-sentence summation of your entire project. Writing a summary is often a good exercise to determine exactly what you are trying to do. It can clarify the project's theme or idea in a concise manner.

The summary is the first thing that funders read when reviewing proposals and if your summary isn't engaging the rest of your proposal may be overlooked.

Some funders provide a limited amount of space for the summary on the application form. If you do not have a specific form required for your summary you might want to state your summary in your application's cover letter.

It is important that your summary be clear and concise. Don't waste space trying to go into too much detail. If you have space, make sure you describe who you are, the scope of your project, and the amount you are requesting.

 Applicant Information

The Applicant Info section is designed to provide proof to possible funders about why you are the right person to execute your project, including information about how your skills, history and talent will guarantee that the project is realized successfully. While different from the Biography section of your proposal, which is about your art career, credentials can include information about other jobs you have had that are not art related, but have given you the skills to do a project. Maybe you were a welder in a former life, or you were a manger at a company. Both could have given you skills that were particularly suited to the funding request.

Some funders will ask for letters of reference to support a credential ilisting. Make sure that you give ample time to anyone you ask to write you a letter of recommendation and provide information about who and what they are writing the letter for.

Project Description

This is the section where you should go into full detail about your project. Be sure to include all-important details, but do not include things that are self-evident or common sense. You want to be clear, but not talk down to your reader. If there is something missing in this section that remains unclear, the funder will have questions about the project. Be specific and detailed.

Be sure to make the goals of your project clear. List your and how you plan to get there. An objective is a specific and measurable outcome of your project. If you have stated a need or problem, then this description should provide relief.

Be sure to distinguish between methods and objectives. Objectives don't speak about the results. The funder is going to know what you have accomplished at the end of the project. Just because you have completed the project does not give the funder an idea of the outcome of the project. Be sure to state what objectives you want to accomplish. The method is what you will do to accomplish the project –the activities you will conduct in order to accomplish your objectives. The funder will want to know why you have chosen these methods, and why you think they will work. If you are not asked how you will evaluate the project later in the application form, here is the place to include your plans for evaluation. (See evaluation section)

Project Distribution

This is where you state how the project will be disseminated or distributed, Use this section to explain how you are going to take what you have done out into the public realm. Be sure to describe your target audience. If you plan to make a book or CD, how will distribute it? If your end goal is to stage a performance, where you will perform it?

This section should also include how you will get the word out about your project, whether through advertising in a publication, sending announcements, or emails. Include details as to how you will let the larger public know about your work.

Funders do not want to fund something that sits in your hall closet, or does not make it into the public realm. They want you to give serious consideration as to how the project will be seen or used.

Introduction

This is the section that the funder will read after your summary. Often a preliminary reviewer screens the first batch of proposals to make sure that the applicant has followed proposal guidelines. The introduction section may determine if the proposal is passed on to a specialist, or to the grant panel.

The introduction should be fairly short, and give the reader an idea of who you are and the context of the project you are proposing. The introduction is the part of the proposal where you establish your credibility.

Sometimes it is a good idea to take all the sentences that you have removed from your summary and include them here. This is just a basic overview, and specific details should be

saved for the project description area. Be sure to pay attention to word and page limits specified by the funder.

 ## Project History

This part of your application should state what led you to develop this project and ask for funding. This part of the application is not your resume or credentials, but a perspective on why you are doing this project.

Sometimes this section is called the problem assessment or needs assessment part of the application. Here you will need to show that you have researched why your particular project will make an impact or fulfill a need. Be very specific but not unrealistic. For example, don't explain the entire scope of world hunger and then state that your art-project food distribution cart will cure hunger. Instead focus on the raw facts, the nitty gritty. Funders will appreciate your forward thinking and rigorous research.

If others have done projects in the area you are interested in, you should explain why your project is different, or better than previous projects. Make sure you do the research in this area and highlight the unique parts of your project.

You should also address the specific funding goals and criteria that the funder is interested in supporting. Don't go overboard with trying to do a project larger than is realistically feasible. Be specific and narrow down the problem to one that can be addressed with additional resources. Make sure that the funder is aware of your knowledge of the problem or reason for the project.

 ## Project Timeline

A timeline details when you plan to accomplish tasks specific to your project. Besides providing you with a long-term to-do list, a comprehensive timeline shows potential funders that you are organized, proactive, and prepared.

Begin your timeline by starting with the date farthest into the future. This could be when you turn in the evaluation of your project. Now work backwards. Make sure to list specific deadlines your funder prescribes. Projects can lose funding and institutional support if deadlines are not met. Structuring your timeline in this manner will help you foresee all the obstacles, events, and tasks you will have to accomplish. Include enough detail to make sure that your reader understands that you have thought out your steps clearly and logically.

Make sure your timeline is realistic, that you have allotted enough time for each task. If you don't know how long a specific task will take, err on generous side, building in a buffer so that you can finish what you need to get accomplished without tasks piling up and becoming unmanageable.

 Evaluation

This section should address how you plan to evaluate your project and determine if you met your goals and objectives.

An evaluation can determine how effective your project was, and also serve as a tool to provide information necessary to make changes to your program or project in the future. If you have trouble determining what criteria to use in evaluating your project, look again at your objectives. If you plan on making a lasting impact in the community, what would be the way you would determine if this actually happened?

You want to show active methods for evaluating your work. Some evaluation techniques include interviews, reviews, attendance, questionnaires, all designed to measure specific outcomes. Evaluations can take place both in-house, or by an outside evaluator.

 Funding Resources

There are numerous resources you can consult for proposal and grant writing. Remember, grant writing is a learned skill and, like any skill, takes practice. If you really want to learn to write stellar grants consider seeking the advice of a grant writing professional. Look for workshops in your area and find a funding research center in your city. If there is a Cultural Affairs Department in your city, give them a call to find out local research possibilities. The web is full of grant writing resources.

ArtDeadline www.artdeadline.com

Artist Help Network www.artisthelpnetwork.com

Federal Funding Opportunities www.arts.gov/federal.html

Grant Online Database www.pen.org
National Assembly of State Arts Agencies www.nasaa-arts.org

NYFA Source www.nyfa.org/nyfa_source.asp?id=47&fid=1

Philanthropy News Digest foundationcenter.org/pnd

Grant Writing Resources Blog http://grant-writing-resources.blogspot.com/

Nonprofit Guides http://www.npguides.org/index.html

Minnesota Council on Foundations http://www.mcf.org/mcf/grant/basics.htm
http://www.scribe.com.au/Plain-English-Sample-Chapter.pdf

http://www.grantwritersonline.com/pdf/grant_proposal_checklist.pdf

For more resources see GYST's Links and Resources section.

 Future Funding

If your project has a long timeline, you will need to address how you will fund your project into the future to ensure longevity and sustainability. If your project is intended to last for a short time, or if your proposal simply requests one-time equipment purchases or services, you don't need to list sources for future funding, unless you are building in funding for future maintenance or upgrades.

It is not sufficient just to say you promise to look for additional funding. You should provide detailed descriptions of these funding sources and plans for alternative funding sources. Maybe you intend to collect earned-income from your project through merchandise sales or ticket sales. How can these sales be made more sustainable?

 Budget

The budget you provide is a very important aspect of your proposal. It should reveal the concise descriptions of the expenses and income for the project. It should generally fit on one page, and be divided into categories such as personnel, services, supplies, in-kind donations, facility expenses etc. Start by separating your budget into two primary sections: Income and Expenses.

Income is where you list all the budgetary items that are paid for. This is where you list in-kind donation, which are cash, supplies, services and/or labor that are donated by you or your organization, or are being donated by other people or organizations. Itemize these in as much detail as possible.

Expenses are detailed lists of all the expenses included in your project. Break this into

manageable sections, like artist fees, exhibition fees, reception fees, advertising, printing, etc. Include subtotals and totals to make your budget easier to read.

Do not pad the budget with unnecessary purchases. Funders are very savvy about expenses, and generally know what most things cost. Be clear, state amounts, and justify what you are asking for. Only ask for what you need. You might want to attach quotes for services. Often three quotes for each service will show a funder that you have done your research to find the most affordable price. Remember, a grant is not a gift, it provides the resources for working.

If you are receiving funding from any other source, you should list it here. Whether another funder, individuals or in-kind support, funders will often fund projects that have additional support elsewhere, or are supported by an organization which has agreed to present your project.

See the sample budget below.

INCOME		
Source	Description	Amount
Government		
	Cultural Affairs Department (awarded)	$2500.00
Foundations		
	Money for Artists Foundation	$600.00
Individuals		
	Daddy Bigbucks	$500.00
	Fairy Godmother	$500.00
	Dealer Dude	$200.00
	Angel	$525.00
	TOTAL Contributions	**$4825.00**
In-Kind		
	Sir Prints A Lot (discount on fee)	$100.00
	Maggie The Musician	$500.00
	Scruffy the Sculpture (discount on fee)	$500.00
	Captain Curator (discount on fee)	$500.00
	Advertising Discount (College News)	$100.00
	Advertising Discount (Art News)	$500.00
	Advertising Discount (LA Times)	$400.00
	Whole Foods Market (reception)	$60.00
	Grocer (reception)	$40.00
	Trader Joe's (reception)	$50.00
	TOTAL In-Kind Contributions	**$2750.00**
Earned Income		
	CD Sales (20 at $10 each)	$200.00
	Workshop Income	$200.00
	Artist Print Fundraiser	$400.00
	TOTAL Earned Income	**$800.00**
	TOTAL INCOME	**$8375.00**

EXPENSES		
Source	Description	Amount
Personnel		
	Captain Curator Fee	$1000.00
	Arty the Artist	$500.00
	Maggie the Musician	$500.00
	Scruffy the Sculptor	$500.00
	Performing Peter	$500.00
	TOTAL Personnel	**$3000.00**
Advertising		
	Advertising Discount (College News)	$200.00
	Advertising Discount (Art News)	$1000.00
	Advertising Discount (LA Times)	$800.00
	Blog Ad (Artslant)	$200.00
	TOTAL Advertising	**$2200.00**
Materials and Supplies		
	Canvas	$800.00
	Paint	$200.00
	Lumber for stretchers and pedestals	$950.00
	TOTAL Materials and Supplies	**$1950.00**
Reception		
	Whole Foods Market (reception)	$60.00
	Grocer (reception)	$40.00
	Trader Joe's (reception)	$50.00
	TOTAL Reception	**$150.00**
Printing		
	Sir Prints A Lot (postcards)	$200.00
	Wall Vinyl	$250.00
	TOTAL Printing	**$450.00**
Insurance		
	Smith's Art Insurance	$625
	TOTAL Insurance	**$625**
	TOTAL Expenses	**$8375.00**

20: Tracking Proposals

 Objectives

Understand an organizational strategy for keeping track of grants written and pending.

Create a system to keep track of those grants you receive and when they need to be invoiced.

 Things to Consider

You may or may not know how easy it is to forget who you have sent what and when. Think about and write down the benefits of keeping track of proposals and grants.

 Tracking Proposals

Keeping track of who and when you have sent out proposals is a really good idea. It can be embarrassing If you forget that you sent a proposal 4 months ago, and send one again. It is a good idea to keep track of when you sent a grant or funding request, and when you should hear back from the funder. This way, if you should have been notified by a certain date, you can contact the funder or exhibition space to inquire about your proposal, but not before.

It will also allow you to keep track of when you sent a proposal, so that you can follow up with another one after a sufficient period of tIme.

Basic information to keep track of:

- Who the proposal was sent to.
- Date proposal sent.
- Contact name.
- Contact address.
- Contact phone.
- Contact email.
- Date when you should receive a reply.
- Whether the proposal is pending, accepted or rejected.
- What project or exhibition you applied with.

Follow-up information:

- When you can invoice for payment should you receive a grant.
- When and how you should follow up should you receive an exhibition slot.
- Keep track of all payments.

21: Contracts and Agreements

 ## Objectives

Understand the importance of contracts

Understand the list of contracts to use for personal use or as a checklist to a contract you receive from a gallery or organization

 ## Things to Consider

Think about and write down when and where an artist should have a signed contract. Think about how to get around those galleries who will not sign a contract and how to address it.

An arts attorney can address these and other legal issues.

 ## Introduction to Contracts

NOTE: These sample contracts are for checklist purposes only. You use these contracts at your own risk and you do not hold GYSTInk responsible for any unfavorable outcomes associated with the use of these contracts.

If you have any questions about legal language, please consult one of the references included as part of this program, or contact a lawyer. Use these items to see if there is anything missing in your contract, or if you need to change a contract you have been sent.

As a general rule, any time you enter into an agreement pertaining to money, or long-term associations, like gallery representation, you need to have a lawyer look over the agreement. If your contract is complicated, or you do not

understand it, it is advisable for you to contact an attorney. Hundreds of artists have been bullied into signing contracts they don't understand. Take your time and go over important contracts with a lawyer.

Contracts are useful for a number of reasons. They spell out agreements between parties that are enforceable by law. They clarify legal issues and add a sense of professionalism to any agreement. A contract can be verbal, but a contract in writing, signed by both parties, is always better.

When working with friends it is always a good idea to draw up a simple written contract. Make sure the contract is clear and specific. Sticking to this contract can help you avoid trouble in the future and maintain your friendship.

A contract should state each party's obligations, the scope of work, and the agreement as to compensation. It does not have to be written in legalise unless there is something specific for a complicated project. Make sure the entire contract includes all the agreements you have with the other party.

 # Contract For the Sale of an Artwork

AGREEMENT made as of the _____ day of _____, 20_____, between _____ _____ (hereinafter referred to as the "Artist"), located at _____, and_____ (hereinafter referred to as the "Collector"), located at _____ _____with respect to the sale of an artwork (hereinafter referred to as the "Work").

WHEREAS, the Artist has created the Work and has full right, title and interest therein; and WHEREAS, the Artist wishes to sell the Work; and WHEREAS, the Collector has viewed the Work and wishes to purchase it; NOW, THEREFORE, in consideration of the foregoing premises and the mutual obligations, covenants, and conditions hereinafter set forth, and other valuable considerations, the parties hereto agree as follows:

Work Title: _____

Date of Creation: _____

Signature location: _____

Medium: _____ Size: _____

Framing specifications: _____

Edition: _____

• If the work is an edition, there are laws that require you to include the following information:

Method of production (lithograph, silk-screen, digital print): _____

Size of the edition (how many prints did you make): _____

How many multiples are signed: _____

How many are unsigned: _____

How many are unnumbered: _____

How many proofs exist: _____

The quality of any prior editions: _____

Whether the master image has been canceled or destroyed: _____

Sale

• The Artist hereby agrees to sell the Work to the Collector. Title shall pass to the Collector at such time as the Artist receives full payment.

Signatures:

Signed by _____ (The Artist) On _____(date)

and _____ (Collector) On _____(date)

NOTE: These items are for checklist purposes only. If you have any questions about legal language, please consult one of the references included as part of this book, or contact a lawyer. Use these items to see if there is anything missing in your contract, or if you need to change a contract you have been sent.

 Invoice for the Sale of an Artwork

Date of sale: (include day, month and year)
Artist's name:
Artist's address:
Artist's phone number and email:

Purchaser's name:
Purchaser's address:
Purchaser's phone number and email:
Description of the Work:
This Invoice is for the following Artwork created by the Artist and sold to the Purchaser (and should include:)

Artwork information
Title:
Year of Creation:
Medium:
Work Dated:

Size:
Framing or Mounting information:
Location of Signature:

Editions
• Is the work a limited edition?
• What is the method of production?
• What is the size of the edition?
• How many multiples are signed?
• How many are unsigned?
• How many are numbered?
• How many are unnumbered?
• How many proofs exist?
• The quantity of any prior editions (of the same image).
• Has the master image been cancelled or destroyed?

Pricing
Price of the artwork sold:
Delivery charges:
Total:

Sales or transfer tax (if applicable):
Other charges:

Payment agreement
Information regarding payments (details on payment schedule):
Date of final payment:

Signatures: (Both parties should sign the contract with the date)

 # Contract to Commission an Artwork

DISCLAIMER: This contract is written as a checklist and guide only. You should in no way use this contract in its current state as a binding agreement between you and any individual, corporation, gallery or venue. When entering into an agreement with any institution for short or long-term work a lawyer or attorney skilled in legal practices pertaining to the arts should first review any contracts signed. You can use this contract as a starting point for drafting an agreement for a commission, but do not rely on this contract in its present form and do not sign it until you have had legal counsel look at it and suggest alterations or changes.

• Date of the Agreement (include day, month and year):

• This agreement is between _____ (the Artist) and _____ (the Purchaser)

• AGREEMENT made as of the _____ day of _____, 20___, between _____ _____(hereinafter referred to as the "Artist"), located at _____ (the city and state, the country if necessary), and _____ _____(hereinafter referred to as the "Purchaser"), located at _____ _____ (the city and state, the country if necessary) with respect to the commissioning of an artwork (hereinafter referred to as the "Work").

Information About the Preliminary Design:
• The Artist agrees to create a preliminary design in the form of _____ _____(studies, sketches, model, drawings etc.)

Further description of design aspects: _____ _____ _____

Date the preliminary design is to be delivered to the Purchaser:

• The Purchaser's written approval of the preliminary design:

• The Purchaser will pay the Artist $_____ upon the signing of this agreement. Initialed by _____ The Artist and _____ Purchaser.

Description of the project to be undertaken
Title:
Medium:
Size:
Price:
Work Performed in the creation of the work:
Additional information about the project:

Purchaser has _____ (days, weeks, months, years, etc.) to request any changes to work in the _____ (design, first, second, final stages).

Changes must be submitted in _____ (mail, email, in-person, etc.) form.

Artist will charge _____ (hourly change rate) on top of regular costs, for executing these changes.

In the event that The Artist falls ill, or has a disability preventing the progress of the completion of The Work, the project can be extended for a maximum of _____.

Should there be any delays that are beyond the control of the Artist the project may be extended for a maximum of_____.

Initialed by _____ The Artist and _____ Purchaser.

Payments
• The initial date of payment to the Artist upon beginning the Work:
• Payments scheduled during the construction of the Work:
• Final payment is due:
• Any additional expenses to be incurred by the Purchaser (gas, travel, etc.):
• Applicable sales tax to be paid by The Purchaser:

• Agreement as to the completion of the Work:
Describe,in detail what the completion of the work entails. _____

When work is complete The Artist will send the Purchaser a written notice of the completed project and the amount due.

Initialed by ———————————— The Artist and ———————————— Purchaser.

Delivery of Work, Insurance, Shipping and Installation
• Date of Delivery of Work (if applicable):

• Who is responsible for insurance, liability, shipping and installation?:

• At the completion of the Work, the Work will be shipped via (name carrier):

• Work will be shipped to (include the address of the delivery):

• Work will be installed in the following manner:

Initialed by ———————————— The Artist and ———————————— Purchaser.

Termination of the Work
• If the Purchaser does not approve of the preliminary design, the artist shall keep all payments made and the agreement shall terminate.

• The Artist may terminate this agreement in the event the Purchaser is more than sixty days late in payment; however nothing herein shall prevent the Artist bringing suit based on the Purchaser's breach of contract.

• The Purchaser may terminate this agreement if the Artist fails without cause to complete the Work within ninety days of the completion date stated herein. In the event of termination, the Artist agrees to return to the Purchaser all payments made to the Artist, but shall not be liable for any additional expenses, damages or claims.

• The Purchaser may terminate this agreement in the event the illness of the Artist causes a delay of more than six months or if events beyond the Artist's control cause a delay of more than one year of the completion date provided. The Artist shall retain all payments made pursuant to the above.

• This agreement shall automatically terminate on the death of the Artist. The Artist's estate shall retain all payments made pursuant to the above.

• Termination of any agreement will be made in writing.

Initialed by ———————————— The Artist and ———————————— Purchaser.

Ownership, Copyright, Privacy
• Title of the Work remains with the Artist until the Artist is paid in full.

• If the Artist terminates this contract, the rights to the Work remain with the Artist, and the Work can be sold to another customer. The Purchaser shall return all drawings and rights to the Artist.

• If the Work is terminated by the Purchaser in the event of illness or events beyond the control of the Artist or Purchaser, the Purchaser shall own the Work in whatever degree of completion and shall have the right to complete, exhibit and sell the Work if the Purchaser so chooses. The Purchaser has the right to keep the preliminary drawings in order to complete the project.

• The Artist reserves all rights of reproduction and all copyrights to the Work, the preliminary design, and any incidental work made in the creation of the Work. The Artist shall receive authorship credit in the event of any reproductions of the Work.

• The Purchaser gives to the Artist permission to use the Purchaser's name, picture, portrait and photograph, including but not limited to exhibition, display, advertising, trade and editorial uses, without violation of the Purchaser's right of privacy.

• The Artist shall have the right to access of the Work for _____ period of time, for exhibition or other event, at no cost to the Purchaser. The Artist will notify the Purchaser _____ before the work is needed for exhibition or event.

• Stipulations as to the agreement for future exhibition and access:

Initialed by _____ The Artist and _____ Purchaser.

Maintenance, Repairs
• Who is responsible for the maintenance of the project:

• Details of the maintenance agreement:

• Any and all repairs during the lifetime of the Artist shall have the Artist's approval. The Artist will be given the opportunity to make the repairs and restorations at a reasonable fee agreed upon between The Purchaser and The Artist.

Initialed by _____ The Artist and _____ Purchaser.

Alteration or Destruction

• The Purchaser agrees not to intentionally destroy, alter, modify or change the Work in any way.

• If any alteration occurs after receipt by the Purchaser, the Work shall no longer be represented as the work of the Artist without the artist's written consent.

Initialed by _____ The Artist and _____ Purchaser.

Heirs and Non-assignability

• This agreement is binding to all heirs, successors, assigns and personal representatives, and the agreement covers these heirs, successors, assigns and personal representatives.

• Neither party has the right to assign this agreement without prior written consent of the other party.

Initialed by _____ The Artist and _____ Purchaser.

Alterations, Waivers, Notices, and Change of Address

• Any alterations to this agreement shall be made in writing

• Include any waivers in writing as part of this contract:

• The Purchaser shall notify the Artist of any changes to the address of the Purchaser or change in the location of the artwork. The Artist shall also notify the Purchaser of any changes of address.

Signatures:

Signed by _____ (The Artist)
On _____ (date)

and _____ (Purchaser)
On _____ (date)

• Both parties shall sign and date the contract

NOTE: These items are for checklist purposes only. If you have any questions about legal language, please consult one of the references included as part of this program, or contact a lawyer. Use these items to see if there is anything missing in your contract, or if you need to change a contract you have been sent.

 # Contract for Receipt and Holding of Artwork

• Date of the Agreement (include day, month and year):

• This agreement is between _____ (the Artist) and
_____ (the Recipient)

• AGREEMENT made as of the _____ day of _____, 20_____, between
_____(hereinafter referred to as the
"Artist"), located at _____(the city and
state, the country if necessary), and _____
_____ (hereinafter referred to as the "Recipient"),
located at _____
(the city and state, the country if necessary) with respect to the receipt and holding of
artwork(s) in the attached Schedule of Artworks (hereinafter referred to as the "Work").

Purpose
• The Artist agrees to entrust the artworks listed on the Schedule of Artworks to the
Recipient for the purpose of (list the purpose):

The Schedule of Artworks shall include the following information for each artwork.
• Title of the Artwork.
• Medium of the Artwork.
• Description of the Artwork.
• Framing or mounting information for each work
• The value of the Artwork.
• If the insured value is different than the stated value of the Artwork, list here as well.

Initialed by _____ The Artist and _____ Recipient.

Acceptance
• The Recipient accepts the listing and the values of the Schedule of Artworks as accurate if
not objected to in writing by return mail immediately after the receipt of the artworks (or
list time agreed upon to respond):

Initialed by _____ The Artist and _____ Recipient.

Ownership and Copyright
• Copyright to The Works listed in the Schedule of Artworks is own by:
• The Works listed in the Schedule of Artworks are owned by:

• The Recipient agrees not to reproduce, display, copy or modify the works. The Recipient will not allow any third party to reproduce, display, copy or modify the works without written consent of the Artist.

Initialed by _____ The Artist and _____ Recipient.

Loss, Theft or Damage
• Recipient agrees to assume full responsibility and be strictly liable for loss, theft or damage to the articles from the time of (a) shipment by the Artist, (b) receipt by the Recipient until the time of (a) shipment by the Recipient or (b) receipt by the Artist

• The method of transportation for The Works:

• Reimbursement for loss, theft or damage to an artwork shall be in the amount of the value entered for the artwork on the Schedule of Artworks. Both Artist and Recipient agree to the value shown on the Schedule of Artworks.

Initialed by _____ The Artist and _____ Recipient.

Insurance
• Who is responsible for insurance of the artwork and at what time:

• How is the work insured during shipping or delivery:

• List who is responsible for insurance during installation and during the show or event:

Initialed by _____ The Artist and _____ Recipient.

Holding Fees
• Date the artwork shall be returned to the Artist:

• Amount charged to the Recipient for each day the artwork is held over the return date:

• The above amount for failure to deliver The Work shall be paid to the Artist on a weekly basis.

Initialed by _____ The Artist and _____ Recipient.

Arbitration
• Artist and Recipient shall agree to submit all disputes hereunder in excess of $_____ to arbitration before___/___/___ at the following location _____

under the rules of the American Arbitration Association. The arbitrator's award shall be final and judgment may be entered on it in any court having jurisdiction thereof.

Initialed by _____ The Artist and _____ Recipient.

Modifications
• Any modification to this agreement shall be made in writing.

• Include any waivers in writing as part of this contract:

• The Recipient shall notify the Artist of any changes to the address of the Recipient or change in the location of the artwork. The Artist shall also notify the Recipient of any changes of address.

Initialed by _____ The Artist and _____ Recipient.

Signatures:

Signed by _____ (The Artist)
On _____ (date)

and _____ (Recipient)
On _____ (date)

Company or Organization of Recipient (if applicable) _____

NOTE: These items are for checklist purposes only. If you have any questions about legal language, please consult one of the references included as part of this program, or contact a lawyer. Use these items to see if there is anything missing in your contract, or if you need to change a contract you have been sent.

 # Artist Gallery Contract/ Consignment/ Account

DISCLAIMER: This contract is written as a checklist and guide only. You should in no way use this contract in its current state as a binding agreement between you and any gallery or venue. When entering into an agreement with any institution for short or long-term work a lawyer or attorney skilled in legal practices pertaining to the arts should first review any contracts signed. You can use this contract as a starting point for drafting an agreement between you and a gallery for exclusive or nonexclusive representation but do not rely on this contract in its present form and do not sign it until you have had legal counsel look at it and suggest alterations or changes.

• Date of the Agreement (include day, month and year):

• This agreement is between _____ (the Artist) and _____ (the Gallery)

• AGREEMENT made as of the _____ day of _____, 20_____, between _____(hereinafter referred to as the "Artist"), located at _____(the city and state, the country if necessary), and _____ _____ (hereinafter referred to as the "Gallery"), located at _____ (the city and state, the country if necessary) with respect to artistic representation as stated in this agreement.

Scope of the Gallery
• The Artist appoints Gallery to act as the artist's _____ exclusive (or) _____ nonexclusive agent in the following geographic area _____ _____for the exhibition and sales of artworks in the following media: _____.

• The Gallery shall document receipt of all works consigned hereunder by signing and returning to the Artist a Record of Consignment in the form annexed to this contract as Appendix A.

Initialed by _____ The Artist and _____ Gallery.

Terms and Termination
• This agreement shall last for a term of _____ years.

• This agreement and will be terminated by either party giving sixty days written notice to the other party.
• This Agreement shall automatically terminate with the death of the Artist; the death or employment of the Gallery dealer (name specifically) elsewhere; if the Gallery moves outside the area of _____; or the Gallery becomes bankrupt or insolvent.

• On termination, artworks consigned shall immediately be returned to the Artist (or estate) at the expense of the Gallery.

Initialed by _____ The Artist and _____ Gallery.

Exhibitions
• Detailed list of schedule of exhibitions (number of solo exhibitions, etc) and frequency of exhibitions both within and outside Gallery:

• Detailed list of number of exhibitions of Artist's work in group shows both within and outside the specified Gallery:

• Detailed list for scheduled exhibitions (if there is only one exhibition for nonexclusive representation, list it here. Include dates and hours of operation):

• Detailed list of who pays for what for exhibition expenses, and other Gallery expenses such as transportation of the Artwork including insurance and packing, advertising, catalogs, announcements, framing, special installation requirements, opening reception costs, shipments to buyers, transportation of the work back to the Artist at the end of the exhibition, and if the work remains at the gallery after the exhibition has finished. Attach a separate sheet if necessary:

• Detailed list of responsibilities for photographing the work and who gets copies and originals:

• Detailed list of who retains ownership of frames, photographs, negatives and any other tangible property after the exhibition:

• The Artist has artistic control over the exhibition and the artwork.

• The Artist must approve quality of reproduction of the work for promotional and advertising purposes.

• No shared expenses should be incurred by either party until there is prior written consent of the other party as to the amount of the expense.

Initialed by _____ The Artist and _____ Gallery.

Commissions, Prices, Payments
• Commission percentage of the retail price of each work retained by The Gallery after the sale of each work:

• Commission percentage of the retail price of each work retained by The Gallery after the sale and receipt of payment of each work:

• If this agreement is for exclusive representation, The Artist agrees to give percentage of all sales of work by The Artist's (from the Artist's studio or outside the Gallery) to The Gallery.

• Detailed information as to whether commissions for Work count as studio sales requiring a percentage to the Gallery:

• Gallery agrees to sell the Artist's works at the retail prices shown on the Record of Consignment, subject to the Gallery's right to make customary trade discounts to select purchasers such as museums and collectors.

• Maximum percentage of discount the Gallery is allowed to use:

• The Gallery shall pay the Artist all proceeds due to the Artist within thirty days of sale.

• No sales on approval or credit should be made without the written consent of the Artist unless under the following conditions:

• The first proceeds received by the Gallery shall be paid to the Artist until the Artist has been paid all proceeds due.

Initialed by _____ The Artist and _____ Gallery.

Accounting & Inspection of Books
• The Gallery shall furnish the Artist with an accounting every _____ months in the following form agreed upon by the Artist and the Gallery:

• The first date that this accounting will be mailed or given to the Artist:

• For each sale of The Artist's work, the Gallery shall list the date of sale, the sale price, the name and address of the purchaser, the email of the purchaser (if available), the amounts due the Gallery and the Artist, and the location of all works consigned to the Gallery that have not been sold.

• In the event that this agreement is terminated; the Gallery shall provide an accounting to the Artist.

• The Gallery shall maintain accurate books and documentation with respect to all transactions entered into for the Artist.

• Upon written request, the Gallery shall permit the Artist or the Artist's authorized representative to examine the books and documentation during normal business hours.

Initialed by _____ The Artist and _____ Gallery.

Insurance, Loss or Damage
• The Gallery shall insure the work for _____ percent of the retail price shown in the Record of Consignment.

• The Gallery shall be responsible for the safekeeping of all consigned works.

• The Gallery shall be strictly liable for loss of or damage to any consigned Artwork from the date of delivery to the Gallery until the work is returned to the Artist or delivered to a Purchaser.

• In the event of damage that cannot be restored, the Artist shall receive the same amount as if the work had been sold at the retail price listed in the Record of Consignment.

• If restoration is undertaken, the Artist shall have a veto power over the choice of restorer.

Initialed by _____ The Artist and _____ Gallery.

Copyright & Security interest
• The Gallery shall take all steps necessary to insure that the Artist's copyright of the consigned works is protected, including but not limited to requiring copyright notices on all reproductions of the works used for any purpose whatsoever.

• Title to and a security interest in any works consigned or proceeds of sale under this Agreement are reserved to the Artist.

• In the event of any default by the Gallery, the Artist shall have all the right of a secured party under the Uniform Commercial Code and the works shall not be subject to claims by the Gallery's creditors.

• The Gallery agrees to execute and deliver to the Artist, in the form requested by the Artist, a financial statement and such other documents that the Artist may require to perfect its security interest in the works.

• In the event of the purchase of any work by a party other than the Gallery, title shall pass directly from the Artist to the other party.

• In the event of the purchase of any work by the Gallery, title shall pass only upon full payment to the Artist of all sums due hereunder.

• The Gallery agrees not to pledge or encumber any works in its possession, not to incur any charge or obligation in connection herewith for which the Artist may be liable.

Initialed by _____ The Artist and _____ Gallery.

Assignment
• This Agreement shall not be assignable by either party hereto, provided, however that the Artist shall have the right to assign money due him or her hereunder.

Initialed by _____ The Artist and _____ Gallery.

Arbitration
• All disputes arising under this Agreement shall be submitted to binding arbitration before _____ in the location of _____ and the arbitration award may be entered or judgment in any court having jurisdiction thereof. Notwithstanding the foregoing, either party may refuse to arbitrate when the dispute is for a sum of less than $_____.

Initialed by _____ The Artist and _____ Gallery.

Modification
• All modifications of this Agreement must be in writing and signed by both parties. This Agreement constitutes the entire understanding between the parties hereto.

Initialed by _____ The Artist and _____ Gallery.

Governing Law
• This Agreement shall be governed by the laws of the State of _____.

Signatures:
Signed by _____ (The Artist)
On _____ (date)

and _____ (The Gallery)
On _____ (date)
Gallery Address: _____

Attach the following Appendix A & B:

Appendix A: Record of Consignment

This is to acknowledge receipt of the following works of art on consignment:

Title	Medium	Description	Retail Price

Appendix B: Statement of Account

Date:
Accounting for the period of _____ to _____.
The following works were sold during this period:
(Include)
• Title
• Date Sold
• Purchaser's Name and Address
• Sale Price
• Gallery Commission
• Payment Due the Artist
The total due you of $_____ is enclosed with this Statement of Account.

The following works remain on consignment with the Gallery:
• Title
• Location
Signatures:

_____ (The Gallery) On _____ (date)

Gallery Address: _____

NOTE: These items are for checklist purposes only. If you have any questions about legal language, please consult one of the references included as part of this program, or contact a lawyer. Use these items to see if there is anything missing in your contract, or if you need to change a contract you have been sent.

✳ Contract for an Exhibition Loan

• Date of the Agreement (include day, month and year):

• This agreement is between _____ (the Artist) and
_____ (the Exhibitor)

• AGREEMENT made as of the _____ day of _____, 20_____, between
_____(hereinafter referred to as the
"Artist"), located at _____(the city and
state, the country if necessary), and _____
_____ (hereinafter referred to as the "Exhibitor"),
located at _____ (the city and state, the country if
necessary) with respect to an exhibition loan as stated in this agreement

Artworks:
• The Artist agrees to loan the following artwork(s) to the Exhibition Site (if a Schedule of
Artworks is attached, state so here):

• If the work is an installation, include specific elements and state it is an installation.

• If the work is a public art project, or site-specific work, describe and state so.

Title:
Medium:
Size:
Date Created:
Price (if for sale):
Insurance Value:
Condition of work:
Framing and Mounting information:
Commission taken by Exhibitor:

Duration of Loan:
• The Artist agrees to loan the Exhibitor the above works for the time period commencing
_____ (date) and concluding _____ (date).

Exhibition Information
• Title of the exhibition:
• Date of the opening reception:

• Hours of Gallery/Venue operation:
• The Exhibitor agrees to exhibit the Artist's work to the artist's specifications.
• The Exhibitor agrees to post accurate Artwork labels as provided by the artist.
• The Exhibitor agrees to post accurate prices for work (if applicable) as provided on the attached Schedule of Artworks.

Artist's Fees
• The following fee(s) shall be paid to the Artist in exchange for exhibition of the above works:

• Payment schedule for the above artist's fees:

Delivery
• Work shall be delivered to the Exhibitor by the following date(s):
• Work shall be delivered to the Exhibitor using the following service:
• Delivery expenses shall be paid for by:
• The Exhibitor shall agree to provide a written description of any damage to the artwork within five days of delivery.

Insurance of Artwork
• The Exhibitor shall be responsible for loss or damage to the works from the time of shipment from the Artist through the time of delivery back to the Artist.

• The Exhibitor shall insure each work for the benefit of the Artist for the full value listed on the Schedule of Artworks listed above.

Use of Work
• The Exhibitor shall agree that the loan of the works listed in the Schedule of Artworks is for the purpose of Exhibition only.

Installation of Artworks
• Detailed list of who is responsible for framing work, installation of work, and cleaning and repairs to venue after work is de-installed:

Copyright and Reproduction
• The Artist shall reserve all reproduction rights, including the right to claim statutory copyright, on all works listed on the Schedule of Artworks listed above.

• The Artist _____ gives permission _____ denies permission to photograph the works for publicity and documentation purposes.
• The Artist _____ gives permission _____ denies permission to photograph the work for any catalog reproduction.

Labeling:

• See attached labels corresponding to the Schedule of Artworks above. Include what information each artwork label should include. Is the work in the collection of the Artist? Include exact formatting for the title, and if it should include a copyright notice.

Return of Artworks

• Artworks listed in the Schedule of Artworks shall be returned to the artist by the following date:

• Artworks listed in the Schedule of Artworks shall be returned to the artist using the following service:

Signatures

Signed by _____ (The Artist)

On _____ (date)

and _____ (The Exhibitor)

On _____ (date)

Exhibitor Address: _____

NOTE: These items are for checklist purposes only. If you have any questions about legal language, please consult one of the references included as part of this program, or contact a lawyer. Use these items to see if there is anything missing in your contract, or if you need to change a contract you have been sent.

 Artist's Lecture Contract

• Date of the Agreement (include day, month and year):

• This agreement is between _____ (the Artist) and
_____ (the Sponsor)

• AGREEMENT made as of the _____ day of _____, 20_____, between
_____(hereinafter referred to as the
"Artist"), located at _____(the city and
state, the country if necessary), and _____
_____ (hereinafter referred to as the "Sponsor"),
located at _____ (the city and state, the country if
necessary) with respect to an artist lecture as stated in this agreement.

Lecture Specifics
Date(s) of the lecture:
Time of the lecture:
Location where lecture will take place:
Length of lecture:
What is expected of the artist:
What kind of work examples are expected and in what format:

Payment
Compensation or fee paid to the Artist for the lecture:
Date payment is due:
The following expenses shall be paid to the Artist:
Who will take care of any travel and lodging arrangements:

Performance
• Should the Artist be unable to perform for the dates specified due to illness or other
unforeseen circumstances, the Sponsor will reschedule the Lecture, and the payment due
to the Artist remains the same.

• If the Artist cannot reschedule, this contact is terminated.

• Should the Sponsor cancel the contract, under the following circumstances; payment shall
be made to the artist as follows:

Late Payment
• If payment to the Artist is late the following late fees shall apply:

Incidentals
• Printing costs for handouts, class materials, and programs shall be covered in the following manner:

Copyrights and Recordings
• The Artist _____ gives permission _____ denies permission for the lecture to be recorded.
• Should the Artist give permission for the Lecture to be recorded it must be in the following format(s): • No use of this recording (other than for educational purposes usually) without the written permission of the Artist shall be allowed.
• Both parties agree that the Artist shall retain the rights to such recordings.
• Additional compensation shall be paid to the Artist for any such use.

Insurance
• If artworks are used (instead of slides, CD's or other media representations of artwork) insurance shall be provided for the event, including transportation of works.
• Insurance costs shall be covered by the Sponsor and shall be equal in value to a Schedule of Artworks attached to this agreement.

Packing and Shipping
• In the case that artwork or materials are needed for the Artist's lecture, costs for packing and shipping shall be covered in the following manner:

Modifying the contract
• Modification of the agreement shall be done in writing between the Artist and the Sponsor.

Schedule of Artworks
• If original artworks are used, a Schedule of Artworks is included with this contract.

Signed by_____ (The Artist) On _____ (date)

and_____(The Sponsor) On _____ (date)
Sponsor Address: _____

NOTE: These items are for checklist purposes only. If you have any questions about legal language, please consult one of the references included as part of this program, or contact a lawyer. Use these items to see if there is anything missing in your contract, or if you need to change a contract you have been sent.

 # Contract for Transmission, Sales, Rental Media

DISCLAIMER: This contract is written as a checklist and guide only. You should in no way use this contract in its current state as a binding agreement between you and any individual, corporation, gallery or venue. When entering into an agreement with any institution for short or long-term work a lawyer or attorney skilled in legal practices pertaining to the arts should first review any contracts signed. You can use this contract as a starting point for drafting an agreement for the transmission, sales, or rentals of a media commission, but do not rely on this contract in its present form and do not sign it until you have had legal counsel look at it and suggest alterations or changes.

• Date of the Agreement (include day, month and year):

• This agreement is between _____ (the Artist) and
_____ (the Distributor)

• AGREEMENT made as of the _____ day of _____, 20_____, between
_____(hereinafter referred to as the "Artist"), located at _____(the city and state, the country if necessary), and _____
_____ (hereinafter referred to as the "Distributor"), located at _____(the city and state, the country if necessary) with respect to the commissioning of an artwork (hereinafter referred to as the "Work").

Commission
• The Distributor commissions the Artist(s) to create a media work with the working title of
_____ hereinafter referred to as "the Work".

• The Artist(s) shall have the right to the following facilities for the production of the Work, which shall be provided (without charge/with the following charges):

• The Work shall be approximately _____ minutes in length, and deal with the subject of:

• All artistic decisions with respect to the Work shall be made by the Artist(s).

Payments
• For the rights to transmission of the Work granted to the Distributor, the Artist shall be paid the sum of $_____.

• The fee shall be paid _____% upon the execution of this contract, with the remainder to paid the day of transmission.

• The Distributor shall reimburse the Artist(s) for the following expenses:

Ownership and Copyright
• All rights, title and interest in and to the Work and all constituent creative and literary elements shall belong solely and exclusively to the Artist(s), including ownership of copyrights and the master, as well as any copies created for the purposes of transmission.

• It is understood that the Distributor shall copyright the Work in the Artist's name(s), and all rights not specifically granted to the Distributor are expressly reserved to the Artist(s)

Grant of Transmission Rights
• The Artist(s) grant the Distributor the exclusive/non-exclusive right to have _____ releases of the Work in the following formats:
for a period of _____ days/months.

• A release is defined as _____ performances/screenings of the Work in a consecutive period, beginning with the first day the Work is transmitted/screened.

Integrity of the Work
• The Distributor shall not have the right to edit or excerpt from the Work except with the written consent of the Artist(s).

• The Artist(s) agree to the following terms for distributing excerpted works in the following formats, for advertising or promotion:

• Credit to the Artist(s) and copyright for The Work shall be supplied whenever the work is reproduced for advertisement, publicity, catalog, or publication purposes.

Damage, Loss or Insurance
• The Distributor shall be responsible for loss or damage to works in their possession for purposes of commissioning media work from the time of shipment from the Artist through the time of delivery back to the Artist.

• The Distributor shall insure each aforementioned work for the benefit of the Artist for the full value listed on the Schedule of Artworks included in this agreement.

• Should the Distributor be at fault for lost or damaged work listed on the attached Schedule of Artworks, the Distributor shall pay the Artist(s) the full retail value for the lost or damaged works.

Sales/Rental
• Work commissioned by the Distributor may be duplicated for sales or rental under the following conditions:

• The Distributor has _____ exclusive _____ nonexclusive rights to the sales of The Artist's commissioned work.

• The Distributor may sell _____ copies for the following duration of time, under the following conditions:

• The price of the Work sold shall be as follows:

• The rental price for the Work shall be as follows:

Marketing
• The Artist grants the Distributor the rights to market the work in the following manner:

 The Artist reserves the right to preview and approve any and all marketing material prior to their release.

Accounting
• The Distributor shall provide quarterly reports to the Artist(s) that include a list of items sold or rented.

• The Distributor shall also include any information from a screening, how many people attended and how many paid.

• The Distributor shall maintain accurate books and documentation with respect to all transactions entered into for the Artist.

• Upon written request, the Distributor shall permit the Artist or the Artist's authorized representative to examine the books and documentation during normal business hours.

Publicity
• The Artist(s) grants the Distributor permission to use the Artist's name or biography for publicity purposes on the following conditions:

• The Artist(s) grants the Distributor permission to use the attached Publicity Images for publicity purposes on the following conditions:

Termination
• If the Work in question is not shown for any reason, the Artist(s) is still entitled to timely payment as detailed in this agreement.

• This agreement and will be terminated by either party giving sixty days written notice to the other party.

• This Agreement shall automatically terminate with the death of the Artist(s); the death or employment of the Distributor (name specifically) elsewhere; if the Distributor moves outside the area of _____; or the Distributor becomes bankrupt or insolvent.

• The Distributor may terminate this agreement if the Artist(s) have not followed through with terms listed in this contract or the work is not completed in a timely manner as per the following conditions:

• Upon termination of this agreement, all copies of the work shall be returned to the Artist(s) no later than _____ after agreement is terminated.

Arbitration
• All disputes arising under this Agreement shall be submitted to binding arbitration before _____ in the location of _____ _____and the arbitration award may be entered or judgment in any court having jurisdiction thereof. Notwithstanding the foregoing, either party may refuse to arbitrate when the dispute is for a sum of less than $_____.

Modification of Contract
• All modifications of this Agreement must be in writing and signed by both parties. This Agreement constitutes the entire understanding between the parties hereto.

Governing Law
• This Agreement shall be governed by the laws of the State of _____.

Signatures:

Signed by_____ (The Artist) On _____(date)

and _____ (The Distributor) On _____ (date)

Distributor Address: _____

NOTE: These items are for checklist purposes only. If you have any questions about legal language, please consult one of the references included as part of this program, or contact a lawyer. Use these items to see if there is anything missing in your contract, or if you need to change a contract you have been sent.

 ## Licensing Contract to Merchandise Images

DISCLAIMER: This contract is written as a checklist and guide only. You should in no way use this contract in its current state as a binding agreement between you and any individual, corporation, gallery or venue. When entering into an agreement with any institution for short or long-term purposes a lawyer or attorney skilled in legal practices pertaining to the arts should first review any contracts signed. You can use this contract as a starting point for drafting an agreement for the licensing of images, but do not rely on this contract in its present form and do not sign it until you have had legal counsel look at it and suggest alterations or changes.

• Date of the Agreement (include day, month and year):

• This agreement is between _____ (the Artist) and
_____ (the Licensee)

 An example would be:

AGREEMENT made as of the _____ day of _____, 20_____, between
_____(hereinafter referred to as the
"Artist"), located at _____(the city and
state, the country if necessary), and _____
_____ (hereinafter referred to as the "Licensee"),
located at _____with respect to the use of a certain
image created by the Artist (hereinafter referred to as the "Image") for manufactured
products (hereinafter referred to as the "Licensed Products").

Text that describes the agreement (the licensing of an image)

Grant of Merchandising Rights:
• The Artist grants _____ an exclusive _____ non-exclusive right to use the Image,

The title of the Image:
Description of the Image:
Year of Creation:
Medium:
Size:
Framing or Mounting information:
Location of Signature:
Work Dated:

Editions
- Is the work a limited edition?
- What is the method of production?
- What is the size of the edition?
- How many multiples are signed?
- How many are unsigned?
- How many are numbered?
- How many are unnumbered?
- How many proofs exist?
- The quantity of any prior editions (of the same image).
- Has the master image been canceled or destroyed?

- The image listed above was created and is owned by the Artist,
- The image will be used for the following purposes:

- The license for the image will exist from _____ to _____ after which time the Licensee will have no licensing rights to the image.

Who owns the copyright.
- The Artist owns the copyright of the Image.
- The Image must be accompanied by the following copyright symbols/artist name/ logos when appearing in any printed or digital form:

Advance and Royalties
- The Artist will receive an advance payment of _____ by the following date:

- The Artist will receive the following percentages of royalties of the net sales in the following manner:

- The payment plan for those royalties is as such:

Inspection of Books and Records
- The Licensee shall maintain accurate books and documentation with respect to all transactions entered into with regards to the Artist's work.

- Upon written request, the Licensee shall permit the Artist or the Artist's authorized representative to examine the books records concerning sales of the Licensed Product(s).

Samples
- The Licensee shall provide the Artist with samples of the finished product in the following manner and quantities:

• The Artist shall be able to purchase the finished product at the manufacturer's cost.

Quality of Reproduction
• The Artist shall retain the right to approve the quality of the reproduction, and not withhold approval unreasonably.

Promotion
• The Licensee will promote and distribute the product in the following ways and formats:

Reservation of Rights
• All rights not specifically transferred by this Agreement are reserved to the Artist.

Indemnification
• The Licensee shall hold the Artist harmless from and against any loss, expense, or damage occasioned by any claim, demand, suit or recovery against the Artist arising out of the use of the Image for the License's Products.

Assignment
• Neither party shall assign rights or obligations under this agreement, except that the Artist may assign the right to receive money due hereunder.

Nature of Contract
• Nothing herein shall be construed to constitute the parties hereto joint ventures, nor shall any similar relationship be deemed to exist between them.

Modification of Contract
• All modifications of this Agreement must be in writing and signed by both parties. This Agreement constitutes the entire understanding between the parties hereto.

Signing
Signed by _____ (The Artist)
On _____ (date)

and _____ (The Distributor)
On _____ (date)
Licensee Address: _____

NOTE: These items are for checklist purposes only. If you have any questions about legal language, please consult one of the references included as part of this program, or contact a lawyer. Use these items to see if there is anything missing in your contract, or if you need to change a contract you have been sent.

 California Resale Sticker

If you are an artist working in California or if your work sells in California, consider printing out this form, filling it in, and affixing it to the back of your work.

ATTENTION COLLECTOR:

If this Art Work is resold in California or the seller resides in California, a royalty of five percent (5%) of the amount of sale is due to _____ _____ (the Artist) pursuant to California Civil Code Section 955. Failure to pay the Artist this royalty will subject the seller to legal action and payment to the Artist of Attorney Fees and Court costs incurred to collect this royalty. Please forward payment to

Name

Address

City, State, Zip

Phone

email

website

 # Certificate of Authenticity

This certifies that the attached work of art is by _____,
born _____
Artist Signature: _____
Date Signed: _____

ART ID #:
Title: _____
Year Created: _____
Size: _____
Medium: _____
Description of Work: _____

Edition Name (if applicable): _____
Number in Edition (if applicable): _____
Print Number (if applicable): _____
Number of Proofs (if applicable): _____
Copyright Year: © _____
Name of Artist: _____

All copyrights to the work of fine art this certificate accompanies are reserved to the artist.
Reproductions of the accompanying work may not be made without permission.

 # Model Release Form

Model Release Form

There are many rules regarding when you need permission to record individuals, the likeness of individuals in particular settings or environments. Always use a model release form when you record a person in video or still photography or any media likeness, including painting. A general rule is if you can accurately see their face on the finished product you must have them sign a model release form.

Payment
List payment if you are compensating your model either in the form of money or a copy of the finished work. If you are not compensating your model check NO COMPENSATION:
• The Artist Agrees to compensate the Model in the form of:
_____ or ___ NO COMPENSATION

In return for the use of their name, picture, portrait or photograph in all forms and media and in all manners, including composite or distorted representations, for advertising, trade, or any other lawful purposes.

The Model waives the right to inspect or approve the finished work, including written copy that may be created in connection therewith.

The Model is of legal age and has read this release and is familiar with its contents.

Signatures
MODEL: _____ DATE: _____

ARTIST: _____ DATE: _____

Consent (if applicable)
• If the Model is underage, the parent or guardian of the minor must sign a contract stating that they understand the above, and have the legal authority to execute the release. Be sure to delete the statement above that they are of legal age.

NOTE: These items are for checklist purposes only. If you have any questions about legal language, please consult one of the references included as part of this program, or contact a lawyer. Use these items to see if there is anything missing in your contract, or if you need to change a contract you have been sent.

 Property Release Form

Always use a property release form when using any private property.

Payment
• Fill in this if you are compensating the property owner either in the form of money or a copy of the finished work. If you are not compensating the property owner check NO COMPENSATION.

• The Artist Agrees to compensate the Property Owner in the form of:

or _____NO COMPENSATION

In return for the use of their property in all forms and media and in all manners, including composite or distorted representations, for advertising, trade, or any other lawful purposes.

The Property Owner waives any right to inspect or approve the finished versions, including written copy that may be created in connection therewith.

The Property Owner is of legal age, and has read this release and is fully familiar with its contents.

Signatures

Property Owner: _____
DATE: _____

ARTIST: _____
DATE: _____

22: PR, Marketing, & Networking

 Objectives

Understand the basics of marketing and why it is important to an artists' career.

 Things to Consider

Think about your own and others experiences of how networking works in the arts. Write down kinds of networking that can be done, and how not to do it.

Things To Do

Create a new networking opportunity for yourself and follow through.

Practice writing a press release for the show. Remember that it is important to communicate clearly to the press.

 Public Relations

Getting The Word Out: Publicizing Your Project

So you've worked hard creating your art, developing a project, and now you want to let the world know about it. This might mean you have secured a venue to show your work, or you simply want to let people know about a new project you're ready to show. In order to let the most people know about your work and attract the appropriate crowd of visitors, collectors, press, and curators, you'll need to develop a PR campaign.

Great PR generates a buzz by notifying the right people and the right media outlets about events they are likely to want to attend or write about. A good PR campaign is targeted at these individuals and focuses on getting people interested in your work.

The first thing you will want to do is figure out your target audience. These are the people you ABSOLUTELY want to reach. Everyone else outside of this target audience is an added bonus for your event. The key to developing your PR strategy is to cast as wide a net possible to attract your target audience without overreaching and going over budget or expending too much effort.

Figure out your target audience by thinking about who you want to see your work. Do you want to attract a certain kind of crowd? How old is your target audience? What is their background, community, culture, income,

education? What language(s) do they speak? Where do they live? Where do they work? All of these will factor into where you publicize your project and how you let people know about what you are doing.

The language you use to describe your project or event should be both understandable and interesting. Use descriptive language and short, concise sentences. Always include images when possible.

There are lots of techniques you can use to get people to attend and/or participate in your project, including:

• Sending out press releases and event info to local press outlets like newspapers, magazines, radio stations and television networks.

• Using email and websites like Facebook and Myspace to let anyone and everyone know about your event.

• Mailing postcard invitations to your mailing list and the host venue's mailing list.

• Putting up flyers in places where your target audience is likely to be, like coffee shops, places of worship, theaters, businesses, gyms, clubs, libraries, etc.

• You can put flyers in grocery bags, or ads on the bags themselves.

• You can insert your flyer as a "stuffer" in the Sunday newspaper.

There are thousands of ways artists have publicized their projects, from simple word of mouth to skywriting. The trick is figuring out what method will reach your target audience. Be sure to create a PR budget before you begin

publicizing your project as costs can quickly get out of hand. When creating your budget you might also want to create a "time budget" that will help you decide how much time you are willing to spend publicizing your event. Sending out emails can take a few minutes, but putting up flyers can take hours, even days.

Press Mailing Lists

One of the best ways to let people know about your project is to send out press releases to local newspapers, magazines, radio, television, and other publications. For more information on how to write a press release see the Press release section of this manual.

Putting together a press mailing list, in addition to and separate from your personal mailing list, is a good idea. If you haven't already begun compiling your own press list begin immediately by imputing these contacts into a database like GYST's software provides. Many artists rely on gallery press lists, but if you are working independently, or showing your work in a non-art space, a comprehensive press list may be unavailable.

If you are starting your press release from scratch consider doing the following:

• Visit your local library and ask for a local and national media directory. This will list up-to-date information on news editors, writers, and reviewers working for major US and international publications.

• Visit the websites of every publication you would like to notify about your project. Get names and contact info for reviewers, critics, and editors. A great resource for doing this research is http://www.newsdirectory.com/

• Collect contact info for local nonprofits.

• Make sure to include University Newspapers, small neighborhood newspapers and newsletter services. A great resource for finding alternative press outlets is http://www.altpress.org/

• Get the contact info for all your local radio and TV news outlets. For radio station contacts visit http://www.radio-locator.com/

• Go online and download advertising specs from print publications. These usually include information about the demographics these publications cater to. Knowing this can help you craft a better, more targeted, press release.

You can also ask around for press contacts. Ask a local nonprofit if you can borrow their press list. Ask other artists, schools, or even galleries you have exhibited work in for their press list. If they don't want to give you the list in digital form (on a CD) ask if you can provide mailing labels and pay for printing so that you wont actually have access to the computer files.

You really shouldn't ever have to pay for a mailing list, but some cities have arts organizations that keep track of mailing lists that are for sale. A frequently used resource in the Los Angeles area is the CARS list, which rents out names and addresses of people who voluntarily sign up to receive information about arts and culture.

What to send out:

• Press Release
• Event Fact Sheet
• Press Packet
• Public Service Announcement
• Email Save The Date
• Email Event Announcement

Personal Mailing Lists

Your personal mailing list is probably your most important marketing tool. You want to keep your personal list up to date and private. It is never too soon to start your own mailing list. Start with your friends and family, then do some research for other venues that might be interested in your work.

Word of mouth publicity is priceless and hard to generate but here are some tips for ensuring that your personal contacts help you in creating a buzz about your project:

• Send individualized emails to your friends, family and colleagues. Start with a short note asking them to personally attend your opening. You absolutely don't want them to think you just cut and pasted an introduction. After this you can paste a standard invite to your show, which states basic information as well as the body of a press release.

• Don't send press releases to your friends and family.

• Write short personal notes to friends and family on postcard invitations.

• Send a save the date up to one month before your event.

• Let your personal contacts know that they can forward event details to their own contacts. Thank them for doing this.

Marketing Your Work

Selling work takes great effort but it is important to sell it professionally. If you stay in your studio and do not get out much, selling work will be more difficult.

Being Prepared

• Is your portfolio up to date, including recent artist statement, updated resume, work descriptions and images?

• When someone asks you what kind of art do you make, do you have an "elevator speech" prepared? This is a 30 second description of your work, that could take place in the time it takes to get from one floor to another should you meet someone in an elevator or just about anywhere.

• Do you have a web site you can direct buyers to?

• Is your name and contact information on everything that you send out?

• If you found out that there was a show that your work would be perfect for, how long would it take you to put a package together for a proposal that includes images, work descriptions, artist statement, resume, annotated work description list, etc.? If you cannot do it in a few days, you need to improve your organizational and professional practice skills.

• Have you taken the time to figure out what work is for sale and how you would price it?

• Is your work on display now or do you have a show or studio opening coming up in the future?

• Is your mailing list updated with possible collectors or buyers?

• Have you sold art in the past or are you just starting to sell work now?

Publicizing Your Artwork

The best way to sell work is to first let people know about it. To do this you need to get out there and make connections. You need to make sure that people know that you have work for sale.

• Have you told everyone you know that you are a working artist and selling your work?

• How recently have you attended an art show or gallery opening?

• When is the last time you had a studio visit?

• Do you have a business card with your contact information and something about your work?

• Are you applying for shows?

• When you introduce yourself, do you let people know you are an artist?

• Do you go to lectures and events?

• When is the last time you contacted existing collectors, or potential collectors?

Things You Should Never Do

• Cold Call

• Direct Mail Marketing or Spamming

• Over-market. People will get tired of you pushing them to buy your work.

• Brag

• Use pretentious language

• Gossip

How to Market Your Work

• Build relationships with potential buyers over a period of time. Sometimes it takes a while for people to either make up their minds, or to learn enough about you to feel comfortable.

• Have an open studio and invite people on your mailing list who might be interested in buying your work. During the open studio, don't fill up the studio with friends who will hang around and occupy your attention.

• Learn about collectors and find out what their needs are.

• Encourage word of mouth referrals. Ask people to bring a friend to a studio opening.

• Cultivate relationships with collectors who have bought your work before and maintain contact with them.

• Sell work from your studio at a discount, or consider payment plans, or ways of selling your art by package (i.e.. two or more works for a larger discount).

• Do not do anything to damage your reputation.

• Have the utmost integrity at all times.

• Have materials ready at all times to either send out, give to those who come to your studio or to include in proposals.

• Always offer a money back guarantee.

Describing Your Work

It is hard to market your work if you have no idea how to describe it. Write a short paragraph that is interesting and that will invite more questions. Practice saying it out loud until you do not need to refer to your notes any longer. Try it on your friends and family before you try it on strangers or collectors.

Always be truthful about your work. Make sure that the description you have come up with truly represents your work. I cannot tell you how many times an artist statement has not truly represented the work. If the work does not match up, then make more work, or change the statement.

Introducing Yourself to Others

Artists are often at a loss to understand when to introduce themselves to curators, dealers and other art world people. The answer is yes if you have a reason, no if you do not. Introducing yourself with "Hi, I am an artist" is not a good reason. However, if you are introduced by someone else, or have been introduced before, be sure to have your elevator speech ready. If there is a common interest then introduce yourself with confidence.

If you have a mutual acquaintance or you have useful information then start with that. You want them to feel comfortable. If you are thinking of yourself and not them, forget about it. If you need to, find a way to get introduced by someone they know, but only with cause. Be sure that the person who introduces you is respected because you will be professionally connected to them.

A serious and thoughtful artist will always leave a better impression than one who is inappropriate

or pushy. Take your time, as you have the rest of your life to make a good impression. Avoid trying to sell too much too fast.

Buying Mailing Lists

While a mailing list is important, buying a gallery list or other type of mailing list is usually a waste of time unless you are a well-known artist. If the receiver has never heard of you, it will probably end up in the trash, electronic or otherwise. Save your money (not just on the list but also the printing and mailing costs) and make connections by networking and attending events. No one likes to get emails from someone they do not know unless there is a good reason.

Generating a Mailing List

Make sure that you have a sign-up mailing list at every event you do. Get names from other artists or art organizations, dealers who you are represented by or other sources. Have a subscription button on your web site to gather email addresses of visitors.

Selling Your Work Online

Email Marketing

Never send out emails unless you have a good reason or noteworthy news. It is a good idea to always send out mail with a subject line, as some people will not open it unless they recognize your name. Be sure that the subject line is something to catch their eye, and make it as far from spam type titles as possible.

Within your emails, be sure to include all the content, even if it is on the attachment. If all the information is in the attachment they might skip over it and never return. Include contact information and a link to a web site if they want more details, but the basics should be in the body of the email.

Keep the message short and precise and do not use lengthy prose. Who, what, when, where and why is a good phase to keep in mind. Lots of extra text can be put in an attachment or on your web site for more information.

If you are announcing a new web site, or an addition, direct people to the site, but also tell them where to look and why. Do not just direct them to the site and expect them to figure it out.

If you do not have a web site, do not send large files, and no more than two images at one time. Keep them under 60 to 80K at the most. 20–30K is optimal. If they want to receive a larger image, they can ask for it.

Target your recipients carefully, and create a separate list for those whom you email about your art. Be sure to use the BCC (blind carbon copy) for emails so that the recipient does not get everyone's email in their file, as this is not only annoying, but you may be giving away private information.

Avoid mass emailings. Adding a personal note in your email can make a big difference, and will make your recipient feel like they have been singled out, instead of lumped into a bulk mail send.

If you have things to announce on a regular basis you might want to consider a regular newsletter that people get used to receiving, or can request on your web site. You can send an introductory copy and ask them to subscribe, but do not send out the newsletter to any one else.

Never send large, unsolicited emails.

Using Art Marketing Agents

Some companies make money by marketing art and artists. They may offer to create advertising for several thousand dollars, and do a mailing with a brochure with photos of your work, a cover letter and a resume. They usually have a set list to mail to, and give you a number of brochures to mail yourself. Be wary of these companies, as you can do this yourself for significantly less money and towards a more receptive audience

If you decide that you just do not have the time, and you have the money to spend, be sure to check the companies references before you engage with them. Find out how many artists they have promoted and who the artists are. Contact a number of these artists and find out what the results were. Find out if they recovered their money, or if it increased their sales at all.

Be sure the company sends you at least five mailers that they have created for other artists. Check similarities (if all the brochures are the same, it could be tacky) or if the information is tailored for each artist. If their mailing list is receiving the same mailer every time, it probably has a direct exit to the trash can.

You can also check out the businesses that receive these mailers and ask them how they are received. Make sure that they do not mail a whole bunch of packets together with other artists. If you are paying for individual treatment, then demand it.

Most galleries, agents, dealers and other arts people are not usually impressed by slick advertising, as it comes across as trying to buy your way into the market. Networking is still the best policy, and your work will pay off in the long run.

If you need brochures printed, and you do not have the skills or the time and you lack a lot of funds, try contacting a local school with a graphic design department. Students are always looking for money, and a good graphic designer can be recommended by a faculty member.

Brochures and Catalogs

Catalogs are very expensive, but there are other options for you to consider such as a small publication (8 – 20 pages) with just a few images, your artist statement, or an essay by someone you know. This could be a great collaboration with a writer, and you may be able to split the costs.

A good catalog is useful in promoting your art. You can use it to reach people who live in other places, and it is a great gift for someone who may be interested in your work. A catalog can also be a good record of your work, and they are used extensively as research tools for curators, scholars, teachers and libraries.

Be sure to include your artist statement, resume and other writings as well as images. Consider what you put in the catalog carefully, and do not overload it with information that does not support you, or that will embarrass you later. No long diatribes about your childhood or other personal information unless it is relevant to the content of the work. (See Artist Statement section.)

Before you publish the catalog, have a number of people look at it, read it and give you their opinions. If you hear criticism, consider it carefully and consider making changes. Although color is most striking, black and white can be more affordable. There are conventions for catalogs that every good graphic designer will know. Do some research, look at other

artists catalogs and get some good ideas before you start.

Resources

http://www.artjob.com/cgi-local/displayPage.pl?page=article_template.html&sid=PUT_SID_HERE&article_number=3

Gebbie Press: The all in one media directory
www.gebbieinc.com

 # Press Releases, Fact Sheets & Press Packets

About Press Releases

A press release is the most important part of an effective PR campaign. Like everything else it takes time and practice to write a good press release. If a news outlet doesn't cover your event don't get discouraged. There's a lot of news out there. The important thing is to be persistent. The more times your name/organization comes across the editor's desk, the more recognizable you will be and the more likely you are to get coverage in the future.

A press release gives reporters a one-page summary of your event or exhibition. It should be "scannable," which means it should use key descriptive words and short, concise sentences. It should clearly state the basic features of the event:

• Who: The artist, the organization, or performers
• What: The event or exhibition and what it will present
• Where: The venue
• When: The duration of the exhibition, hours of operation, and opening dates.
• WHY: Why is the exhibition or event important, why is it occurring now, in the space where it occurs?

• Contact info: Who will answer questions from the press?

The press release should convey the audience the work is geared to. Most importantly, it should set your project apart from the rest by relaying clearly and succinctly WHY YOUR EVENT IS WORTH COVERING. The more your press release reads like a ready to publish article the better, as this makes for less work for the media outlet's writer.

Press Release Contents Checklist

• Date for release of information. (i.e. for immediate release)
• Contact name, phone number and email.
• Title of show or event.
• Dates of show or event.
• Hours the show or event will be open to the public.
• Date and time of an opening reception.
• Directions if needed.
• Parking info if needed.
• Acknowledgments.
• If the space is wheelchair accessible, note this on the press release.
• State the availability of photos or transparencies.
• Have any images you are including ready for the release date.

Rules for a Press Release:

• Use 8.5" x 11" white paper.
• Use a minimum of 11pt. Font.
• Type your press release (no handwritten text)
• Only print on one side of the paper.
• If the press release can be listed immediately in a calendar or a review write FOR IMMEDIATE RELEASE at the top.
• Keep releases one page long if possible.
• Make sure the margins are one-inch on all sides

- Use a standard font like Times, Helvetica, or Arial.
- Make sure you have an eye-catching headline at the top of the release.
- All body text should be, at minimum, 1.5 spaced.
- Make sure the opening line gives a brief synopsis of the show or event.
- Make sure you use descriptive language so the reader can "see" the work.
- Don't use overly verbose language and don't be overblown or dramatic, eg. "The best artist in the universe".
- Don't try and be artsy or poetic – cut to the chase.
- If your press release is more than one page long put the word "MORE" at the bottom of the first page.
- End your press release with a boilerplate, which can be a one-sentence description of your artistic vision or practice.
- Put three number symbols (###) at the bottom of the last page of a press release to indicate the end.

Press Release Structure: ªSee the sample Press release°

Event Fact Sheet

An event fact sheet provides the minimal information needed about the exhibition or event. It can be sent along with a press release, or in place of it when only basic info is needed. It answers the important 5 W's: Who, What, Where, When, Why and provides contact info. You can send an event fact sheet to a Calendar/Events editor instead of a press release. Send event fact sheets to newspapers at least three weeks before your event. Send event fact sheets to magazines three months ahead of time. (Event Fact Sheet Structure: See sample event fact sheet)

Press Packets:

Press packets provide all the necessary and relevant information different press outlets might need when reporting on your event. They can be quite expensive to produce, so choose who you give them to wisely. If you are sending valuable materials and you want them back, consider sending a self-addressed stamped envelop (SASE) along with the packet. The news outlet might not mail it back but it's worth trying, especially if you are sending books or DVDs.

A Press Packet can include:

- An introduction or cover letter
- A Table of Contents page listing what is in the packet
- Letters from donor organizations or a list of sponsors
- Press release(s)
- Artist bio(s)
- Past reviews of the artist(s)
- Artist Resume(s)
- Information about the venue
- Images of the work on a CD and an Image inventory list
- Images should be both "print ready" at 300dpi and "web ready" at 72dpi.
- Business cards for the artist and venue
- A catalog or pamphlet from the show

Containers for press packets can be as simple as a plain folder in a standard manila envelope and as complicated as a custom-made shoulder bag with multiple programs and press releases included. While professional presentation is important, remember that it is what is inside the press packet that really matters.

How to organize your Press Packet:

From The New York Foundation for the Arts (NYFA):

A press kit should be organized in a folder and should include all of your promotional material including:
• Organization Info (in left side of folder)
• Event Info (in right side of folder)
• Organization's brief history
• Board of trustee list
• Misc. marketing materials
• Any relevant or recent press coverage
• Press release for current event
• Program for event
• Bios for artists, if applicable
• Images from event

In general, press kits are made available for attending press at the opening night of an event or at a press preview. Press kits do not need to be sent to press ahead of time unless there is a particular media contact that you are expecting or hoping will review your event.

 Press Timeline

Be sure your information is correct and gathered together a week before you need to send out the press information. Have someone else look over all your press materials to make sure your project description and venue information is clear.

3 months before the show or event
Most magazines have a three-month publishing deadline. Make sure you call publications for their requirements. Make sure the venue has all your information about the project way ahead of time.

3 weeks before the show or event
Most newspapers and weekly publications require a three-week event deadline.

1 week before the show or event
Send out an invitation to your emailing list. Remind any reviewers via Email.

After the event

If a reviewer writes a favorable review about your show send a follow-up thank you email. This shows that you are reading their writings and will establish contact for the future.

Sample Press Release

{Logo goes here}

Contact: Jane Doe, Jane's Title FOR IMMEDIATE RELEASE
Venue hosting event
555 Sample St.
Sample Town, USA 12345
Venuewebsite.com
Tel: (555) 555-5555
Cell: (555) 555-5555
Email: mail@myemail.com

GYST WRITES SAMPLE PRESS RELEASE TO HELP ARTISTS OF ALL KINDS RULE THE WORLD
Artists Everywhere Can Use It To Write Their Own

The first sentence should hook the reader with metal talons. They should be unable to resist the information in your press release. The first paragraph should say who is presenting work, what the event will feature, where the event is, when the event will take place, and why people should go. These Five W's are very important.

The second paragraph should state the most important features of the event. Use facts and descriptive language to talk about the event. GYST always says, "Including a quote from the artist or a respected reviewer or the venue in your press release is always a good idea because publications always like to provide a quotation from a knowledgeable source."

Use the rest of the paragraphs in your press release to state facts about your exhibition in descending order from most to least-important. Keep sentences short.

Make sure your press release is free of spelling and grammar mistakes. Provide interesting, relevant information about your project and why it is important to art, the community, or contemporary, news-worthy issues, and you will be more likely to get news coverage.

Any additional info, like a special photo op date or other info can go below ###.

✳ Sample Event Fact Sheet

{Logo goes here}

Contact: Jane Doe, Jane's Title
Venue hosting event
Tel: (555) 555-5555
Cell: (555) 555-5555
Email: mail@myemail.com

EVENT LISTING Date of Opening

(Host Venue) proudly presents

"Title of Event"

By (Name of Artists)

Opening Reception:	January 12, 2009
Time:	7:00PM – 9:00PM
Location:	555 Sample St.
	Sample Town, USA 12345 *wheelchair accessible
Exhibition Dates:	January 12 – Feb 20, 2009
Contact:	Venue Phone Number
	Venue email address
	Venue website
Admission:	Free

Program: This is a two or three sentence description of your project. It should be one paragraph l long and describe what will happen and why people should go see it.

Sponsors: Include this section if applicable.

23: Presenting Yourself

 ## Objectives

Understand how to deliver a presentation to a public panel or during a studio visit.

Rehearse strategies you can take to be productive and effective during public lectures.

Things To Do

1. If you do not have a lot of experience talking about your work in public, find a group of friends, preferably a small group, so as to not overwhelm yourself, and give a little presentation:

• You could present images projected on a wall, or on your computer.

• Emphasis would be placed on drawing upon your artist statement to talk about the work samples presented.

•You can have your friends fill out Evaluation forms for you, so you can get an idea of how well you did, and how effective your presentation was.

 ## Presenting Yourself

You will come across many situations where you have to present yourself and your work: job interviews, studio visits, curator visits, public art presentations, lectures, workshops, grant interviews, symposiums, teaching demonstrations for interviews, collectors, gallery talks, museum walkthroughs, reviewers/ writers, presentations to funders, producers and more. The following are considerations you should address before you present yourself. Preparing ahead of time can make a significant difference in how other people perceive you and your work.

Consider:

• Who are you meeting with and what is the context? Are you meeting at a gallery or organization, at a coffee house or at your studio? Do you have to drag your materials with you, and how will you present them?

• What are you seeking and why are you seeking it from them? Be clear about your intentions. Are you asking for general support or something very specific? Has the purpose of the meeting been established, or will you have to articulate it?

• What is the relationship that you have or want to have with the person you are meeting or presenting to? Are you asking for a short or long-term relationship?

• What is the amount of time you have to present? Do not try to fit an hour-long

presentation into a half hour. You should leave time for discussion in any situation.

• How you are presenting the materials? Is the equipment on-site, or do you have to provide your own? Do you need to be there early to make sure everything is working and that your slides are right side up?

• How will you present yourself? How will you be perceived? How will you connect with them? How can you ensure that the passion and enthusiasm you have for the project is best conveyed?

• How can you ensure that the information is clear? Do not use art jargon or fancy words if you can help it. Do not be condescending—simply engage.

• Consider how to be persuasive without being overbearing.

• Think about how you will present yourself as well as your work. How does your background and history relate to what you are presenting?

• How much background is needed to understand the project?

• You will need to convey what you are asking for and why. Consider how you will present your request. Be sure that you ask specifically for what you need, and make sure you understand what the results will be.

• Do not assume that the person understands what you request. Be sure to get feedback on the project in order to clarify your intent.

• Consider what the person you are presenting to wants on their end. Make sure you understand their priorities and interests.

• Make sure that you make eye contact. Many artists tend to look at the slides or monitor and their own work when talking to an audience. This can render you inaudible.

• Engage your audience, including the people in the back of the room. Try not to look at the ceiling when talking. There is an old adage that says, "Just think of everyone in the room being naked." If this doesn't work for you, or just makes you feel all icky, try just publicly acknowledging that you are nervous, because the audience can usually tell anyway. People are usually more sympathetic to presenters who say outright that they are a little nervous. You will feel better and it will humanize you to your audience.

• Consider your wardrobe for your presentation or meeting. Dress appropriately and comfortably.

Real Life Story

An emerging artist in Los Angeles applied for a public art project for the first time. She was accepted as a finalist—one of three—that was required to present her project to a panel. Having never done this before, she was nervous about her presentation. She decided to schedule three nights in her studio to invite her friends and peers, and people who had done public art and presentations before. She invited them to her studio, and did a dry run through of the presentation. Afterwards, she had a discussion about what worked and what did not work. She got great feedback, and later she did her final presentation to the public art panel. She got the commission.

She said that she never would have gotten the commission if she had not practiced before an audience. Do not underestimate practicing your presentation, especially if you are nervous.

 Presentation Evaluation Form

Use this form to evaluate your classmates' presentations. While listening to the presentation, record your feedback on this form and evaluate the following speaking points.

Artist Presenter _____

1. What was your overall impression of the presentation as a whole?

____ Great ____Good ____Fair ____ Not so Good ____ Poor

2. Was the speaker:

____ Well prepared ____Somewhat prepared ____Not prepared

3. How well did the speaker communicate with the audience?

____ Great ____Good ____Fair ____ Not so Good ____ Poor

4. Was the speaker enthusiastic about their work during the presentation?

____Yes ____ No

5. Was the speaker clear about expressing ideas about their work?

____Yes ____ No

6. How would you rate the work samples shown?

____ Great ____Good ____Fair ____ Not so Good ____ Poor

7. Did the work express the ideas that were expressed during the presentation?

____ Yes ____ No ____Not sure

8. Did you learn anything new about the artist and their work during the presentation?

____ Yes, if so what? _____

9. What was the most engaging part of the presentation?

10. What was the least engaging part of the presentation?

Any other comments?

24: Elevator Speech

✳ Objectives

Understand the importance of being able to talk about your work in a shot period of time.

Understand when to give the elevator speech.

Be able to explain your work in a clear and concise manner that is compelling and engaging in less than 30 seconds. The time it takes to get from the 10th floor to the lobby.

✳ Things To Do

1. Read the text on the concept of an elevator speech and why you should have one.

2. Think about and write down the times when you would and would not use this strategy.

3. Write down three active phrases about your work, not complete sentences.

4. Then develop them into three full sentences.

5. Memorize them and use them to construct your elevator speech.

6. Use a timer/watch to time yourself for 30 seconds. Have a friend be the "curator", and time keeper and say "Elevator doors close" which is the hint that you should begin conversing. After 30 seconds, acknowledge time is up , but finish your presentation. The idea is to understand how long 30 seconds is. You can easily do this by yourself with a timer and a mirror.

7. Practicing this makes a world of a difference and can improve your demeanor and lessen any anxiety you may have about speaking to others about your work quickly and confidently.

Elevator Speech

The idea of an elevator speech comes from the business world, and is a metaphor for how much time you might have in an elevator traveling from the top floor to the bottom floor and the time you might have to introduce yourself or talk about your work. This is an exercise designed to get you comfortable with talking about your work during these short meetings.

Here's how it goes:

You have been at a party on the 10th floor and it is getting late. It is a party with lots of other artists, curators and arts patrons. As you leave the party and walk to the elevator, you notice that there is a curator you met briefly at the party in the elevator. You really didn't get a chance to talk with this curator, so you jump in the elevator. The elevator doors close....

You have 10 floors to engage in a conversation.

Since you have met the curator before, you can ask about his or her work, or what they are working on. They might ask you about your work. This could take place anywhere, not just in an elevator. The idea is to be able to say something engaging and interesting about your work in a clear, short and concise way. Once a person shows interest, you then can continue the conversation with more details.

One format for talking about your work is to answer the question, "So, what kind of work do you make?" with a casual description similar to what you already have written in your artist statement. Now this doesn't mean that you should come off as if you are reciting your artist statement word-for-word; that would just sound robotic. Instead, think of how you can relay this information in a social way. Say "I make X kind of work using X kind of materials." Be animated and descriptive. Give the curator time to respond to your description.

Then, you might want to talk about the project or works you are working on right now. This does two things. First, it lets the curator know that you are actually a working artist, that you spend time making art. Secondly, it invites the curator to engage in a discussion with you about your immediate interests. This can be invaluable, as the curator might have fresh ideas, resources, or texts that might help your project. Finally, if the curator is interested in your project they might ask to come to your studio for a visit.

A good way to end a conversation of this sort is to share business cards or an announcement for a show you are in. Always try to leave a trail so that the person you are talking with has some way to find you again. If you don't have something to exchange, you might have lost an amazing opportunity for yourself. You might choose to ask if the curator does studio visits, and that you would be interested in showing them your work (if they seem interested).

It is very important that you practice this exercise a few times before it actually happens in real life. The more you practice talking about your work in a short, casual and relaxed manner, the easier it will be to discuss your work with strangers. This kind of interaction will occur countless times in the course of your art career, so getting used to it is something you simply have to do.

25: Self-Publishing

 Objectives

Understand what self-publishing is and how to self-publish a book.

 Things To Do

Create a preliminary plan for your self-published book.

✳ Self-Publishing

Back in the day self-publishing was expensive and time-consuming. Artists would have to use their own time to Xerox black and white magazines and bind them themselves. Color publishing was even more expensive. And order to get a nice, hard cover book you had to work with a publishing house, which meant you had to answer to someone else when it came to design decisions, release dates, distribution, etc. Independent 'zines are still made using Xerox machines and really DIY processes, but for those who want a more polished look, self-publishing is an accessible option.

While publishing houses are absolutely necessary when it comes to contributing to the larger art discourse, self-publishing has definitely broadened the field. Self-publishing has developed to the point where artists everywhere can see their books realized at a relatively affordable price with a quick turnaround. This book you are reading was self-published.

Preliminary Questions

If you want to create your own book it's best to research your options and plan way ahead of time. Here are some questions to ask before you begin designing your book:

• What is your bottom line cost per item? This means the most you are willing to spend to print each book. Deciding this ahead of time will help you make some tough decisions later.

• Do you want your book to be in color or black and white? Black and white books cost much less to print, but some images simply must be in color. If you do decide to print your book in color you may have to sacrifice page count to meet your bottom line budget. Also if you print you book using images make sure to consult with your publisher to ensure that image quality is not diminished.

• How long will your book be? A 24-page book obviously costs less to print than a 240-page book. But while you are doing your research pay attention to how publishers charge for pages printed. Sometimes a publisher will charge the same amount for a book between 144 and 184 pages. Do your research.

• How good are you at designing books? A poorly designed book can create a horrible reading experience and may even make your work look bad. If you do have some design experience you are in luck. Even if you know the basics of a program like InDesign you can design a good looking book. For those artists who don't know how to use design programs,

some self-publishers have great intuitive publishing software available for download from their website.

• How do you plan to distribute your book? If you only want to send your book around to select collectors or galleries this might influence how many books you want to initially print. If you are planning to sell many books at an event, like a fair or an opening, you might need to order many more books at once. While one of the joys of self publishing is that you can print books on-demand, meaning one at a time, it does take time to actually print the books, sometimes as long as three weeks. So if you need a number of books by a certain date you need to plan ahead.

Publishing Your Book

How you publish your book varies depending on which self-publishing service you go with. No matter what service you use make sure you do the following:

• Some publishing companies like Blurb or Lulu put their own logo on final books and you have to pay a small fee to have this removed from you book. It is worth the small fee to do this because having their logo on your book makes it look less professional.

• Make sure you have had someone responsible read and edit your book before sending it to press. A good copy editor will read through your book and find grammar and spelling mistakes. You might consider paying someone to copy edit to make sure you end up with a flawless book. No matter what, have at least two different sets of eyes look at your book before it goes to press.

• If time permits consider ordering a test copy of your book to get a feel for the printer's paper stock and printing quality. You don't want to spend hundreds of dollars ordering dozens of books only to be dissatisfied with the end product. Once you get your test book consider the weight of the paper, how vibrant the colors are, the quality of the printing. Remember, it's best to get your book designed and printed correctly the first time around than have to redesign and reorder it many times, which can get costly and make your designer go insane.

Pricing and Distributing Your Book

Your book serves multiple purposes. It's a portfolio of sorts, something that can develop your collector base. It's an academic tool that can help you secure teaching and lecture positions. Because your book can do so much for you, it needs to be priced to sell. So, unless your book is part of a limited edition run, an artwork in itself, you want to make your book affordable so that you cover your production costs and make enough money to continue printing your book.

Be realistic when pricing your book. Usually this means charging twice what it cost to print the book. Most artist's monographs are priced under $60. If you try and sell your book for more than this you might find your clientele list shrinking. If you absolutely must sell your book for more than this, consider including a drawing or print with each copy. That way your book will be more appealing to a collector base that may not have enough money to buy your more expensive art but still want to support you.

Once you have printed your book you might consider shopping it around to local independent bookstores to see if they might be interested in selling it to the public. For example, bookstores like Ooga Booga and Skylight Books in Los Angeles routinely sell self-published artists books. Quimby's

Bookstore in Chicago also sells artists' books. And New York City is filled with dozens of places that stock books self-published by artists. If you don't live in these cities consider sending a copy to one of these stores with a great letter of introduction (see cover letter). Definitely consider joining together with other artists and DIY publishers to sell your books at a local coffee shop, nonprofit or bookstore.

Once you have printed your book you will want to market it like you would your art. Start a facebook page for your book, start a blog, twitter about your book. Invite others to support your publishing efforts by spreading the word. Start an online lottery for your book, where the winner gets a signed copy of your publication. No matter what, make sure to get your book out to as many interested collectors as possible.

Resources

Self-publishing made easy online by Elinor Mills Staff Writer, CNET News
http://news.cnet.com/Self-publishing-made-easy-online/2100-1038_3-6148342.html

How to self-publish a book ... and who should be doing it by Simon Haynes
http://www.spacejock.com.au/SelfPublishing.html

6 Ways to Publish Your Own Book by Shevonne Polastre
http://mashable.com/2009/03/01/publish-book/

Self-Publishing Companies
Lulu
http://www.lulu.com

Blurb
http://www.blurb.com

iPhoto
http://www.apple.com/ilife/iphoto/#print

Café Press
http://www.cafepress.com

Create Space
https://www.createspace.com/

WeBook
http://www.webook.com/

Xlibris
http://www2.xlibris.com/

26: Meetings

 Objectives

Understand the importance of meetings and some do's and don'ts for attending or conducting meetings.

 Things To Do

Write down what you think constitutes a good meeting. Think about what has and has not worked in your past experiences.

 Meetings

Meetings are, or will be, an important part of your art career. This is where things happen, and your participation is crucial. How you conduct and present yourself can be vitally important.

Here are some tips for keeping things on the right track.

1. Always be on time. If you are perpetually late, the folks you are meeting with have to waste their own time waiting for you. Make sure you know where you are going and how long it takes to get there. Luckily for us, we now have mapping programs on the web that will give us all this information. When in doubt, call the person you are meeting with to double check directions.

2. Dress appropriately. This does not mean a suit and tie. This does mean that you are clean, and that it looks like you have considered your appearance. We are lucky that casual is often OK in the arts, but be considerate of who you are meeting with and what to wear.

3. If possible, create and know the agenda for your meeting. Setting and creating an agenda means that everyone attending is on the same page, and understands just what will be discussed.

4. If you are hosting the meeting, have basic comfortable seating and at least water or everyone to drink.

5. Be sure to set up what takes place next, either another meeting, or a set of notes that gets distributed to everyone so you are all sure of the results of the meeting. Be sure everyone understands their roles and deadlines before the meeting breaks up.

6. Always follow up. Either with a thank you for the meeting, or with follow-up details.

27: Fundraising Without Writing Grants

 Objectives

Understand the basics for raising money without writing grants.

Generate ideas for fundraising.

✳ Things To Do

Write down ideas and brainstorm on ways to raise money without writing grants. Can you think of any local organization that has done this. Were they successful?

Try to develop a fundraising plan. Think about the scope of your plan and whether or not you are including a diversity of fundraising sources.

✳ Fundraising Without Writing Grants

Fundraising can be a daunting task, and writing grants requires a lot of time and effort. There is a lot of competition for a small amount of funds. Coming up with other strategies to raise capital is essential for contemporary artists. The more diverse your funding sources, the more stable your practice will be. Get creative about your fundraising ideas. Do searches on the web to see how other artists and organizations raise funds and if you want to write grants but need more guidance, consider using a fiscal sponsor as a partner. Partnering with a fiscal sponsor means that a nonprofit organization receives money on your behalf (often less a small percentage to pay for their legal and accounting fees). As long as the nonprofit's mission matches your own project, this is

worthy of consideration. However, never create a partnership with a nonprofit if you are going to take the money and run. Artists have burned many nonprofits by not completing projects and tarnishing the reputation of the fiscal sponsor, so please, be respectful.

Some Ideas to consider:

• House Parties – Organizations like MoveOn and grass roots projects have thrown house parties as fundraisers for a long time. Morrie Warshawski has written a book called "The Fundraising Houseparty" and he describes the common elements:

1. People receive an invitation to come to a party at a private home.

2. The invitation makes it clear that the evening will be a fundraising event.

3. Participants arrive and are served some refreshments.

4. Participants sit through a brief presentation.

5. The Host or a Peer —someone articulate, enthusiastic and respected by participants— stands up and asks everyone to make a contribution. Thousands of dollars can be raised in one evening.

• Film Screenings – Screen a film at someone's house, in a parking lot, storefront window or other site. Sell tickets and ask everyone to bring a beach chair. In addition, sell popcorn to the audience for additional revenue. If you are raising money for a new film, showing an old

one that is really great might inspire those who like it. You might also screen a short example of the current film you are working on.

• Performance – Hold a performance at someone's house, or other venue. Sell tickets. Use a theater on a dark night. Do it in public.

• Sales of Artwork – Have an open studio tour, make artwork available on your website.

• Services – While an old standby, events such as the car wash, bake sale, and other ideas might be updated to make them more interesting or educational.

• Auctions (of anything, including services) – While art auctions are always taxing on artists (who are perpetually asked to give everything away for free) there is no reason why you have to auction art in order to make money. Art related services can be auctioned off such as framing, crating, photography, documentation, etc. and auctions can require a minimum bid to ensure that the artist gets a cut of the sale.

• Block Parties – Another take off on the house party idea. Get a permit and block off your street for an event or find a public park and create an event.

• Direct Mail (letters to friends and family) – come up with an interesting idea for a letter to ask for funds. You might ask for a small amount from many people for your worthwhile project. 80% of donations in the US come from individuals, so don't discount them.

• Yard or Garage Sale – Got stuff you can sell? Collaborate with other artists to do a giant yard sale or studio sale. Market it to other artists as a studio sale, and sell all those supplies you have collected but do not use anymore. You would

be surprised at how many artists need discounted supplies and how great your studio will look with all that extra room.

• Money Catching Machine (pneumatic cash transport mechanism) – Machine Project in Los Angeles created a money catching machine which they describe as follows: "Bring cash money to put in our ramshackle and potentially dangerous pneumatic cash transport mechanism. A network of clear acrylic tubes connected to a high powered vacuum system running along the ceiling of the MACHINE PROJECT will pull proffered dollars right out of your hands, with little to no effort by us and much amusement on your part." Built and installed by Mark Allen, Ryan O'Toole and Brian Tse, it is installed in the exhibition/ project space at the gallery. No one can stop with just one dollar.

• A New Twist on Events – While some events have been around a long time, consider a new twist to them. Side Street Projects in Pasadena, CA has put on a Phantom Ball for 15 years which "takes place" on April 1st (no foolin'). The actual event does not exist, and you get to choose something you have been wanting to do a long time instead of dressing up and going to another chicken dinner! But in this case, if you choose to buy tickets to this non-event, you get a "commemorative photo" of the event you did not go to by a fairly well known or up and coming artist. Sight unseen, you get a discount. Once the image is unveiled, the price increases.

• Donation Button – Have a website? Consider adding a donation button to the site for a specific project. Not a nonprofit? Then look for a fiscal sponsor.

• Product Sales – You may have a creative idea for a product that relates to your project, such as a CD of your music, video of your last performance, books, artwork etc. Have a one-day sale and include every artist you know who has a CD of music, video or performance. Or have a party. Most artists like to go to parties, and why not have some things for sale?

• Dinners – Create a special dinner for donors. Hire artists to perform, read poetry, or provide other entertainment that relates to the project. Invite a special guest, such as an important artist or author. I have been to excellent theme dinners (all guest wore white), dinners where the food is so creative you can't tell what it is, and performance dinners.

• Have a Raffle – When I first began to raise money for a nonprofit, one of the ways that we paid for the receptions was to offer raffle tickets to the viewers during the openings. It included lots of items and services, often related to the content of the work being shown. Sometimes the exhibiting artist would pitch in and create a small work, or offer an artist book.

• Make a Wish List – Instead of writing grants to get "things" consider going to the manufacturer and asking directly for a donation of that item. Need 10,000 cotton balls? Go to the source. Arrange to work with a fiscal sponsor if they need a tax write off. Send your wish list along with a letter requesting money as an option for those who don't have the cash to spare, but just might have something else you need to have or borrow. I once got 20 parking meters donated from a national company. This was crucial, since you can't buy a parking meter at your local store.

• Cook Off – Lots of artists cook. Have an event like a Chili Cook Off where folks buy tickets to taste all the different kinds of dishes. Maybe you can relate the dish you cook to your project.

• Partnerships – Consider creating partnerships with other businesses or nonprofits that can help you get things done for your project. They don't have to agree to show the work, but may help you with contacts or other support. Find an organization or business that is interested in the same ideas you are.

• Paid Ads – You can solicit paid ads for your website. Use Google Ads as a way to make life easy. For every click, you get paid.

• Repair Items and Re-sell – Consider taking in donations such as used tools, cleaning them up and re-selling them. You can fix bicycles, electronics, or other items.

• Rich Uncle or Aunt – Say you have a rich uncle who has agreed to give you some funding for your project. If he needs a tax write off, set up a fiscal sponsorship with a nonprofit so he can get the tax write off and you can get the funding. So, the idea here is to be creative about donated and earned income strategies to help diversify your arts funding. Funders love this entrepreneurial spirit and artists benefit from more consistent cash flow. Think smart, act creative and bring in money and supplies.

No matter what, don't quit.

28: Studio Visits & Open Studios

 Objectives

Understand the importance of studio visits and how they can further your career.

Understand how to get a studio visit as well as how to conduct a studio visit.

 Things to Consider

The best way to evaluate your ability to have successful studio visits and or open studio sessions is to do it.

 Things To Do

Create a mock studio visit environment so you can practice. Invite friends, or someone familiar with your work.

 Studio Visits

Introduction

Studio visits can be arranged with gallery dealers, art consultants, other artists, nonprofits, curators, and basically anyone who has the time to look at your work and talk about it with you. Studio visits can be as formal as meeting with a dealer with the hopes of being asked to participate in the gallery, or as informal as inviting a friend over to discuss your newest body of work.

Studio visits are a useful tool for making new connections with other people in the art world. When you start to develop a professional relationship with another artist or curator consider asking him or her over for a studio visit. Inviting fellow artists over for studio visits can also prove an invaluable opportunity to rehearse talking about your work and to hash out new ideas. Having a studio visit can also help you overcome the nervousness that accompanies showing new work to a public audience. The more you meet with people you know and respect, the better you will be when talking about your art with strangers.

Be Prepared

Before you invite people over for a studio visit you might want to think about what you are going to show them. There are many different types of studio visits. You might schedule a visit simply to introduce someone to your work. For this kind of studio visit you don't necessarily have to have new work to show. You can show them older work you still have in your inventory, or you can show them work in a portfolio, or even introduce them to your work using the Artwork Inventory section of your GYST software.

You might schedule a studio visit to talk about a new body of work. When you have this kind of studio visit you will want to have your new work ready to show in a clean, well-lit environment. Don't clutter this kind of studio visit with older work. You might confuse your guest.

It's always good to prepare for a studio visit by having a few questions about your work ready to ask your guest. Clearly state your intentions with the work and ask your guest if your intentions are present in the work. Ask about framing, lighting,

ideal exhibition environments. Ask your guest if your work makes them think of work by other artists. This will provide you with conversation starters during awkward silences. Make sure to have a pen and paper at the ready for notes.

Always make sure you give detailed instructions on how to get to your studio, and how to get into your studio. Remember to give them your contact information so they can get in touch with you should they get lost.

Remember that studio visits can last as short as 10 minutes, or longer than an hour. Curators, critics, and dealers often go on several studio visits a day, so when you schedule your studio visit agree on the duration of the visit and take into account that your guest may be busy. Always provide something to drink, at least water, during your studio visit. Make sure there is a clean place to sit and let your guest know where they can sit. There is nothing more embarrassing than inviting someone over, and then having them end up sitting on your art.

Don't get drunk or do drugs during your studio visit. Remember that too much caffeine can make you jittery and nervous.

Have your artist statement and resume available, even if you have sent one to your guest already. Reviews, announcements from shows or other printed materials can help them understand the work. A description of the work can also be useful, as well as providing additional descriptions of past work. This can be in addition to the artist statement, especially if your work is fairly complicated.

During the visit

Remember that you represent your work. No matter how great your work is, if you appear uninformed, arrogant, or rude you may put off your guest and miss exhibition, funding, or representation opportunities. So always have basic tact, humility and politeness. Do not brag. You will look really stupid and pretentious. Do not be dramatic or demanding. Trying to convey a sense of emergency will only distance the visitor.

Start out by giving them a tour of your work, explain what you are up to and sit back and wait for their response. This is the time to focus on your work—do not go off on tangents. The visitor may ask you many questions about your work. Be calm and try to mirror your guest's attitude. If they talk a lot, try to keep pace. If they want to be quiet, try to slowly ease them into a new conversation.

Remember, sex is not a career advancement strategy; bed dealers for entertainment purposes only—and keep it separate from a studio visit.

Meeting With Dealers

If you are meeting with a gallery director about possible representation it's important to be prepared with the right attitude and questions. Do not bring your prejudicial attitudes towards the art business, art dealers, art galleries, or the system of the art world into a studio visit. It is best to work through these issues in therapy, with friends, or keep them to yourself.

Remember a gallery is not interested in working with new artists who bring that type of baggage to their roster of artists. They last thing they need is more drama. They are in the business of selling work. Do not give the dealer or curator a hard time. It is always easier to get along with an artist who is pleasant to work with.

Never argue a commission split. Learn why dealers deserve their percentages on your own time, not

theirs. If you believe that the commission split is not fair, you should find another gallery. Beware of scamming dealers, but also respect those dealers who expect 50/50 as they usually earn their part of the commission through hard work.

It is good not to scare them with the first meeting. Never tell a dealer or the person visiting your studio that they are missing the true meaning of your artwork. The work should speak for itself, as you will not have the opportunity to be a personal docent at your exhibition. If the visitor has trouble understanding your work or how it relates to your message, it is usually your problem, not theirs. Curators, critics, and most people in the art world rely on art for their livelihood and they spend a lot of time looking at art, and are usually pretty good at evaluating work. These people are usually good bellwethers for how others will perceive your work. Do not offer them the challenge of selling your work if they are uncertain or disinterested. Acting desperate can make you come across as naïve. It is a good idea to show work that is available to the dealer or curator, and to be clear about what work is unavailable and why.

If the dealer begins to talk about a relationship with their gallery, ask about specific details, such as exhibition schedules, what to expect, their future exhibition schedule. Find out what you can do next. You might be invited to participate in a group show, or they may wait to think about the visit. Do not be impatient, and do not hound them. The studio visit is usually an indicator of how you are as a person as well as an artist. If they do not give you something then and there, be sure to ask them if you can keep them posted about future work. This will give you a reason to add them to your mailing list or to contact them again in the future with a new or finished body of work.

 # Open Studios

Having your studio open for either a special event or as part of an open studios weekend can be a great way to show off your work, make connections and practice speaking about your work.

Setup

If you are doing your own publicity, make sure that you provide good directions to get to and in your studio.

Make sure that you provide signage. Visually grab passersby and engage them with some interesting visuals to attract them into the space.

Be sure that there are places to sit, as many open studio events can be exhausting. Better that they sit to rest in your space than in someone else's.

During the Event

Make your guests feel comfortable. Greet them, offer to answer questions, be hospitable. If you have problems relating to people, talking about your art, or dealing with money issues, have a friend or acquaintance on hand to help you out.

Make sure your guests feel comfortable. Offer them some water (which one should always have, if not something more interesting) and let them know you will answer any questions they may have about the work. If you expect it to be busy, you might have a friend on hand to help you out.

Hang the work to its advantage, with the space cleared around the work. Hang far apart enough to not crowd each work. Be sure there is adequate lighting.

A wide range of works and in various price ranges will encourage buyers to look closely. A small sale may lead to a larger one later. So don't get discouraged if you don't make a big sale.

Written materials are always a good idea. Business cards, printed announcements, an artist statement and resume are good choices. If you are busy talking to someone else, they can at least read the materials at hand.

Consider all reasonable offers. Offer payment plans. Take initial payments and hold the art until paid-in-full. Your mission is to sell work, or at least make the visitors aware of what you are doing as an artist. Have a mailing list sign up sheet handy so you can gather names and addresses or Emails of those who are interested in knowing what you are doing. They are potential buyers.

What NOT To Do

Do not hide out in the back room or make yourself scarce. Be sure you speak to everyone, do not just hang out with your friends. After all, your friends can come back to see you. Acknowledge the presence of visitors and greet them as they come in the door. Be accessible.

Do not hide modestly priced art and only show the most expensive pieces. That instantly eliminates a huge percentage of potential buyers.

Do not increase your prices for the occasion; if anything, lower them. You might make a sign that says your prices are reduced for the duration of the open studio by a certain percentage. It just might get their attention. Most collectors do not expect to pay full retail at an open studio. If you have a gallery, make sure they know your retail price.

Do not over pack your studio with too much work or work you just want to liquidate. This comes across as tacky and they may not take you seriously.

After the Event

Follow up with interested collectors by sending out all requested materials, including images. Update your contact list by adding new Emails and mailing addresses to your GYST database.

29: Critique Groups

 Objectives

Understand what critique groups are for.

Understand how to start and maintain a critique group.

Understand what to ask in a critique group

 Things To Do

Start a critique group and have participants write about their experiences so as to create an even better critique group.

 Critiques

Starting a Critique Group

A good critique group can be one of the best tools an artist can have to help build a conceptually solid practice. Critiques can help an artist better understand how their work is communicating to a larger audience. Regular critiques also help to develop critical thinking and public speaking skills. Perhaps the most beneficial thing about a critique group is that it builds a community of artists familiar with each others' work. Critique groups often end up exhibiting work together and sharing resources.

Most critique groups start in art schools as part of a required class. These critique groups usually function because the artists involved are in classes together and are in constant dialogue with one another. After school sometimes these groups stay in touch, usually with less participants.

Consider how many people you want in your crit group. Having many participants, 10 or more, means you will have many viewpoints, multiple voices, and a greater support system in the future. But with ten or more people you will have less time for each other's work. Since you shouldn't all try to show work during the same crit, each participant will have to wait long periods in between crits.

A smaller crit group of less than ten people ensures that each person gets a regular critique of their work, and a smaller group can provide for more intimacy and bonding in the group.

Decide how long you want critiques to be and how many artists will get their work critiqued during each session. One of the biggest mistakes critique groups make is trying to review every person's art during one session. Generally it takes a minimum of one hour to adequately critique an artist's work. Most grad school programs hold critiques that last 3 hours or more for each artist's work. While each critique group has its own needs, try starting out your critique group at three hours total, with each artist's work receiving a one-hour critique. If this seems too long, consider shortening the critiques, if it seems too short, try critiquing only two artists' work for an hour-and-a-half each.

Next think about the people who will take part in the critiques. A crit group can consist solely of Fine Artists, but it can also include curators, critics, and other art world people. Having a diversity of opinions present will help to ensure that no one viewpoint will dominate the group.

Getting multiple points of view will also help you better understand how your work speaks to a variety of people.

Also consider the kind of work the critique group makes. Having a group made entirely of painters can inspire great conversations about paintings, but it can also limit the scope of the discussion. Try and mix up the critique group with artists dealing with a range of subjects in a variety of media. This way each artist will be well-versed in the language of each kind of art.

If you are having trouble finding other artists to join the critique group, try going to your local arts nonprofit. Inform them of your endeavors and ask if they have any recommendations. They may send out an email to their members, post something on their website, or even offer to host the critiques at their facility.

Consider inviting guest critique moderators to lead the group. Reach out to local critics, curators, or arts professionals and ask them to moderate the group. Pool resources and try to compensate guest moderators for their time by paying them a small fee.

Holding a Critique Session

The first thing to decide is where you are going to have the critique. If the artists in your critique group have large studio spaces, you're in luck! But if the people in your group are like most artists, their studios are small and can't comfortably accommodate more than four or five people. Try finding a space that can fit everyone in the group, like a school or nonprofit. The most important part is that there is comfortable seating, adequate wall space and lighting. If one or two artists in your group have large studios, ask them if they wouldn't mind sharing their space for critiques.

A good rule of thumb is to have the critique group arrive a little ahead of time. People are usually late for critiques, as it takes time to bring and set up work. So ask that people arrive 30 min. ahead of time to help with installation and to socialize. Remember, critiques should be fun and provide time for socialization. Ask people to bring snacks and drinks. If everyone in your critique group is comfortable drinking alcohol, consider bringing wine or beer. A few drinks may just loosen the group up. But always remember that too much booze can lead to arguments and a very jumbled critique.

Consider establishing regulations for the crit group so that everyone knows the rules and responsibilities of each member. Crit rules can include dues each member must pay for refreshments, crit moderators, space rental, etc. They can also include an understanding of civility and how crit members must behave when discussing work. Members can be required to attend a certain number of critiques each year, and to contribute to discussions. Having these details worked out ahead of time can help your crit group avoid conflict later.

Decide ahead of time who will moderate the critique. Having a moderator will insure that everyone gets a chance to share their opinions about the work. The moderator should be in charge of keeping time and sticking to a rigid schedule. A good moderator will know when the conversation is dwindling, when to start a new line of communication, and when to politely ask that an overzealous commenter wrap up their points. The moderator should try to be as objective as possible, steering away from any and all value judgments. A good moderator will respond to any type of criticism about the work with the question, "Did anyone feel differently?" This ensures that all opinions get addressed.

Once you have decided who the moderator will be you will want to start critiquing work.

Critiquing Work

There are many different ways to address discussion of works during a critique and each critique group decides on different ways they want to discuss work. Here are a few ways to think about structuring your critique group. Try a few out and see what works for you:

1. Consider having each artist whose work is being critiqued write a list of questions they want the critique group to answer. These questions can be about anything and everything pertaining to the work. The benefit of using this kind of critique format is that it ensures that the artist's specific concerns are addressed and there is a wealth of topics for conversation.

2. Another approach is a more free-form critique. This critique starts when anyone has something to say about the work. On the plus side, this format can lead to discussions about topics peripheral to the work. On the downside, this kind of critique can distract from discussions about the actual work in the room. Additionally, this kind of critique is most likely to lead to one or two people dominating the critique with their own point of view.

3. One more approach involves creating a round robin discussion where each person in the critique group takes turns explaining their reactions to the work, addressing the following questions:

• What is the work presented?
• What does the work do when presented in this way?
• What aspects of the work are beneficial and why?
• What aspects of the work can be improved upon and how?

You might consider asking each critique member to write down their answers to these questions and give them to the person whose work is being critiqued. This will allow the artist to receive written feedback about their work and ask questions based on these responses. This format works well for groups with members with writing abilities, and with groups where members can take time to write down their responses.

4. Some artists find it helpful to use a critique session to discuss a project in process. This can mean talking about ideas and articles that are influencing their work. Artists taking this approach can send an article or topic of conversation to their critique group before the critique, and then use the actual critique time to discuss the article. Another approach is to ask the critique group to discuss a particular exhibition at a museum or gallery. This kind of critique doesn't have to occur in a studio but can occur on-site or at a local coffee shop, bar, or restaurant.

No matter how you decide to structure your critique group, always try to keep in mind that the primary purpose of any critique is to help the artist and provide constructive criticism, so they can make their work better and more conceptually sound. So it's always a good idea to check in with the artist being critiqued to make sure they are getting what they want out of the critique.

A good rule of thumb when critiquing anyone's work is to sandwich bad news in-between praise, so begin with praise, what works, then talk about what seems to not be working, and end with praise. This is particularly important when discussing a new work of art or a work of art among strangers.

If you find your crit group floundering, it there are far too many long awkward silences, or you just

want to broaden the topics you address, consider the following sources of content as a jumping off point. This list is from an excellent article called "On The Manner of Addressing Clouds," written by Thomas McEvilley for Artforum in 1984.

Try addressing the following sources of content:

1. Content that arises from the aspect of the artwork that is understood as representational.

2. Content arising from verbal supplements supplied by the artist.

3. Content arising from genre or medium of the artwork.

4. Content arising from the material of which the artwork is made.

5. Content arising from the scale of the work.

6. Content arising from the duration of the work.

7. Content arising from the context of the work.

8. Content arising from the work's relationship with art history.

9. Content that accrues to the work as it progressively reveals its destiny through persisting in time.

10. Content arising from participation in a specific iconographic tradition.

11. Content arising directly from the formal properties of the work.

12. Content arising from attitudinal gestures (wit, irony, parody, and so on) that may appear as qualifiers of any of the categories already mentioned.

13. Content arising in biological or physical responses, or in cognitive awareness of them.

Keeping a Critique Group Together

It can be very hard to keep a crit group together. People leave for many reasons, like job or family obligations, sickness, fatigue, or conceptual or artistic differences with the group. The best way to keep the group together is to maintain constant open conversation, honesty, and, most importantly, trust and respect for one another. No one wants to spend every critique having their work berated or picked apart, and no work or artist deserves such unconstructive criticism. So first and foremost, try and keep things civil and comfortable.

One way to maintain cohesion in the critique group is to stay in touch outside of the critique group. Make sure to attend each others' openings and events. After all, many artists join crit groups to develop their networking group and obtain support from fellow artists. So show up and support your fellow critmates.

Consider setting up an online resource so your crit group can stay in touch outside of the crit sessions. This can be in the form of a chat room, a facebook group, or a simple email list. This can also let group members share opportunities and news in an effective way.

Show together. The people in a crit group are often the greatest experts on each others' work. So consider organizing an exhibition of each other's work and curating work so that it proposes a conceptual argument. Showing together can be a great cooperative endeavor and can bring publicity to the work of the entire group.

30: Legal Issues

 ## Objectives

Understand the differences between different copyright laws.

Understand some basic legal issues that affect all artists.

Understand copyright laws that students may need to use in the future.

 ## Things To Do

Read through the literature on this carefully. It is very useful information for reference and you may find that a local arts attorney offers free consultations should anything come up.

 ## Copyright Information

Disclaimer: Copyright law is constantly changing as new legal rulings and legislation alter definitions of artistic ownership and copyrightable material. For detailed information and the specific language of the copyright law, go to the official Web site of the U.S. Copyright Office; see "Resources and Links".

Definition of Copyright

Copyright is a form of protection provided by the laws of the United States (Title 17, U.S. Code) to the creators of "original works of authorship," including literary, artistic, dramatic, musical, and certain other intellectual works. This protection is available for both published and unpublished works. Section 106 of the 1976 Copyright Act generally gives the owner of copyright the exclusive right to do and to authorize others to do the following:

- To reproduce the work in copies or phono records;
- To prepare derivative works based upon the work;
- To distribute copies of the work to the public by sale or other transfer of ownership, or by rental, lease, or lending;
- To perform the work publicly, in the case of literary, musical, dramatic, and choreographic works, pantomimes, and motion pictures and other audiovisual works;
- To display the copyrighted work publicly, in the case of literary, musical, dramatic, and choreographic works, pantomimes, and pictorial, graphic, or sculptural works, including the individual images of a motion picture or other audiovisual work; and
- In the case of sound recordings, to perform the work publicly by means of a digital audio transmission.

In addition to copyright, certain authors of works of visual art also have the rights of attribution and integrity as described in section 106A of the 1976 Copyright Act.

It is illegal for anyone to violate any of the rights provided by the copyright law to the copyright holder.

Who Owns a Copyright?

Copyright protection begins from the time the work is created in fixed, tangible form. The

copyright in the work of authorship immediately becomes the property of the author who created the work. Only the author or those deriving their rights through the author can rightfully claim copyright.

Works Made for Hire

In the case of works "made for hire," where an artist has created the work while in his/her capacity of employee, the employer and not the employee is considered to be the author and copyright holder.

Collaborations

Where a work was created jointly by more than one artist, the authors of a joint work are all co-owners of the copyright in the work, unless there is an agreement to the contrary. Copyright in each separate contribution to a periodical or other collective work is distinct from copyright in the collective work as a whole and vests initially with the author of each contribution.

Ownership

The mere ownership of a book, manuscript, painting, or any other work does not give the possessor of that work its copyright. The law provides that transfer of ownership of any material object that embodies a protected work does not of itself convey the copyright or any interest in the copyright. This remains in the possession of the creator and is often referred to as the underlying artist's copyright, distinct from the physical object that embodies it.

Transferring a Copyright

Any or all of the copyright owner's exclusive rights or any subdivision of those rights may be transferred to another party, but the transfer of exclusive rights is not valid unless that transfer is in writing and signed by the owner of the copyright conveyed or such owner's duly authorized agent. This practice is comparatively rare in the U.S. and is almost never knowingly engaged in by European artists.

State Laws

Copyright is a personal property right, and it is subject to the various state laws and regulations that govern the ownership, inheritance, or transfer of personal property as well as terms of contracts or conduct of business.

How Long Is a Work Copyright-Protected in the United States?

A work's copyright status depends on when it was first created. See below:

• Work Created on or After January 1, 1978
A work that is created (fixed in tangible form for the first time) on or after January 1, 1978, is automatically protected from the moment of its creation and is given a term of copyright protection enduring for the lifetime of the author plus an additional 70 years after the author's death. In the case of "a joint work prepared by two or more authors who did not work for hire," the term lasts for 70 years after the last surviving author's death. For works made for hire, and for anonymous and pseudonymous works (unless the author's identity is revealed in Copyright Office records), the duration of copyright will be 95 years from first publication or 120 years from creation, whichever is shorter.

• Work Created Before January 1, 1978
Works originally created before January 1, 1978, but not published or registered by that date:

These works have been automatically brought under the statute and are now given federal copyright protection. The duration of copyright in these works will generally be computed in the same way as for works created on or after January 1, 1978, namely, the life-plus-70 or 95/120-year terms will apply to them as well. The law provides that in no case will the term of copyright for works in this category expire before December 31, 2002, and for works published on or before December 31, 2002, the term of copyright will not expire before December 31, 2047.

• Works originally created and published or registered before January 1, 1978: Under the law in effect before 1978, copyright was secured either on the date a work was published with a copyright notice or on the date of registration if the work was registered in unpublished form. In either case, the copyright endured for a first term of 28 years from the date it was secured. During the last (28th) year of the first term, the copyright was eligible for renewal. The Copyright Act of 1976 extended the renewal term from 28 to 47 years for copyrights that were subsisting on January 1, 1978, or for pre-1978 copyrights restored under the Uruguay Round Agreements Act (URAA), making these works eligible for a total term of protection of 75 years.

The Sonny Bono Copyright Extension Act

The Sonny Bono Copyright Extension Act, enacted on October 27, 1998, further extended the renewal term of copyrights still subsisting on that date by an additional 20 years, providing for a total term of protection of 95 years from the date of first U.S. publication if the work was published before January 1, 1978. For all works created or first published after January 1, 1978, the term of protection was extended by 20 years from the previous term

of protection of the lifetime of the artist plus 50 years, to the lifetime of the artist plus 70 years.

Unpublished Works

All works that are unpublished, regardless of the nationality of the author, are protected in the United States. Works that are first published in the United States or in a country with which the United States has a copyright treaty or that are created by a citizen or domiciliary of a country with which the United States has a copyright treaty are also protected.

How Long Is a Work Copyright-Protected Worldwide?

The term of copyright protection varies from country to country around the world, as determined by national legislation. The countries of the European Union, however, harmonized their respective terms in 1994. In the E.U. countries, the term of protection is the lifetime of the artist plus 70 years, except in Spain where the term is life of the artist plus 80 years, and in France where the two world wars have served to give artists whose careers were affected by the wars, a cumulative term of life of the artist plus 84 years and 203 days.

What Is "Public Domain"?

A work that is no longer copyright protected is considered to be "in the public domain." It should be noted, however, that photographs of works of art in the public domain may themselves be copyrighted and will likely require a license for publication, even though the public domain works which are the subject of the photos are no longer protected.

The Berne Convention & International Laws

There is no such thing as an "international copyright" that will automatically protect an author's works throughout the entire world. Generally speaking, protection against unauthorized use in a particular country depends on the national laws of that country.

However, most countries do offer protection to foreign works under certain conditions, and these conditions have been greatly simplified by international copyright treaties and conventions.

Berne Convention for the Protection of Literary and Artistic Works

The most significant international copyright instrument is the Berne Convention for the Protection of Literary and Artistic Works of September 9, 1886. The Berne Convention has approximately 170 members, including the United States, which joined in 1989. The Berne Convention is based on national treatment, meaning that a Berne member country must extend the same treatment to the works of nationals of other Berne member countries as are enjoyed by its own nationals. Furthermore, the Convention obligates member countries to adopt minimum standards for copyright protection.

The Universal Copyright Convention ("UCC Agreement") of September 1952

The UCC Agreement was created to provide an alternative to the Berne Convention. The United States ratified the UCC in 1955. The UCC imposes fewer substantive requirements than the Berne Convention. For countries that are members of both the Berne Convention and the UCC, in cases of conflict between the two conventions the Berne Convention prevails.

The Agreement on Trade-Related Aspects of Intellectual Property Rights of April 15, 1994 ("TRIPS Agreement")

The TRIPS Agreement became an annex to the agreement establishing the World Trade Organization (WTO). In addition to providing for international minimum standards of protection in the area of intellectual property, TRIPS also establishes standards for the enforcement of such rights. It also restores U.S. copyright to foreign works, which were deemed to have fallen into the public domain by virtue of their failure to fulfill the formalities previously required by U.S. Copyright Law.

The World Intellectual Property Organization Copyright Treaty of December 23, 1996 ("WIPO Copyright Treaty")

The WIPO Copyright Treaty also supplements the provisions of the Berne Convention to provide stronger international protection to copyrighted material in the digital environment.

See also Visual Arts Rights Act and check out your state laws.

Copyright Links:
US Government webpage on Copyright: http://www.copyright.gov/

Visual Artists Rights Act

All artists, collectors, and art dealers should be aware of the laws protecting certain rights of the artist and their artworks. These rights extend beyond copyright laws, and apply to the artist even if the artist is not the copyright holder.

On October 27, 1990, Congress passed the Visual Artists Rights Act and included it the Copyright Act of 1776 as Section 106A. VARA generally provides for the rights of attribution and for protection of the physical integrity of certain works of art. This means that the artist has the right to be recognized and listed as the author of their work and that his or her name cannot be used or listed as the author of any work he or she did not create. VARA also allows the artist to have his or her name removed from a work he or she created in the event that the work is distorted or otherwise changed as indicated when the process of doing so would be harmful to the artist's honor and reputation.

There are some limitations to VARA in the definitions set forth in the copyright law. The impact of the exclusions stated below are significant since VARA provides that the inclusion of a work of visual art in any of the kinds of uses set forth in (A) is not deemed a "destruction, distortion, mutilation, or other modification" of that work of visual art and thus an artist cannot use VARA to prevent such use. Further, any work that is done by the artist as a work made for hire is also not covered by VARA.

Specifically, the Act specified a definition of a "work of visual art" which states that these moral rights apply only to:

1) a painting, drawing, print or sculpture, existing in a singly copy, in a limited edition of 200 copies or fewer that are signed and consecutively numbered by the author, or, in the case of a sculpture, in multiple casts, carved, or fabricated, sculptures of two hundred or fewer that are consecutively numbered by the author and bear the signature or other identifying mark of the author, or

2) (2) a still photographic image produced for exhibition purposes only, existing in a single copy that is signed by the author, or in a limited edition of 200 copies or fewer that are signed and consecutively numbered by the author.

Moreover, section 106A is titled "Rights of certain authors to attribution and integrity" and specifically recognizes that authors of a work of visual art:

(1) shall have the right-

(A) to claim authorship of that work, and

(B) to prevent the use of his or her name as the author of any work of visual art which he or she did not create;

(2) shall have the right to prevent the use of his or her name as the author of the visual art in the event of a distortion, mutilation, or other modification of the work which would be prejudicial to his or her honor or reputation;

This allows the artist to have his or her name removed from a work he or she created in the event that the work is distorted or otherwise changed as indicated when the process of doing so would be harmful to the artist's honor and reputation.

(3) subject to the limitations set forth in section 113(d), the artist shall have the right –

(A) to prevent any intentional distortion, mutilation, or other modification of that work which would be prejudicial to his or her honor or reputation, and any intentional distortion, mutilation, or modification of that work is a violation of that right, and

(B) to prevent any destruction of a work of recognized stature, and any intentional or grossly negligent destruction of that work is a violation of that right.

The above sections allow an artist to prevent the indicated acts provided that those acts harm the artist's honor or reputation. Subsection (B) above however, is limited to works of "recognized stature." However, the statute later says that modification of a work of visual art that results from the mere passage of time or the "inherent nature of the materials" is not subject to the above provisions, nor is any modification that results from the conservation of the work nor which arises as a result of the public presentation of the work unless such acts are the result of "gross negligence."

The rights of the artist as to works created on or after the effective date of VARA exist until the end of the calendar year in which the artist dies. However, as to those works created prior to the said effective date but as to which the title has not passed from the artist prior to that date, the rights last for the duration of the rights of copyright (read "When Do Copyrights Expire?") As to works created by joint authors, the rights expire at the end of the calendar year of the death of the last surviving artist.

Further, the rights granted to artists cannot be transferred to another party since they are granted only to the artist and the transfer of title to the actual work of visual art does not operate as a transfer or waiver of any of these rights unless there is an express, written waiver by the artist. Conversely, the waiver of any of these rights does not operate as a transfer of title to the underlying work nor to any rights of copyright in the underlying work unless the artist expressly agrees in writing.

In summary, when rights are granted to one segment of society, in this case artists, it means that restrictions are placed on another segment such as the owners of works of art. This is true under the laws of copyright, trademark, and other rights such as laws that do not deal with intellectual property issues.

The rights embodied in VARA (and indeed broader rights than those) have been recognized within the European Union for many years. The motivation for passage of VARA may have been to bring the United States more in line with the EU in that regard but even on a more commercial level, protecting the creative process and creators. Today, intellectual property is our means of production, and drives our economics.

Information for this article has been taken from various Web sites and publications and includes the US copyright Web site, the Visual Artist Rights Act text, and the National Endowment for the Arts.

Read the full text of VARA: http://www.law.cornell.edu/uscode/17/usc_sec_17_00000106---A000-.html

Visual Artists Rights Act Text

Title VI - Visual Artists Rights Act

Note: This text is taken from the web, and all formatting is the result of that text)

[*601]
SEC. 601. <17 USC 101 note> SHORT TITLE.

This title may be cited as the "Visual Artists Rights Act of 1990".

[*602]
SEC. 602. WORK OF VISUAL ART DEFINED.

"A 'work of visual art' is —

"(1) a painting, drawing, print, or sculpture, existing in a single copy, in a limited edition of 200 copies or fewer that are signed and consecutively numbered by the author, or, in the case of a sculpture, in multiple cast, carved, or fabricated sculptures of 200 or fewer that are consecutively numbered by the author and bear the signature or other identifying mark of the author; or

"(2) a still photographic image produced for exhibition purposes only, existing in a single copy that is signed by the author, or in a limited edition of 200 copies or fewer that are signed and consecutively numbered by the author.

"A work of visual art does not include —

"(A)(i) any poster, map, globe, chart, technical drawing, diagram, model, applied art, motion picture or other audiovisual work, book, magazine, newspaper, periodical, data base, electronic information service, electronic publication, or similar publication;
"(ii) any merchandising item or advertising, promotional, descriptive, covering, or packaging material or container;
"(iii) any portion or part of any item described in clause (i) or (ii);
"(B) any work made for hire; or

"(C) any work not subject to copyright protection under this title."

[*603]
SEC. 603. RIGHTS OF ATTRIBUTION AND INTEGRITY.

(a) RIGHTS OF ATTRIBUTION AND INTEGRITY. — Chapter 1 of title 17, United States Code, is amended by inserting after section 106 the following new section:

"§ 106A. Rights of certain authors to attribution and integrity

"(a) RIGHTS OF ATTRIBUTION AND INTEGRITY. — Subject to section 107 and independent of the exclusive rights provided in section 106, the author of a work of visual art —

"(1) shall have the right —

"(A) to claim authorship of that work, and

"(B) to prevent the use of his or her name as the author of any work of visual art which he or she did not create;

"(2) shall have the right to prevent the use of his or her name as the author of the work of visual art in the event of a distortion, mutilation, or other modification of the work which would be prejudicial to his or her honor or reputation; and

[**5129] "(3) subject to the limitations set forth in section 113(d), shall have the right —

"(A) to prevent any intentional distortion, mutilation, or other modification of that work which would be prejudicial to his or her honor or reputation, and any intentional distortion, mutilation, or modification of that work is a violation of that right, and

"(B) to prevent any destruction of a work of recognized stature, and any intentional or grossly negligent destruction of that work is a violation of that right.

"(b) SCOPE AND EXERCISE OF RIGHTS. — Only the author of a work of visual art has the rights conferred by subsection (a) in that work, whether or not the author is the copyright owner. The authors of a joint work of visual art are coowners of the rights conferred by subsection (a) in that work.

"(c) EXCEPTIONS. — (1) The modification of a work of visual art which is a result of the passage of time or the inherent nature of the materials is not a distortion, mutilation, or other modification described in subsection (a)(3)(A).

"(2) The modification of a work of visual art which is the result of conservation, or of the public presentation, including lighting and placement, of the work is not a destruction, distortion, mutilation, or other modification described in subsection (a)(3) unless the modification is caused by gross negligence.

"(3) The rights described in paragraphs (1) and (2) of subsection (a) shall not apply to any reproduction, depiction, portrayal, or other use of a work in, upon, or in any connection with any item described in subparagraph (A) or (B) of the definition of 'work of visual art' in section 101, and any such reproduction, depiction, portrayal, or other use of a work is not a destruction, distortion, mutilation, or other modification described in paragraph (3) of subsection (a).

"(d) DURATION OF RIGHTS. — (1) With respect to works of visual art created on or after the effective date set forth in section 610(a) of the Visual Artists Rights Act of 1990, the rights conferred by subsection (a) shall endure for a term consisting of the life of the author.

"(2) With respect to works of visual art created before the effective date set forth in section 610(a) of the Visual Artists Rights Act of 1990, but title to which has not, as of such effective date, been transferred from the author, the rights conferred by subsection (a) shall be coextensive with, and shall expire at the same time as, the rights conferred by section 106.

"(3) In the case of a joint work prepared by two or more authors, the rights conferred by subsection (a) shall endure for a term consisting of the life of the last surviving author.

"(4) All terms of the rights conferred by subsection (a) run to the end of the calendar year in which they would otherwise expire.

"(e) TRANSFER AND WAIVER. — (1) The rights conferred by subsection (a) may not be transferred, but those rights may be waived if the author expressly agrees to such waiver in a written instrument signed by the author. Such instrument shall specifically identify the work, and uses of that work, to which the waiver applies, and the waiver shall apply only to the work and uses so identified. In the case of a joint work prepared by two or more authors, a waiver of rights under this paragraph made by one such author waives such rights for all such authors.

"(2) Ownership of the rights conferred by subsection (a) with respect to a work of visual art is distinct from ownership of any copy [**5130] of that work, or of a copyright or any exclusive right under a copyright in that work. Transfer of ownership of any copy of a work of visual art, or of a copyright or any exclusive right under a copyright, shall not constitute a waiver of the rights conferred by subsection (a). Except as may otherwise be agreed by the author in a written instrument signed by the author, a waiver of the rights conferred by subsection (a) with respect to a work of visual art shall not constitute a transfer of ownership of any copy of that work, or of ownership of a copyright or of any exclusive right under a copyright in that work."

(b) CONFORMING AMENDMENT. — The table of sections at the beginning of chapter 1 of title 17, United States Code, is amended by inserting after the item relating to section 106 the following new item:

"106A. Rights of certain authors to attribution and integrity."

[*604]
SEC. 604. REMOVAL OF WORKS OF VISUAL ART FROM BUILDINGS.

Section 113 of title 17, United States Code, is amended by adding at the end thereof the following:

"(d)(1) In a case in which —

"(A) a work of visual art has been incorporated in or made part of a building in such a way that removing the work from the building will cause the destruction, distortion, mutilation, or other modification of the work as described in section 106A(a)(3), and

"(B) the author consented to the installation of the work in the building either before the effective date set forth in section 610(a) of the Visual Artists Rights Act of 1990, or in a written instrument executed on or after such effective date that is signed by the owner of the building and the author and that specifies that installation of the work may subject the work to destruction, distortion, mutilation, or other modification, by reason of its removal, then the rights conferred by paragraphs (2) and (3) of section 106A(a) shall not apply.

"(2) If the owner of a building wishes to remove a work of visual art which is a part of such building and which can be removed from the building without the destruction, distortion, mutilation, or other modification of the work as described in section 106A(a)(3), the author's rights under paragraphs (2) and (3) of section 106A(a) shall apply unless —

"(A) the owner has made a diligent, good faith attempt without success to notify the author of the owner's intended action affecting the work of visual art, or

"(B) the owner did provide such notice in writing and the person so notified failed, within 90 days after receiving such notice, either to remove the work or to pay for its removal.

For purposes of subparagraph (A), an owner shall be presumed to have made a diligent, good faith attempt to send notice if the owner sent such notice by registered mail to the author at the most recent address of the author that was recorded with the Register of Copyrights pursuant to paragraph (3). If the work is removed at the expense of the author, title to that copy of the work shall be deemed to be in the author.

"(3) The Register of Copyrights shall establish a system of records whereby any author of a work of visual art that has been incorporated in or made part of a building, may record his or her identity [**5131] and address with the Copyright Office. The Register shall also establish procedures under which any such author may update the information so recorded, and procedures under which owners of buildings may record with the Copyright Office evidence of their efforts to comply with this subsection."

[*605]
SEC. 605. PREEMPTION.

Section 301 of title 17, United States Code, is amended by adding at the end the following:

"(f)(1) On or after the effective date set forth in section 610(a) of the Visual Artists Rights Act of 1990, all legal or equitable rights that are equivalent to any of the rights conferred by section 106A with respect to works of visual art to which the rights conferred by section 106A apply are governed exclusively by section 106A and section 113(d) and the provisions of this title relating to such sections. Thereafter, no person is entitled to any such right or equivalent right in any work of visual art under the common law or statutes of any State.

"(2) Nothing in paragraph (1) annuls or limits any rights or remedies under the common law or statutes of any State with respect to —

"(A) any cause of action from undertakings commenced before the effective date set forth in section 610(a) of the Visual Artists Rights Act of 1990;

"(B) activities violating legal or equitable rights that are not equivalent to any of the rights conferred by section 106A with respect to works of visual art; or

"(C) activities violating legal or equitable rights which extend beyond the life of the author."

[*606]
SEC. 606. INFRINGEMENT ACTIONS.
(a) IN GENERAL. — Section 501(a) of title 17, United States Code, is amended —

(1) by inserting after "118" the following: "or of the author as provided in section 106A(a)"; and

(2) by striking out "copyright." and inserting in lieu thereof "copyright or right of the author, as the case may be. For purposes of this chapter (other than section 506), any reference to copyright shall be deemed to include the rights conferred by section 106A(a).".

(b) EXCLUSION OF CRIMINAL PENALTIES. — Section 506 of title 17, United States Code, is amended by adding at the end thereof the following:

"(f) RIGHTS OF ATTRIBUTION AND INTEGRITY. — Nothing in this section applies to infringement of the rights conferred by section 106A(a)."

(c) REGISTRATION NOT A PREREQUISITE TO SUIT AND CERTAIN REMEDIES. — (1) Section 411(a) of title 17, United States Code, is amended in the first sentence by inserting after "United States" the following: "and an action brought for a violation of the rights of the author under section 106A(a)".

(2) Section 412 of title 17, United States Code, is amended by inserting "an action brought for a violation of the rights of the author under section 106A(a) or "after" other than."

[**5132] [*607]
SEC. 607. FAIR USE.

Section 107 of title 17, United States Code, is amended by striking out "section 106" and inserting in lieu thereof "sections 106 and 106A".

[*608]
SEC. 608. <17 USC 106A note> STUDIES BY COPYRIGHT OFFICE.

(a) STUDY ON WAIVER OF RIGHTS PROVISION. —

(1) STUDY. — The Register of Copyrights shall conduct a study on the extent to which rights conferred by subsection (a) of section 106A of title 17, United States Code, have been waived under subsection (e)(1) of such section.

(2) REPORT TO CONGRESS. — Not later than 2 years after the date of the enactment of this Act, the Register of Copyrights shall submit to the Congress a report on the progress of the study conducted under paragraph (1). Not later than 5 years after such date of enactment, the Register of Copyrights shall submit to Congress a final report on the results of the study conducted under paragraph (1), and any recommendations that the Register may have as a result of the study.

(b) STUDY ON RESALE ROYALTIES. —

(1) NATURE OF STUDY. — The Register of Copyrights, in consultation with the chair of the National Endowment for the Arts, shall conduct a study on the feasibility of implementing —

(A) a requirement that, after the first sale of a work of art, a royalty on any resale of the work, consisting of a percentage of the price, be paid to the author of the work; and
(B) other possible requirements that would

achieve the objective of allowing an author of a work of art to share monetarily in the enhanced value of that work.

(2) GROUPS TO BE CONSULTED. — The study under paragraph (1) shall be conducted in consultation with other appropriate departments and agencies of the United States, foreign governments, and groups involved in the creation, exhibition, dissemination, and preservation of works of art, including artists, art dealers, collectors of fine art, and curators of art museums.

(3) REPORT TO CONGRESS. — Not later than 18 months after the date of the enactment of this Act, the Register of Copyrights shall submit to the Congress a report containing the results of the study conducted under this subsection.

[*609]
SEC. 609. <17 USC 101 note> FIRST AMENDMENT APPLICATION.

This title does not authorize any governmental entity to take any action or enforce restrictions prohibited by the First Amendment to the United States Constitution.

[*610]
SEC. 610. <17 USC 106A note> EFFECTIVE DATE.

(a) IN GENERAL. — Subject to subsection (b) and except as provided in subsection (c), this title and the amendments made by this title take effect 6 months after the date of the enactment of this Act.

(b) APPLICABILITY. — The rights created by section 106A of title 17, United States Code, shall apply to —

(1) works created before the effective date set forth in subsection (a) but title to which has not, as of such effective date, been transferred from the author, and

(2) works created on or after such effective date, but shall not apply to any destruction, distortion, mutilation, or other modification [**5133] (as described in section 106A(a)(3) of such title) of any work which occurred before such effective date.

(c) SECTION 608. — Section 608 takes effect on the date of the enactment of this Act.

 Other Artists' Rights

Resale Right / Droit de suite

A number of foreign countries recognize a resale right or *droit de suite*, as it is often called. This right stipulates that artists may financially participate in the commercial resale of their original works of art. Recognizing that reputation -- and hence the value of creative works -- is often slow to build in an artist's career, the resale right is a measure designed to allow artists to participate in the appreciation in value of their works when they are resold after the initial sale. The resale right has existed and been administered successfully in numerous foreign countries for years, most notably in France. Laws providing for the resale right were recently harmonized in the European Union. In the United States, however, federal law and almost all state laws fail to provide this right to artists. California is the only state to enact a resale royalty law. As with copyright, the duration of the resale right is usually the lifetime of the artist plus 70 years.

Rights of Publicity & Personality

Rights of publicity (also sometimes referred to as rights of personality) refers to an individual's (or an individual estate's) exclusive right to authorize how the name, voice, signature, image or likeness of the individual may be used. Many copyrighted works incorporate photographs or other images which depict individuals (for example Andy Warhol's "Marilyn Monroe") and publicity rights may be an issue in the reproduction of these works for certain purposes. Similarly, in order to use an artist's name, signature, or likeness in an advertisement, the advertising agency must clear the artist's rights of publicity with the artist or estate.

Moral Rights

Moral rights are the rights of an artist to maintain the integrity of his/her work and to receive full and proper attribution for his/her work. Moral rights reflect a personal interest in the work and usually are attributable only to the author (that is, unlike copyright, such rights cannot be transferred to another party). The United States was initially reluctant to adopt moral rights laws, but after its adherence to the Berne Convention, the United States was obliged to enact the Visual Artists Rights Act ("VARA") in 1991, recognizing an artist's limited right of attribution, right of integrity, and right to prevent the derogation or destruction of certain works of art.

Restoration of Foreign Copyrights in the U.S.

On December 8, 1994, the President of the United States signed into law the Uruguay Round Agreements Act ("URAA"). The Act contains specific provisions which require the U.S. to restore full recognition to all foreign

works which fell into the public domain in the U.S. due to noncompliance with formalities imposed by United States Copyright law, provided the source country is a member of the Berne Convention or the World Trade Organization. The bill to restore copyrights brought the United States at long last into virtual compliance with Articles I - XXI of Berne and especially with Article XVIII s.1, which obliged newly adhering states to honor the copyrights of existing member nations.

As a result, all foreign works which had been exploited in the U.S. without authorization in the past because of failure to comply with U.S. formalities were restored to full copyright protection, effective January 1, 1996. The Act supplanted that portion of the North American Free Trade Agreement (NAFTA) which provided U.S. copyright restoration for certain Mexican and Canadian motion pictures which had fallen into the U.S. public domain because of failure to comply with U.S. copyright formalities.

Section 514 of the Act is titled "Restored Works." It amends Section 104A of the U.S. Copyright Code (Title 17) and reads as follows:

104A. Copyright in restored works.
 "(a) AUTOMATIC PROTECTION AND TERM.-
 "(1) TERM.-
 "(A) Copyright subsists in accordance with this section in restored works, and vests automatically on the date of restoration
 "(B) Any work in which copyright is restored under this section shall subsist for the remainder of the term of copyright that the work would have otherwise been granted in the United States if the work never entered the public domain in the United States.
 "(b) OWNERSHIP OF RESTORED COPYRIGHT.-
 A restored work vests initially in the author or initial rights holder of the work as determined by the law of the source country of the work. In the definitions section of the Act, the terms restored copyright and restored work are defined in the following fashion:

"(5) The term 'restored copyright' means copyright in a restored work under this section.
"(6) The term 'restored work' means an original work of authorship that -
"(A) is protected under subsection (a);
"(B) is not in the public domain in its source country through expiration of the term of protection.
"(C) is in the public domain in the United States due to -
"(i) noncompliance with formalities imposed at any time by United States copyright law, including failure of renewal, lack of proper notice, or failure to comply with any manufacturing requirements;

All those who reproduced foreign works without artist authorization prior to the date the President signed the URAA, on December 8, 1994, are deemed to have relied on the understanding that the works were in the public domain. Such parties are therefore called Reliance Parties in the Act. Under the copyright restoration provisions of the Act, the restored copyright holder may make a claim against a reliance party in one of two ways:

First, a copyright holder or his agent may file a Notice of Intent to Enforce a Restored Copyright against a Reliance Party (referred to in the Act as an "NIE") with the U.S. Copyright Office. This must be done within 24 months after the date the copyrights were restored. For all European countries, this meant no later than 24 months after January 1, 1996 (the date on which Berne works become eligible for restoration). Such a filing, when published in the Federal Register, was effective against all reliance parties. This initial period has of course passed.

However, it will not be necessary to file an NIE with the U.S. Copyright Office to claim a restored copyright against a specific reliance party. Thus, the second way to claim a restored copyright is to serve a notice directly on a particular reliance party. Most importantly, such direct service may be made at any time and is not limited to the 24 month period mandated for formal filing with the Copyright Office.

Reliance Parties have 12 months from the date they were served with an NIE or from the date of publication in the Federal Register (whichever is earlier) to sell the stock of copies they made prior thereto. Upon the expire of the 12-month grace period, the reliance party may continue to exploit the work only if it comes to a satisfactory agreement with the copyright holder and pays agreed compensation to the owner of the restored work.

It is also important to emphasize that only those reproducing works prior to December 8, 1994 qualify as reliance parties. All other uses of a restored public domain work commenced after that date are actionable infringements of the restored copyright. A party that has made a new use after December 8, 1994, without authorization of the copyright holder, does not qualify as a reliance party since it should have known of the new legislation, and is thus to be treated as a copyright infringer, subject to the penalties of law, with no grace period to sell out the infringing goods.

Digital Millennium Copyright Act (DMCA)

On October 28, 1998, the Digital Millennium Copyright Act (DMCA) of 1998 was signed into law, implementing World Intellectual Property Organization (WIPO) copyright treaties of 1996 and updating U.S. copyright law for the information age. It is "designed to facilitate the robust development and worldwide expansion of electronic commerce, communication, research, development, and education in the digital age" (Senate Rpt. 105-190), while providing for enhanced protection of copyrights in the digital environment.

Key among the topics included in the DMCA are provisions concerning the circumvention of copyright protection systems, fair use in a digital environment, and Internet service provider (ISP) liability, including details on safe harbors, damages, and "notice and takedown" practices. In general, the DMCA limits Internet service providers from copyright infringement liability for simply transmitting information over the Internet. ISP's, however, are expected to remove material from Web sites that they host which appear to constitute copyright infringement.

A summary of the DMCA can be found at the U.S. Copyright Office at the following Web page:

http://www.loc.gov/copyright/legislation/dmca.pdf.

31: Documentation

✳ Objectives

Understand the importance of documentation of artists' work.

Understand the different ways to document work

✳ Things To Do

Do some research online, or in person (artists you know) and ask them if you can see documentation of their work. Look for styles you like or visually work well. Ask them how they document their work and their success with the way it looks.

Have someone look at your documentation and give you feedback.

✳ Documentation

Next to the original physical work itself, documentation of your art is probably the most important part of your art practice. Good documentation is the best long-term investment you can make in your art practice. It will be the backbone of your art archive, and will be the primary factor in how your entire practice is viewed long-term.

How you document your work determines everything, from how it is reproduced in print publications, to how it is seen on the web. Visual documentation will often be the only thing curators, writers, or grant panels will see of your work. So having good documentation of your work can mean the difference between getting a grant, securing an exhibition, or being rejected or passed over for opportunities.

Many times, documentation is all that is left over from non-permanent work, like temporary site-specific sculpture, happenings, performances, etc. In cases like these, the documentation will be the only thing that survives, and can actually become the work itself. This is why it is very important to plan how you will document your work ahead of time.

This section is not going to go into specifics with regards to the kinds of cameras or film or lights you should use to document your work. Every individual work of art requires a unique kind of documentation. Accurate documentation can vary with lighting conditions, the kind of work you are photographing, and how you want your end product to look.

Tools

A good graphics program. The industry standard here is Adobe Photoshop, which, sadly, costs a pretty penny. Other alternative, and free, options are available, like:

• Pixel
• Splashup
• GIMP

While graphic tools like Photoshop make it very easy to retouch images after they are taken, it's always best to get the right shot the first time around. So make sure you have the right camera, lighting, background, framing, and formats for your photographs.

The Camera

It used to be that all applications required slides, which meant work had to be photographed in slide form and then these slides had to be duplicated. The process was time consuming and very expensive. Thankfully, the art world has moved past slides and into the digital age. So in general you don't need to shoot slides, and instead should always have high-quality digital images of your work. This means you need a digital camera that can capture images in a RAW format. RAW format is the original, unaltered format a digital camera processes. Usually any digital Single Lens Reflex (SLR) camera that takes photos at 8MP or more will do the trick. The most important thing about this kind of camera is not just that it can take very high-res images, but that it lets you manually adjust exposure rates, white balance, and a host of other features. Costing around $500 and more, these cameras are not cheap, but considering that the cost of photographing, developing and duplicating slides just a few years ago could run you way more than $500, the digital revolution seems to be a bargain. Take your time when buying a camera for documenting your work. Ask around and buy used or refurbished cameras from your school or fellow students.

When you are shooting with your digital camera, you should, in general (not as a water-tight, all the time rule) use these guidelines:

• Set the ISO to it's lowest setting. This will reduce noise, or graininess, in the final photo.
• Set the camera to capture the image in the highest, most memory guzzling format it can. If your camera can shoot in RAW or TIFF format then use that setting. If you use up your memory card quickly consider buying a card that can hold more memory.

• Don't use the zoom function. Zooming in causes your camera to interpolate, which is like making up information for the photo. Instead of zooming, move your tripod closer.
• Don't use your camera's built in flash. It will distort the color and shadows.
• Fill the frame with as much of your work as possible without cropping anything out of the picture. This will let you get the most detail in your shot.

The Tripod

Never photograph work without a tripod. Failure to use a sturdy tripod will result in unfocused images and a splitting headache. Invest in a lightweight but stable tripod, preferably with a built in level.

Lighting

Make sure you light your work evenly and brightly enough so that all relevant aspects of the work can be seen clearly. The Sun is the ultimate light source, it's what our eyes adjust all other light for and it's the easiest light to use when photographing work. So if you can photograph your work using natural sunlight, primarily 4pm sunlight (not noon or in shade), you are in luck! However, photographing work in the sun can be its own challenge because you don't want to confuse the work with a cluttered outdoor background. So if you use natural sunlight be sure you have a neutral black, grey, or white background.

If you can't photograph work in natural sunlight you will need to control two things: the lighting source and the white balance.

If you can afford it, invest in studio strobes on tripods, attached to white umbrella reflectors. One of the best things about photographing work digitally is that you can instantly review photos

once you have taken them. If you can, review a few test shots for accurate color and lighting.

If you are photographing 2D work, use two lights positioned 45 degrees from both the artwork and the stationary camera. Make sure the lighting is even over the entire work. If you are photographing 3D work leave one light at 45 degrees from the work and position the other light closer to the work, at less than 45 degrees. Photographing with this light source will heighten the shadows and texture in your work.

There are some excellent publications about photographing your artwork. See Chapter 6 in Margaret Lazzari's book, The Practical Handbook for the Emerging Artist, or other books written specifically for artists. There are also good resources on the Web. See Resources Section.

Saving Image

Once you have taken your photos, you will need to save them in your computer.

1. The first step is transferring the RAW photo files to your image archive database. You will probably want to peruse your photos and weed out any sub-par or blurry images.

2. Then separate these good images by individual works. You might want to rename the files with the artwork's inventory number and the word ORIGINAL. If you have questions about how to assign inventory numbers, check out the Artwork Inventory section of this manual.

3. Once you have these images selected, put them in a Hi Res Images folder on your computer. You might want to make a dedicated ORIGINALS file, nested in this Hi Res folder. Once you have the original files in this folder you never want to alter them, ever. These are like your negatives, the

ultimate archive of your work. Altering the images decreases the image integrity, and can lead to things like pixilation, interpolation, etc. Instead, when you need to color correct these files, resize them, crop them, etc. You will want to use the Save As feature and save these in a Lo Res Images file nested in your Archive folder on your computer.

Additionally, you will want to save each image in your archive in the following formats:
• Archival RAW image (we addressed this before)
• 300dpi JPG file used for prints. Make sure it is no more than 8 x 10in. (This can also go in the Hi Res Images file).
• 72dpi GIF or JPG file used for internet images. Make sure it is no more than 800 pixels wide. (save this file in your Lo Res folder).

Documenting Using Video

Consider hiring a professional videographer to shoot your work, as well as direct and edit the tape. A poorly shot video is a waste of time and money, and you may have lost the opportunity to capture your best work. Do not skimp on the quality of your documentation.

If you are documenting the work yourself make sure you have a high-quality camera and adequate lighting. Don't rely on your camera's light source. Remember that poor lighting can ruin any documentation.

Keep the focus on your work and on documentation, do not try to make the portfolio of your performance into an artwork itself. There is nothing more distracting than trying to see a tape of a performance with so many flourishes that the work is not fully represented.

Shooting at rehearsals can be important. This way you will not play to just the camera, but to the whole audience.

Include the entire work on the tape just in case your audience wants to view more of the work. Always cue your tape to the best part. Always label the tape with your name, title, length and date of the work, unless specified otherwise.

Always credit your collaborators, if any. It fosters a sense of community.

Additional Resources

http://www.dallasartsrevue.com/resources/How-to-Photo-Art.shtml

http://arthistory.about.com/od/collecting_and_appraising/l/bl_photoartqt.htm

 ## Scanning & Archiving

An artists practice can be documented in many different forms. Back in the day, artists had to document everything with slides. Thankfully, those days are over and work can be documented using digital technology. If you have your old slide archive sitting around you should consider scanning any and all old slides and negatives of your work and importing these images into your database.

Here are some things you may consider scanning:

• Slides
• Film Negatives
• Transparencies
• Printed photographs
• Important documents like contracts, forms, etc. that are not available as digital documents
• Articles and printed matter about you and your work
• Printed research and photos pertinent to your practice

Scanning work and documents makes this physical information readily available and just makes sense now that everything is becoming digitized. Also digitized work is permanent, doesn't degrade with time and the elements, and if you back up your digital copies, you will always have a comprehensive archive of your practice. If your work is small and two-dimensional, you might consider scanning it as a form of documentation, you might get better image resolution and save time and money on lights and camera equipment.

The Scanner

Scanners range in cost depending on their resolution and quality of their scan. For basic scanning a less expensive scanner costing $99-$200 will do you just fine. Some scanners just scan reflective surfaces while other costly scanners ($200-500) offer the option to scan film negatives and/or transparencies. A professional scanner ($1000 or more) will help you get the quality you need but can be expensive to buy.

Most scanners come with scanning software that allows you to change the settings (e.i. resolution, size dimensions, bit rate, sharpening, dust, and select the type of flat objects you are scanning). The typical settings are as followed:

• 8 bit (48-24bit), 300 dpi, optional pixel dimensions/ sizes.
• When scanning, it's always good to scan files as tiffs, as a larger file, that way you can always downsize your files for web images, emails, or even up-size for digital printing, etc.

For scanning slides, it is important to keep you work area clean especially if you are scanning slides, film negatives, or transparencies. Dust

can be a major problem and cause more work time trying to get rid of all the dust picked up by the scan, so properly clean your scanner and workspace before use to increase efficiency. Some useful things to invest in are a dust free cleaning cloth, a can of compressed air, and professional photo gloves.

Remember to always keep a back up and/or burn your images files to a disk or to your hard drive to make safe-keeping and archiving easier.

Slides

Slides are quickly becoming a thing of the past as everything becomes digital. Nevertheless, many artists still have slides and insist on taking slides of their work. Having good quality slides, and expensive transparencies (taken with a large-format camera), can be a great tool when you are reproducing work large-scale or in print. So, for artists who still have slides, this section is for you.

Caring For Slides

Preservation of slides is crucial to your archives. Plastic slide mounts are preferred because cardboard mounts will bend and split. Bent slides or slide mounts that are too thick will jam a carousel and may destroy your slides. Slide-film has a shelf life expectancy of 25 years which is why it is crucial to not only know how to shoot slides but how to care for them.

If you have an archive full of slides you will need to have them digitized. This can be done with a high-quality scanner. If you don't have access to a high-quality slide scanner, consider hiring an artist or arts organization to scan your slides for you. GYST offers an affordable scanning service to artists, if you are interested in using this service visit gyst-ink.com.

About Slides

Slides are actually bits of 35 mm film exposed in the camera. One side of a slide is a bare acetate base, while the other (the image side) is a complex, multi-layer film of gelatin and dyes. Both sides are delicate.

Always view slides on a light table before paying for processing or taking them home. Often times, dust and debris accumulates on slides, which can be removed with canned air that is 100% ozone safe. This product can be found at electronic stores or camera shops.

To properly store slides, slip them into archival slide pages that hold 20 slides each. If non-archival slide pages are used, the slide emulsion will adhere to the surface of the plastic and peel off. The best way to archive slide pages is in three-ring binders stored upright. Pages stored flat press the plastic against the emulsion, which is bound to cause problems. Always keep slides protected from heat, light, moisture and dirt. To safeguard against loosing a set of slides in a fire, rent a safety deposit box or buy a firebox and keep your master slides there.

Labeling Slides

There is no universal slide labeling format. The information on the slides is crucial to your archives because it is a historical record. Create professional looking labels by using either the GYST software or Microsoft Word to create slide labels using Avery 5367 or 8167 label sheets. Do not hand write labels, for poorly labeled slides can lead the viewer to believe you do not care about your work.

Using professional photographic silver tape to mask out an unwanted backdrop is acceptable. Silver tape can be purchased at a photo supply

shop or through mail order. Silver tape is not duct tape. It is the only tape that will block 100 percent of the light. Mask carefully and keep edges straight.

If you must submit slides for review, always include a self-addressed, stamped envelope to better ensure the return of your slides. If you are submitting more than four slides, do not use a #10 business envelope. It is very difficult to try to fit 20 slides in a business envelope.

Check your slides periodically to make sure that they are labeled properly and that the labels are not sticking to each other. Also, project the slides to check for damage.

Slide orientation:

• Clearly mark the slide so that the person putting the slides in the carousel tray or projector knows the front from the back and the top from the bottom.

• A signal dot (usually red and marked with a pen, not a stick-on dot) should be placed in the lower left hand corner of the front side when it is in the correct position for hand held viewing. Once the tray is loaded, all the red dots will be visible and positioned so that the dot is seen in the upper right hand corner. You might want to consider making the red dot with a pen, as many purchased red dots tend to fall off or get caught in the projector. Using arrows as well as a red dot to clearly mark the top is appropriate. Add the word front, if need be.

For multiple views of 3-D work, label with numbers and A, B, C, D, or detail-A.

Each slide should have labels that provide the following information:

• Your name.

• Title of your work. All titles should be italicized or underlined. If your labels are handwritten, simply underline the title.

• The medium. Be reasonable in your choice of terms. Slide label space may affect your word choice, so select your terms well.

• Date of completion.

• Dimensions. Whenever you provide dimensions for a work of art, you must use the following conventions:

• Three-dimensional works: Height x Width x Depth (always in that order)

• Two-dimensional works: Height x Width (always in that order)

• Keep your units of measurement consistent. Within the Unites States, measurements are typically recorded in feet and inches. Outside the United States the metric system is normally used. Both are acceptable.

• Whichever system you select, try to be consistent.

Examples:

Correct	6 ft. x 2 ft. (ft. = feet)
Correct	6′ x 2′
Correct	72 inches x 24 inches (in. = inch)
Correct	72″ x 24″
Incorrect	72 inches x 2 feet (don't mix system of units)

To convert centimeters to inches: 1 in. = 2.54 centimeters (cm.)

• Location. If the work is part of an important collection or gallery show: name gallery, a site-specific piece, a building, etc., you should indicate the location.

• Condition. If the work has been removed or destroyed, that should be indicated.

• Contact information: phone number and/or Email

Additional Tips on Submitting Slides of Your Art

Keep in mind that jurors, museum curators, art dealers, and art administrators sometimes look at thousands of slides at one time. Make sure that the information you provide answers any possible questions that they may have.

Some of the questions that come up when viewing slides are:

• **"Where is the art in this slide?" or "Where does the art start and end?"**
If your background image overwhelms the art it will be hard to see the work. Use plain grey, white, or black neutral backgrounds, and avoid fancy backdrops. Do not set your painting on a chair in your yard, and include the chair and yard in your image. If you must do this, then be sure to tape the edges of your slide with silver tape, which is available at any photo supply store.

• **"Is this the same artist?"**
Try not to confuse the viewer with work that is so varied in nature that it looks like multiple artists made it.

• **"Whose slide is this?"**
Always include your name on the slide, always.

• **"Which way is up?"**
It is important to have your slides upright when projected. Provide all the information needed to ensure this. Also, double check the slides after you have loaded them into your slide pages to make sure.

• **"What is this made of?"**
If you can, include this information on the slide, and always in your work description sheet. Include the materials if at all possible, don't just write "mixed media."

• **"What size is it?"**
You may be surprised at how often a viewer cannot tell the size of a work. Be sure to include this information if it is not clear in the slide. This is why some artists will include an installation view with a person in it for scale.

Always follow directions

If the application asks for ten slides, send ten and only ten slides. Sending more means you cannot follow directions.

Only submit requested materials. DO NOT submit additional materials.

Never send original slides. Duplicate your slides and send copies.

Bent slides and loose labels will jam a carousel and destroy slides. Take care to ensure the quality of your slides and labels.

Always include a self-addressed, stamped envelope for the return of your slides.

32: Career Options for Creatives

 ## Objectives

Expand the understanding of the kinds of jobs that are available for creatives.

Understand the factors and hurdles facing students when they seek employment.

 ## Things to Consider

As an artist, you may have had so many jobs that it is interesting to write down and think about all of them. Opening up avenues of jobs that most artists may not have thought of is a good way to expand your assumptions of what jobs artists can do.

 ## Things To Do

Go on Craigslist or use other online avenues to find jobs and then write down ones that you hadn't thought of or are interesting.

Finding a Job

The average American getting out of college today can expect to have five careers during his or her lifetime.

A study of Harvard students, ten years after graduation, shows that those who had specific goals made salaries three times greater than the salary of the average Harvard graduate. Those with written goals made ten times the average.

Rarely does an artist make a living exclusively from sales of their work, even if they become fairly well known artists. Many artists hold down a number of jobs in their life. The key is to find a job that allows you to keep making your work and that is satisfying or at least challenging.

There are lots of resources for locating jobs. A good resource is Margaret Lazzari's Book, The Practical Handbook for the Emerging Artist, Chapter 12, Jobs. (Harcourt College Publishers). She outlines ways to think about finding a job and offers suggestions for jobs you might not have thought of that relate to art making and creativity.

See also Caroll Michel's book How to Survive and Prosper as an Artist, Chapter 9, "Generating Income: Alternative to Driving a Cab."

Chapter 2 in Art That Pays, by Adele Slaughter and Jeff Kober, 'A' Job, 'B' Job.

Many cities have an arts list-serv, in Los Angeles it is Los Angeles Culture Net (LACN), a Yahoo users' group. Most job announcements and opportunities for artists are listed here. Finding a list-serv in your own city may help you keep posted about what is going on in the arts in your city.

Employment Status Definitions

Full-Time

If you can find full-time work that you enjoy and still have time/energy to devote to your art practice, then go for it. A full-time job is generally 40 hours a week. Working full-time gives you better job security, more money, and sometimes health and retirement benefits. Some full-time jobs are paid by the hour and

others are salary based. The trick is to have enough time and energy to continue making your artwork.

Part-Time

Part-time work is generally paid by the hour. It rarely has benefits such as health insurance and retirement, but it is a good way to try jobs out to see if you like them. It gives you more flexibility for making your artwork, and can sometimes relieve boredom. Part-time teaching often becomes full-time. Consider a part-time job while you are interning at a company you love or while taking classes.

Freelance/Consulting

Working as a consultant or a freelance job means more than handing out your business card and expecting a call. It means you are in business for yourself. You should make sure that you understand what it means to be in business. Reading the Self Employment and Business sections of this manual will help you get started.

The benefits of being self-employed are choosing your own hours, being able to say no to a client, taking expenses off on your taxes, and charging the rate you are worth if you can get it. You get to choose your own health plan if you can afford it, and you determine where your business goes.

The disadvantages are not knowing how to run a business, paying for your own mistakes, and bearing sole responsibility for job security. There is a lot more paperwork; for example, you need to pay your own social security and benefits. When you work with others, each new project may be a collaboration with a group of individuals that are brought together for that

project. When the project ends, you will either go on to another one with a different group of people, or if it was successful, perhaps work with them again.

Temp Agencies

Temp agencies (temporary work) want experienced people for most jobs and will usually test your skill set. Temp agencies vary widely in terms of pay, but joining one may be a great way to get experience and network. MacTemps, Manpower, MacPeople, Strategic Staffing, Smith Hampton & Devlin, all claim to place desktop publishers and graphic designers, along with word processors.

Internships

Many companies and organizations offer internships, which provide experience and training in exchange for work. A few will also offer an hourly wage. On average, an internship lasts for one to six months. Make sure that the internship will actually train you to do something, and get specifics in writing before you start. You should get a job description in writing, along with the number of hours per week, the length of the internship and the skills you will learn in writing. Some internships just use you for busy work, but a good internship can lead to great connections and sometimes full-time employment.

Informational Interviews

One of the best ways to find out about a particular industry or company is to do interviews with current employees who work in the industry you are interested in. This interview is a way to get information, not necessarily a job. Asking someone to chat with you is taking time out of their day, so treat

them with respect, take them out for coffee or tea, or a drink after work.

Try to use this interview to clarify your goals and gain information that may not be advertised. Many jobs are found by word of mouth, so make sure you take the opportunity to get the inside scoop. This is also a good way to practice an interview, and get additional information so you know what kinds of questions to ask at a formal interview. Doing research ahead of time is crucial, as you want to know as much about the industry or career you are asking about.

Finding a person to interview might be as easy as asking a relative or someone you know who works in the field. If all else fails, you can write to the company and request an informal interview with someone who works there, perhaps a department head. If you send a letter, include your resume, and any other helpful materials you may have. Asking for information is a great way to get support if they like you. They just might recommend that you apply for a position. Be sure to send a thank you note to the person you interview. Dress appropriately and keep it short.

Your Goals

There are six main goals of informational interviews:

• Establish rapport with the interviewers. Get to know them personally.

• Get advice on your job-search, particularly on improving both your approach and your presentation.

• Let them know who you are. Be genuine and interested.

• Find out about your job market. Ask about latest developments, publications to read, or professional groups you should investigate.

• Get referrals. If you have not received names by an interview's end, it is appropriate to ask for them.

• Be remembered favorably. Before leaving, tell an interviewer that you would appreciate being kept in mind in case s/he hears of anything.

Some Questions You Might Ask

Prepare a list of your own questions for your informational interview. The following are some sample questions:

• On a typical day in your position, what do you do?

• What training or education is required for this type of work?

• What personal qualities or abilities are important to being successful in this job?

• What part of this job do you find most satisfying? Most challenging?

• How did you get your job?

• What opportunities for advancement are there in this field?

• What entry-level jobs are best for learning as much as possible about this job?

• What are the salary ranges for various levels in this field?

• How do you see jobs in this field changing in the future?

• Is there a demand for people in this occupation?

• What special advice would you give a person entering this field?

• What types of training do companies offer persons entering this field?

• Which professional journals and organizations would help me learn more about this field?

• From your perspective, what are the problems you see working in this field?

• If you could do things all over again, would you choose the same path for yourself? Why? What would you change?

• What do you think of my training and experience in terms of entering this field?

• With the information you have about my education, skills, and experience, what other fields or jobs would you suggest I research further before I make a final decision?

• What do you think of my resume? Do you see any problem areas? How would you suggest I change it?

• Who should I talk to next? When I call him/her, may I use your name?

Getting To The Interview

Before the interview, make sure to do the following:

• Examine your likes and dislikes in previous work and learning situations – what kinds of projects have inspired you?

• Determine your careers goals – what jobs, in what industries, do you want?

• Make an exhaustive list of your strengths, abilities and past experience that supports those career goals.

• Define your preferred employment status - full-time, part-time, contract.

• Research the companies that you would like to work for.

• Write a thorough, readable resume, which clearly defines your abilities and experience.

• Write a brief, sincere, informative cover letter that explains why you want to work for this particular company, and how you will benefit them.

• Send your resume, letter and work samples (if available or necessary) to target employers.

Phone Calls

When on the phone with a prospective employer, let the other person do most of the talking. A phone interview should establish your communication skills, not be an opportunity to tell the interviewer your entire career history.

When taking a call from a prospective company or a recruiter, do so when you are ready and comfortable. If a call comes at a bad time, say so and reschedule.

Be prepared, but be yourself!

The employment interview is one of the most important events in a person's experience, because the thirty minutes to one hour spent with the interviewer may determine the entire future course of one's life.

Interviewers are continually amazed at the number of candidates who come to job interviews without any apparent preparation and only the vaguest idea of what they are going to say. Other candidates create an impression of indifference by acting too casual. At the other extreme, a few candidates work themselves into such a state of mind that they seem to be in the last stages of nervous fright.

These marks of inexperience can be avoided by knowing what is expected of you and by making a few simple preparations before the interview.

Preparing For The Interview

Preparation is the first step for a successful interview. Thus, it is important to:

• Know the exact place and time of the interview, the interviewer's full name and correct pronunciation, and the interviewer's title.

• Do your research. It is helpful to know the age of the company, what products or services they supply, where their plants, offices or stores are located, what their growth has been, and what their future growth potential is. There are a number of publications that provide information about prospective employers. Most of them can be found in any college or public library. A brokerage office or your bank may also be able to supply you with pertinent information about companies.

• Prepare the questions you will ask during the interview. Remember that an interview is a "two-way street." The employer will try to determine through questioning if you have the qualifications necessary to do the job. You must determine through questioning whether the company will give you the opportunity for the growth and development you seek.

Some probing questions you might ask:

• Can you provide a detailed description of the position?

• What is the reason the position is available?

• Is there an anticipated indoctrination and training program? Do you get paid during the training?

• Are advanced training programs available for those who demonstrate outstanding ability?

• What are the earnings of successful people in their third to fifth year?

• What are the company's growth plans?

• What is the next step in the hiring process?

Things To Do and Not To Do

You are being interviewed because the employer wants to hire people, not because he wants to trip you up or embarrass you. Through the interaction which will take place during the interview the employer will be searching out your strong and weak points, evaluating you on your qualifications, skills and intellectual qualities, and will probably probe to determine your greatest value.

Creative people can enjoy a more diverse dress style than some other professions. However, be sure to research the interview on this point. If everyone else wears suits, you can expect they will look for the same in prospective employees. Nowadays though, creative agencies have relaxed the expectation of formal dress. Nevertheless, it is usually better to overdress a bit than to be under dressed.

Drive by the interview site if you have not met people at the job or seen the operation. See how people going in and out of the building dress and what the atmosphere is like. Visiting the site will also ensure that you know how to get there.

More Do's and Don'ts

• DO plan to arrive on time or a few minutes early. Late arrival for a job interview is inexcusable.

• If the employer presents you with an application to complete, DO fill it out neatly and completely.

• DO NOT rely on your application or resume to do your selling for you. Most employers will want you to speak for yourself.

• DO greet the employer by their surname if you are sure of the pronunciation. If you are not, ask them to repeat their name.

• Give the appearance of energy as you walk. Smile! Shake his/her hand firmly. Be genuinely glad to meet the employer.

• DO wait until you are offered a chair before sitting. Sit upright in your chair. Look alert and interested at all times. Be a good listener as well as a good talker. Smile.

• DO NOT smoke even if the employer smokes and offers you a cigarette. DO NOT chew gum.

• DO look a prospective employer in the eye.

• DO follow the employer's leads, but try to get the employer to describe the position and the duties to you early on in the interview so that you can relate your background, skills and accomplishments to the position.

• DO NOT interrupt or finish questions for the interviewer.

• DO NOT answer questions with a simple "yes" or "no". Explain briefly but in complete sentences. Tell those things about yourself which relate to the situation.

• DO make sure that your good points get across to the interviewer in a factual, logical, sincere manner. Stress achievements. For example: projects completed, processes developed, savings achieved, systems installed, etc.

• DO NOT lie. Answer questions truthfully, frankly and as "to the point" as possible.

• DO NOT ever make derogatory remarks about your present or former employers or companies.

• DO NOT "over answer" questions. The interviewer may steer the conversation into politics or economics. Since this can lead to a tricky situation, it is best to answer these questions honestly but briefly.

• DO NOT be defensive, or say any more than is necessary.

• DO NOT inquire about salary, vacations, bonuses, retirement, etc. during the initial interview UNLESS you are positive the employer is interested in hiring you. If the interviewer asks what salary you want, indicate what you have earned but that you are more interested in opportunity than in a specific salary amount at the present.

• DO always conduct yourself as if you are determined to get the job you are discussing, even if you have reservations. Seem interested. Never close the door on an opportunity. It is better to be in a position where you can

choose from a number of positions – rather than only one.

Be Prepared To Answer Questions Like:

• Why did you choose this particular vocation?

• Why do you think you might like to work for our company?

• What do you know about our company?

• What qualifications do you have that make you feel that you will be successful in your field?

• What do you think determines a person's progress in a good company?

• Can you get recommendations from previous employers?

• Can you take instructions without feeling upset?

• What is your major weakness?

• What have you done which shows initiative and willingness to work?

• Are you willing to relocate?

• How do you spend your spare time? What are your hobbies?

• What type of books do you read? How many books per year?

• Have you saved any money?

• Do you have any debts?

• What job in our company do you want to work toward?

• What jobs have you enjoyed the most? The least? Why?

• What are your own special abilities?

• What types of people seem to rub you the wrong way?

• Define cooperation.

• Do you like regular hours?

• What contributions to profits have you made in your present or former position to justify your salary level there?

Negative Factors Evaluated By An Employer

During the course of the interview, the employer will be evaluating your negative factors as well as your positive factors. Listed below are negative factors frequently evaluated during the course of the interview and those that most often lead to the rejection of the candidate:

• Poor personal appearance.

• Overbearing, overaggressive, conceited, "know-it -all".

• Inability to express thoughts clearly: poor poise, diction, or grammar.

• Lack of planning for career: no purpose or goals.

• Lack of interest and enthusiasm: passive and indifferent.

• Lack of confidence and poise: nervousness.

• Overemphasis on money: interested only in the best dollar offer.

• Evasive- makes excuses for unfavorable factors in record.

• Lack of tact, maturity, courtesy.

• Condemnation of past employers.

• Failure to look employer in the eye.

• Weak, reluctant handshake.

• Lack of appreciation of the value of experience.

• Failure to ask questions about the job.

• Persistent attitude of "What can you do for me?"

• Lack of preparation for the interview – failure to get information about the company resulting in inability to ask intelligent questions.

What to say and not to say

There are many fatal mistakes that a candidate can make during an interview. Many HR Managers, Department Managers, Vice Presidents and Presidents have talked about the pitfalls of candidates that look good on paper, but in person they lack the skills needed to secure a job opportunity. Here are just a few tips on interviewing that may help you.

• Arrogance, righteousness and the inability to listen will certainly eliminate your chances of receiving an offer.

• Be concise in your conversation and in answering questions. Many candidates talk themselves out of a job by talking too long and get into trouble by being contrary. Limit each response to 60 seconds or less.

• Others are rejected in the interview because they lack enthusiasm and energy. DO NOT put your listener to sleep!

• Show interest, but DO NOT oversell yourself. If you oversell yourself it may come back at you on the job.

• Your job is not only to sell yourself to the interviewer but also to find out if the job is a good fit for you. You do not want to accept something that is going to be counterproductive or not good for your career.

• Prepare for the interview. Be well groomed and neat. Most importantly, know something about the company, its culture and its competitors. Ask about the needs of the company.

• Have good questions about the job. Ask about the future of the company. Ask the interviewer what kind of person that they are looking for. Then be quiet and LISTEN!

• DO a self-assessment. Be prepared. Be positive and do not put down your previous or present employer.

• Be aware of the interest level of the interviewer and be sure to ask for their card.

• Be on time, do not smoke, drink, or chew gum. Thank the interviewer for their time. Close by asking what will be the next step.

• A follow-up call to your recruiter and a thank you letter to the interviewer is a must.

Arts Related Jobs

There are many jobs available for fine artists. Working for a gallery, nonprofit arts organization, or museum may require

knowledge of art history, art restoration, exhibit design, selling, management skills, budget planning, writing skills, people skills, database management, precise organization, and other specialized knowledge. These skills can be learned through non-art related jobs and then applied to the needs of an arts organization. Remember that there will always be a learning curve when working for any arts organization— each has a unique focus, specific client base, donor base, office dynamic and arts focus.

There are many arts related jobs, including:

museum/gallery personnel
arts administrator
teacher or professor
art restoration
lab and shop technician
slide librarians/photographers
office staff
art librarian
fundraiser
artist assistant
writer for hire
printmaker
web designer
graphic/commercial artist
interior design
entertainment industry work
design fabrication
commercial photographer
computer/video work
decorative murals
fabricator
preparatory
curator
cake decorator
docent
art photographer
art store employee
entertainment industry work (fabrication, set design etc.

editor (all media)
art journal publisher
landscape design

Through volunteerism, internships, and work/ study programs, you can build your resume and train in art-related work. Ask yourself the following questions:

• Do you have software skills?

• What about imaging software (Photoshop, scanning, layout programs)?

• Do you have graphic arts experience?

• Do you have experience working with prints and/or printers?

• Do you have any language skills, or marketing experience?

• Are you good with people (the public) or are you a back room kind of person?

• What kind of salary or hourly wage/hours do you need to cover living and studio expenses?

• Do you need benefits such as health insurance or a retirement plan? Can you do without it?

• Do you need to work for someone else or do you have the skills and drive to be self-employed?

• Do you need flexible working hours in order to do your work, or can you work a 9 – 5 job?

• Are you an inside person or an outside person.
• What kind of job would be good for you to learn new skills that will support your artwork?

Look for Job Listings on the web, in publications, list-servs and at your local

university of college. Contact personnel offices at companies that pique your interest. Ask all your friends, your current or former teachers, other artists, professionals, and people who have a high regard for you.

GYST also hosts a skills bank where artists can post their skills, look for work, hire other artists, and get information about different arts related jobs. Sign up for an account today! Visit gyst-ink.com.

If you just can't stand the idea of working for someone else, or settling for a job that does not fit you, consider starting your own business. The world could use some additional artist run businesses.

See the Hybrid Career Section.

33: Curating

 Objectives

Understand the specifics of being a curator and an artist.

Understand the basic elements required of a curator.

Ask questions in order to determine how a curatorial perspective works.

 Things to Consider

Think about what a curatorial practice is and assumptions you have about curators.

You may want to seek out a curator and see how they got started, what they look for in artwork, and their intentions when being an active curator.

 Things To Do

1. Curate a show using artists' work that you like or enjoy. Perhaps they relate to your practice in some way and you can include yourself.

2. Write a paragraph on what a curatorial project proposal might look like.

 Curating

The role of a curator is vast and varied and has changed a lot over the years. The primary role of a curator is to assemble or select collections of works of art, or art projects grouped around an idea or theme. Many artists are also curators and often a curatorial project is launched in response to events or concerns in the artists' community or with regards to the ideas investigated in the artist's practice. Many artists curate shows as a way of gathering various artistic voices together to create new meaning or to create/extend a context for their own work. Curating a show that has a completely different subject matter and can also be intellectually rewarding.

Curating is a great way to make connections with other artists, to expand ideas about your own work, to create a dialogue within a particular community, or to give an idea a public face. Whether in a traditional gallery space or a public site, curating can give an artist experience and exposure, which may lead to a job, new work, or a newly defined community.

Where To Start

There are many places to start in the curatorial process. You may have a theme or an idea in mind, or you might need to do research and visit exhibitions. Once you have the structure for your curatorial project, you need to compile a list of artists to contact. Think about your immediate connections, then ask other artists and mentors for suggestions. Next you will probably need to do some fieldwork by visiting these artists at studio visits.

Often a curator goes to a studio with an idea of what they want, and they choose work accordingly. This model can result in interesting shows, but the downside is that it primarily highlights the curator's point of view. The artists are somewhat secondary to the curator's point of view.

Another curatorial model is to define the content and the context of the exhibition based on the sensibilities of specific artists or certain topical issues. This model is less about shopping and more about context: instead of choosing specific works, the curator asks the artists to create work or choose their own work specifically for the exhibition. This model truly highlights the artists' voice but it may be risky and can change the curatorial voice and/or position of the exhibition. Artists are often great judges as to how their work fits into the content of a show. For those curators who demand to have the last word, they can finalize the choices before the exhibition is installed.

Context

Ask yourself what types of arts organizations might be appropriate for your curatorial project. A guest curator may have much more creative leverage at a nonprofit space versus a commercial gallery, where revenue is needed to keep the lights on. Always think beyond the white walls of the gallery and remember that many site-specific projects and storefront locations can produce excellent exhibitions.

Consider the following:

• What is the context of the exhibition? How will the show relate to where it is held and the current events that frame it?

• How will you conceptually frame your exhibition?

• Who is your audience?

• Do you want to include local, national or international artists?

• What is your budget?

Remaining Professional

Curating existing work is very different from curating work that has yet to be made. Working with your friends is sometimes a challenge, so work hard to maintain both the friendship and a working relationship. As a curator, you are in a position of authority.

When word spreads that you are curating an exhibition, many artists you know or are acquainted with will come out of the woodwork. Some may go as far as courting your interest in their work even if it is not appropriate for the show. Remain strong and professional in your interactions; never take anything personally and avoid desperate artists. It is often uninteresting when curators invite only their friends to participate in a show.

As a curator, it can be very difficult to control the community's response to your show. You have to be willing to stand by the artists you include, and the conceptual ideas that underscore the exhibition on a public platform.

Curator as Artist

There has been a lot of discussion, both pro and con, about the curator as artist. There is a strong notion that if the curator includes his or her own work it is a reflection of their ego. Yet, if the artist curator were truly egotistical, they would do a solo exhibition. These rigid definitions of the role of the curator can be shifted and expanded, as well as influence the curators' position in their relationship to organizing exhibitions. The most important thing is to try and avoid obvious conflicts of interest. Usually trained arts professionals can tell when a curator has taken advantage of an exhibition opportunity, so only include yourself in your curated shows if your work makes sense

and adds to the conceptual and aesthetic statement of the show.

Publications

Creating a publication in conjunction with an exhibition can be a great historical record that may provide artists with a way to extend the creative reach of the show into the future. Sometimes catalogs have other functions and a target audience outside the art scene. There are many ways to self-publish a catalog.

Alternative Venues

Exhibitions do not always need to take place in a traditional location. An exhibition can exist in your local newspaper or on the Internet. Alternative sites for art are always good, particularly ones that take the site's distinctive features into consideration. Great exhibitions have taken place in really odd places. Artists have exhibited their work in shopping carts where advertisements are usually located, in parking spaces outside world fairs, in semi-trucks, rented sites at flea markets or in storage spaces in storage buildings. It is good to challenge the conventions of display.

Margaret Lazzari has a chapter on curating in her book, The Practical Handbook for the Emerging Artist, Chapter 10. Harcourt College Publishers.

 # Gathering Voices: Curatorial Perspectives

Gathering Voices: Some Curatorial Perspectives
Transcript from a panel presentation
Karen Atkinson

This essay was first presented at a gathering of curators in Banff, Canada, and later published in a book titled Naming a Practice: Curatorial Strategies for the Future, Banff Press.

I was asked to address different models of curatorial practice. One of the things I am interested in is "how the lines blur" between models of practice as a curator, (whether we can call it 'traditional' or otherwise), organizer, historian, artist, or critic. I'm interested in gathering voices as a model to talk about what we all do. How we gather and represent voices has implications on how or if those voices are heard. Clearly, how we frame those voices is important. This framing includes the curatorial model, the context, i.e., institutions of all kinds, our assumptions, and the language we use. We are all in some position of authority. How and if we acknowledge our positions becomes crucial.

I could have read the opening paragraphs of a number of press releases which are fairly descriptive in terms of how institutions present themselves, how they frame exhibitions, what language they use, and whom they think their audience is. I am sure you can all imagine the descriptive phrases without my reading them. Press can be a good indicator for the study of representation.

There is an article that I give my first year students each year which was written by Thomas McEvilley and published a number of

years ago in Artforum called "In The Manner of Addressing Clouds or 13 Ways of Looking at a Blackbird". It lays out 13 ways of deriving content from a work of art such as formal aspects, (scale, color, medium, etc.), historical context, knowledge of the artist who makes the work, friends and personal info. etc. For instance, you can't quite look at Carl Andre's sculptures anymore without knowing that he supposedly pushed his wife out the window. It really makes a difference in terms of how you look at work. The context of that work has now changed. There are aspects which the article does not list which my class discusses such as gender, race, sexual preference, and he doesn't talk at all about content from a curatorial context specifically. One of the things I ask my students, for instance, is why they make paintings on a rectangle. It's really shocking to them because they have rarely considered the automaticness in choosing certain ways of making art.

I was thinking last night about this article and began to look at the correlation between curatorial practice and the different ways that content is derived in terms of curatorial practice. There are so many decisions and factors that determine how our work as curators and organizers gets read. Certainly the institutions we work in and who we represent is a factor and that can lend content to our exhibitions.

Assumptions about what you say as a curator can be based on the history of the institution. I was talking to someone yesterday and they asked me particularly about a particular curator. They were making assumptions about the institution and him as a curator. A lot of speculating of course. I went on to explain some of the things that this curator had done before and what he was known for in the

States. And all of the sudden, they were thinking about watching to see what happens, instead of assuming that things would be status quo. Those sorts of elements are also important in terms of how we're seen by our own histories as curators as well. Often, it's difficult to control the content of our work, but if we don't think about it, it's very problematic.

Who is included, or more than likely who is not included in exhibitions, signs of the institution and its relationship to the community where the institution is located or "non-institutional projects," and attempts to present ourselves outside the institutional context are all indicators of our projected content. I'm not sure there is any such thing as a non-institution, but I think it's certainly debatable. In addition, our gender, race, and age as curators, our own histories, the successes and mistakes we make, how we position ourselves in a historical context, or how accessible we are, are all part of the curatorial model we use and has implications on how the project maybe received. Are the voices we have gathered heard? Or repressed in the name of our own ideas?

I want to present some models to look at. Some of them are my own, developed for various reasons, in which I will attempt to explain. Others, are models that are out there in the world and you may or may not have used them, or have any use for them. I've spent a lot of time presenting various models to artists and talking about self-generating projects. Questions of access always come up, especially for those artists who don't quite fit into the model the institutions are looking for. Over the years I have created something called "The Alternatives List" which lists over a hundred options for artists, ways of working or presenting that have been tried by either curators or artists. There is some overlap in

terms of how artists worry about the presentation of their own work and how organizers or curators present work. Both are thinking of how the work will be read, the artists within the curators ideas, and the curator who is often using the artists work to present ideas. There's been a lot of discussion about the curator as artist, both pro and con.

My own work as an artist has a lot to do with how I look at curatorial practice, particularly my own. For many observers my own work blurs the distinction between how I work as an artist and how I gather voices together around a certain issue or set of ideas. In the late seventies I was working in slide form, not reproductions of other work but creating work in slide form, sometimes with audio, sometimes not. I would rear-screen project them in store front windows without their being validated as art by any source or institution. None of the teachers I had at the time could understand anything about what I was doing what-so-ever. In the eighties I found a number of other artists working in slide form and decided that instead of just projecting my own work, that I would gather a group of artists' projects together. Not only did I ask a number of artists who were already working in slide form but I asked a number of artists who were interested in the nature of site, understood the relationship of their work to a particular place, and essentially challenged them to make work in this way.

This project called "Projections In Public" has been presented in storefront windows throughout the States and Canada, and exchanges are underway for France, Britain and Australia. I think that the nature of putting a group of voices together was beneficial because I was interested in my work having a dialogue with other artists. The first time I got funding for this project though, I ran into a snag. The institution decided that since I was the one who gathered the voices I could no longer participate in the project, and automatically I was defined and perceived as what we call "the curator". In order for me to be able to do the project and receive the funding, I had to take my work out of the project, even though that was the catalyst for how the project started in the first place. The way it was explained to me and has been explained to me many times since, is that there is some sort of notion that if the curator includes his or her work it has something to do with ego. I find that interesting because I think that if I was interested in ego as an artist I would do a solo show and do the work myself, not add a bunch of artists to the project. The challenge of those rigid definitions and the idea of always being put into particular slots has continued to generate thoughts about what my position is in relationship to gathering voices as a way of defining my curatorial position.

The projection project usually takes place in a site which is not an art site, so in San Diego I projected in an architect's office; an architects office by day and an exhibition space at night. In Los Angeles, the site was a flower market by day and an exhibition site at night. It has projected through the theater doors on 42nd street in New York at Intar Multicultural Gallery, and in a furniture store in Grand Rapids Michigan, etc. In each project, I've always included local artists wherever the project has taken place, as well as more nationally known or internationally known artists. One of the reasons I have continued this exhibition is you can jump on the plane with it in your briefcase, which means very low shipping costs. It also includes up to 30 artists at a time, so it can present a lot of voices for a very reasonable cost.

I did a stint at a nonprofit artist run organization in San Diego where I was the Director of Exhibitions and Programming. I found that all the money and funding went to a very small area in the city. Everything went downtown or to various arts institutions and there were really no art presentations happening outside of that area. I decided to secure some money and commission projects in three different neighborhoods which traditionally had absolutely no arts funding or arts spaces. Well, one of those neighborhoods had a museum, but never really showed local artists. I asked an artist from each of those diverse neighborhoods to create a project that would include a performance, take place in a public site somewhere in that neighborhood, would be a collaboration with other artists within that neighborhood, and would include a projection of some kind. This took place in three different neighborhoods and the intention was for the audience to travel from site to site in places they had never been in that city. For instance, in Southeast San Diego, which is predominantly Afro-American, there was a film and a performance in front of the Taco Bell stand in which people in the community interacted. We were singing gospel songs out on the street at the end of this performance! So I'm interested in how institutions can depart from what they normally do and present projects in other ways.

As part of my own work as an artist I sometimes secure an exhibition somewhere and then ask 20 artists to present a component of that show. Sometimes curators have a hard time with this. I understand why on one level, but I think about being able to open things up in some way and having these rigid categories challenged, about what's allowed and what's not as an artist is important.

I've done a number of installations where I transformed the gallery into a public space. I created a corporate boardroom, a lawyer's office and a tourist office within the exhibition space. The lawyer's office was created to fight for the reauthorization of N.E.A., and was called "Atkinson & Associates, ARTorneys at Work". I asked 35 artists to design postcards that would be sent to all the congressional districts, congress persons, and senators who were on the reauthorization committee. It was a way of including other voices about what was being said. It wasn't just me talking about this particular issue; I added lots of other artists and in the process viewers sent over 10,000 postcards, so all these artist projects were piled on these congress persons' desks. In the tourist office, which critiques the language of discovery and its relationship to tourism, I asked artists to design postcards and maps that remap their own desires. This is an ongoing project. This may seen simple, but the distinctions become blurred when you have to check a box on the grant application, "solo" or "group". Or when an institution misrepresents your work to their own advantage.

I have one more example in terms of how I as an individual artist have included people in my own work. There is a public art project which is scheduled to open December 1, 1993. It's titled "For the Time Being" and consists of 20 parking meters which I've wired for sound. I've commissioned 20 artists and writers to write audio text projects for the meters. The writers are either HIV positive or have AIDS, or have asked their friends and family to write a text for the project, which is then recorded on tape. When the viewer feeds the meter with a quarter, the tape plays, and when the meter runs out the tape is silent. These meters are being placed in 20 locations throughout the city, in such public sites as museums, artist-run

centers, city halls (both in West Hollywood and Los Angeles), community centers, a book store, AIDS centers, building lobbies, anywhere that's a public space where there's a lot of foot traffic. The project is my design, and for me, asking others to participate is a way for these voices to be heard in a different context (or actually any context). I don't think that many of those voices are heard very much at all outside of very specific places or publications. The money collected for this project is going towards a fund being started by Side Street Projects, an artists' run nonprofit which I co-direct, to support artists with AIDS in the fabrication of their work. So it's a very circular project. What I like about this project is that these meters can change sites throughout the city, be an ongoing project, and more artists can be commissioned. The tapes rotate from place to place. So, am I the artist? The curator? The organizer? All three?

I have been collecting ways that different curators practice. I'll present some of them here, not necessarily as something better or worse than anything else, but just to look at them. I'm sure that everybody here can add to them and talk about their own experiences in terms of how you choose a model for presenting work.

I think that one of the reasons many people have developed new ways of curating has a lot to do with access in terms of artists having access to institutions, or whether anybody will talk to them from the institutions. Who curators visit when they travel to other cities to look at work are usually the same institutions. They all go to the big museums and galleries and ask who's doing work in town. They might go to the artist-run centers but what I think happens is it usually ends up being the same recurring list of artists that get looked at.

One of the curatorial models can be described as the shopping curator, in which the curator goes to the studio, has an idea of what they want to do and what to say, and chooses the work accordingly. (I'll take one of those and two of those and...). I think there are both good and bad aspects about this.

Another model would be that the curator creates the content and the context of the exhibition based on the different sensibilities of the artists whose work they become familiar with, or by certain issues "in the air." But instead of choosing specific works the curator asks the artists to create work or choose their own work specifically for the exhibition. I think this is more risky. I think it also changes the position of the voice and the framing of the exhibition. We can argue about that. I myself find that the exhibitions I've worked on with this model are inherently more interesting and the work is rarely pushed by a non-artist to fit the context of the show. Artists are often a great judge as to how their ongoing work fits into the content of a show when they construct or choose the work accordingly. For those curators who demand to have the last word, they can always see those choices before they arrive in the exhibition space. But it's less about shopping and more about context. The artist's voice is usually more apparent in the exhibition.

Armando Rascon created what he calls "The Multicultural Reading Room." He asked 30 artists from all over the States to present 2 or 3 books that had made a difference in their lives in terms of how they thought about multiculturalism and what influenced how issues were formed for them. The exhibition traveled to a number of different sites and then was donated to a library as part of their permanent collection. It automatically created a situation in the library where the acquisition pushed past its book

collection and expanded the boundaries of what the librarian might have chosen. Another example of creating a situation where more than one voice speaks and where something quite wonderful can happen.

Other exhibitions are created when a curator chooses a number of artists who choose another artist to be part of an exhibition. It expands the pool of artists but I often find this is very arbitrary experience. I think there are many possibilities for going past a number of people that one knows. This model might work best for studio visits.

An artist invites his/her friends to participate in a show he/she curates. This is usually not very interesting. It's very arbitrary.

There's the free-for-all where everybody hangs works, which is the model for mail art, fax art shows, etc. "Quality" is always an issue with these projects, and most professional artists don't participate in these kinds of projects.

There's a space in San Francisco called the Galleria de la Raza. They were very frustrated with the fact that the projects being proposed for their space were not very interesting. Shows leaped from one fanatic idea to another. So they sat down as a committee and created a whole year of ideas they wanted to address and things they wanted to accomplish for the year. But instead of curating within their own institution, they opened it up for proposals from the field, with the guidelines determining the content of the submissions. What's happening is that they are getting a lot of different solutions and ways of looking at the issues they are interested in. The mission of their programming remains consistent, but the way this mission is accomplished has been opened up to some great ideas they never would have thought of

themselves, and the issues that are important for them to address as a space are being addressed. There are exhibitions in which the work is changed or altered by the audience. Perhaps the viewer is asked to participate by adding or altering an element to the work, or by moving parts around the space. So who's the artist?

Another model is the neighborhood committee or project. There are some interesting debates going on in Los Angeles in which a community wants to do a mural. It's being blocked in every way possible by the powers that be within the city. They are really struggling with the idea that a community or neighborhood can actually choose what they want in their neighborhood. So there is this interesting dilemma that's going on between who has the power to actually block an artwork supported by the very people who live there, which is interesting to me. It's a reversal of the Richard Serra phenomenon. The mural happens to chronicle the history of the Black Panthers.

There is a current exhibition going on at Exit Art in New York and it's called "How Do You Play the Game." They have invited five highfalutin' curators in New York to create an exhibition within that site. It's a collaborative, conceptual exhibition project which will investigate the curatorial process and reveal how curators' choices reflect their aesthetic and critical values. The show is conceived of as a game in which the participants, five curators of contemporary art, will each take turns selecting and installing work of art chosen in response to the other curator's selections. In the succeeding weeks, the five curators will take turns independently choosing and installing new works. It changes and expands each week reflecting and reinforcing curatorial dialogue. This is the plan anyway. It will be interesting to see the results. This model foregrounds curatorial practice within the exhibition.

In Baltimore, a project was created where artists were hooked up with business owners/workers who were non-artists. They were people who had never worked with artists before and they each worked on a collaborative page for a publication. They were interested in alleviating the situation where the artists are separate from everybody else. They presented these collaborations in a publication or newsletter which then was distributed throughout the city. So it's very interesting that, for instance, someone who ran a shoe store collaborated with an artist and presented a page work. I think that catalogues as exhibition sites can be very interesting. Most catalogues I see have a particular format and those formats could be pushed in a different direction to have different functions than the traditional documentary style presentation of work. Perhaps it can function as an artwork in itself, or an exhibition in print. It can circulate with different intentions than its traditional one.

Often, I try to create publications with exhibitions in which the artists in the exhibitions have control over their own pages. Sometimes the catalogs have other functions and have a target audience outside the art scene. For instance, for a recent project called "Just Take This: woman/pain/medical histories," all the artists did a page for a publication. It included information about hot lines, phone numbers, health groups, AIDS information, etc. This was distributed to women's health centers throughout all of Los Angeles. When the project traveled to San Francisco, we did the same thing with local information. It was a way of bridging this element between artists and how the work is presented. People from those health centers and women's centers were coming into the gallery to see the work.

Exhibitions don't always need to take place in a particular site. It might be a publication stuffed into your local newspaper, or on the Internet. Alternative sites for art are always good, particularly ones that take site into consideration. Exhibitions have taken place in really great odd places. Artists have exhibited their work in shopping carts where advertisements are usually located. In parking spaces outside world art fairs, in semi trucks, rented sites at flee markets for installations, storage spaces in storage buildings, created performances in model homes, and generally developed some really great locations for the unexpected. One artist altered all the stop signs in a neighborhood and held a reception out of the trunk of his car. Opened the trunk hood, and there was the wine and cheese.

It's good to challenge the conventions of display. Like asking a student why they paint on a rectangle.

One last example. There's a group of six artists in Los Angeles, including myself, who have created an exhibition in which is titled "The Curators." All the artists are the curators of the exhibition, so there's no division, there's no one curator. Those six artists are the curators, the writers of the catalogue and the artists in the exhibition. Each artist's work will address a curatorial model or issue in some way. It's a way of collapsing and exploring this notion between defining who is speaking under what definition.

I don't know how helpful this all is, but it seems to me that the most important factor is how we frame the work we do or how we are framed by things out of our control. Our voices as curators and the voices of the artists we gather are important elements to our culture. Perhaps by being aware of our decisions and the language we use the way our work is perceived will come closer to our intentions.

34: Starting A Nonprofit Arts Organization

 ## Objectives

Understand the basic things you should consider when starting an art space.

Understand what is involved in starting a nonprofit organization.

 ## Things to Consider

Think about and write down local artist run spaces, or those known to you.

Think about the kinds of artist run spaces as not all of them choose to go nonprofit.

Write down a description for a fantasy space and what it would entail for artists to benefit.

 ## Things To Do

Visit to an artist run space of your choice, and write a short page on their mission, submission policies, etc..

 ## Starting A Nonprofit Arts Organization

Starting a nonprofit organization can take a surprising amount of work. It is a good idea to research your options. If you are only doing one project, by all means, find a fiscal sponsor instead of starting an organization. (See Fiscal Receiver section) If you are going to do projects over a long period of time and will create a board of directors and all that it entails, then consider starting a nonprofit. Since there is so much information on this topic, we are including a number of web resources.

It is a good idea to speak with someone who has started an organization before. Remember that the laws governing the formation and running of nonprofits vary from state to state. Contrary to popular belief, you do not need a lawyer to start a nonprofit. Just do your research and talk to people who are savvy about the process of incorporation.

If you are considering establishing a nonprofit organization, the Foundation Center may provide you with essential resources. The following is a list of resources that discuss how to incorporate as a nonprofit organization. Some technical assistance organizations provide help with starting a nonprofit organization. Check with your local bar association, Lawyers for the Arts or the Alliance for Nonprofit Management.

Web Resources For Starting A Nonprofit Organization

Foundation Center Online Course: "Establishing a Nonprofit Organization" (http://fdncenter.org/learn/classroom/establish/index.html)

This tutorial describes 12 tasks that need to be accomplished during the process of establishing a nonprofit organization. Issues include board development, creating bylaws, filing for federal tax exemption, recruiting staff, and developing an overall fundraising plan.

Internal Revenue Service: "FAQs Regarding Applying for Tax-Exemption" (http://www.irs.gov/charitiesarticle/0,,id= 96590,00.html)

Includes links to IRS Publication 557, "Tax Exempt Status for Your Organization" which is available in PDF format, or call 800/829-3676 to order this essential document free.

Internal Revenue Service: "Tax Information for Charitable Organizations" (http://www.irs.gov/charities/charitable/index. html)

Includes a step-by-step review of the application process.

The Nonprofit Resource Center (http://www. not-for-profit.org)

Designed for administrators, board members and volunteers of nonprofit and tax-exempt organizations, as well as people who are considering forming a nonprofit organization.

Alliance for Nonprofit Management (http:// www.allianceonline.org)

An experienced network of nonprofit management support organizations, which provides assistance with organizational and human resources development, fundraising, finance, and marketing.

The Internet Nonprofit Center's FAQ for startups (http://www.nonprofits.org/npofaq/ keywords/1l.html)

Provides numerous resources related to establishing a nonprofit organization.

BoardSource's free e-book, "Starting a Nonprofit Organization." (http://www.boardsource.org/client files/ EBooks/Vision.pdf)

A checklist for starting a nonprofit organization.

About.com's Starting a Nonprofit Organization: One-Stop Answer Page (http://nonprofit.about. com/library/weekly/blonestart.htm)

Includes questions a board should ask about starting a nonprofit organization and steps for getting started.

Books and Articles for Starting a Nonprofit

Blazek, Jody. TAX PLANNING AND COMPLIANCE FOR TAX-EXEMPT ORGANIZATIONS: Rules, Checklists, Procedures. 4th ed. Hoboken, NJ: John Wiley & Sons, 2004.

This compendium of compliance tools and information provides practitioners and nonprofit managers with step-by-step guidance to establishing and safeguarding the tax-exempt status of an organization.

Bromberger, Allen R. et al., eds. GETTING ORGANIZED. 5th ed. New York, NY: Lawyers Alliance for New York, 1999.

Introductory manual for attorneys representing organizations that wish to incorporate as nonprofits. Provides important addresses and telephone numbers, and sample forms and exhibits.

Connors, Tracy D., ed. THE NONPROFIT HANDBOOK: Management. 3rd ed. New York, NY: John Wiley & Sons, 2001.

Comprehensive reference guide to the policies and procedures shared by small and medium-

sized nonprofit organizations. Contains drafts of policies and procedures as well as sample plans, forms, records and reports.

Kirschten, Barbara L. NONPROFIT CORPORATION FORMS HANDBOOK. Eagan, MN: West Group, annual.

Covers registration and reporting requirements for IRS-designated tax-exempt organizations and contains sample forms for incorporation and operation of nonprofit organizations in many states.

Kunreuther, Frances. "TO 501(C)(3) OR NOT TO 501(C)(3): IS THAT THE QUESTION?" Nonprofit Quarterly vol. 10 (Winter 2003) p. 26-9.

For some groups, the 501(c)(3) incorporation may not further their work. The article provides some considerations that should be examined.

Mancuso, Anthony. HOW TO FORM A NONPROFIT CORPORATION. 6th ed. Berkeley, CA: Nolo Press, 2004.

Step-by-step guide to forming a nonprofit organization that meets the requirements for a federal tax exemption under 501(c)(3) of the Internal Revenue Code. Includes questions to consider before starting one, and forms. It tells you step by step how to fill out the forms.

Olenick, Arnold J. and Philip R. Olenick. A NONPROFIT ORGANIZATION OPERATING MANUAL: Planning for Survival and Growth. New York, NY: The Foundation Center, 1991.

Addresses the essential financial and legal aspects of managing a nonprofit organization. Divided into four parts: 1) Long-Range Considerations, 2) The Vital Role of Financial Management, 3) Operational Management, and 4) Outside Accountability.

Starting a Nonprofit. Washington, DC: National Minority AIDS Council. [2003]. Also available online: (http://www.nmac.org/tech_assistance/ ta_resources/Org_Effectiveness/NonProf.pdf)

This manual is designed to facilitate the ability to quickly and effectively start a nonprofit, register it with state officials, and obtain tax-exempt status from the Internal Revenue Service.

Tesdahl, D. Benson. THE NONPROFIT BOARD'S GUIDE TO BYLAWS: Creating a Framework for Effective Governance. Washington, D.C.: BoardSource, 2003.

Provides a basic definition of bylaws and an overview of related issues and area bylaws should address.

Warda, Mark. HOW TO FORM A NONPROFIT CORPORATION. 3rd ed. Naperville, IL: Sphinx Publishing. 2004.

Provides basic information about the steps involved in establishing a nonprofit organization, and the methods for protecting tax-exempt status. Covers startup procedures, applying for tax exemption, running a nonprofit corporation, and fundraising. Numerous checklists and worksheets are included. Appendices include state-by-state list of nonprofit laws, a sample document of by-laws, and nonprofit legal forms.

Williams, Denice (ed.) and Néstor Vázquez (trans.) Del Dicho al Hecho: Una Guía Para Crear con Éxito Una Organización Sin Fines de Lucro. [In Spanish]. New York, NY: Community Resource Exchange. 2004.

Provides a basic definition of bylaws and an overview of related issues and area bylaws should address.

35: Finding a Studio

 Objectives

Evaluate what a studio space means to you as an individual artist.

Understand just what questions should be asked when you are looking for a studio.

Understand how to look for, find, and maintain a studio.

Things To Do

Research various studio type options in your city.

Have someone from Cultural Affairs or other studio space organization talk with you about how to find a studio.

Consider your studio options. (i.e. kitchen, living room, sharing, day space, live-work etc.)

List the needs you have for a studio, as in what you need to make, what space you need etc. Think about the pluses and minuses of sharing a studio.

 Finding a Studio

One of the most important things in the practice of any artist is their studio. Studios provide a dedicated space for researching, conceptualizing, creating, experimenting, and exhibiting work. A studio is like an artist's office. But, since each artist's practice is different, each studio is different. Some artists require large warehouse studios for the production of monumental work. Other artists don't have

a conventional studio at all and may work at the kitchen table or at a coffee shop. The most important thing is to find a studio that works to your advantage and is affordable and sustainable. Here are some tips to think about before you choose a studio that is right for you:

• Figure out how much you can afford for a studio space. Remember to calculate expenses for set up, lighting, electric bills for heating and air-conditioning, etc.

• Consider your existing resources, such as an additional room in your home or apartment. Can you work in the garage or basement?

• Calculate the space that you actually need to make your work. If you are on a tight budget, consider the minimal amount of space necessary.

• What kind of facilities do you need? Industrial voltage (220) for electrical needs? How many electrical outlets? Adequate ventilation? Natural light? Can the space get dirty? Concrete floors and high ceilings? A sink and bathroom facilities? How many walls do you need for flat work? Oversize doors?

• Do you want to have proximity to other artists? Do you work better in isolation or within a community of artists?

When you have an idea of what kind of studio you want consider these questions when looking for a space:

• Is the space in a convenient location? Is it long commute from your home?

• Do you feel safe working late at night alone? Is there an alarm system on the building? Will curators/critics/dealers feel comfortable visiting your studio?

• Is the space zoned for live/work, or day use only?

• Is there 24-hour access?

• Are the utilities on a separate meter? Who is responsible for utility bills?

• Is there adequate water, air conditioning, or heat? Will your work get damaged due to extreme heat or cold?

• Who are your neighbors and what is the noise factor, both during the day and at night?

• How much noise will you make in your studio and will this be acceptable to your neighbors?

• What kind of parking is available?

• What kind of neighborhood is it in?

• What was the space used for previously? You want to make sure you are not renting a space that has remnants of toxic chemicals or other problems.

• Are pets allowed? Will the pets bother studio mates or neighbors?

• Who is responsible for maintenance or pest problems? Are you responsible for interior maintenance and is the landlord responsible for keeping the building up to code?

• Can you make improvements to the space (build walls) and what is the agreement for these improvements?

• Who is responsible for liability and renters insurance?

• Is there a loading dock or an elevator to move large works?

• What are the security issues?

• How long is the lease? Can you sublet any part of your space?

• What are the agreements for rent increases?

• Are there restaurants, coffee shops or material supply stores in the neighborhood?

• Is there trash or recycling on the premises? Do you need to get a commercial trash bin?

• If you make improvements, will you be able to pass on the expense to the next tenant?

No Studio? It's Cool

Some artists have a practice that doesn't necessitate a studio, often called a post-studio practice. These artists can work at a desk, a park bench, or anywhere. If you are one of these artists never apologize for your lack of a studio. You can still have studio visits with collectors, critics and curators. Maybe you want to consider having your visits at a coffee shop or comfy environment where you can show work on a laptop or in a portfolio.

Sharing your studio

Many artists choose to share their studio with other artists. Working in proximity to other artists can make for an inspirational environment full of exchanging ideas and opinions. Before subletting your studio or sharing a studio with other artists, think about these questions:

• Before you sign the lease on your new studio ask your landlord if you can sublet the studio or get a studio mate. You don't want to violate your lease agreement.

• Make sure you have good communication with your studio mates because financial arrangements can get sticky if not first agreed upon. Remember, your studio is a space for you to create and any bad feelings with your studio mates may hinder you from even going to the studio in order to avoid them.

• When you have a studio mate be open and generous with them about when and with whom you have studio visits. This will create a collegial environment, instead of fostering competition.

• Plan regular open studios with your studio mates. Sharing open studios will bring more visitors and foster a sense of community.

36: Teaching

 Objectives

Understand the basics of what it takes to get a teaching job.

Understand the materials and proposals necessary when applying for a teaching job.

 Things to Consider

What are the requirements for teaching? You can find these answers in the liteature in this manual, but also online in job announcemets, or simply calling an institution's Human Resources office.

Since most teachers get hired through the College Art Association, research about how CAA works and get involved in the organization.

Try to understand the difference between a teaching resume and an artist resume. Maybe you will consider writing your own teaching philosophy.

 Developing a Teaching Portfolio

What is a teaching portfolio?

A portfolio or dossier is a collection of material that depicts the nature and quality of an individual's teaching and students' learning. Portfolios are structured deliberately to reflect particular aspects of teaching and learning – they are not trunks full of teaching artifacts and memorabilia. At its best a portfolio documents an instructor's approach to teaching, combining specific evidence of instructional strategies, and effectiveness in a way that captures teaching's intellectual substance and complexity. (William Cerbin, 1993)

A teaching portfolio is a measure of actions and a reflection on those actions and is broken up into two basic sections: evidence and evaluations. Evidence is proof that you have taught, what you taught, and how you taught it. Evaluations are reflections on this process. You may want consider creating multiple teaching portfolios for different educational situations. For example, if you teach both studio art and web design, you might want to create two separate teaching portfolios highlighting the strengths you have particular to these fields of study.

How are teaching portfolios used?

As a "product" (for decisions – evaluative, summative):

• to communicate your teaching to a potential employer.
• to communicate your teaching to students, colleagues, community.

As a "process" (for development – formative, reflective):

• to record your teaching experiences over time.
• to provide themes and evidence for your evaluative portfolio.

What goes into a teaching portfolio?

Cover Letter

Remember that your cover letter should attract your reader's attention, summarize your accomplishments and leave them wanting to pour over the content of the teaching portfolio. Make sure you state up front what you want to achieve from having them look at your portfolio. List the position(s) you are applying for and alert them as to how they can get more information about your teaching history.

Curriculum Vitae

This is different from your artist resume. Your Curriculum Vitae is a list of all of your professional accomplishments and is intended for an academic environment. Refer to the College Art Association's guidelines for formatting your CV: http://www.collegeart.org/guidelines/visartcv.html

Teaching Philosophy

This is a rumination on your specific teaching philosophy. Your teaching philosophy should detail why you teach and what outcomes you intend to create with your instructions. It doesn't necessarily discuss the specifics of your classes but instead focuses on why you do what you do. Your philosophy should also detail the techniques and pedagogy you use to instruct your students. You will also need to state how you measure your effectiveness as a teacher. As you do with your artist statement, you will need to constantly update your teaching philosophy and put it through many drafts before it's finished. Your teaching philosophy may be a section separate from all of the other parts of your teaching portfolio or may incorporate all of the other sections listed here. Be careful to read requirements for submissions.

Teaching Experience and Responsibilities

After preparing your teaching philosophy you will need to collect all the supporting evidence to prove your effectiveness as an instructor. This will be a paragraph-form history of all of your past teaching jobs with descriptions of your specific responsibilities. This can be a list of courses with course descriptions and a brief discussion of the pedagogy you employed for each course. This can also be course syllabi you have written.

Teaching Methods and Strategies

This section should detail what specific methods and strategies you use to connect with and educate your students. Have you developed an original approach to teaching your subject matter? Do you incorporate original materials or technologies into your lectures? Explain those here.

Examples of efforts to Improve Teaching: workshops, experiments in pedagogy and methodology

These can be classes or seminars you have attended. You can also include any critiques or feedback you have from superiors or mentors as to your efforts to improve your teaching skills.

Statements from colleagues like observations and critiques:

This is a collection of evaluations from superiors, department heads, faculty advisors, colleagues, or administrative officials who have observed you teaching both in class and out of class.

Teaching Goals: short- and long-term

This may be part of your teaching philosophy essay. Your teaching goals should outline what

you plan to accomplish with your classes, both in the short term and long-term. Consider both academic and personal goals here.

Publications on Teaching

These can be examples of anything you have published relating to teaching or the educational field.

Awards, Honors or Other Recognitions

Include copies of all letters of distinction and awards pertaining to your teaching or academic excellence.

Invitations to speak/teach

Include a list of places you have been invited to speak, lecture, review portfolios, or teach.

Video of you teaching

This can be a sample of you teaching in the classroom environment. Choose footage highlighting interesting teaching techniques and interaction with students.

Student scores on standardized tests

Make sure to maintain the anonymity of your students when submitting these materials.

Examples of Student Work

These can be student essays, collaborative work, documentation of artwork created as part of class assignments, and course-related assignments.

Examples of student success outside of school

If you have helped your students secure employment outside of school include that information. If you have helped students get into graduate programs, include that information.

Alumni Testimonials

If your students are alumni of the school you are submitting to, ask them to write a letter about your effectiveness as a teacher.

Graded work

Include examples of work you have evaluated. Make sure to include a range of work, from excellent to poor, along with your comments and evaluations as to why you assigned those grades.

How can you begin to work on a teaching portfolio?

• Reflect on your teaching individually; talk about your teaching with others.

• Get feedback on your teaching from several sources – students, peers, supervisors, video.

• Reflect on student learning in your field. How do students learn? What challenges do they face?

• Keep records of your teaching, feedback you receive, and plans to develop your teaching.

• Seek out teaching opportunities.

Resources

Center for Instructional Development and research,
http://depts.washington.edu/cidrweb/
TLBulletins/1(1)TeachingPortfolios.html
How to Prepare a Winning Teaching Portfolio
Secure an Academic Job with the Ultimate
Interview Tool © Marilyn Michaud
http://universities.suite101.com/article.cfm/

how_to_prepare_a_winning_teaching_
porfolio#ixzz0Xu6wbrPhhttp://universities.
suite101.com/article.cfm/how_to_prepare_a_
winning_teaching_porfolio#ixzz0Xu5miRS8

The Teaching Portfolio: a handbook for faculty,
teaching assistants and teaching fellow by
Hannelore B. Rodriguez-Farrar A Publication of
The Harriet W. Sheridan Center for Teaching
and Learning, Brown University ©Third Edition,
Revised 2006
http://www.brown.edu/Administration/
Sheridan_Center/docs/teach_port.pdf

37: Starting a Business

 ## Objectives

Understand why you should have a business license if you need one.

Introduce basic ideas of how to get a business license.

 ## Business License

If you are selling any artwork yourself, it is a legal requirement to have a business license. It allows you to file for a DBA (Doing Business As) so that you can operate under a business name of your choice. (You can also operate a business under your own name.) If you receive a grant, it may be required to have a business license. If you already have a business license, then apply for a resale license in order to sell work and buy materials at wholesale prices. You will need to fill out a resale card for each vendor you purchase from, but it will save you money because you will be eligible for a discount. Also, you will not have to pay sales tax on goods that are used to produce works for sale because the sales tax gets passed on to the retail buyer.

Beware that most state IRS services are now wired to city governments. This is significant because not only are you required to have a business license, but also a city or county license. Many artists have received warnings about declaring income on their tax return without having a business license. There can be fines and legal hassles, which you want to avoid. You can also get into a lot of trouble if you have employees and do not follow the requirements.

The following are reasons why you may want a business license:

• Need for the liability protection provided by a corporation or LLC

• Need for more than one owner of the business

• Need to isolate some specific business venture or project like a film, book, musical or other artistic venture

• Need to raise capital for a specific venture or project by bringing in investors

• Separation of ownership and control of business operations

• Desire to shift income to other family members, associates or friends thereby taking advantage of lower income tax rates

• IRS audit concerns: sole-proprietorships have been for many years and will probably continue to be number one on the IRS audit hit parade; other formal business entities are less likely to be targeted

• Tax savings available in particular entities; for example the potential payroll tax savings available in "S" type corporations

• Working in a multi-state environment – a corporation is probably the most portable and practical entity for artists working across state lines

Where to get a business license

For information on how to obtain a city or county business license, look under the city and/or county government pages in your telephone book—locate "business" under the "licenses" heading.

Or simply go on the internet to your city our county's municipal website.

Artists as a business entity

Most artists operate as sole-proprietors. Eventually, you may want to set yourself up as a different kind of business entity. A sole-proprietorship means that there is one owner and that the income and expenses you incur will directly affect your personal finances. However, the flexibility of a sole proprietorship allows you to have direct control over the direction of your "company" as an artist.

An artist has three choices of entity: the sole-proprietorship, partner/LLC and corporation. By consulting with a tax professional and an attorney, artists can discuss, in detail, the legal and financial advantages and disadvantages of each entity. Many cities have a "Lawyers for the Arts" organization that teaches workshops on such matters. The web also has lots of information on business matters, but beware of web sites that offer to file your paperwork for a fee. They usually overcharge more for something you can easily do yourself.

In larger cities, there are usually multiple sites where you can go to fill out a form, write a small check, and get your license the same day.

If you are delinquent in filing for a business license, apply and get one before the end of the year, as it may be retroactive for the year.

Don't wait. Just do it.

As a reminder, professional consultation with an attorney, tax professional, and artists in your community will help you to develop an informed opinion regarding business structures.

38: Loans & Other Financial Options

 Objectives

Understand the idea of loans, where to apply for them, and things you need to consider when applying for loans.

 Things to Consider

Doing research online is probably one of the best ways to find information, compare the kinds of loans, and what is available to you and for what.

You may also seek out financial advisors who give free consultations.

 Loans and Other Financial Options

Loans from Nonprofits

Many nonprofit organizations offer loans to artists. The amounts and fees for these loans range widely. Some of these loans go towards completing a project that only pays out upon project completion. For instance, the New York Foundation for the Arts will give a loan that may not exceed 80% of the contracted amount for a project. There is a 3% fee of the loan amount. The loan is usually good for 120 days. You should check your options carefully.

Artist Project Loans

Some organizations will loan you money for a contracted project. Since some grants and funding are not paid at the beginning of a project, you have to figure out how to raise start up funds.

Some nonprofit organizations have come up with a solution, and will loan you the money against the contract. The amounts they charge to do this are well worth it, and can help you actualize your project. After all, they need to pay their own accountant and legal folks to process your loan.

Emergency Loans

There are funders who will award you an emergency loan for various reasons such as health, a catastrophe or personal issues. You can find these on the web or in the library. (See Emergency Loans section.)

Pay Day Loans (not a good idea)

These companies will give you an advance on a certain amount of money until you get paid. They often have a fee associated with a particular amount. For example, a typical $250 loan can have a fee as high as $45. You secure this loan by writing a post dated check drawn off a checking account, which is deposited on the said date. Normally, the loan matures in two weeks, at which time you are expected to pay the loan and fee in full.

If you cannot pay the required amount then you can pay the fee ($45) and roll the original loan amount ($250) over for another two weeks, where again you will be faced with either paying the entire amount due or the fee and roll the loan for another two weeks. If you roll the loan over just once, you have paid $90 to borrow $250!

Borrow from friends and family or even a bank or credit union if you are strapped for cash. Or better yet, sell your art! But stay away from these types of organizations.

VA Loans

Pros: The Department of Veteran Affairs guarantees fixed-rate VA loans for qualified veterans of the United States Military. Offered in terms of 15 or 30 years, VA Loans usually do not require a down payment and have less stringent criteria than conventional loans. These loans will also accept funds from gift programs, other loans or grants from certain sources to be used for the down payment (if required) and closing costs. As of December 2004, the maximum loan amount was raised to $359,650.

In addition to debt ratios, VA Loans use a residual income calculation to assess applications. For example, say a lender allows a debt to income ratio of 30% and requires a residual (leftover) income of $1000 per month. This means that although each month 30% of the borrower's income goes towards debt, after debts are paid the borrower must have $1000 remaining to allocate towards property expenses.

So, if the borrower had an income of $1200 per month and debts of $360/month, s/he could not qualify for the loan. This is because although the borrower meets the debt ratio requirements ($360 is 30% of $1200), s/he does not meet the residual income requirement ($1200-$360 = $840).

In this example, the borrower would need to earn at least $1360 per month to meet both the debt ratio and residual income requirements ($1360 - $360 = $1000).

Private Mortgage Insurance is not required for VA loans. It is replaced by a VA funding fee instead. This fee varies from 1.25% to 3.3% of the value of the property and is used to help operate the program by paying claims to lenders who would otherwise lose money by making loans to sub-prime (under qualified) borrowers who default on their loans. This fee is also used to pay lenders that normally would not make these loans were if not for the VA funding fee.

Cons: You can only get this loan if you are a qualified veteran that served in one of the branches of the United States Military. In addition, this loan can only be used for residential property. You must also occupy or intend to occupy the property as a home for yourself within a reasonable period of time after closing the loan. This means that the loan cannot be used to purchase rental-only property. The loan amount generally cannot exceed $359,650.

Jumbo Loans

Pros: This type of loan is used when the loan amount exceeds guidelines set by the major secondary mortgage market purchasers – Fannie Mae and Freddie Mac. As discussed earlier, Fannie Mae and Freddie Mac are federal government-sponsored investors that purchase loans on the secondary mortgage market. Remember that lenders selling residential mortgage loans to Fannie Mae (or Freddie Mac) must follow their underwriting guidelines in order to participate.

In 2005, the residential loan limit for one-family loan was set at $359,650 in the continental US and $539,475 in Alaska, Hawaii, Guam and the U.S. Virgin Islands. Any single loan that exceeds Fannie Mae's limits is considered a jumbo loan

and will carry a higher interest rate than a conventional fixed-rate mortgage. This is a good loan to have if you need more money to secure the space you want and if can afford it.

Cons: The interest rate may be higher on these large loans. Thus, the loan may have a higher monthly payment and will cost more over the long run due to the interest rate. Because Jumbo Loans are typically considered higher risk, the criteria for securing these loans is typically very strict and you will need to have a higher income level to qualify. Due to the recent economic downturn and the financial troubles of Fannie Mae and Freddie Mac, these loans are harder to find and to pay off. Make sure you read all the documents associated with your loan very carefully and consider consulting with a certified accountant before signing one of these loans.

Government Loans

Unlike many home buyer programs, government loans, such as a Federal Housing Administration or FHA backed mortgage, are not limited to first-time homeowners. Selected guidelines for standard government loans include:

• Terms have 15 or 30 years with either a fixed or ARM loan

• Gift funds from a nonprofit organization, family members or friends can be used for the down payment

• Loans are assumable, meaning another party can take over the loan as long as they meet all of the loan requirements and qualifications per the FHA guidelines

• Maximum total debt ratio is 41%

• Loan amounts are capped

• No payment reserves are required for mortgage insurance

Cons: These types of loans have both income caps and limits on the mortgage amounts. Government loans also include additional criteria that borrowers must meet to obtain the loan, depending on the program.

Construction/ Permanent Loans

Loan programs are available to assist borrowers who would like to build a new property. Construction loans are available, as well as a combination construction/permanent option that features a single closing.

The loan would be secured by a mortgage on the land and the property, once it is built. The construction loan usually has a short term (12-24 months) to allow time to complete the building and may then convert to a permanent mortgage on the completed property. With such a loan product, one has to decide whether to incur the additional risk of building a space.

FHA Mortgage

Pros: The Federal Housing Administration (FHA), established in 1934, is the oldest and largest insurer of residential mortgage loans in the U.S. A FHA loan offers lower down payment loans for qualified borrowers when compared to a conventional loan. Both fixed and adjustable rate mortgage products are available and usually only require a minimum cash investment of 3%.

FHA loans will also accept funds from gifts, other loans or grants from certain sources to be used for down payments and closing costs. Unlike conventional loans, the maximum property debt ratio is increased to 29%

compared to the 28% allowed for conventional loans and the total debt ratio can be as high as 41% versus 36%.

In addition, while a conventional loan may require you to have at least a two-month payment reserve (money in the bank to cover the mortgage and/or insurance) this is not a requirement for FHA loans.

Cons: These types of loans have both income caps and limits on the mortgage amounts. Certain down payment assistance programs paired with government loans may have income caps placed on them, as well.

Emergency Relief for Artists

Crisis Management

There are generally two kinds of emergencies that qualify for an emergency loan: large scale disasters and personal emergencies.

Large scale disasters inflict a wide range damage, such as a hurricane, earthquake, or terrorist attack. These kinds of crises destroy livelihoods and communities in an instant, and it often takes many years for these neighborhoods to recover. Personal injuries include an accident or sudden illness, physical injuries, house or studio fires, and floods.

Encountering both types of emergencies at the same time can be overwhelming. Fortunately, there are a number of emergency support programs. It is a good idea to know the basis of what is available before you are in a crisis.

About Emergency Support Organizations

In the US, there are a number of organizations that provide emergency support to individual artists. Some of these organizations work with specific disciplines such as musicians, while others concentrate on a particular ethnic group or geographic region. Not every region is covered, so planning ahead can make a difference. Most of the emergency loan organizations are nonprofits started by artists, who raise funds from foundations, charities, guilds and unions; very few of them receive government funding. Most of these organizations work in crisis mode themselves because crises are unending.

There are many simple things you can do to survive an unforeseeable crisis. (See the Hazards section and the Earthquake Preparedness section.)

Learning from Others

It is crazy to think that all emergency situations can be avoided. However, their devastating impact can be tempered or reduced. Consider, for instance, the aftermath of the Nisqually earthquake in Washington State in February 2001, from which Washington artists (mostly visual artists) reported $1.3 million in losses, including $890,000 in inventory. Luckily, the Seattle-based arts service organization Artist Trust, in collaboration with the King County Arts Commission, Seattle Art Commission, Washington State Arts Commission, and the National Endowment for the Arts, quickly set up an emergency support program called Artists' Quake Aid (AQUA). Through AQUA, Artist Trust was able to distribute $40,000 in aid within weeks to artists suffering the greatest losses (grant amounts ranged from $250 to $1,500). Reported losses included damage to artwork and equipment, workspace, work time, emotional trauma, and the breakup of artistic communities. In the AQUA Final Report, Artist Trust points out several important findings

about the ways in which many artists organize their lives and maintain their artistic production, all of which are applicable to most emergency situations, regardless of the type or scale of the emergency:

• Many artists live so close to the edge financially that they cannot sustain a disaster of any kind.

• Many artists live and work in unsafe conditions.

• Most artists do not carry insurance for their artwork as this insurance is difficult to find, very expensive, and has high deductibles. Furthermore, the value of artwork is hard to determine.

• Many galleries do not carry insurance for artwork on exhibition or in storage, for the same reasons that artists do not carry it.

• Government resources are often unattainable by artists who are not viewed as having a "business."

Additionally, artists do not feel that they are part of the general public (they tend to marginalize themselves). They therefore do not tend to utilize the existing emergency support infrastructure offered to them by social service organizations such as the Federal Emergency Management Agency (FEMA), American Red Cross, and the Salvation Army. However, the reverse is also true. Many social service organizations do not quite know how to handle artists and their specific needs. What is important here is to think outside the box. In emergency situations, in particular, artists should also pursue programs for the general public. This includes community programs, support groups, programs serving students, faith-based programs, etc.

What Situations Are Eligible for Emergency Support?

When struck by an emergency, what should you do? Before applying to an emergency organization, it is important to understand the distinction between what they term valid emergencies and avoidable ones. The majority of emergency support organizations draw a clear line between the two. Valid emergencies can be characterized as absolutely unavoidable. They are life-and-death situations such as medical emergencies, fires, floods, natural disasters, etc. Emergency situations of one's own making, although difficult, are not eligible for emergency support. This category includes circumstances such as bad financial planning, credit card debt, child support, defaults on student or other loans, eviction because of refusing to pay rent, etc. Emergency organizations are also not set up to assist with special opportunities such as sudden and unexpected performance/exhibitions overseas, residencies, and professional conferences (although there are many programs nationwide, similar to NYFA's Special Opportunity Stipends, that support special opportunities). None of these situations constitute unavoidable, life-or-death emergencies.

Types of Emergency Support

Emergency organizations generally provide one or more of the following areas of support:

emergency grants, emergency low-interest loans (these have to be repaid), and emergency assistance. Emergency grants can range from a couple hundred to several thousand dollars. Emergency loans come in the same amounts, and are usually accompanied by a grace period of about a year to give artists time to get back on their feet before the repayments start. Lastly, many emergency organizations (and non-

emergency organizations, too) give artists technical assistance concerning how to pick up the pieces and proceed with their lives, and some will work with other social service organizations on an artist's behalf. Whatever the form of support, responsiveness (i.e., a quick turnaround time) and access to information and resources are rules by which these organizations live and breathe.

It is also good to know that most organizations do not prioritize artistic merit. Generally, an organization will review an artist's résumé simply to verify that she or he is a "professional" working artist. The organization will also weigh the need and the degree of crisis. Lastly, artists stricken with multiple emergencies over the course of several years may reapply to many emergency organizations for help.

Emergency Support Organizations

In addition to hosting further roundtables, creating partnerships among emergency organizations, and advocating for greater emergency relief, NYFA launched a brand new database on its web site in the fall of 2002. The database, developed in partnership with the Urban Institute in Washington, DC, builds upon NYFA's Visual Artist Information Hotline, a clearinghouse of information on more than 2,000 support programs for visual artists. It makes comprehensive, up-to-the-minute information available on nearly 5,000 support programs for artists working in all disciplines: visual arts, media arts, design arts, dance, music, theater, performance art, and literature. The database is searchable, and is available free 24/7 on NYFA's new web site.

List of Emergency Organizations

The following is an extensive, though by no means definitive, list of emergency organizations.

Please call or check the organizations' web sites to get the latest programmatic information and eligibility requirements.

Literature
Academy of American Poets
American Poets Fund (for poets with illness or emergency)
212.274.0343
www.poets.org

American Society of Journalists and Authors Charitable Trust
Llewellyn Miller Fund (for writers who are unable to work)
212.997.0947

Authors League of America
Authors League Fund (interest free loans for emergencies)
212.564.8350

Carnegie Fund for Authors
Grants-in-Aid (for commercially published book authors)
516.877.2141

Human Rights Watch
Hellman-Hammett Grants (for writers internationally who are victims of political persecution)
212.290.4700
www.hrw.org

Pen American Center
PEN Fund for Writers and Editors with HIV/AIDS (for HIV/AIDS-related illness)
PEN Writers Fund (for published or produced writers)
212.334.1660
www.pen.org

Media Arts
Motion Picture and Television Fund (for
members in emergency situations)
800.448.8844
www.mptvfund.org

Multidisciplinary
Commonwealth Council for Arts and Culture
(Northern Mariana Islands)
670.322.9982
www.nasaa-arts.org/new/nasaa/gateway/
NorthernM.htm

Herbert and Irene Wheeler Foundation
Emergency Grants to Artists of Color (for
housing, medical, fires, floods)
718.951.0581

J. Happy-Delpech Foundation
Grants to Midwest Artists with AIDS or Serious
Illnesses (for medical emergencies)
312.342.1359

Louisiana Division of the Arts
Director's Grant-in-Aid Program (for special
opportunities and/or emergency situations)
225.342.8180
www.crt.state.la.us/arts

Montana Arts Council
Opportunity Grant (for special opportunities
and/or emergency situations)
406.444.6430
www.state.mt.us/art

Performing Arts
Actors' Fund of America
www.actorsfund.org
212.221.7300

Conrad Cantzen Shoe Fund (funds up to $80
per year to purchase one new pair of shoes)

Entertainment Industry Assistance Program
(EIAP) (for counseling, advocacy and aid)
Senior and Disabled Program (for the disabled
or age 62 or older)

AIDS Initiative (for AIDS counseling, support
groups, emergency aid, and housing)
Mental Health Services (for treatment, housing,
rehabilitation, and funding)

American Guild of Musical Artists (AGMA)
212.265.3687
www.musicalartists.org

AGMA Emergency Relief Fund (for AGMA
members)

American Guild of Variety Artists (AGVA)
General Sick and Relief Fund (for illness and
emergencies)
212.675.1003

Associated Musicians of Greater New York Local
802
Lester Petrillo Memorial Fund for Disabled
Musicians (for disabled AFM members)
Local 802 Emergency Relief Fund (for eviction,
disconnection of utilities, medical assistance)
212.245.4802
www.local802afm.org

Dancer's Group Studio Theater
Parachute Fund (for San Francisco-area dance
community for HIV/AIDS or illness)
415.920.9181
www.dancersgroup.org

Episcopal Actors Guild of America
HIV/AIDS Relief Program (for actors with HIV/
AIDS)

Emergency Aid and Relief Program (no
description available)

212.685.2927
www.actorsguild.org

International Association of Blacks in Dance
Emergency Fund (for IABD members)
215.713.0692
http://iabdconference.com

Jazz Foundation of America (for jazz musicians)
212.245.3999
www.jazzfoundation.org

Music Maker Relief Foundation
Emergency Relief Program (for medical, fire, theft)\
919.643.2456
www.musicmaker.org

Musicares
Musicares Program (for artists nationally in emergency situations)
212.245.7840
www.grammy.com

Musicians' Assistance Program (for drug and alcohol treatment and recovery)
888.627.6271
www.map2000.org

Musicians Foundation
Emergency Assistance Grants (for professional musicians)
www.musiciansfoundation.org
212.239.9137

Rhythm and Blues Foundation
Gwendolyn B. Gordy Fuqua Fund (for R&B musicians who performed under Motown label during 1970s)
202.588.5566
www.rhythm-n-blues.org

Santa Fe Jazz Foundation
Grants for Emergency Medical Aid (for jazz musicians with medical needs)
110 Vuelta Chamisa
Santa Fe, NM 87501-8582

Screen Actors Guild Foundation
Emergency Assistance Grants (for needy, sick, indigent, and aged SAG members)

Catastrophic Health Fund (for SAG members with illness or injury)
323.549.6708
www.sagfoundation.org

Society of Singers
Financial Assistance (for singers internationally)
323.651.1696
www.singers.org
Sweet Relief Musicians Fund
Emergency Assistance (for medical, drug or alcohol dependency, and unemployment)
www.sweetrelief.org

Theatre Bay Area
Mary Mason Memorial Lemonade Fund (for theater workers in San Francisco-area with illness)
415.430.1140
www.theatrebayarea.org

Will Rogers Memorial Fund
Financial Assistance (for medical expenses and disabilities)
877.957.7575
www.wrinstitute.org

Visual Arts
Adolph and Esther Gottlieb Foundation
Emergency Assistance Program (for catastrophic emergency)
212.226.0581
www.gottliebfoundation.org

`Artists' Fellowship
Emergency Funding Grant Program (for illness, disability, distress)
212.255.7740

Berkshire Taconic Community Foundation
Artists Resource Trust (ART) (for mid-career artists in New England)
www.berkshiretaconic.org
800.969.2823
Change, Inc.
Emergency Grants (one-time only grants for artists anywhere in US)
212.473.3742

Chicago Artist's Coalition
Ruth Talaber Artists' Emergency Fund (for emergency situations)
www.caconline.org
312.670.2060

Craft Emergency Relief Fund
Emergency Grants, Loans and Services (for craftspeople anywhere in US)
802.229.2306
www.craftemergency.org

Photographers + Friends United Against AIDS
Critical Needs Fund (for photographers with HIV/AIDS)
212.219.2672
www.icomm.ca/~pfcda

Visual Aid
Art Bank (makes available free art materials to Visual Aid artists)
Voucher Program (supply vouchers to Visual Aid artists for free art materials at local retailers)
Exhibition Program (plans, curates, and exhibits work by Visual Aid artists)
415.777.8242
www.visualaid.org

Visual Aids
Visual AIDS Artists Materials Grant (for Visual Aids members with low income)
212.627.9855
www.visualaids.org

Other Emergency Services

American Red Cross
www.redcross.org

Federal Emergency Management Agency (FEMA)
202.566.1600
www.fema.gov

Salvation Army
800.SAL-ARMY
www.salvationarmy.org

Small Business Administration (SBA)
800.827.5722
www.sba.gov

Legal Resources

Volunteer Lawyers for the Arts (VLA)
212.319.2787 x9—Art Law Line
www.vlany.org

Legal Aid Society
212.732.5000
www.legal-aid.org

39: Residencies

 Objectives

Understand what residencies can do for artists.

Become familiar with information on residencies, where they are, and how to apply for them.

 Things To Do

Seek out an artist who has been a part of a residency. Since residencies often market themselves like educational programs, the website will give you the "feel" but not necessarily the truth. Find someone who has been a part of one and ask them what their experience was like.

Residencies

This article written for the gyst blog by Caitlin Strokosch, Executive Director of the Alliance of Artists Communities, 2008.

Artists communities, colonies, residencies, workspaces… they go by many names but share a common purpose: to provide artists with dedicated time and space to create new work. Rather than focusing on the end product, artists communities offer artists the opportunity to explore, take risks, experiment, and collaborate. They are, in essence, research-and-development labs for the arts. You've probably heard of a few—The MacDowell Colony, Vermont Studio Center, Skowhegan, Anderson Ranch—but with some 250 artists' residencies in the U.S. and another 500 internationally, there is something for everyone, for every artistic approach, and for every stage of your creative process

Artists communities began in this country around the turn of the last century and were created as a kind of utopia, removing artists from their everyday lives to provide solitude and a community of like-minded people in a rural retreat setting. Fast-forward 100 years and you'll find that there are as many utopian visions as there are residencies and each balances solitude and community in its own way—from studio residencies in a Manhattan skyscraper to a secluded cabin in the Oregon woods.

Some statistics:

• The average-length residency is 4-6 weeks, with some as short as a few days or as long as a few years

• The average number of artists-in-residence at a time is 9, while a quarter host only 1 or 2 artists at a time (the most is 50)

• Roughly 60% of residencies are in rural areas and small towns, while 40% are in urban areas

• Residencies serve emerging, mid-career, and established artists in equal measure

• 70% of residencies are multidisciplinary—serving visual artists, writers, composers, choreographers, filmmakers, and others—while 24% focus just on the visual arts

Choosing the right program for you requires research, so that the experience is positive for

both you and the organization. Here are a few things to consider:

What you get besides getting away.

The difference between a residency and working in your home studio is more than just dedicated time and space. Residencies offer an opportunity to expand your own resources, whether in the form of community, financial or technical support, access to equipment, collaborators, or presentation of your work. Choosing a residency can be similar to selecting a college—it's not just the reputation that matters, but the people, the environment, the alumni support, and the style of the place that makes it a good fit.

Cost

The total cost of a residency includes whether there are fees required or stipends provided, but also includes the direct costs to you (including meals, materials, and transportation), as well as the indirect costs (loss of income, or whether you're maintaining a home while you are away, among other factors). For example, a "free" residency that lasts 6 months and does not provide meals may cost you more in the end than a 4-month residency that charges fees but provides food and materials. Many residencies that charge fees also have scholarships available, and most state arts councils have small grants for professional development that can be applied to travel costs and such. Artists who just look at the advertised bottom line may miss out on a great experience.

Length of time

How much time can you take? How much time do you need? A long stretch of time to work on a novel, start a new direction in your work, or explore different techniques? A short residency to finish editing, sketch some ideas, move to the next phase of a project? Do you need a 2-week break while still maintaining your home, job, and family, or a 6-month change of scenery? Some residencies have a set length, while others let you choose how much time you need. Consider different phases of work that could be accomplished in different spans of time, too—a week may not be the time you need to paint a new series, but it may be just right for sketching new ideas.

Community

Don't get hung up on geography. You can find isolated, bucolic retreats in the middle of a city, or vibrant activity in a rural area. The community within the residency is as important as the external community. But location certainly matters if you're looking for international residencies, if your work incorporates the people and places around you, if you have a limited ability to travel, or if you are looking for a studio (as opposed to live-in) residency in your own community.

For example, choosing a residency program in the heart of Manhattan is sure to offer you a connection to the local community, but what about rural residencies or small towns? How much community is fostered by the residency program itself, and how much is available to artists to pursue on their own? And what if you'd rather work in isolation? Geography alone does not dictate how much connection to community you'll find; instead, consider how many other artists will be in residence (if it's a large group, that may provide its own community), what other programs the organization has in the community (workshops, exhibitions, performances, etc.), and how much access there is to transportation and other means for interacting with others outside the residency.

International residencies require some additional considerations of community. First of all, do some research on the cultural norms and expectations of the host country/region. For example, if you are a female artist considering a residency in a primarily Muslim country, what will that mean for you? As a US citizen will you be viewed with any particular bias by community members/other artists? Additionally, knowing what the internal residency community is like for the visiting artists is important. Are the other artists-in-residence international or primarily from the host country? What languages will be spoken? How much support is offered to artists in attempting to acclimate to the local community/culture? What kind of local community interaction is expected of the visiting artists? Understanding what it means to be a global artistic citizen is critical when considering international residencies. Also remember that no matter where you choose to go, you are a de facto representative of your home country/culture and all the positives and negatives that entails.

Living environment

While not all residencies provide living space, many do. The living environments of residencies vary as much as the programs themselves: dorm-style housing, private rooms in a larger house, or individual cabins or apartments; there's also workspace that is separate from the living facility, or living and working in the same space. How meals are handled varies as well, from who provides groceries to who prepares food, how many meals are provided, and whether kitchen facilities are private or shared by all artists. Preparing dinner together as a group can be a wonderful way for artists to get to know each other; for others, not needing to schedule around meals affords them more time to work.

Workspace

Some residencies provide private studios (like a cabin or an enclosed room), others are semi-private (sectioned-off spaces within a larger workspace), and others have collective workspaces (typically for those media that require specific equipment, like printmaking or glassblowing). Consider your working style, the number of other artists in residence at a time, and at what point in your process you'll be working (some stages may need more privacy than others).

Think, too, about your technical needs. Some residencies provide facilities, equipment, and technical assistance that support specific art forms (for example, metal, wood, and printmaking workspaces; dance floors and theater space; recording studios; kilns, darkrooms, and digital media labs) while others offer raw space. Consider what your art form requires, and what stage of your work will be best suited for a residency. For example, if you create artwork that requires large space and equipment to complete, a residency with a smaller unequipped studio may still serve you while you're in the beginning stages of your project.

If you're overwhelmed, don't be. These are just tools for familiarizing yourself with the options. Check out the organizations' websites, talk to the staff, and go with your gut. Apply to as many programs as you can, and here's how you can prepare:

Documentation

You should have well-documented examples of your recent (last 3-5 years) work. The quality of your materials reflects the quality of your work. And be sure that your documentation is in the requested format (eg, slides vs. digital photos;

cassettes or DATs vs. CDs). If you're not sure, it's a good idea to contact the artists' community to determine what formats they prefer. It's also a good idea to ask how your work will be viewed (eg, 3 slides at a time, 15 seconds of video, etc.).

Artistic Statement

You should prepare a statement about your work. Many residency programs require this as part of the application. Even if such a statement is not specifically required, it is helpful to be able to articulate your personal artistic statement.

What you intend to do while in residence

Artists' communities focus on the process, rather than the product, of art. However, some residency programs ask what you plan to do while in residence. Even if you are applying to a program that does not require such a statement, you may find it helpful to consider this. Often this is more about an ability to conceptualize how you might use your time than it is a specific work plan. Artists-in-residence can, and often do, change course one in residence; experimentation is par for the course.

Financial Preparedness

While many residency programs do not charge fees to artists, it is important to plan for the financial impact of being away from your home/job/regular life for any period of time.

Mental Preparedness

No one can tell you how you will experience your residency. No two artists' communities are alike, and the staff and other artists in residence will vary as well. While some find isolation to be inspiring, others struggle with the solitude and separation from families and friends. Choosing the right residency depends on what environment is best for you, among many other things. You may find it helpful to ask friends or colleagues who have attended residency programs what their experiences have been, and many artists' communities have "Survival Guides" that will help you to know what to expect. The MacDowell Colony's Roadmap to a Residency offers some insight—from application to the return to life after a residency—from ten former artists-in-residence.

Unstructured time is a gift, but it may also be your greatest enemy. No one looking over your shoulder, no crits, no deadlines. Sounds great, right? But enter that studio with its blank walls and don't be surprised if what you experience is closer to panic than bliss. And for those of you who have been out of school for a while, juggling day jobs and the myriad other things that drag you away from your creative practice, that empty studio can be pretty scary, too. Don't worry though – bliss comes later. Learning how to get stuck, unstuck, develop new ideas, throw them out, start new again… these are life-long tools that lead to breakthroughs and discoveries.

Whether you leave your residency with a full sketchbook, a gallery show, new friends, an armful of canvases, or simply plans, you will find yourself validated and nurtured as an artist and part of a community of artists who have traveled that way before.

To find out more about artists' residencies, visit www.artistcommunities.org

40: Fiscal Sponsorship

 ## Objectives

Understand what a fiscal sponsorship is, how to apply for one, and things to consider when seeking a fiscal sponsor.

Fiscal Sponsorship

Overview

Fiscal sponsorship is an affiliation between a 501(c)3 tax-exempt organization and a nonexempt project that renders the latter eligible for grants from government agencies, private foundations, corporations, and individuals. Fiscal sponsors may also provide services such as accounting and administrative support, and usually charge an administrative fee for such services. Artists and nonexempt organizations must apply for fiscal sponsorship in order to receive any charitable contributions.

Example

Lets say you have a rich uncle who supports the arts and wants to help fund your next project. (We should all be so lucky!) He will not be eligible for a tax deduction if he gives you money directly, and you would be liable for taxes on the gift.

The solution is to find a fiscal sponsor. Start by trying to find a local arts organization whose mission statement supports the kind of project you are doing. Send them a well-crafted letter asking them if they would be willing to receive the gift from your uncle. If planned properly, this can be a win-win situation.
Usually, fiscal sponsors ask you to send in a description of your project, your resume and any visuals and supporting documentation. They may require a budget as well. They will usually present your proposal at their next board meeting. Your project must fit within their mission in order to be a legal transaction.

They may require a flat fee or percentage of your gift in order to pay for legal, accounting fees, and staff labor. The typical percentage for a fiscal sponsorship is between three and ten percent. You can usually negotiate to pay more for additional services that you could not otherwise obtain. You should never begrudge this percentage because being a fiscal sponsor requires a large amount of work on the part of the host institution. The fiscal sponsor Is both financially and legally responsible for projects to which it administers funds. For example, the fiscal sponsor could be liable to its board and funders if you do not complete the project.

It is advisable to sign a contract with a fiscal sponsor. Be sure to keep a copy of all correspondence between the donor and the fiscal receiver, as well as your own paperwork.

Resources

New York Foundation for the Arts
http://www.nyfa.org/level2

Lawyers for the Arts

Fiscal Sponsorship: 6 Ways to Do It Right
by Gregory L. Colvin
Colvin describes the six forms of fiscal sponsorship recognized by the IRS.

41: Negotiation

 ## Objectives

Understand the basics of negotiation, why people negotiate, and how to negotiate.

 ## Things To Do

Think about and write down the situations where you would apply these strategies.

Ask other artists how and when they have had to negotiate during their art careers.

 ## Negotiation

Negotiation is an active part of getting things done. It is the way that we go about getting things we need or want, and we do it every day. Things such as a raise, when a paper is due, getting a fee for a commission, or when you can fit in dinner with a friend are all negotiations. They range from informal negotiations, such a lunch with a friend, to setting up tasks for an exhibition with a curator. When you negotiate, you want to come to terms that are mutually beneficial for all parties involved. Negotiation is a collaborative problem solving process, which can cultivate long term relationships based on mutual trust. Good negotiation skills can help you avoid misunderstandings, hard feelings and miscommunication with others.

There are a variety of ways to negotiate, but the following are some tried and true ways you should consider the problem or issue you are working to resolve. A negotiation does not mean that it is divisive or negative, it is just a way of agreeing what works best for everyone.

1. Always separate the people from the problem or issue. This is not a place for emotions but for a cool and collected interchange.

2. Look at the problem objectively. Presenting the issue to another colleague who is not involved may help you see the issue clearly. It may help you to see the situation from a variety of perspectives rather than your own.

3. Make sure that everything you are discussing is clear. Ask the other party to explain anything that is unclear. Do not assume you know what they are talking about, as it could create a misunderstanding.

4. Focus on interests and not positions. You might have the same interest, but not the same position on how to get there. Let everyone voice ideas before making a decision or an assumption.

5. Clarify positions and points of view that might be different. For instance, a gallery might see the sale of your work one way, and you might see it in another. For example, the gallery might not be able to pay you the same day they are paid for a work, and they may have good reasons. (These issues should always be discussed before you enter into a gallery relationship.)

6. Look at things for other perspectives to see if you can understand a different way of looking at the problem and concentrate on how a decision can work for you both.

7. Make sure you know the information needed to make an intelligent decision. Know the situation for all perspectives. When in doubt, do some research about the issue.

8. Brainstorm different options before making a decision to see if there is a better solution.

9. Insist on using objective criteria for a decision. Are there standards or procedures that are used in the field? How do other organizations, artists, galleries deal with the issues being addressed?

10. When negotiating a fee for instance, know what others get paid for similar work. If you are asking for more, make sure that you have a reason to back it up.

11. Look at other contracts and agreements. Do any of the points work in your situation?

12. Never yield to pressure from another party. Do not agree to something because you are desperate. It might turn out badly. Consider though, that a solution that does not work for the parties involved and leaves one of you feeling bad about the situation, or worse really pissed off, might not be the best solution after all. Try to find a solution where both parties leave the negotiations civilly.

Remember, you are looking for a long-term relationship with those who you are working with, and you want to be able to work with them in the future. Negotiation can be a key player in developing long term relationships, so make sure this is a part of your practice and get really good at it.

42: Letters of Recommendation

 ## Objectives

Understand what makes a great letter of recommendation

Understand how to get great letters of recommendation to support your projects and artwork.

 ## Things to Consider

Sometimes it is easier to think about things that you should not do, such as call someone up after 10 years and ask for a letter, when you have not spoken to them for that amount of time.

Think about strategies to ensure that the letters get written, and how to set it up so they are written on time.

 ## Letters of Recommendation

You will likely need many letters of recommendation during your art career. Here are some helpful hints to help you make the process easy and rewarding for both you and the person writing your letter of support.

1. It is a good idea to maintain a relationship with someone who can write you a letter of support. Don't ask someone you have not seen or talked to for 10 years to write you a letter. First of all, they don't know about your recent work and your current activities and interests. If you have a favorite teacher, keep in contact with them and let them know about your exhibitions and accomplishments.

2. If at all possible, never ask someone to write a letter at the last minute. You should give at least two weeks to write a letter. Many people get asked to write letters all the time, and they may have their own deadlines to consider.

3. Always ask them if they have time to write a letter. Then send them all the pertinent information to write the letter successfully. You should send them:

• The name of the person the letter needs to be addressed to, along with the organization and address.

• Information about what you are applying for and a description of what it is.

• Any background information on your connections with the organization.

• The deadline the letter must be receive by or postmarked.

• Sending postage for the letter is a great way to make sure your letter is mailed on time.

• Send your newest artist statement and resume.

• If they are unfamiliar with your most recent work, send them to a website or include Lo Res images with your request.

• Include a text that describes your project or application.

4. Be sure to thank them for writing a letter for you. Writing letters of recommendation takes a

lot of work to do it right. Make sure you let the person writing your letter of rec. know how appreciative you are.

5. Always follow up with the person writing your letter of rec. to thank them and make sure it was mailed on time.

5. Try to spread your letters around to various people, as you might burn someone out if you ask them too often.

6. Consider doing something really nice for them as a thank you. Send flowers, a gift certificate, or a nice card. Something other than an email is especially noticed.

Often persons in positions of authority – teachers, managers, gallery and museum directors, are inundated with requests for letters of recommendation. They may request that you write your own letter of recommendation and send it to them for approval, at which time they will review it, perhaps edit or add to it, and sign and send it off. This is a normal and accepted practice in the art world. If you find yourself in this situation try to write as professional a letter as possible. Don't overinflate your accomplishments, but don't be shy either. As always, write many drafts of your letter before you send it off to make sure that you haven't included any grammatical or spelling errors.

43: Public Art Projects

 Objectives

Understand what Public Art is.

Understand why and how you apply for public art projects.

 Things To Do

Find a public arts administrator who is willing to talk about the process of how it works, how artists are selected and what defines public art. Many people are willing to share this information with you.

 Public Art Projects

Public art projects can range from those that are government funded or governmentally legislated art acquisition programs for new construction or major renovation projects, to guerilla type art activities in public sites. Many cities have a public arts component that regulates a percent for art program, or creates opportunities for public art as part of a city or country program. Some public transportation authorities have programs, while others are created and organized by arts organizations and museums. There are mailing lists, list-serves and blogs about public art.

There are a few things to know before you get started:

• RFQ stands for Request for Qualifications. Sometimes agencies put out an RFQ, asking artists to submit their qualifications for creating public art. This might include previous public

art commissions, jobs you have had that increase your qualifications, such as welding, coordinating large projects or experience in other ways.

• RFP stand for Request for Proposals. This is a specific request for a detailed proposal on what you are proposing as a public art project. This includes a project description, qualifications, budget, time-line and other items. This is usually a very specific proposal that outlines a specific project for a specific site.

• It is a good idea to get on the mailing lists of institutions that generate or coordinate public art. These could be your local Cultural Affairs Department, part of the city government, or a list-serve that lists public art competitions. You will find almost everything on the web.

• Public art projects are often awarded based on a competitive process. The RFP is sent out with a deadline requesting a proposal. The proposals are usually read and reviewed by a panel of your peers, other artists who have public art experience, a representative from the funder or business or development firm, or a curator or consultant for public art. The list is narrowed down to usually three finalists. Those finalists are then given a stipend to develop a detailed proposal and mock up of the project, and asked to present to the review committee on a certain date. The final award for the project is usually chosen from these three finalists.

Being awarded a public art commission can be rewarding and exciting, but there are some things to consider about working in this field.

• It can take a long time to finish a public art project, sometimes up to 10 years.

• You will often be working with engineers, architects, city officials, developers and the like, with whom you may need to negotiate. People skills are a must.

• You may be asked to sign a lengthy contract, which can be quite complicated, and it may be beneficial to contact a lawyer to explain all the logistics and fine print.

• Artists often lose money on projects, especially if they are inexperienced. Working with professionals and professional fabricators to get your budget correct is a plus.

• It is important to NOT propose something you have no idea about, or no experience working on. It can lead to a financial nightmare.

6. Your project might change based on a number of factors, including community input, engineering issues or just plain bureaucracy.

7. Don't be afraid to ask a lot of questions to those who you feel can help you out. Be patient, and don't be afraid to learn.

A great resource for public art is "The Artist's Guide to Public Art: How to find and win commissions", by Lynn Basa, Allworth Press, 2008.

44: Health & Safety

 ## Objectives

Understand basics of health and safety issues.

Introduce ideas about health and safety and where to get additional information.

Knowledge to keep artists from hurting or poisoning themselves.

 ## Things to Consider

Hopefully there is some sort of mandatory class or workshop at your school or local arts center where these issues are discussed. You could find an expert, or at the very least, do some research on the supplies you have been using and how they are being used to determine if you are putting yourself (or others) at risk.

 ## Health & Safety

Materials in General

It is imperative that you know about your art materials and the hazards they can pose to your health and safety. Many artists have died from exposure to hazardous materials.

A list of must-read resources about how to avoid hazards and dangerous materials is at the end of this section. Each material you use has its own properties and hazards so you should look up the specific materials that you work with. Remember, you need to be familiar with not only the materials you use but also any materials others use in your presence. If you share a studio with someone, the chemicals

they use could pose a risk to you too. Take precautions before you begin working!

Experimental Materials

When making art, do not be naïve about the materials you use. Educate yourself by speaking with experts who know the long-term properties of substances. These people may be chemists, physicists, doctors, professors, engineers, etc. Explain to these professionals what materials you use and how you use them. Problems may arise in terms of longevity, deterioration, chemical changes or color shifts. Consider if such changes can be strategically incorporated into the artwork with pleasing results or if they will pose a liability.

Always be aware of the ramifications of using 'experimental materials' from the perspective of a curator or buyer. Be forthcoming about what you do/don't know about the chemistry of your materials.

Work Related Heath Issues

Hazardous conditions and materials found in many industrial workplaces are often present in art workspaces. When hazards are identified in an industrial workplace, safety training and information may be required, but these resources are less often available to artists who work alone or in small groups.

If others have access to your workspace or you hire assistants, be sure to mandate safety instruction. Data sheets on all materials should be located in your studio. These can be found

on the web. Make sure that you provide information on all materials, as well as training and protective equipment. This is a serious matter—materials can be hazardous and fatal. ALWAYS wear eye goggles when working with hazardous materials and enforce the policy with your assistants and studio mates.

There are many factors other than dangerous materials that contribute to an unhealthy workplace. If you work extended hours trying to complete a project, you may find yourself exhausted and overworked. This can lead to accidents. Do not disregard symptoms of extreme fatigue, nausea, or sickness in order to make a deadline. Seek advice or help immediately.

Many art hazards may not appear dangerous at first but can lead to serious health issues over time. Do not procrastinate seeking help or you could damage your health permanently. Chronic illness resulting from exposure to harmful materials may affect your life, your ability to work, or your health. Painters can develop neurological and other disorders from long-term solvent exposures. Musicians can develop permanent hearing loss from exposure to loud music even in specifically designed acoustic settings. Pottery artists may find that they are unable to continue work at the wheel because of Carpal Tunnel Syndrome from extended work schedules or because of poisoning from glaze chemicals. If you want to be able to continue to work long into the future, take these warnings seriously. Many chemicals never leave the body and over time accumulate to create irreversible symptoms.

Other Health And Safety Considerations

Because disasters like earthquakes, floods and fires pose their own set of risks, preparation for all these events is important. (See Insurance section for more information on floods and fires in your studio.)

Earthquake Preparedness for Studio

Take stock of your studio and consider making a few common-sense adjustments as needed. The primary concern should be the protection of life and limb. No matter how valuable objects may be, hazards to human safety must be addressed first:

• If materials are toxic or flammable, consider storing them in an appropriate storage area. You can get flammable storage from a number of sources.

• Check for items that may fall and either break or hurt someone. Large objects on upper shelves and stacks of lumber or shelving not secured to the walls are very dangerous.

• Make sure large objects cannot fall or tip over and prevent people from getting out of the studio or blocking the exit. Exit pathways must be clear and open.

• Store valuable artwork and equipment so that it cannot be damaged or cause additional destruction. Repairs can be extremely costly.

Much earthquake damage can be attributed to one of these basic causes:

• Objects tipping over

• Objects colliding into other objects or surfaces

• Objects falling off shelves, tables, pedestals, etc.

Do NOT Procrastinate

Procrastination will hinder prevention. Take the time to reduce the risk of damage or bodily

hard. Small measures can make a big difference and are not costly. Securing shelving to the wall so that it does not tip over or go flying across the room is a cheap solution to a big problem.

Put away tools in cabinets or storage areas, put caps on paint thinner etc., and keep your studio uncluttered. It may save your life.

Be Practical

Take the necessary steps to solve a problem. If putting something away is inconvenient, then consider what needs to be stored for long or short periods of time.

Risk Reduction For The Studio

Tipping Hazards

Tipping occurs when an object slides across a surface until it encounters a point of resistance and then trips over that obstruction. Tripping can also occur when an object has a high friction bottom that will not slide and has a center of gravity high enough to topple it. To avoid tripping of objects, follow the same steps for securing or lowering the center of gravity.

• Secure unstable items to more stable ones such as walls, pillars, or mounts, thus limiting motion.

• Lower the center of gravity.

• Place heavier items on lower shelves.

• Lay tall things on their sides.

• Fasten items to a base that has a larger footprint and is thus harder to tip.

• Place weights inside vessels.

• Enclose items so that they are contained in a box or other structure with a wider footprint and thus a lower center of gravity.

• Allow items to slide on the surface where they are sitting as long as they are not able to slide and fall off.

• Anchor small objects such as glass and glazed ceramics with dental wax, "quake" wax or silicone. (These items can be purchased at most art supply stores.) This is a very effective technique, especially when coupled with the addition of weight to lower the center of gravity. Use three to four small balls of wax on the bottom of object. Place object on substrate (shelf or pedestal) with a slight twist. Remove in same fashion to shear wax layer. Do not use on low-fire ceramics as wax can pull pieces from poorly vitrified ceramics as well as pulling gold-leaf decoration from porcelain. Wax can also migrate into unfinished surfaces.

Collision Hazards

• Collision damage occurs when an object slides and strikes another object or surface without tipping over.

• Increase bottom friction and lower center of gravity.

• Place padding or separators between objects. A grouping of objects (such as ceramics or glass) are best placed close together with foam, cardboard, or even folded newspaper separating them on a set of shelving that has been secured against tipping.

Falling Hazards

Objects may be damaged by falling from a shelf, workbench, or display stand. 2D work

may be damaged by falling off a wall. To reduce falling objects:

• Limit the availability of edges by applying a lip to a surface or stretching a light rope or bungee across the opening of a set of shelves to limit the ability of objects to fall off the shelves.

2D Work Hung on the Walls

• Secure the lower edge so that the panel cannot flap and stress the hanging attachments. "Secure-T" security fasteners will retain lower edge best, but rubberized poster adhesive putty will secure bottoms fairly well. (This is not an archival product so keep off actual art surfaces.)

• Upper hanging hardware must be well secured.

Pedestals

• Anchor objects with wax or a mount

Other Hazards In The Studio

Flammables

• Ideally all flammables should be in a National Fire Protection Association (NFPA)-approved steel flammables cabinet that is secured to a wall. That said, the greatest concern is with breakage and spillage, especially if those materials are in use at any given time.

• Equip all storage cabinets with doors that latch.

• Use boxes or plastic tubs or containers to sequester and contain the spillable contents.

• Use a wheeled cart with tray type shelves to help contain any spillage as well as allow limited dislocation.

• Buy materials in plastic containers whenever possible.

• If you have transferred hazardous materials from their original package, make sure that the new package is labeled with its hazardous contents.

Gases

• Gas cylinders for welding or other purposes must be secured to a wall to keep from tipping over. Even those on two-wheeled welding carts must be secured.

• Caution: Gas cylinders are under high-pressure. If damaged, they can explode or become flying projectiles. When purchasing a gas cylinder, please consult with sales staff regarding tank safety precautions.

Equipment and Tools

Large tools

• Secure to walls or pillars.

• Lower the center of gravity with weight at the bottom.

• Fasten base to larger footprint of plywood.

• Fasten base to floor.

• Place tool on mobile base to allow limited dislocation.

Small tools

• Store in cabinets with latching doors.

• Put neoprene or rubber compounds on underside of toolboxes to increase friction.

• Use racking system to organize and secure tools in convenient locations.

Lumber and awkward-sized materials

• Secure items with eyebolts into wall studs at strategic intervals and nylon rope to snug up stacks.

• Build storage racks to enclose and store materials. These racks must be well built and secured to a wall or pillar.

Paintings and Panels

Use same techniques as above.

Glass, Ceramics and Fragile Items

• Place on foam-lined shelves with separators or foam cavities to isolate objects from one another.

• Support rounded objects with foam to keep them from rolling.

• Store objects in boxes with padding and separators.

Mental Health

The following will help you to keep a good outlook on your art life:

• Get enough sleep.

• Do not have a poverty mentality.

• Do not try to do it all alone. Find a community or kinship with other local artists to avoid isolation.

• Do not stop before you start. Get into the studio regularly.

• Give back and mentor within your community. Helping will always come back to you.

• Get feedback on your work regularly from your peers not only your dealer, art consultants or exhibition submissions.

• Have motivation, ambition and productivity about your practice.

• Keep work/living space free of clutter.

• Do not disconnect from the needs of your body.

• Clear out the clutter in terms of physical space, time, mental and emotional well-being, relationships, and above all your health.

• Challenge yourself by working in collaboration.

Pointers

• Take each step as it comes.

• If you are already established in another occupation and you are making a change, it is advisable to do so slowly. Think intelligently when making decisions.

• As an artist you will have two main roles: creating art and marketing art. Understand where one ends and the other begins.

• Challenges come with every endeavor. When you come up against one, tackle it with wisdom. Understand whether the challenge is personal or professional.

• Competition is part of the art world no matter what you are doing. Think of it as making

progress toward your goals. There is a space for everyone. Know where your own space is.

• Understand when your personal life needs to take priority. You will need the energy to make your business thrive. If your personal life is in chaos, it will be hard for your professional life to take a different path.

• It is a good idea to understand what kind of investments you can make in your career—such as time, money and labor—in order to reach your goals.

• Get the support of your family and friends. Be sure they understand what it is you need to do and how they continue to fit into your life. Do not neglect those who are important to you.

Post-Exhibition Blues

Most artists get depressed after an exhibition. Be aware of depression and take steps to avoid it or to alleviate it. Below are common expectations artists have after an exhibition:

• Exposure in a public and professional context.

• Pride at having friends and relatives acknowledge an important part of who you are.

• Hearing strangers talk about your work (for better or for worse).

• Getting a review.

• Selling your work—selling out a show as an ultimate goal.

• Exposure to and recognition from important collectors, critics and curators.

• Recognition from another gallery.

Avoiding Post-Exhibition Blues

• Take a trip/vacation immediately after the opening.

• Schedule meeting times at the gallery with friends to allow yourself the opportunity to talk about the work with a receptive listener.

• Put out a guest book and encourage comments on your work.

• Start a new series of work before the work for the show is removed from your studio, or keep a favorite piece behind in order to inspire you to create a new series.

Resources

• The College Art Association's CAA News has an excellent issue, Volume 29, No. 4, July, 2004. It has detailed articles and lots of resources.

• Thomas Ouimet's Safety Guide for Art Studios, United Educators Insurance. www.ue.org

• The Environmental Virtual Campus (EVC) web site www.c2e2.org/evc/ArtIndex.html includes best practices for the artist's studio and lists ways to protect you from hazards.

• Michael McCann's Art Safety Procedures: A Health and Safety Manual for Art Schools and Art Departments. www.uic.edu/sph/glakes/harts/index.html

• Each material has a Material Safety Data Sheet. You can usually get this from the supplier of the material or by calling or writing the company. Keep these sheets in a binder in your studio for quick reference.

• OSHA is the Occupational Safety and Health Act passed in 1970. It is also the Federal agency that issues standards on health and safety. Information can be found on their Web site at www.osha.gov.

• Arts, Crafts, and Theater Safety (ACTS) offers the only worldwide free art-and-theater-hazards information service providing health and safety counseling for art workers; professional safety, ventilation and industrial hygiene advice; educational materials; an extensive technical library; and referrals to physicians and other professional sources.

Arts, Crafts and Theater Safety
181 Thompson St., #23
New York, NY 10012
212/777-0062
ACTSNYC@cs.com
www.artscraftstheatersafety.org
http://craftemergency.org

• The Art and Creative Materials Institute, Inc. (ACMI) is a nonprofit association of manufacturers of art, craft and other creative materials. Since 1940, ACMI has sponsored a certification program for art materials certifying that these products are nontoxic and meet voluntary standards of quality and performance. Their web site offers lots of valuable information about the safety of artists' materials.

The Arts and Creative Materials Institute, Inc.
PO Box 479
Hanson, MA 02341
781/293-4100
www.acminet.org
• You can find numerous sources on the Web for your particular practice as well as in a number of publications.

45: Experimental Materials

 ## Objectives

Understand the nature of experimental materials.

Create awareness of experimental materials issues for the artist and the art world in general.

Experimental Materials

When making art, do not be naive about using unique or experimental materials and be aware of their permanence. Educate yourself by speaking with experts who know the long-term properties of unconventional materials you may be using. These people may be chemists, physicists, doctors, professors, engineers, etc. Explain what you are using, how it is being used and get their opinion. Common problems are longevity, deterioration, chemical changes or color shifts. These changes can be strategically incorporated into the artwork with pleasing results, but you should be aware of the materials' physical properties.

There are numerous online resources that provide technical data on materials. It is worth your while to look them up in order to save yourself from health problems, and to understand how these materials stand up over time. Many artists have died from overexposure to hazards, many because they did not know their own materials.

Always be aware of the ramifications of using 'experimental' materials, including how they may affect a dealer, collector, an art audience or a gallery. Be forthcoming to potential clients

about what you know about the chemistry of your materials. No one wants to buy something that they expect to last a lifetime and have it fall apart or change substantially over a decade or two.

Many artists forget the impact of experimental materials on their viewers. Using things that mold or decompose in the gallery can lead to serious health problems for gallery workers and viewers who have allergies. Not all galleries are knowledgeable about all materials, so it is your responsibility as an artist to keep them informed. At one gallery a work on display was full of grass that made viewers with allergies very sick and another work produced about 100,000 flies. When the curator opened the door to the gallery, it reeked of flies and maggots. You do NOT want to get sued for someone getting hurt.

When in doubt, research!

46: Insurance

 Objectives

Understand the basic kinds of insurance an artist should consider.

Know how to go about getting insurance and doing research.

 Insurance

There are three types of insurance that artists should have: health, liability and property. The first is your health insurance. It used to be difficult to get individual health insurance, but now there are many companies that provide individual benefits, and the cost is often cheaper than what a small business would pay. Consider getting multiple insurance policies—such as renter's, studio and car insurance—with one broker in order to obtain a discount.

There are a number of organizations that also provide access to health insurance. Check out the Health Insurance section for more information. Also, Fractured Atlas has tons of information about health insurance for artists http://www.fracturedatlas.org/site/healthcare/

Liability insurance is a necessity if you have a studio. If visitors to your studio are injured on site, they can sue you for medical and other damages. Check with your insurance company to find out about the coverage you need. Call your local nonprofit art organization to see if there is a local arts insurer in your area.

It is also advisable to get property insurance to cover your artwork during transport and when

in an exhibition. The host venue should cover the work but do not assume that they have insurance. The shipper usually covers the work in transit. There are many different types of property insurance, some cover work from wall to wall, others just cover shipping. Be clear about what you are purchasing and read the contracts thoroughly.

The following resources are provided for information only, and are not meant as endorsements.

Resources

Property and Liability Insurance

American Craft Council offers a property/casualty insurance program, merchant credit card program, long-distance telephone rates, package delivery, vehicle rental, magazine subscriptions and educational resources.

American Craft Council
72 Spring St.
New York, NY 10012
212.274.0630
council@craftcouncil.org
www.craftcouncil.org

Arthur J. Gallagher & Co. of NJ insures original artwork for loss and damage in the home, studio, exhibit and in transit.

Arthur J. Gallagher & Co. of NJ
1501 Hamburg Turnpike
Wayne, NJ 07470
973.696.4600 or 973.686.2309

Artist Trust has a list of northwestern insurance companies that provide Commercial General Liability coverage and/or Special Event coverage.

Artist Trust
1835 12th Ave
Seattle, WA 98122
206.467.8734
866.218.7878
info@artisttrust.org

Arts & Entertainment Insurance offers a variety of insurance packages for film and video production, commercial photography, audio production/music and more. They also offer a variety of benefits for stylists, performance and visual artists, advertising firms and computer graphic companies.

Arts & Entertainment Insurance
PO Box 1048
Marblehead, MA 01945
800.676.9374
info@aeinsurance.com
www.aeinsurance.com

The Center for Creative Innovation has information on insurance for artists. Located in Los Angeles, they provide many other support services as well. They can be found online at www.cci2000.org.

The Crafts Report, a monthly business magazine for the crafts professional, provides crafts resources on its web site, including a fire/liability/health insurance resource guide. www.craftsreport.com

Craftsman Protection Plan offers property insurance for home, studio, work-in-progress, raw materials, tools, work-on-exhibit and work in transit.

Association and Society Insurance
Craftsman Protection Plan
PO Box 2510
Rockville MD 20852
301.816.0045 or 800.638.2610 ext. 103
custsvc@asicorporation.com
www.asicorporation.com

The CSI Group is an entertainment insurance broker providing insurance consulting/coverage for the entertainment industry. Programs are available for: concert promoters, touring artists, theaters, event production, exhibitors, film production, booking agencies, etc.

CSI Insurance Management
2920 Taylor St.
Dallas, TX 75226
800.204.1523
www.csicoverage.com

Flather & Perkins has two basic policies for artists, a $500 general liability plan that covers slip-and-falls (medical payments), product liability, loss of equipment other than computers (computers are a separate area of coverage), business vehicle accidents and fires, and a $1,500 fine arts package that covers the value of the artwork itself when there is damage, theft, or destruction in and out of one's studio. Part of that plan covers works-in-progress, paying the artist labor and materials costs if the piece was less than half completed when damaged or destroyed and the full selling price if the object was more than half finished. Flather & Perkins, Inc.

888 17th St. NW
Washington, DC 20006
800.422.8889
info@flatherperkins.net
www.flatherperkins.net

Hartford Financial Services Group, Inc. provides small and home-based business insurance.

The Hartford
Hartford Plaza, 690 Asylum Ave.
Hartford, CT 06115
860.547.5000
www.thehartford.com

Independent Insurance Agents & Brokers of Washington offers a full range of products for home, rent and business.

Independent Insurance Agents & Brokers of Washington
15015 Main St., Suite 205
Bellevue, WA 98007
425.649.0102
info@wainsurance.org
www.wainsurance.org

Insurance Information Institute aims to improve public understanding of insurance.

Insurance Information Institute
110 William St.
New York, NY 10038
212.346.5500
www.iii.org

Insurevents.Com insures most areas of the entertainment, sports, leisure and special events industry. They provide policies that are needed for events including general liability, adverse weather, event cancellation, property, prize, auto, workers' compensation, accident, and medical coverage.

Insurevents.Com
6033 W Century Blvd., 4th Floor
Los Angeles, CA 90045
800.279.6540
support@insurevents.com
www.insurevents.com

Jewelers Mutual Insurance Co. provides property and liability coverage for businesses, a jeweler's block policy for inventory, or insurance for personal jewelry.

Jewelers Mutual Insurance Co.
24 Jewelers Park Dr.
Neenah, WI 54956
800.558.6411
communications@jminsure.com
www.jewelersmutual.com

John Buttine Insurance provides coverage strictly on a per-show basis, costing $175 for up to $2 million in general liability protection and $300 for $50,000 in property coverage.

John Buttine Insurance
125 Park Ave., 3rd Floor
New York, NY 10017
800.964.4454
www.buttine.com

MusicPro Insurance Agency provides insurance for the music professional. Coverage for instrument and equipment, studio, tour or composer liability, travel accidents and business.

MusicPro Insurance
45 Crossways Park Dr.
Woodbury, NY 11797
800.605.3187
Insurance@MusicProInsurance.com
www.musicproinsurance.com

Near North National Group established Fine Arts Risk Management, Inc. to provide property insurance of fine art and collections for museums, galleries, dealers and private and public collections.

NNNG Fine Arts Risk Management
875 N Michigan Ave.

Chicago, IL 60611
800.859.6719
nnng_info@nnng.com or www.nnng.com

Safeco offers a variety of business products and coverage. Your agent will talk through your needs and recommend a combination of coverage from Safeco's menu of products, including: business property and income, business liability, commercial auto, worker's compensation, crime & burglary, and umbrella coverage.

Safeco
4333 Brooklyn Ave. NE
Seattle, WA 98185
206.545.5000
www.safeco.com

Small Business Service Bureau (SBSB) is a national small business organization whose members are self-employed, have home-based businesses, etc. SBSB offers business overhead insurance for home-based businesses.

Small Business Service Bureau
554 Main St., PO Box 15014 Worcester, MA 01615
800.343.0939
membership@sbsb.com
www.sbsb.com

Thomas & Pratt Insurance has insurance policies for artists.

Thomson & Pratt Insurance Associates, Inc.
1223 Wilshire Blvd., Suite 590
Santa Monica, CA 90403
877.334.6327
www.fineartguy.com

USAA: provides products and services to help military members and their families reach their financial goals. They offer services for banking, investing, insurance, financial guidance, shopping and discounts.

 ## Objectives

Understand basics of health insurance and what options are available to artists

 ## Things To Do

Research what health insurance options are available to you and schedule an appointment with a health insurance agency to talk about your health insurance policy.

 ## Health Insurance

This article was originally published as part of GYST's Artists At Work Newsletter and has been reposted on the GYST blog at www.gyst-ink.com*

Long-Term Care: Taking Care of the Future
By Michael Grodsky

"It can never happen to me" is no way to look at the future. If you knew that your home had a two-out-of-three chance of experiencing significant damage by fire, how would you protect yourself against that risk? Your first thoughts might be about moving to a different location! But what if all residences had that risk? Your options include accept the risk and do nothing, transfer the risk by purchasing insurance, or self-fund against the risk.

Taking Care of the Body Electric

The risk we're addressing today is the possibility of needing and paying for Long-Term Care—for you, your family and loved ones. When it comes to your future, make sure you see the big picture. After all, life is full of surprises. I was surprised to learn that more than 70% of us who live to "retirement" age will need long term care at some time in our lives.

We don't have to lose independence and control over our lives as we get older. Instead, long-term care planning is about living well as we age. Currently, 83% of long term care is provided in the home or community, while only 17% is provided in a nursing home. (1) However, 40 percent of people over the age of 65 will need care in a nursing home for some period of time, and the average cost in Los Angeles is over $80,000 per year. (2) According to the nonprofit American Health Care Association (www.ahca. org), "Failure to prepare for the cost of a nursing facility stay or other long-term care is the primary cause of impoverishment among the elderly."

LTC is not just for the elderly:

Accidents and sudden illnesses can happen to anyone regardless of age or how well you take care of your health. 40 percent of people currently receiving long-term care are adults 18 to 64 years old. (3) Long-term care insurance can help protect against these potential financially devastating events. The key is to plan early, know our options, and to take action to ensure a good future.

Medicare doesn't cut it

Disability or health insurance do not provide long-term care, and in general neither does Medicare. In California Medi-Cal (4) will pay for long-term care, but a person's assets generally

have to be paid down to $2,000 or less in order to receive benefits. After death, Medi-Cal may recover costs of care from the estate. Steve Lopez' article "State reaches Into grave for funds" describes one person's discovery of this estate recovery program . (Los Angeles Times, October 21, 2007).

But the California Partnership does

The California Partnership for Long-Term Care (5) is an innovative program of the California Department of Health Services in cooperation with a select number of private insurance companies. These companies have agreed to offer high quality policies that must meet stringent requirements set by the Partnership and the State of California. It can take the guesswork out of selecting a high quality policy.

The Partnership's mission is to provide affordable, quality long-term care insurance protection, so you won't be forced to spend everything you've worked for on long-term care.

A unique feature of the Partnership policies is that it protects you from having to spend down your assets, should you use up your private long-term care benefits and need to apply for Medi-Cal assistance. The asset protection feature enables you to purchase policies with coverage equal to the amount of assets you want to protect from approximately $47,000 up to your total assets - with the assurance that these assets are protected for life, no matter how extended or expensive your long-term care needs may be. Without a Partnership policy, you could only achieve lifetime asset protection by purchasing lifetime coverage... something most people cannot afford. This added protection comes only with the purchase of a Partnership policy.

The bottom line: cost and eligibility

Long-Term care insurance is expensive because the costs it insures against are so high. If you purchase ltc insurance you're covered from day one, and you're paying a sum each month or year instead massive expenses over a short period of time. But unlike health insurance premiums that increase with a person's age, long-term care premiums are fixed by the person's age when they first obtain insurance. It's never cheaper than when you're 30 years old, and the cost of waiting exceeds the money you'd save by delaying.

The good news is that although premiums are fixed, benefits are NOT, because of a policy feature called inflation protection. For example, a $310,000 lifetime benefit might cost a 48 year-old married person $2,000 during the first year of coverage. 30 years later at age 78, the lifetime benefit is now over $1,250,000 because of 5% annual compounding. The premium is still $2000 per year (It is possible that future rate increases may be approved by the State of California, affecting everyone equally. Individual rate increases are not allowed).

Regarding eligibility, there is no guarantee you will be accepted. The requirements vary based on an applicant's age, medical history, medical follow-up, functionality, and cognitive awareness. Any change in your health increases your risk of being uninsurable. Below we'll mention some other ways of planning for ITC expenses.

Upon whom are you counting for help if you need LTC?

Are you going to rely on friends and family? Whether they're working or not, assisting you could be one of the most demanding situations your family and friends will ever encounter.

Even if their intentions are good, will they be physically and emotionally capable of providing you with all the care you need? Could they afford the loss of income, and would you feel comfortable with the sacrifices your caregivers may have to make?

What does LTC insurance cover?

It pays for a variety of services and supports to meet health or personal care needs over an extended period of time. Most long-term care is non-skilled personal care assistance, such as help performing everyday activities such as bathing, eating, dressing -- even shopping, cleaning, cooking, and paying the bills.

What if I invest the premium cost myself instead of paying for insurance?

Because costs for long-term care continue to rise each year, not only do you need to consider the costs today, but also what sum may be needed in the future. By purchasing insurance you're covered with the maximum benefit from day one.

How much can I afford to pay?

General guidelines suggest premium cost should not exceed 7% of income. You need adequate cash reserves and income to make sure you can afford the ongoing payments. The younger and healthier you are the better in terms of your premium cost. Long-term care insurance is not the right choice for every person.

What if I don't need long-term care after all? Are there alternative ways of insuring the risk?

Most ltc policies allow a "return of premium" rider for additional cost. Other financial products include whole life insurance policies with a long-term care rider – if you need the long-term care benefits they are available to you, but if not you can use the account value yourself or pass to heirs.

Are there any options for those who are not insurable due to health conditions?

Some companies have a rider that allow an uninsurable spouse to receive benefits. Others specialize in insuring higher-risk people. Lastly, there are annuity products that include long-term care benefits.

As with any insurance or financial product, there is no "one size fits all" solution. Financial suitability, needs and circumstances should determine the selection of any long-term care solution.

I hope that you, your parents, and loved ones will not ever need long-term care. "It can never happen to me" can be a valid way to look at the future, as long as you have a plan for "If it happens to me." But many people are simply unwilling to face up to the likelihood they will some day need long term care. Fully half of those surveyed agree with the statement, "long-term care is something I won't need until I am older, and I don't want to think about it now." ("Americans Fail to Act on Long Term Care Protection," American Society on Aging, May 2003). Visit the California Partnership for long-term care website for more information.

Footnotes

1. Georgetown University Long-Term Care Financing Project, Fact Sheet Article: "Who needs long-term care?," May 2003

2. Genworth Financial 2007 Cost Of Care Survey. (http://tinyurl.com/23r2fo)

3. U.S. Dept of Health and Human Services. (www.longtermcare.gov)

4. Medi-Cal (http://www.dhcs.ca.gov/services/medi-cal/Pages/default.aspx)

5. The California Partnership for Long-Term Care (http://www.dhcs.ca.gov/services/ltc/Pages/CPLTC.aspx)

 Objectives

Understand basic tax issues and things that artists need to keep track of in order to file the right kind of tax forms.

 Things to Consider

You can find an arts accountant to talk about financial and tax issues. Most other accountants do not know about arts laws, so an arts accountant is a must.

 Things To Do

Download the tax forms you think you need (based on research) and practice filling them out.

 Introduction to Taxes

It is important that you understand just how the IRS looks at an artist's business. If you choose to hire an accountant, it is vital that she or he understands the tax code as it pertains to the arts. Many artists have been audited by the IRS because they were given bad advice by an accountant who was good at general tax information, but wasn't knowledgeable about how tax law effects artists. Ask your fellow artists, nonprofit organizations or your local Lawyers for the Arts for suggestions. (See also Business Licenses and Self-Employment sections)

Taxes

This is a brief overview of tax preparation and is by no means an exhaustive be-all end-all solution to your tax questions. Plenty of web sites will give you more detailed information, or you can contact your local government office.

You will need to file both state and federal taxes, as well as 1099 forms. If you collect money for goods, you will need to charge and file sales taxes, which differ from state to state. You may also be required to charge and file city taxes. If you have employees, you will need to know the laws for employee taxes. If you are overwhelmed, this is a good time to consult an accountant. Be sure that your accountant understands the art laws, or you may get into trouble.

Most visual artists are considered "self-employed" in regards to filing their taxes. In a legal and taxpaying sense, this means that your "business" as an artist, and you as an individual taxpayer, are one and the same. There is no legal separation, such as one would have in a corporation, partnership, LLC or other legal entity. The artist usually files a "Schedule C" as part of their regular 1040 income tax form, which is where you report your art income and expenses. The artist may file a form 8829 for the home office (studio) deduction and will also be required to pay self-employment tax (Schedule SE) on your net income (profit) as well as federal income tax. All these forms are part of the year-end 1040 income tax filing. As a self-employed artist, you will usually be required to pay estimated quarterly taxes using Form 1040-ES if your Federal tax liability is over $1,000 for the year.

For the IRS, deductible business expenses are:

• Incurred in connection with your trade, business, or profession

• Must be "ordinary" and "necessary"

• Must "NOT be lavish or extravagant under the circumstances."

It does not take much analysis to see that these guidelines are not an exact science. The artist has a large group of basic expenses that easily fit the above criteria: travel (hotel, meals, etc.), vehicle and transportation costs, equipment, art supplies, home studio expenses, legal and professional fees, gallery costs and commissions, etc. Below are some of the more complex and contentious deduction areas.

Is Being An Artist a Business?

For tax purposes, to comply with the IRS, an artist must consider if their art practice is a business or a hobby. Artists often have financial losses—overhead exceeds the profit brought in by the sale of the artwork. When does the tax code determine an enterprise to be a business as opposed to a hobby?

Hobby

Although you must claim the full amount of income you earn from your hobby, hobby-related expenses are generally deductible only to the extent of income produced by the activity. Therefore, if you do not generate any income from your hobby, you cannot claim any deductions. Furthermore, even those hobby expenses which can be deducted are subject to an additional limitation: they are considered miscellaneous itemized deductions on Schedule A, which are deductible only to the extent that they exceed two percent of your adjusted gross income. By contrast, if your activity can be classified as a bona fide business, you may be able to deduct the full amount of all your expenses by filing a

Schedule C. In short, a hobby loss will not cut your overall tax bill because the tax law stipulates that you cannot use a hobby loss to offset other income.

Business

As a business you can deduct a net loss from other income you earn, such as wages and salaries. How does the IRS determine whether your activity is a hobby or a for-profit business? The Internal Revenue Service publications discuss these nine criteria:

• Whether you carry on the activity in a businesslike manner.

• Whether the time and effort you put into the activity indicate you intend to make it profitable.

• Whether you are depending on income from the activity for your livelihood.

• Whether your losses from the activity are due to circumstances beyond your control (or are normal in the start up phase of your type of business).

• Whether you change your methods of operation in an attempt to improve profitability.

• Whether you have the knowledge needed to carry on the activity as a successful business.

• Whether you were successful in making a profit in similar activities in the past.

• Whether the activity makes a profit in some years, and how much profit it makes.

• Whether you can expect to make a future profit from the appreciation of the assets used in the activity.

The primary determinant is your ability to make a profit at what you are doing. If your efforts result in a profit in three out of five consecutive years, your activity is presumed not to be a hobby by the IRS. You may have to prove to the government that you have made a genuine effort to earn a profit. Therefore, keep meticulous business-related records and conduct yourself in a businesslike manner.

You need to keep track of the following expense items:

travel expenses
office rental (whether at home or not)
commissions or payment to managers or employees
equipment used in your trade
auto insurance and repairs
supplies and materials
special clothing or safety equipment for your work
legal and accounting
fees or services
bank fees
studio rent and expenses
utilities including phone/internet
entertainment and meals related to your business
business fees
rental of equipment
publications and research materials, periodicals
fees for workshops and other seminars
memberships or other dues
shipping or mailing
repairs or maintenance
insurance
advertising
sales taxes

You need to keep track of the following income items:

proceeds from the sale of your work
income from rented or leased work
wages or salary paid for work as an artist, including honoraria, commissions, fees and stipends
grants, awards and fellowship funds
copyright royalties for published or distributed works
advance payment for work to be completed in the future
sales taxes

You should have the following information for each item:

Date
Amount
Buyer
Reason for the income or expense
Check number or other tracking number or indication of other form of payment

Sales Tax

Each state has a different sales tax. Check the business section of your state web site, or call the State Board of Equalization.

Out of State Sales

Most states do not charge for sales made out of state.

Resale Cards

If your client is buying wholesale, and intends to resell your work, and they have a resale license, you do not charge tax. If it is a resale buy, and they are not going to resell it, you should collect the sales tax.

49: Bartering & Trading

 ## Objectives

Understand the legal issues about bartering and trading.

Understand how bartering and trading can work for artists.

Bartering and Trading

Artists often barter and trade their work in exchange for goods and services, such as medical and dental work, outside labor, materials and supplies, and rent. It is important that you know how the IRS regards such transactions so you do not get yourself into trouble.

There are two kinds of bartering and trading systems: the "retail trade" exchange and the "corporate barter." Most artists engage in retail trade, since corporate barter applies to multimillion-dollar companies. Applicable federal, state and local taxes must be paid on both transaction types. An example of a retail trade exchange is trading a painting for another commodity. Assuming that the trade is for items of equal value—say, the car and painting are each valued at $2,000—then each receivable must be treated as income. This means that both the car "buyer" (artist) and the car "seller" owe federal, state and local taxes on $2,000.

If the artist barters for supplies and materials to be used for making artwork, the tax ramifications are different: artwork is taxable to the receiver as if it were a retail sale; the artist can deduct the fair market value of the goods, as with any other business expense.

There are "Barter and Trade Exchange" groups that help facilitate such transactions. You can find them online by doing a simple web search.

Artists have been taken to court to pay back taxes on bartered items that were not reported as income to the IRS. Check the laws and be sure to keep a record of all transactions. If the IRS audits you, they will look for such failures to disclose.

Here is an example from the IRS web site: An artist gives a work of art she created to the owner of an apartment building in exchange for 6 months rent-free occupancy. The artist must report the fair market value of the apartment as income on Schedule C or Schedule C-EZ (Form 1040) and the apartment building owner must report the fair market value of the artwork as rental income on Schedule E (Form 1040). Both should agree to report the exchange.

Be sure you work out any details of bartering or trading with your gallery dealer; your agreement with them might be violated should you choose to barter without giving notice.

In addition, make sure that you are bartering a fair and equal trade. If you are bartering a work that is worth $1,000 for a $500 trade, you are selling yourself short. Artists deserve respect for their work, as does any other working professional.

Resources

The IRS's website on Bartering:
http://www.irs.gov/businesses/small/article/0,,id=113437,00.html

IRS Tax rules on Bartering:
http://www.irs.gov/businesses/small/
article/0,,id=188094,00.html

50: Billing & Collection

 ## Objectives

Understand the basic aspects of billing and collections in order to make sure you get paid.

Billing and Collection

It is very important that you keep track of all the sales of your work and not rely on a gallery to do this for you. Galleries go out of business, lose records, or even sometimes try to deny payment to artists. Having accurate records for each sale will help you to collect payments, arrange accurate tax records, and generally insure that you are paid for your work.

Make sure to create a bill of sale for each commercial transaction, as well as for barters and trades. You can create this using the forms in this manual or your GYST software. You might also want to use the GYST software to generate a contract for more complicated transactions.

A bill of sale should include the date, title, size, description and medium of the work, and the buyer (including address, phone number and email). The price of the work and the terms of payment are important, as well as any delivery information. (See contract section for examples of Bill of Sales)

If you make special payment plans for certain individuals, make sure to include the payment plan in the bill of sale. You should always retain the work until the final payment is made.

Always maintain a list of the work you have on consignment with a dealer, a gallery or an art consultant. Forms for loans to galleries and institutions are available in the GYST software.

If you work with a gallery make sure to get a list of works that have sold, including names, addresses, phone numbers and emails. You might want to request that the gallery provide you this list for each fiscal quarter. While some galleries don't want to give you this information, it is illegal for them to withhold it.

Simply put:

• Know where you work is at all times.

• Keep in touch with all clients regarding sales.

An artwork's provenance—the history of where it has been shown and in which collections it has been included—is crucial for your records, and is often referenced in monographs. Being disorganized means more work for curators down the road. (Imagine having a retrospective without knowing where your art is located!) Labeling the back of the work may facilitate such record keeping and is good for posterity. Use the GYST software to generate provenance lists and artwork inventory labels.

Make sure your collectors know about the Visual Artists Rights Act and any state Resale Royalty Acts when they acquire work. (See Legal Section)

51: Charitable Contributions

Objectives

Understand what constitutes a charitable contribution.

Understand the basic legal issues of charitable contributions.

Understand when something is tax deductible.

Charitable Contributions

Since artists are always being asked to donate something, before making a commitment to donate, consider the following:

• A charitable gift is a voluntary transfer of money or in-kind goods or property that is made to a 501(c)(3) organization with no expectation of a commensurate return. If the donor receives a financial or economic benefit in return for the gift, it is not a deductible contribution, unless the donation's value surpasses the value of benefit to the donor.

• Only donors who itemize deductions on their federal or state income tax returns may deduct gifts to qualifying nonprofits.

Therefore, a donor must keep records of contributions. For contributions less than $50, a canceled check, or cash or credit card receipt, will suffice. For contributions of $250 or more, the donor must obtain a written acknowledgment from the charity with the date and the amount of the contribution, as well as a list of any benefits, and an estimation of the value of those benefits.
There are special rules as to what can be donated. For example, in-kind services do not always carry a deductible value. It is a good idea to check if your donation merits a tax deduction.

See the Independent Sector Web site at www. IndependentSector.org for more information.

Donating Work (self-commissioning)

As an artist, never assume that an institution or organization wants your donated artwork in their collection. Always query organizations about their acquisitions policies, acquisitions budget, or whether they buy art at all. With this knowledge in mind, consider if your artwork fits within their parameters. This will save you time and effort.

Set realistic goals. Do not solicit organizations or museums that will not consider donations from artists who do not have a prior history with museums and public institutions. Never cold-call any major organizations to sell them an expensive work of art. These sorts of accomplishments accrue gradually during the course of an artist's career, and as the artist builds recognition within the art community. You have got to work your way up to major commissions and large sales while setting more realistic short-term goals.

Leave the judgment of your work to museum curators and art business professionals, such as dealers and art consultants. Be open to selling and exhibiting your work at organizations that you might have overlooked at first. In other words, do not limit the circumstances in which your work can be sold and bought.

Make sure your asking price is significantly higher than demonstrated in your resume. Start by comparing your prices to those of artists with similar experience and accomplishments.

52: Commissions

 ## Objectives

Understand how commissions work and the things you need to consider when considering taking on a commission.

 ## Commissions

Basic Rules of Commissions

Successful commissions come from communicating directly with the client before and during the process of creating artworks. Setting up a clear relationship with the client enables you, the artist, to respond effectively to the client's concerns, requests and needs. When taking on a commission, it is crucial that you are able to be flexible and work well with people.

If you take on a commission from a client you do not know, be warned about a few pitfalls. No matter how badly you need the money, never sell your work or your services for less than they are worth. It may come back to haunt you later on in your career. Always meet with the potential client to discuss the details of the commission, preferably at your studio. This way the client has an opportunity to see a variety of pieces. Otherwise, you will feel constrained to produce a specific composition or style.

For a commission to work both the client and you have to imagine the creation of the art in pretty much the same way. Differences in initial perception can lead to problems later in the process, when it is often too late to make changes without incurring additional expenses.

Questions to ask a prospective client about a commission:

• Find out how many works the potential client has commissioned and their prior experience. Ask for the names and contact information of artists they have commissioned before and use them as references. The larger the number of commissions, the less likely you are to encounter problems.

• If the client has never commissioned an artwork before, find out what they want and make sure you can give it to them. If they have unrealistic expectations that you cannot fulfill, turn down the job. Often, first time clients do not know the processes of commissioning, so you may need to train them. Understanding the contract, the timeline, and the costs are as important as coming to terms with their more subjective requests.

• Ask the client what they want to see in the final project. Look for broad answers that have to do with the way your art makes them feel, if they are interested in a specific message, what you stand for as an artist, etc. Very detailed or specific answers may mean that they will try to micro-manage the project. The clearer the understanding you have of their desires, the better you will be able to respond.

Make sure you find out what elements they do NOT like. The less they do not like, the better. If they do not like something that you cannot do much about, warn them now rather than later, or turn down the commission. Finding out what they do not want will help you avoid potential pitfalls.

• Find out if they will be the only one approving the art. You want a "yes" answer here. The more people you have to please, the less likely you are to succeed. If someone else is going to approve the work you may need to meet with them as well.

• Be sure to ask them if there are other questions or requests not addressed in your agreement. An answer like "not really" is always good. Hopefully, you will not get a long involved answer.

• Go ahead with a commission only after you and the client are on the same page and have signed a contract. See Commission Contracts in this manual.

• To avoid a client backing out of a commission allow the client to periodically view the progress of the artwork and get their approval. This way you and the client will avoid any miscommunications about the final piece. Another way to avoid conflict is to encourage dialogue while under contract and never change the aesthetics of the artwork once it is under way. The more homework you do prior to accepting the commission, the more likely you will know how to conduct yourself while creating the work.

Contracts with Commissions

The contract should include the following information: basic characteristics of the art, payment schedule, late payment fees, completion time, and final delivery date. Verbal agreements are never a good idea and can result in disputes down the road. Always require a one-third advance of the total cost of the commission, which will take pressure off of your production schedule. The non-refundable advance commits the client to buying into a successful outcome or artwork.

Refusing a Commission

Once you accept a commission, never wait until the last minute to start the work; waiting can get you into trouble. It will hurt your career to be tardy with delivery of your work. Few clients are interested in working with artists who do not take themselves seriously enough to deliver on time.

Never accept a commission that you are unable to competently execute because the client might not be satisfied with the final piece. Also, never let the client have too much control over the final look of the art, lest it feel like he/she is breathing down your neck, which is not fun. Make sure that you are completely satisfied with the final piece.

Lack of effort or skill may backfire later in your career. Be cautious when considering making art outside of your skill level or medium just for the money.

Problems

If you have problems and cannot work them out with your client, you may need to contact an arts lawyer. Remember that Lawyers for the Arts may offer a discounted rate on legal advice.

53: Community Service

Objectives

Understand how community service can benefit an artist.

Community Service

Community service is a good way to keep in touch with what is going on in the art world, your neighborhood or region. You can participate as a volunteer at a nonprofit organization, teach classes in the arts, donate art, or simply stuff envelopes. Every bit helps. Many organizations were founded to help artists develop and perfect their professional skills, as well as provide exhibition opportunities. You can find many of these organizations online.

The website Art-collecting.com has a fairly comprehensive list of nonprofits around the country.

Most organizations have volunteer positions, internships and a board of directors. Contact them directly and ask if they need assistance in any way, particularly if you possess a needed skill, such as graphic design, or you are a technology wizard, or you just want to make new friends and meet other artists.

If you have been supported by nonprofit organizations, please consider giving back by volunteering, donating art or serving on a committee. If you have not directly benefited from the organization, consider supporting them anyway, as it helps the next generation of artists to have a support system.

Consider getting involved with community organizations that support issues pertinent to your work. Also working with nonprofits in your community can influence your art practice and your work can, in turn, bring attention to the nonprofit.

54: Disabilities

 Objectives

Understand basic concepts of art and disabilities. Understand the factors that artist with disabilities face. Understand aspects to consider when making work that the disabled can view.

 Things to Consider

A number of communities have organizations or individuals who work with artists with disabilities. If this is applicable to your interests or concerns, contact them and ask if they can speak with you.

Art and Disability

Written by Christine Leahey for GYST

The arts can offer a unique opportunity for social and economic participation by people with disabilities, and the removal of architectural and attitudinal barriers to their participation should be regarded as a vital extension of the Civil Rights Movement. This section is written by Christine Leahey, a disability rights advocate whose area of scholarship is the confluence of art and blindness. Ms. Leahey graduated from Swarthmore College in 2000 with High Honors in art history and special education, and she has since provided consultation to the Berkeley Art Museum, J. Paul Getty Museum of Art, Los Angeles County Museum of Art, and Philadelphia Museum of Art on the topic of cultural access, specifically for individuals who are partially sighted and blind.

Defining and Disclosing Disability

The World Health Organization recently adopted the most progressive definition of disability in its history. According to the International Classification of Functioning and Health (2000), disability is now defined as a "dynamic interaction between an individual and the environment." This is a radical, paradigmatic shift away from regarding disability as a static, physical and/or mental disease towards an acknowledgment of disability as a highly individualized, lived experience that is profoundly influenced by social participation.

The fact that disability is no longer narrowly defined bodes well for artists with disabilities. As the above definition suggests, artists with disabilities have the prerogative to define their personal experience of disability, and to determine if and how it informs their artistic practice.

One thing is certain: an artist should never feel obligated to disclose to a curator that she or he is disabled. This is especially true if the artist's primary objective is to have her or his work reviewed on its own merit. However, if disability is a prominent theme in the work, or if disability is integral to the artist's self-conception, then it may be appropriate. A subtle mention can be made in a resume or artist statement; a bold remark can be worked into a cover letter. Whatever the choice, it should be presented with confidence.

This is not to say that it will be understood.

Invariably, artists with disabilities will be asked how they are able to produce their art. It is, in fact, the first and most frequently asked question, and it is a loaded one at that. Weighted by stereotypes about what it means to be disabled, it is often a veiled way of asking a very different question. That is, why would someone with a disability ever bother to make a work of art, especially in a medium that the artist cannot perceive in the same way as a non-disabled person? When the question is posed endlessly—and again and again in a tone of disbelief—it can be emotionally exhausting to answer.

Yet, dealing with such honest, albeit naïve, questions may be the single most effective way to increase public awareness about the nature of disability, and about one's artistic process. In the long run, it can prove beneficial to be patient, generous, and self-reflective when asked about the relationship between art and disability, for the questions also create an opportunity for disability to be undefined and redefined, and for the artist to determine how to publicly engage with his or her own disability.

Cultural Access and the Law

Although enforcement mechanisms are sorely lacking, there are legal provisions that protect the rights of individuals with disabilities. Most notable is the Americans with Disabilities Act (ADA 1990). Section 504 of the ADA specifically addresses arts access. The Architectural Barriers Removal Act (ABU 1973) predates this legislation by nearly two decades. Both mandate that buildings cannot have impediments to the free and safe movement of people with disabilities, and they define such things as accessible rest rooms, doorways, and parking spaces. These laws are administered by the Department of Justice because they

safeguard civil liberties. They are most strictly enforced in government buildings and institutions that receive public funds.

The Americans with Disabilities Act is somewhat vague, for it requires only "reasonable accommodations." The Supreme Court has made contradictory and incomplete rulings on how that term is to be defined. Controversy surrounding the term—including the very words it is comprised of and the intent of the legislation's authors—is fascinating and important. However, it is widely accepted by the disability community that attitudinal barriers can be more potent that architectural ones. The way in which an individual or a community with a disability is perceived, treated and portrayed can greatly impact their social and economic participation.

With respect to artists and art audiences that are disabled, a common attitudinal barrier is simply being treated differently than non-disabled folks. For example, the predominant complaint of museum visitors who are disabled is that security guards stalk their every move— sometimes going so far as to follow them out of the building. (This is especially true of individuals who are partially sighted or blind.) The attitude betrays a misconception about disability: that it warrants dependence and mistrust, fear and disdain, and a host of other stereotypes.

Artists and their supporting institutions can reverse this trend by simply welcoming artists and audiences who are disabled, even if they are not entirely certain of the best practices for ADA compliance. Access begins with dialogue. Much as the general public asks artists with disabilities How do you make your art?, artists with disabilities want to know When will you open your doors? So that they can help realize full inclusion and share their art practice within a supportive community.

Organizations can be helpful not only by making their spaces accessible, but also advertising such inclusiveness on all press releases and announcements. Many newspapers and publications add a wheelchair symbol next to Calendar Listings that means that the event is accessible to people with disabilities. Many people who are in wheelchairs will come to your events if they know that they can get in.

Always indicate accessibility on your exhibition announcements. This will increase your audience and, more importantly, will publicize your compliance to a wide audience—demonstrating a best practice for other institutions.

Approaching Curators

To be treated with equal consideration, artists with disabilities must approach curators and exhibition opportunities with a level of professionalism that is equal to that of any able-bodied artist.

There is no denying that obstacles persist, with limited mobility and financial constraints posing unique and major burdens. However, within the mainstream and high-end art markets, artists with disabilities must do much "leveling of the playing field" on their own accord. That is to say, curators should be presented with exactly what they ask for—whether it means meeting a concrete deadline, preparing work so that it is completely ready to hang, or remaining active in the studio. The art market can be extremely competitive and unforgiving, especially when opportunities are prestigious or lucrative, so the best practice for any artist is to be a highly organized, consummate professional.

For emerging artists with disabilities, the advice proffered in this publication applies more or less without exception. It should be added, however, that curators need to be advised of any accommodations well in advance of their need—especially if they will impact an installation or opening reception.

In addition to traditional exhibition opportunities, there are numerous shows around the country that are specifically designed for artists with disabilities. Many of these are annual juried group shows that may require an entry fee and may award cash prizes. Their treatments of disability—as indicated by marketing material and the ways in which work is chosen and displayed—vary widely and depend, in part, on the degree of artist involvement in the concept, how long the exhibit has been produced, and whether or not the organizing institution is arts-related. Not all of these exhibition opportunities are progressive, but many offer applications in an accessible format and excellent nationwide networking opportunities within the disability community. They may serve as an endpoint in themselves or an inspiration to pursue mainstream, integrated opportunities in the arts.

Perhaps it is easier said how not to approach a curator than how to approach a curator because there are countless variables to consider. However, the most important goals for artists with disabilities should be to:

• Keep making artwork, in spite of any challenges posed by a disability

• Ensure that both the curator and the venue respect the integrity and value of the artwork.

Communication

Language provides perhaps the most significant evidence of one's attitude towards, and understanding of, disability.

There are a few simple communication practices that demonstrate respect for individuals with disabilities. First, make eye contact and speak directly to individuals with disabilities. Second, be mindful of how to refer to such individuals. For example, it is more considerate to speak of a "photographer who is blind" than of a "blind photographer." The former is known as People First Language because it privileges the individual over the disability. Lastly, rather than make assumptions, simply ask about disability, for it is a highly individualized, lived experience best explained by first-person narratives.

To artists with disabilities: your artistic statements and self-expression need to be made known. If your message happens to be about disability, know that the subject is indefatigable and the audience vast.

Dealing with the Press

Even though there have always been artists and art audiences with disabilities, the press tends to cover the subject of art and disability as a human-interest story more often than as an arts story. This is a reflection of our society's systemic misconceptions and ignorance about the nature of disability.

Yet, all opportunities for public exposure should be carefully considered, even when the placement and tone of a piece is less than desirable. The reason is that the press can be used as a tool to send the message of full inclusion to the widest conceivable audience.

Individuals with disabilities and their advocates should have polished, concise phrases that best articulate their cause and that model appropriate language about disability. Although editorial input may not be permitted, artists can always be in control of their self-promotion. The ability to speak clearly about one's artistic statement, and one's relationship to disability is therefore imperative.

Also, do not be intimidated by the media. The press generally need and want to be informed about how to address disability issues. Headlines, pull-quotes and emphases may be crafted for shock value, but it should be remembered that these elements are not often determined by journalists, but rather by their editors. Above all, the press should be acknowledged for any stories on disability, and especially those on art and disability. A thank you letter can reinforce that the subject is meaningful, and can rectify any misstatements for the benefit of future press.

Advocacy

It is significant—indeed, revolutionary—that this publication has a section on art and disability. It should go without saying but, as noted above, there have always been artists and art audiences with disabilities, and there always will be. The revolution lies in the fact that their prominent inclusion in the arts has happened only very recently—first getting major public attention in the 1970s (coincident with the Architectural Barriers Removal Act) and more forcefully in the 1990s through today (coincident with the passage and enforcement of the Americans with Disabilities Act).

Artists play a vital role in this social change because they keep political discourse alive, and they offer creative means for calling attention

to inequality. All of the artists who read this publication have the wherewithal—and, indeed, a moral imperative—to influence the full inclusion of artists with disabilities. They need only to be aware that disability exists within artistic communities, and to ask that those communities value equal opportunity.

Forging Complaints

Individuals with disabilities will inevitably encounter discrimination from both people and places in the arts world because—to quote this publication's title—certain people and places in the arts world many not have "gotten their sh*t together"!

Acts of discrimination can be emotionally charged, as they are often rooted in fear and ignorance. In additional to attitudinal barriers, explicit and willful civil rights violations may be experienced. A common infraction is the denial of gallery or museum entrance to individuals with service animals.

An individual's response to such negative experiences can dramatically impact the mission of full inclusion of people with disabilities in the arts. Points for consideration include:

• Did the discriminatory act happen in a public or private space?

• What may have been the intentions behind the discriminatory act?

• Have I attempted to communicate the wrongdoing—to give an initial benefit of doubt?

• Does this person or place have prior experience with the disabled community?

• Am I the best person to forge the complaint, and should I forge it alone?

• How might my reaction impact public perception of the disabled community as a whole?

Many different tactics can be taken—and it is not uncommon for such experiences to become fodder for an artistic statement—but most important is the understanding that every individual has the prerogative to advocate for him or herself.

Pete Accrete, a Sacramento based photographer who is totally blind due to Ruttiness Pigments, says of his conditional approach to advocacy, "I bring Gandhi in the gallery and Malcolm on the bus." That is to say, he generally takes a patient and sympathetic stance when addressing cultural barriers in an artistic setting, where dialogue has proven to be a productive means toward inclusion. By contrast, breaches of safety in public transportation–such as not calling out bus stops and not strapping down wheelchairs—can pose serious health risks. Accrete notes that city transit operators are trained and mandated to enforce the Americans with Disability Act and so should always be held accountable for violations.

It is generally advisable to make a written statement when a discriminatory experience is based on one's disability. This allows time to reflect on the incident and to make the most cogent, respectful response. A polite but firm letter can serve as a document of the incident and may help eliminate future barriers to cultural access.

Resources

Many organizations provide resources specifically for artists with disabilities and have

comprehensive web sites. Often times these organizations provide career development, adaptive resources lists, artists registries, publication resources, calls for entries, grant opportunities, and job listings. For more information, visit:

The National Arts and Disability Center
http://nadc.ucla.edu

Very Special Artists
www.artusa.org/

Art Beyond Sight
www.artbeyondsight.org/

The View From Here
www.zoot.net/theviewfromhere/

National Exhibitions for Blind Artists
http://nebaart.org/

Light House for the Blind and Visually Impaired
www.lighthouse-sf.org/

55: Ethics

 Objectives

Understand the role ethics play in constructing an art practice.

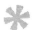 **Things to Consider**

What does having ethics mean to you? How have ethics manifest in your career?

Ethics

Treating Colleagues with Respect

Contrary to what some artists believe, curators, galleries, funders and the art world are not merely a support structure. They are, rather, partners in your creative pursuit. One unflattering aspect of many artists is their attitude of entitlement. They think the world "owes" them support, but it is simply not true.

If you are perceived as self important, you may get a reputation as difficult to deal with, and curators will lose interest, even if your work is strong. Respect their space. They have opinions and ideas of their own, and are not in the business of giving deference to ego.

Having good relationships with colleagues is important, and a collaboration is much more gratifying for everyone. Listen to what others have to say, and consider your role in the relationship.

Don't Be Selfish

Many artists are secretive about what they know and actively avoid sharing their knowledge. If you know an artist whose work fits the prospectus of an exhibition, by all means, let them know about it. Keeping information to yourself only hurts you in the long run. Artists who share information with each other get much further and develop excellent reputations. It is hard to be an artist, so be generous with your friends.

Don't Intrude on Other Artists' Spaces

It is inappropriate to solicit interest in your work at someone else's event, or at a party. Handing out postcards to your show at someone else's opening is tacky. It is okay to give one or two to a friend, but do not stand at the door and hand out your announcements. If you share a studio with other artists, don't invade their studio visits with curators. That is their time. It's OK to say hello, but don't drag the curator to look at your work.

Leaving A Gallery

How you leave a gallery can be really important. If your gallery has been supportive, treat them with respect and dignity. At least show appreciation for your partnership. Leave in a way that will honor your own integrity. Many artists leave newer galleries to partner with bigger galleries that have established reputations. Often an artist thinks the latter will help them advance their careers, but some smaller galleries will work harder for their artists than a gallery with a large roster. Do your research because this may not be the case for you, and gallery hopping will not strengthen your resume.

Reasons to leave a gallery are: not getting paid; your dealer is not actively pushing your work; other artists in the roster have lowered the quality of their work; personality conflict with the gallery or its staff; a breakdown in communication that cannot be rectified; or the reputation of the gallery changes.

Make sure when you decide to leave your gallery you have all the right paperwork and agreements in order. You will need to make sure the gallery returns all your work in a timely manner, pays you for any pending sales invoices, provides accurate records of all sales transactions of your work, and returns any materials, portfolios, or other things you have at the gallery. Depending on your relationship with the gallery, you may need to reconcile bills you owe to the gallery, like charges for framing or fabrication expenses.

Galleries That Tell You What To Make

Many artists have faced the dilemma of having their gallery dictate what kind of work they make. If a gallery encourages you to paint like another artist, or asks you to make five more of those yellow paintings because they sell well, you may be shortchanging your career. This kind of production decreases the value of important work and makes it appear as if you are just making work to sell instead of making work because it advances your practice. Think carefully before you go into production as a commercial artist.

On the other hand, if you have entered into an agreement with a gallery and the agreement stipulates that your work maintain its current conceptual/material attributes, you may need to renegotiate your contract or consider working with the gallery to make them better understand how your practice is shifting. Be true to your own vision, and change galleries if this persists.

Using Other Peoples' Images

An ongoing problem, which has increased dramatically because of the Internet, is that artists use other people's images without giving the artist any credit, or not changing the image enough to make it distinct from the original. Copyright infringement is actually quite serious, so if you are not sure of what is legal and what is not, be sure to check out the GYST copyright section.

Also, while not illegal, making work that looks like someone else's is unethical. Sometimes this happens unknowingly. But, if you saw a great image in Artforum, and then you remade it as your own, you are charging into unethical territory. It is, of course, permissible to give homage to another artist and to demonstrate your influences, but be aware of the gray areas of appropriation.

Don't Steal Other People's Ideas

Here is an exemplary anecdote. A visiting artist came to CalArts and did a lecture and studio visits. He met with a young artist whose work was very specific and distinct. A few months later, the visiting artist opened a show in New York that was a direct copy of the student's work. Since the visitor was a quite well know artist, and few people knew the work of the student, the established artist got great attention. That is, until the students and faculty at CalArts made sure that the art world knew what had taken place. Needless to say, the established artist's reputation has suffered irreparably.

Giving Back

Showing at nonprofit organizations, which are generally supportive of emerging artists, is a good way to start out an art career. Nonprofits

also tend not to require a percentage or take a small amount of any sales. If work does sell, it is smart for you to donate part of the sale of the work to the nonprofit, as they have spent time and money to support you. Once you are more established, consider giving back to those organizations that supported you at the beginning of your career. This way they can continue to support other emerging artists.

Do What You Say You Are Going To Do

If you say you are going to do something at a certain time, do not be late. If for some reason you have a really good excuse, call and let the other person know you are running late.

Other people have busy lives too, and if you do not show up with your work on time, you throw a wrench into everyone else's schedule and they are forced to work around you. You never know what kind of trouble you can generate when you do not follow through.

Desperation

A gallery owner can smell a desperate artist a mile away. Some commercial galleries thrive on desperate artists, asking them to pay fees for submitting work (see vanity galleries and juried exhibitions). Some galleries are now telling emerging artists that they will need to take 90 percent of the sales, giving the excuse that is costing them a lot more money to promote them as an emerging artist. Steer clear of any agreement giving you less than half of all sales!

Avoid appearing desperate. Don't send unsolicited work to galleries. Don't rush to sign contracts without reading them and having a lawyer look at them. Remember, all careers go through ups and downs. The trick is to stay smart and level headed in both good and bad times.

Bitterness

Exuding bitterness about your career is unhealthy and unproductive. It's hard to work with artists who constantly complain. If you are bitter, it is best to keep it to yourself.

The art world is a tough place, and you need to constantly work around obstacles, whether it is your health, a family issue or a job that gets in the way of being an artist. Instead of complaining, change your tactics, look at your career in a different way, and be pro-active.

Keep a diary, visit a therapist, talk to a mentor. There are appropriate places to productively state and address your personal problems and flagging career.

Don't Talk Shit

The art world is a teeny tiny place, and if you talk shit about other people at art openings, it may get back to them. Be wary of how you come across to others when you engage in this activity. Your personality can have a direct effect on whether people will want to work with you.

Be Professional

Your opening is an important time to have your sh*t together. Do not be unreasonably late. Most viewers come to see you, not just the artwork. If someone drives across town and they can only come early because they have somewhere else to be, and you are not there, they might not do it again the next time you have an opening. Also, do not get drunk at your own opening. Be alert and calm.

While it is tempting to only talk to your friends or family at your openings, be aware that this is

a time for you to talk to people uninitiated to your work. If you are showing at a commercial gallery the gallery director will probably want you to talk with critics, curators and collectors in attendance. So say hi to friends and family, be gracious, but also work to promote your work, meet people, make connections, and talk to strangers.

Criticism and Rejection

Remember that if you are not getting rejected, you are not applying enough. Contrary to the typical emotional reaction, rejection should not be taken personally—and may not even be a reflection on the quality of your work. Always try to get feedback on your proposals. Some funders do not allow this, but most will offer comments and, even if it is not their policy to provide explanation, they will respect the question. It may simply be that they are still unfamiliar with your work, or they have recently done too many shows of work similar to yours, or there was not enough information in the application. It is also important to know that most funders have a committee of your peers (other artists, curators, etc.) who rotate with each review panel. Hence, the makeup of the review committee can greatly influence how your work is received. It could be that you just need a little more experience. Do NOT give up applying for grants and other funding. Do NOT give up on applying for shows. Doing your research and making sure your work fits the application requirements is one of the most important aspects of getting grants and exhibitions. If you find out why you were rejected, you may be able to make changes, and reapply next year.

When you make a follow-up call, especially following a rejection, make sure that the receiver has time to chat with you. Other people in the arts are often understaffed and very busy. Some foundations only have one or two employees. Be courteous, and if they are busy, ask them when you can call back. Do not argue with them and just listen. You can ask a clarifying question, but remain professional at all times. You can learn a lot from the experience.

Deception

Deception can ruin a career. Don't lie about your past achievements on your resume because doing this will eventually come back to haunt you. Don't make sales behind your dealer's back and don't lie to collectors about work. If you make art out of materials that will decompose, you should disclose this to your dealer, the curator and the museum. Do not misrepresent the materials. Getting sued over a good joke is no laughing matter.

Artwork on Private Property

Creating artwork on someone else's fence, house, or other property is an issue that you should consider. Graffiti and tagging may be a valid art form, but it is expensive to paint over and clean up. Public property is just that—public; consider how your work will affect others in the community. Always be respectful of private property.

Don't Take Advantage of Other People

Making art that hurts others—such as hurting people to get a good image, or making children cry to get a great shot—should be considered carefully. If you are working with adults, get permission and make sure that they understand what you are doing. Get them to sign a model release form. If you are working with children you will need their parents to sign a release form. If you do work with kids or those who are

challenged in some way, be very careful when using manipulative tactics. You have no idea what terrors you are setting up for their future.

Eco Art

When making landscape art, you should consider if you are actually damaging the flora and fauna. Making an ecological statement, while at the same time destroying the very thing you are working on, is a contradiction. This seems obvious, but it happens all too often.

Privacy

Any work that affects the privacy of an individual should be cleared with that person before being shown. This is the purpose of release forms. Also, consider what it means to use someone else's image in your work, and how it may affect that artist. Getting sued over the use of an image should always be avoided.

Maintain The Safety of Your Audience

Do not use materials that are harmful to you or your audience. Certain chemicals, mold, and other materials may severely affect people with allergies, people with weak immune systems, and children. If you need to use something that might be potentially dangerous, make sure you inform the audience and the gallery with noticeable signage. (See Experimental Materials section).

Documentation of Your Audience

It is important to notify your audience if you document your show and record interactive relationships with your audience. If an individual's likeness is clearly identified, you may want to get them to sign a release form.

Graphic Images

If you are showing work at a space where families gather, you may want to consider how to present the work if it is not appropriate for children. Signage is a good way to warn parents that they are entering territory that may be disturbing to children.

Graduate Work

Sometimes galleries do not show work made in school, even if it is a graduate show. One reason is that they may be avoiding work that reflects a collaboration of ideas between faculty and peers. Some galleries will want to show work that is "totally yours". Also, certain funders prohibit support of student work.

Thank Those Who Support You

Everyone likes to be thanked. Be sure to thank the curator, dealer, or funder. You should at least thank them in person, but a nice note is really special. If you are in an exhibition that publishes a catalog, consider using this as an opportunity to thank those people who helped you with the exhibition. If you get rejected for a grant, or a show, writing a thank you note for allowing you to apply might help them to remember you in the future. If you do not get the teaching job, thank them for the interview. You do not have to be extravagant, just make sure that they know you respect their support.

Asking For Things

From time to time, you will need someone to write you a letter of recommendation. When you ask someone to write a letter, do NOT wait until the week it is due. If they say yes, be sure to send them all the pertinent details: who the letter should be written to and the description

of what you are applying for. Make sure to give them plenty of time to write the letter. Be sure to include information about yourself, particularly if they have not seen your latest body of work, or if you have additions to your resume, which may be helpful in a letter. It is a good idea to keep in contact with those whom you may request a letter from. Consider how selfish it will appear to request support from someone you have not reached out to in a long time. Be generous, and others will reciprocate.

How To Treat Teachers and Established Artists

It is not the job of your former teacher or other artists to get you into a gallery. If you ask someone to recommend you, do not do it out of the blue. Make sure that your colleague is comfortable with supporting your work, and do not expect them to say yes. Artists have a limited number of recommendations that they can use with the people they know. Do your homework, have them over to your studio, and try to wait for them to bring up the subject.

Art Agents

Beware of dealing with art agents. They may say they can help your career, but consider this:

An up and coming artist who was starting to do quite well in their career was contacted by an agency. They offered to help secure shows, do PR and basically make the artist's career. What the artist may or may not have known is that the agents were buying out the shows before they opened. The artists became so desired, because of this market manipulation, that he had shows set up all over the world. Once it was found out that the agents were dealing in fraudulent practices, it destroyed his career. Always be aware of your agents' practices.

Editions

There are laws that govern editions. Editions must be declared at the time they are made. Buyers must be notified of the number of editions in writing. DO NOT make additional prints or photos after you have declared the edition size. Be aware of the consequences of such actions.

Blind Submissions and Approaching Galleries

Less informed artists tend to submit portfolios/packages blindly to galleries or art professionals in order to achieve some sort of instant fame. That is tantamount to sending a message in a bottle out to sea. Most success in the art world is made through being active in the art community and through its extensive referral system.

Shady Collectors

Some collectors may try to negotiate with you at an opening to try to get a price break. Beware of this practice, as it may violate your contract with the gallery, whether written or implied. Send the buyer to the dealer and let them work it out. After all, it is the gallery's responsibility to sell at their venue.

Some "collectors" may artificially inflate their importance to get steep discounts. Never sell yourself short. It's ok to give small 10-20% discounts for known collectors, but anything more than this is unnecessary.

56: Fame

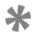 **Objectives**

Understand some basic issues and ideas about fame and how to deal with changes in reputation and notoriety.

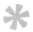 **Things to Consider**

Think about how fame is defined and whether you have to "get it" to "make it".

※ Fame

In the past few years, an increasing number of emerging artists have been interested in the subject of fame. Some are very up front about their aspirations while others are not willing to admit that they want to be famous and instead keep it a secret fantasy. And for those who aren't interested in fame, it is good to be prepared because it can happen even if unexpected and unwanted.

Many artists have a misconception of fame and its importance. The result is that they harm their own career and development as artists. For many emerging artists, fame is a paramount goal and a personal expectation. Unfortunately, for a long time now, a single trajectory has become the ideal for a lot of students. It goes like this: go to art school, get a gallery before you graduate, sell out your show, get as many reviews as possible and network your way to fame, or else forsake your career.

This is sadly ironic since the reality is that a vastly small percent of artists will ever get famous (and have that fame last for more than a few seconds) and yet, the desire for fame is at the core of how many artists manage their careers. The consequence of this is that they fail at creating a sustainable, fulfilling career as an artist. Many artists stop making art, miss opportunities to manage the multiple trajectories that are often part of a lifelong art practice and lose sight of what drove them to become artists in the first place. This doesn't mean fame is bad but it does mean that a false and unrealistic perception of it can thwart a meaningful career and hurt the discipline of art in general.

I contacted a number of famous artists I know and asked them for advice and thoughts about fame. Whether due to busy schedules or a genuine concern about appearing self-centered, not one of them could (or would) respond. I wasn't completely surprised. It seems you either want fame or you don't, and if you have it, you don't want to talk about it.

Strategies

"With the internet, instead of everyone getting 15 minutes of fame everyone gets to be famous to 15 people." – David Weinberger (You didn't seriously think we could write an article on fame without at least some reference to Andy Warhol, did you?)

The desire for fame can be easily exploited so beware and be professional. There are feng shui designers trained in the art of rearranging your household objects to better align your life towards fame and reputation, lots of hucksters penning books who will take your cash in

exchange for advice, companies who specialize in consulting fame seekers, and a hypnosis kit designed especially for artists in pursuit of fame. Articles abound on the Internet of course, and every day seems to usher in a new blog about the art world and its legions of famous artists. There is even a Fame Game designed by artists. Originally conceived as an art project, it is now a social networking site that invites people to reinvent fame.

If fame is your only goal, you have set yourself up for disappointment. (Remember, only a small percent of artists become famous.) For this reason, try to understand why fame is desirable to you. Consider your personal goals in relationship to the idea of fame. We have included a series of questions in the tips and tricks section of this newsletter to get you oriented in the right direction.

It is important to understand the difference between being a good artist and being famous. They don't necessarily always go together. There are many famous artists that do not make very "good work" and there are great artists with lifelong careers who don't get famous.

Defining Fame

"Fame is proof that the people are gullible." - Ralph Waldo Emerson

Fame resides in the minds of others. Fame is not a quality. Not like bravery or honestly, cruelty or greed. There are different communities and being famous in one group doesn't mean you are known by another. When thinking about fame or notoriety, consider whose opinion you care about. And how many people need to know about you? Can you ever be famous enough?

Fame is not necessarily an achievement or characteristic. It is defined by external opinions, often constructed by those in power. It may not matter if you do something horrible, as that will add to your fame. It is something that you simply cannot control, regardless of who you are and what the truth is. And it is something that is hard to shake once achieved, but it may not be everlasting (perhaps lasting no more than 15 days).

I often meet artists who enthusiastically say their goal is to make it on the front cover of *Art in America* or *Artforum*, or be as famous as Andy Warhol. While this is a concrete goal, I don't see the end result as a guarantee of fame. Just peruse the covers of these magazines from 10 years ago and you'll see that many of the artists featured have fallen into relative obscurity. It's understandable that reviews, for example, are important to artists. However, it's not that simple. There are many artists that have endless resumes, reviews and exhibition histories, but are not considered famous. Furthermore, being famous doesn't not mean you make good work, will be remembered, or have a good reputation.

Reputation

"The ceaseless, senseless demand for original scholarship in a number of fields, where only erudition is now possible, has led either to sheer irrelevancy, the famous knowing of more and more about less and less. . . ." - Hannah Arendt

Reputation is not the same as fame. Reputation is what people think about you (it literally means 'think over') and fame is being known and talked about by many people. Reputation usually has posterity and can work in addition to and remain separate from fame. You can be famous and have a bad reputation or have a great reputation and not be famous. You may want to

consider what is more important, to be thought of as someone who does meaningful work or to be known by as many people as possible.

The desire for fame can have deleterious consequences on your reputation. I know a really great artist who was represented by an agent. The agent's company secretly bought out the work before shows opened, creating a false demand. Suddenly, this artist was in museum shows around the world and was on track to becoming really famous. Once the agency's secret strategy was discovered, the artist was ostracized and blacklisted. He became known for his association with dishonesty instead of being regarded by the merit of his art. His career has never fully recovered. Beware of agents. A lot of folks have decided to become agents for artists, fashioning their ideas on Hollywood. Many artists are now wrongly convinced they only need an agent to succeed. I don't know one agent who is trained to represent artists, and most of them don't know any more than you do. The same goes for gallery dealers. I know a lot of dealers who really don't know what they are doing, but have ulterior motives. As always, choose carefully.

The moral of this story is to try and be mindful of those people around you who can damage your reputation in pursuit of their own fortunes. Research the people handling your work, make informed decisions, ask questions, draw up agreements, and be aware of who and what influences discussions of your work.

There are a number of artists who try to tightly control writing on their work. They are articulate about their work, they review all press releases and other copy whenever possible, and they work hard to communicate openly with those who write about them. They always seek to be part of the approval process for articles, fact checking at the very least, to minimize misinformation about themselves and their work.

Motivation

"In the construction of Immortal Fame you need first of all a cosmic shamelessness." -Umberto Eco

How important is it to be famous and how does it impact your work and your relationship with other artists? Fame often means you have to cater to the art market and satisfy current market trends rather than taking risks and making mistakes. Wouldn't it be great if we supported risk taking and allowed each other to make mistakes? It certainly would enliven the work, and make the entire art world more interesting. Artists could actually take desirable risks that art schools teach as vital to creativity. What if we rewarded risk taking?

Rewards and Money

"To people who want to be rich and famous, I'd say, "Get rich first and see if that doesn't cover it." -Bill Murray

Most artists feel that they need to be rewarded for their efforts, and rightfully so. For some, making art is about getting famous and making money. Unfortunately, the "fame brings money" equation is not necessarily true. Many famous artists still have an outside job for financial survival. Even artists considered successful for having critically acclaimed work and museum shows still haven't been able to pay off costly student loans. While it is possible to make a sizeable amount of money off your work, it is best not to plan for that as your only source of income in the long term. And if you are successful, it may not last, so make sure you

have a trustworthy accountant. And, regardless of your success, make sure you plan financially.

Rewards are not always financial. Community impact and social change are examples of meaningful and measurable outcomes that are not necessarily tied to fame and fortune. This kind of success is not market success, but can reap many countless benefits such as popular and critical recognition.

While the desire to make money and the desire to effect change in the world are not mutually exclusive, it's probably best to focus on the latter and plan for the former, lest you suffer at the fickle hand of the market.

Cheerleading

"Fame means when your computer modem is broken, the repair guy comes out to your house a little faster." - Sandra Bullock

It might be important to consider the idea of cheerleading for the creativity of artists. I know artists who have received grants or awards and no one congratulated them out of jealousy. The desire for fame often makes people jealous rather than supportive. Artists are scared to death to share ideas because someone might steal them. Ironically, the fear of sharing ideas makes us less creative since idea generation is often the result of interaction. As creatives, perhaps we can consider trusting our ability to come up with ideas instead of fearfully protecting any particular idea we come up with and balance that by being responsible and mature. We can support our own community by not accepting plagiarism and intellectual theft. And why shouldn't we share both our creativity and our praise with one another? The more artists are supported, the more creative endeavors gain respect.

Visibility and Recognition

"If you feel that . . . what you do this year or in the years to come does not make you very famous, take heart. Most of the best people who ever lived weren't very famous either." - Howard W. Hunter

Actors have the Academy Awards. Musicians have the Grammy's. What if artists were the ones who decided what was good, instead of collectors, galleries, critics and others in power? Creativity and change are risky because failure is possible at every turn. I don't know one artist who is not nervous before an opening of their work. It is usually because they want sales and praise in order to secure more exhibition opportunities. Our emotions as artists should not be controlled by the desire for fame lest the work become trite.

Many people and institutions play a critical role in developing an artist's career. The important question is, "How can artists exert their influence to decide what is important, instead of or in addition to collectors, dealers, galleries and critics?" The answer lies in exercising your own ability to shape the debate by simply showing up and making our presence and opinions known.

The fact is that fame plays a roll in audience building. Because art stars attract large crowds, curators often showcase celebrity artists through group shows and let lesser-known artists piggy back on the success of others. To consider how this works, ask yourself, "If it is raining would you be more likely to go to an opening across town if the show included work by a famous artist or a group of people you had never heard of before?" In the end, you and everyone else out there determines who shows up. If you want to have a say, it's best to support work you value by artists you respect.

And bring people–lots of people–with you. They should do the same when it's time for you to share the spotlight.

The art world now has many awards that are given to artists based on secret nomination. Those who receive those awards are rarely a surprise. Everyone is in the same shows all over the world these days. You don't really have to travel to see the work of someone from another country. I once had a National Endowment for the Arts staff member state that if they got one more proposal to show the work of a famous artist that they were going to puke. So, we can jump on the bank wagon (really, I meant bank), or we can begin to think for ourselves.

Art School

"Fame is proof that the people are gullible." Ralph Waldo Emerson

Sadly, many artists believe that you have to go to art school to become a famous artist. The art world, galleries, and magazines make this clear by the artists they feature. It's true that a degree doesn't guarantee success, but it can help.

Universities and art schools around the world graduate thousands of MFA candidates every year. Many of these students graduate as artists but do not continue in the field as we currently define it, some by choice and some because of circumstance.

While in school it's a good idea not to trash your teachers for your own lack of success. It is not their job to get you gallery representation. Their job is to help you learn to create the best work possible.

The rest is up to you. Don't be jealous of those artists who get more than you do, or who are getting a lot of attention. It might not be their fault and they may not be ready for it either.

In art school, as everywhere else, fame brings attention. It does not matter if there are good teachers or not, or have more to say about their own work than their students', their reputations precede them. Unfortunately, art schools perpetuate fame's seduction by concentrating on famous faculty in their ads or on their websites; it attracts students (and dollars) to their programs. Some programs have famous faculty that rarely, if ever, show up to teach and instead let teaching assistants command the classroom. They usually get the financial rewards in spite of their lack of commitment. The best thing to do is research how well the fame of an artist/faculty member compliments, instead of hinders, their teaching skills.

Instead of rubbing up against those who have achieved fame, give them a break. Use that time to concentrate on learning how to make amazing work, and be able to make it long after you graduate.

Finally Famous

"Just 'cuz you like my stuff, doesn't mean I owe you anything" -Bob Dylan

By all means, compliment a famous artist. Everyone, especially those having to defend his or her territory, needs support. But leave it at that. And when approaching an artist consider their companions and friends who might not be famous themselves. Try not to interrupt their conversations and make sure to introduce yourself to their friends. Consider how it feels to be ignored or interrupted all the time by a fan. It's best to come off as a polite, interested individual than a crazed groupie.

It's a sad reality, but a few artists who become famous are really, really rude. But consider what we ask of them and how we treat them. Rudeness seems to be proportionate to the amount of times one is accosted by fans. Once you are famous, everyone wants to know how you got there and discover your secret so they can follow in your footsteps. Next time you think that if you rub up against a famous person it will rub off on you, forget about it. Let them make their work, and you concentrate on yours. Consider your own role in perpetuating their very public status, and be respectful.

Longevity

"Don't confuse fame with success. Madonna is one; Helen Keller is the other." - Erma Bombeck

Understand the risks of all your dreams. As you figure out your career trajectory, take some time to consider just what it is you want and why. This will help you to make decisions that will affect your future and that have a direct relationship to your artistic practice. Figuring these things out ahead of time can prevent a lot of detours and dead ends. Being flash-in-the-pan famous might be ok for a while, but in the long run, you might value your reputation as an exceptional artist as more important.

Fame is a funny thing, so be careful what you wish for.

The planning section in the GYST software has more detailed advice and tools to help you understand what success means to you and, more importantly, how to achieve it.

57: Finances

Objectives

Understand how finances influence an art practice. Understand how to organize and maintain one's finances.

✳ Finances

For many artists, dealing with finances is not a top priority until a financial emergency strikes. It is typical for artists to not receive a steady paycheck and so it is vital that artists understand their income, their debt, their taxes and their savings.

Always balance your checkbook, and keep track of your receipts. It is a good idea to look over your finances before the end of the year, instead of April of the next. You may need to make adjustments to your budget, by either saving some of your income or spending it on tax-deductible items for your business.

Plan Ahead

You should know how much money you make from your career on a historical and annual basis. You should also have an idea of what you would like to make each year. You can take steps to plan ahead towards your goal.

You should also know your annual expenses. How much of it goes towards your art career? How much do you spend on other items?

Doing a career-focused budget is a smart plan. This should include expenses such as proposals, archival material, business expenses and, of course, the material costs of producing new work.

A budget for your exhibition or project might indicate the need for a new and/or more economical strategy. Knowing this ahead of time can save you money as well as time and aggravation. It does not look good for you to have to postpone a show or change your work at the last minute because of financial concerns that are avoidable.

Plan Way Ahead

Since many artists are self-employed, they must determine long-range plans. This includes a retirement plan. When you sell a work, put some of the income away in a safe place, such as a retirement account, bonds or savings plan. It is never too early to start saving!

Live on Less

Think twice about the way you spend money. Instead of buying a fancy vehicle or long vacation, consider doing something with less money and saving the rest. Living modestly does not mean living in poverty, but rather a good balance of saving and spending. You have to plan with both emergencies and retirement needs in mind.

It is recommended that a person with a steady paycheck put away eight to twelve months of income in case of emergencies. If you are in the arts, it is suggested that you try and put away three years worth of income. This recommendation is not exaggerated, but rather based on prior experience of countless artists.

Credit Cards

Credit cards can get you into trouble faster than almost any other financial issue. Instead of buying lots of art supplies and exhibition materials on credit, consider postponing an exhibition or changing the work. If you cannot pay the bill at the end of the month, reconsider buying it in the first place. If you get into debt, you will not be able to make work in the future, and it could kill your art career.

Keep Receipts

If you ever get audited, you will need to prove your expenses with receipts. Always keep your receipts and try not to throw them in a drawer until tax time. Set aside one day a month to balance your checkbook and keep track of your expenses and income. It will save you a lot of time at the end of the calendar and/or tax year.

Accountants

If you need an accountant, make sure that you find an accountant who understands the arts. Many artists either get into trouble with the IRS, or are missing the benefits of tax deductions, because they are using an accountant who is not savvy about the laws that affect artists. That expense can be taken off your taxes next year.

Pay on a Quarterly Basis

About one third of your income will go to taxes. In addition, you may need to pay Social Security, which is 15 percent. If you do not have an employer, you will need to pay all of this yourself.

Paying quarterly taxes means that you pay quarterly amounts up-front. This spreads your tax obligations out over the course of the year, which is helpful for high-income earners. If you do not

make a lot of money, you will get a partial refund. When you get the refund, consider putting into savings or paying off a debt.

Insurance

Having health insurance is something that many artists feel they cannot afford, but is financially prudent. Price compare group plans against individual and small group coverage. Renter's insurance can also be an important investment in the case of fire, floods or earthquakes.

Investments

Investing is not just about buying stocks. An investment is something you put resources into with the expectation of a return. Putting money into a savings account will result in interest, albeit relatively small. Research other kinds of accounts that may increase your gains. Be sure to understand the level of risk you undertake when investing.

Investing can also be something invaluable that you do for your own personal development, such as workshops and classes or maintaining your health.

Saving Cash Under The Mattress

If you save your money with no chance of a return, you will lose about five percent a year due to inflation. You also might forget which mattress you hid your money in, or it may burn up due to a fire.

Savings Account

There is a low risk, but low rate of return, from savings account, and many do not keep up with the rate of inflation.

Banks

Most banks are covered by depository insurance (they will say "FDIC insured"). However, FDIC insurance only covers a certain portion of savings. Always check your bank's insured amounts.

Certificate of Deposits (CDs)

Certificate of Deposits usually have a higher rate of return than a regular bank account because they tie up money for long periods of time. There is usually a penalty for taking money out of the account before the time limit is met. Some types of CD's are insured, and they are generally a safe investment.

Savings Bonds

Risks vary with savings bonds. Federal bonds usually carry a low risk, but do not carry a high rate of return and do not offer immediate access to cash.

Saving Your Pennies

Precious metals are speculative and run a high risk, as the value can go way up or down. If you are Inexperienced or uncertain about this commodity, then do not pursue an investment.

Stocks

You can invest in a private company (this company does not sell shares on the stock market) or a public company (this company sells shares on the stock market) but be aware that stocks carry a lot of risk. If the company you invest in goes under, so does your money. Most advisors recommend that you educate yourself before playing the stock market without professional guidance.

Mutual Funds

Mutual Funds are a collection of stocks from many different companies. The idea is that if one company loses, then the rest of the companies balance the loss. Most retirement accounts are invested in mutual funds. They are meant for the long haul, and meant to grow over time. If you can afford to live without a portion of your income for the short-term, this might work for you.

Real Estate

Buying a home can entail lots of risk because you must make your payments on the loan or else lose the property. However, a home usually appreciates in value. There are tax benefits associated with owning a home. As with all investments, research is essential.

Investing in a Project or Business

This is considered a high-risk venture because it can have a high return. It might give you a new career or a lot of job satisfaction, but be cautious, well informed, and plan ahead before considering such a move.

Getting Your Finances Organized

Here are some tips for keeping your finances organized:

• Separate Checking Accounts and Credit Cards

Keep your personal and artistic finances separate. Dedicate a separate checking account and credit card just for your artistic income and expenses. Use the artist account to pay for artistic supplies, research materials, marketing expenses, licenses, etc. Deposit any income you make from your artistic endeavors into this checking account.

• Mark Your Receipts

Each time you get a receipt make a note directly on the receipt about the purchase and what it was for (such as art supplies, copies, parking for meetings or a workshop). Make a habit of putting your receipts into a daily file. Once a week, file these receipts after entering them into an accounting program on your computer, or into Income and Expense Charts. Set up categories that you use often for your artistic practice such as Supplies, Office, Studio Rent or Research.

• Taxes

See the Taxes section, or search the web, to learn about tax deductions that you may be eligible for because of your art practice.

Resources

Ask Artemisia
Dr. Art on Buying a Home
Part 1: How Much Can You Afford?
Matthew Deleget, Information & Research Department, NYFA
www.nyfa.org/archive_detail_q.asp?type=6&qid=57&fid=6&year=2002&s=Spring

Mini Financial Plan for Artist
Walks you through several steps on financial organization: Beginner's Financial Planning, Risk tolerance Questionnaire, Gathering Information, Income and Expenses Budget Calculator, Setting Goals, and Debt Management Calculator.
www.theartrepreneur.com/financial planning/financial_plan_for_artists.asp

Free Credit Ratings
This central site allows you to request a free credit file disclosure, commonly called a credit report, once every 12 months from each of the nationwide consumer credit reporting companies: Equifax, Experian and TransUnion. You can also request your report by phone or mail. Monitoring and periodically reviewing your credit report is an effective tool in fighting identity theft.

Be aware that checking your credit too often will result in your credit rating going down so plan accordingly.

www.annualcreditreport.com

58: Budgets

 ## Objectives

Understand why it is important to create budgets for your professional and personal life.

 ## Things To Do

Use the budgets below to plan out various payment plans and financial futures for your professional and personal finances.

Budgets

A good budget can help you see into your financial future and can be the difference between financial prosperity and fiscal ruin. There are many budgets everyone, not just artists, should think about creating in order to get their financial situation under control.

Consider creating a budget for your general household expenses. This entails detailing every single day-to-day expense you incur to live your life. Developing an understanding of how much you pay and for what will help you create better short term and long term plans and give you an idea of what you can trim to increase your savings.

Additionally, you will want to create a master balance sheet (provided below) where you can keep track of all of your income sources and liabilities. This should provide you a better understanding of your net worth and how much you can afford to borrow or invest.

Many artists have debt stemming from various sources, like credit cards, student loans, personal loans, etc. Use the debt management plan below to better understand how you can pay off your debts in both the short and long-term. Remember that no matter how much debt you find yourself in there are resources you can use to create manageable payment plans to get yourself on the path to being debt free.

 Spending Plan

COMFORTABLE - After having a fully funded retirement plan and have at least 6 months of savings in the bank.	
Home Furnishings	$
Vacations	$
Clothes (extra, designer, fun)	$
Hobbies	$
Sports	$
More Savings	$
Insurance (long term care)	$
	$
	$
	$
	$
TOTAL	$

 Family/Individual Balance Sheet

ASSETS	
Checking Account (1)	$
Checking Account (2)	$
Savings Account (1)	$
Savings Account (2)	$
Emergency Fund	$
Cash value of Life Insurance	$
Retirement Account (1)	$
Retirement Account (2)	$
Investment Account (1)	$
Investment Account (2)	$
Value of Home	$
Value of Car (s)	$
Other Asset	$
Other Asset	$
Other Asset	$
Other Asset	$
TOTAL ASSETS	**$**
LIABILITIES	
Amount Owed on Mortgage	$
Amount Owed on Cars	$
Credit Card Balances	$
Other Bank Loans	$
Finance Company Loans	$
Insurance Loans	$
Taxes Owed	$
Other Debts	$
Other Debts	$
Other Debts	$
Other Debts	$
TOTAL LIABILITIES	
NET WORTH CALCULATION	
Value of Assets	$
Minus Value of Liabilities	$
NET WORTH	$

 Debt Management Plan

CREDITOR	REPAY JUST THE MINIMUM, or	REPAY MORE THAN THE MINIMUM
1.	$	$
2.	$	$
3.	$	$
4.	$	$
5.	$	$
6.	$	$
7.	$	$
8.	$	$
9.	$	$
10	$	$
TOTAL MONTHLY REPAYMENT	$	$

Be sure to put this amount in your spending plan.

 Financial Goals Worksheet

FINANCIAL GOALS WORKSHEET Today's Date_____

	GOALS FOR 1 YEAR	DOLLARS NEEDED	SAVINGS TARGET
1.		$ per month	$ per month
2.		$ per month	$ per month
3.		$ per month	$ per month
4.		$ per month	$ per month
	GOALS FOR 2 YEARS	DOLLARS NEEDED	SAVINGS TARGET
1.		$ per month	$ per month
2.		$ per month	$ per month
3.		$ per month	$ per month
4.		$ per month	$ per month
	GOALS FOR 5 YEARS	DOLLARS NEEDED	SAVINGS TARGET
1.		$ per month	$ per month
2.		$ per month	$ per month
3.		$ per month	$ per month
4.		$ per month	$ per month
	GOALS FOR 10 YEARS	DOLLARS NEEDED	SAVINGS TARGET
1.		$ per month	$ per month
2.		$ per month	$ per month
3.		$ per month	$ per month
4.		$ per month	$ per month

59: Housing

Objectives

Introduce basic housing information for artists

✳ Housing

Unfortunately, many creative professionals have internalized the impoverished artist myth, thinking that artists are destined to a life of destitution. Consequentially, many artists think they will never be able to buy their own house or studio. In the meantime, these same artists live in fear of rent increases, deal with greedy landlords, or get priced out of apartments and lofts after they have invested their own time and money on renovations. They constantly move from one neighborhood to another, trying to escape the next gentrification wave. If you feel powerless in a rental situation, you might want to consider saving to purchase your own home, condo or studio. Owning a home means you have equity, which helps with getting loans and building wealth in the future. When you rent your money is just going to a landlord, but when you own your house any investments you make to improve it help to increase your overall worth.

Buying one's own place to live is tantamount to taking a stand against developers. Finding an underutilized building, or house in need of repairs, rather than purchasing something newly remodeled, is also an eco-conscious way of dealing with one's own housing.

If the idea of home ownership is overwhelming, consider consulting with a loan broker who can help you strategize for the future. The following are preliminary considerations:

• Start a savings plan; create a reasonable monthly budget and stick to it.

• Figure out what you can afford.

• Consider asking your family for help.

• Talk with a lender about mortgage options; get a pre-approval.

• Begin actively looking for homes, especially ones that need work—they tend to be less expensive. The old adage is to buy the worst house in the best neighborhood on the best block. You can always make repairs.

About Loans

Most people—and most artists—do not have a lot of disposable income. 99% of home buyers borrow money to purchase their homes. The important question to answer is how much money can you afford to borrow?

To determine this, a lender/bank will take a couple of things into consideration. First, a lender will take a very close look at your financial situation, which basically means the money you make versus the money you owe on any outstanding debts, such as student loans, car payments, etc. Second, a lender will look at your credit rating, or FICO score (FICO is short for "Fair, Isaac and Company," which developed the mathematical formula used to calculate these scores). FICO scores range from 300 to 850 (higher than 660 is generally considered good). Your score will show a lender how much of a risk you carry as a borrower. For instance, if you have repeatedly missed paying credit card bills, defaulted on prior loans, or filed for bankruptcy, these factors will give you a lower credit rating, making you a greater risk as a borrower (FICO scores equaling 620 or lower). By measuring your finances and credit rating, a lender will comfortably be able to provide you with an estimate of the home

loan for which you are eligible. Generally speaking, if you have steady income and good credit, the amount is approximately 2-2.5 times your annual gross income.

Figuring Out Your Monthly Income

To figure out your monthly gross income (that is, your monthly income before taxes), begin by listing your total annual incomes from work, sales or commissions, interest and investments, child support, social security and any other income you receive. Income from your artwork should be included. In order to claim money as income, you must first have declared it to the IRS and paid taxes on it. You cannot include any money under the table. If you plan on buying the house with a spouse or partner, include their income as well.

Figuring Out Your Monthly Expenses

You also need to figure out your monthly expenses. List all of your total monthly expenses, including your car, student and other loans, credit card debts, alimony or child support, storage, rent and utilities, etc. If you are buying the house with a spouse or partner, make sure you include their expenses as well. Here is an additional tip: if you have fewer than ten monthly payments left on any loan, you do not need to include it in your monthly expenses. (You may also want to choose to prepay a loan to get it below ten monthly payments so that you will not have to count it.)

Debt-to-Income Ratios

Before giving you a loan, a lender will compare your monthly gross income and monthly expenses to a ratio called the Debt-to-Income Ratio. The most common Debt-to-Income Ratio is 28/36. The first number (28) is called the housing

expense ratio. It is the maximum percentage (28 percent) of your monthly income that you can spend on your monthly mortgage payment. The second number (36) is called the overall debt ratio. It is the maximum percentage (36 percent) of your monthly income that you can spend on all of your combined monthly debts, including your monthly mortgage payment. Please keep in mind that the larger your down payment on a home, the less important the ratios are to lenders.

Affordability

Between the housing expense ratio and overall debt ratio, the lender will look at whichever is lower when pre-qualifying you for a loan. Please keep in mind that the two ratios only project what you can afford for a mortgage payment, but not what is referred to as PITI—a combination of principal, interest, taxes, and insurance expenses. The principal and interest (your monthly mortgage payment) will depend on the amount of money you borrow, the type of loan you select, and the interest rate. In addition to principal and interest, you will also be responsible for paying real estate tax and homeowner's insurance. The amount of real estate tax will depend on where you live; the cost of homeowner's insurance will be determined by the policy you choose. If you purchase a co-op apartment or condo, taxes, insurance, and, possibly, an association fee (the fee for upkeep of common areas) will be covered by a monthly maintenance fee, which you pay in addition to your monthly mortgage payment.

Getting Pre-Approval

Once you have completed the above calculations, you should feel pretty comfortable with your financial situation. You now need to take the process to the next level: getting a pre-approval from a lender for a loan.

To be pre-approved, you will need to present the following information to a lender: your social security number, home address for the past three years, employment history and salary/income, current monthly expenses, and bank account balances. During the pre-approval process, the lender will verify your information and check your credit. Banks also prefer a recent history of full-time employment, as this indicates a reliable source of income. This is part of what makes purchasing a home difficult for artists, since they sometimes work part-time, or freelance, or cobble together different forms of employment in order to have the free time necessary to create art. Nevertheless, if all goes well, the lender will give you a letter stating that you have been pre-approved for a loan to be applied to the purchase of a home. The letter is usually good for a period of 60 days. The pre-approval process is free and having a pre-approval will make your bid much more appealing to a seller.

Down Payments and Closing Costs

There are two major expenses involved in closing on a home: the down payment and the closing costs. Lenders generally expect you to pay at least 20% of the sales price, up front, as a down payment. However, depending on a variety of factors, the amount of up front money can be as little as 3%-10%. Please keep in mind that if you pay anything less than 20% up front, a lender may require you to pay what is called Private Mortgage Insurance (PMI), which protects the lender in the event that you default on the loan. PMI can add anywhere from .25%-.75% to your monthly interest rate payments, but sometimes this is the only way to get a place of your own. Another way to avoid paying PMI is to ask your family for help with the down payment. If you choose this route, the money they give you must be a cash

gift (not to be repaid—otherwise, it is another financial obligation that a bank would want to take into account), which they should commit to in writing. You should also plan on having additional money set aside for the closing costs, which generally amounts to 3%-6% of the sales price. Closing costs include things like appraisal fees, inspection fees, credit reports, insurance, PMI, taxes, attorney 's fees, accountant's fees, escrow fees, title policy, bank processing, recording fees, etc.

In Summary

You must plan and do research in order to make your dream of owning a home a reality. Ask homeowners about their experience buying a home, taking out loans, etc. Consider working with an arts accountant to guide you through the process of how to save for a down payment, or get a pre-approval.

A Personal Story

My partner and I thought it would be forever before we could afford to buy a house, primarily because we did not seem to be able to save for a down payment. One of our friends, who was quasi-employed and had IRS tax trouble, got approved for a loan to buy a house, and we were shocked. We figured that if he could get a loan, then we should definitely look into it. We did not have a down payment, but took out two mortgages, one for the down payment and one for the home loan. The interest on the down payment loan was high, but we made the payments for the required three years before penalty, and then consolidated the loans. It was more expensive to do this, but it allowed us greater stability with respect to housing and studio space.

60: Keeping Records & Inventories

Objectives

Understand the basics of keeping records and what an artist should keep records of.

Things To Do

Start a list of each of your works and where they are.

Keeping Records

Things to consider regarding record keeping:

• Implement a filing system. Have a file for each exhibition you are participating in labeled with the name, date and location of the exhibition. Within that file have separate manila folders with different headers including correspondence, consignments, images, articles, press releases and press, budget, and invitations.

• Keep track of all exhibitions and grants including acceptance and rejection letters. These files should include the submitted application or proposal, submitted images, and all correspondence. If ever applying again, the previous application will help you to avoid repeating mistakes.

• If teaching, keep track of all of your syllabi, a selection of student work in slides or digital formats and student evaluations for future reference.

• Keep a ledger, either on your computer or by hand, of all your income and expenses.

• Keep track of your billing and collection of payments

• Keep track of your inventory of goods for sale, on consignment, and sold work.

• Keep an image inventory, both digitally and in hard copy form.

• Update files, records, inventory and budgets once a month, at minimum; do not wait until the end of the year.

• Do your taxes on time and remember to file your sales taxes according to the timetable. If you make, sell or donate work, you need to keep track of:

• the artwork's location

• if and when it was sold, and who bought it

• if it is on loan for an exhibition

• whether it is in transit to an exhibition,

• at your studio

• in storage

• at gallery

• destroyed

✳ Inventory

Keeping a comprehensive inventory is especially important if you make artwork in multiples or editions or have work on consignment with a gallery or an art consultant. Do not rely on a commercial gallery to do this for you, because galleries go out of business all the time, lose records or purposefully try to keep their artists in the dark. Create your own records. It is important to be proactive and organized about your business.

If you make work that travels or if you have a series of works with similar titles, it is vital to keep track of where everything resides. Always get a list of the work on consignment with a dealer, a gallery, or an art consultant. Additionally, get a list of works that have sold from a dealer, including names, addresses, phone numbers and email addresses.

It is illegal for your dealer to not give you the names of your collectors. Keep in touch with all clients regarding sales. Know where your work is at all times. The history of where the art has been shown, and the collections in which it has been included, is crucial for your records. Imagine having a retrospective without knowing where your art is located. It just means more work for the curator. Remember that artist's monographs often include a section that tracks the history of the artist's work, what collections it is in etc. Having accurate records is vital to the creation of this index. Labeling the back of the work also aids the buyer and curator in knowing the history of the artwork. Meticulous record keeping may be the only thing to speak for an artist once she or he is gone.

You always want to keep an inventory of images in both digital and hard copy form.

Using either your own digital system or the GYST software to keep track of your work will aid in this process. Always make sure to back up your archive, print out an inventory list, and keep it in a safe, secure place.

Many well-known artists did not keep track of their work at the beginning of their careers. Robert Rauschenberg is a case in point. I toured one of his studios in New York and his staff said that they are still trying to find pieces of his inventory. They also have an extensive collection of photos that have yet to be archived. Don't wait until you are famous. START NOW!

61: Hybrid Practices

 ## Objectives

Understand what a hybrid practice entails.

 ## Things to Consider

Think about various approaches to hybrid practices you might want to incorporate into your practice.

 ## Hybrid Practices

Artist Hybrid Careers and Hyphenated Artists Lecture
Karen Atkinson, New Orleans, 10/09

The great philosopher (Heraclitus, 535 BC) created the term panta rei, which means to create a blurred, fragmented and hyphenated entity, something that seamlessly flows from one form to the next. It means that everything is constantly changing, from the smallest grain of sand to the stars in the sky. Thus, every object ultimately is a figment of one's imagination. Only change itself is real. Eternal flux, defines this conception of reality, like the continuous flow of the river, which always renews itself.

Think of this while I talk about how artists are redefining their own careers on their own terms. Finally, a DIY movement has begun to take shape in the global art world. By this I mean it is no longer underground, as this is not a new idea. 21st century artists have access to an abundance of opportunities unheard of before. The old model of working a grueling day job in order to make your work is thankfully finding it's way to the dustbin. The idea of the starving artist is being replaced by the professionalization and hybridization of the arts. The idea that someone has to give you permission to show your work, or to enter the dialog of the art world luminaries is passé. While you still need a degree to teach at most universities, it does not mean that you need a degree to teach. There are a number of opportunities for presenting your own ideas in a workshop, or through a blog. The art world has changed drastically. When I began showing work, there were few opportunities for emerging artists, women and people of color. Now, emerging artists are being gobbled up and ageism is the new racism in the art world.

Out of necessity, artists have created a number of opportunities for themselves. They work in schools as teaching artists, expanding the very meaning of this timeless job description. They consult with corporations and small business, providing much-needed ideas for a new creative economy. They work at or with nonprofits, as artists in residence, administrators, and programmers. They organize communities and facilitate productive outreach efforts to create real change. Instead of taking a "day job" that they hate in order to make their work, artists are starting their own business in order to create a hybrid practice that creates meaning in their lives.

Artists are also pushing the boundaries of art as they always do, contesting the very definitions of art that have carried over from the last century. Their practices chart new and often contested territory that blurs definitions of the role of the artist. Artists are creating businesses as art projects, inventing fictive artist identities

as a way to navigate around stereotypes, adopting flexible management styles to fit their own practice, networking in participatory ways, creating social and mobile commitments. Some are creating their own communities based on projects and starting tribes instead of groups that rely on geography. A tribe is a collection of like-minded folks who work together, exchange ideas and collaborate. There are no geographic boundaries. A tribe can exist virtually, or physically. It can change constantly with the inclusion of new artists. It can exist for a specific period of time, ie. to do a specific project.

The hybrid career artist has multiple jobs, but takes them all seriously, and one job often has an impact on the other. The most common idea is the teacher who also makes art, but here we are talking about multiple subjects. This is not just an artist who teaches art, but someone who may have a job as a medical technician, or a carpenter or a house painter. These jobs may actually blur together in that the artwork created is heavily influenced by the non-art job, and vice versa. For example, artist Bernard Brunon's work as a house painter is his artwork. Bernard began his career by attempting to make nonrepresentational painting. He also started a business as a house painter, and through this, realized that house painting was the most nonrepresentational painting he could do. So he came up with lingo to talk about this as an art practice and created a brochure and a company. Since then, not only has he painted many houses, but also walls in museums, buildings, and put 1000 coats of paint on an Art Guys billboard in Houston.

Tai Kim is an artist who also started his own business in Los Angeles called Scoops. He makes 100's of different flavors of ice cream as a creative project. Once of the favorites is brown bread and beer. His store has become so popular that he asked Yelp to take him off the list as the most popular ice cream venue because he was too busy. He has the time to make his artwork, and he makes a living at selling scoops. He has received many suggestions to make it a franchise, but he has turned that down, opting to just make a living so he can make his artwork.

Artists' voices are needed in all areas of our society, and this is one great way to infiltrate your ideas as an artist into new territory. Are you contributing your vision as a board member of an organization? Do you bring up new ways of working with your boss? You may not get somewhere all the time, but bringing something up always at least adds a new way of thinking to the group. Starting your own business might be an interesting way to have a career and do something interesting to make money to support yourself. My company, GYST Ink, only hires artists and each of them gets to take time off from their work life in order to work on a show or travel for an artist lecture. A hybrid career no longer separates an art practice from a job. Businesses started by creatives have the potential to take care of artists, while allowing them to continue their art careers.

A hyphenated artist is one who blurs the distinctions between mediums and strategies. One who works with more than one medium or idea. This is usually an additive process more than a merging; like someone who uses both photography and paint for example, or sculpture and music in a way that is not tacked together. Artists have been using hyphenated practices for a long time, but the term has recently been used ad nausea. A true hyphenated artist does not just put paint on photographs, but uses mediums and strategies to create new hybrids, breaking down hierarchies and distinctions, not just blending two mediums.

Basically artists are taking control of their own education, careers and their personal lives in ways that we could never have imagined 20 years ago. In Los Angeles, artists are creating their own "schools" such as Side Street Projects (which I founded in 1991), the Mountain Bar school, Machine Project and the Public School. In each of these organizations, artists teach workshops or classes to other artists and the public. These classes range from intellectual offerings to sewing and circuit board building. They can be free classes, paid classes, or a mixture of both.

Artists may have a huge impact on the future of how art works for a change, using their creativity to restructure, re-sort and reclassify everything they know is true at this point. The landscape is changing not just in terms of what artists are exhibiting, but also in terms of what an art career looks like.

Artists are providing products and services. They are fusing ideas and creating benefits for other artists. They are collaborating, pushing, trapsing, singing, challenging the status quo, and reinventing their way to a hybrid career. Can an artist practice be a business? Do we even care if what we do is art anymore, choosing to concentrate on what matters?

I came up with a theory or explanation a few years ago to help me make sense of this shift. I call it the Vertical or Horizontal Artist Career Strategy. I am not sure that there is much new in this idea, but it helps to see the possibilities that are out there. It is not a perfect solution, and you have to remember that these are gross generalizations, and not all artists fit one model or another. And many artists are somewhere in between these two definitions.

The vertical artist is one that we are very familiar with. Their career goal is to rise to the top of the pack. Their trajectory is usually quite similar: going to art school, getting shows, getting into a gallery, getting written about and, in general, working their way toward getting their image on the front cover of a magazine touting their praises. The vertical artist often has a solo practice, and spends long days in their studio and often alone. They are always searching for ways to "enter the art world". They have come to agree that this is the strategy we must all take to make an art career. They often have a day job for a while until they can dump that for an art career full time, or they may work a day job for the rest of their lives, but still maintain a traditional art career. The goal is fairly simple. The more well known they are, the better options they have. Fame is usually important, though not always. In this scenario the art world tends to treat the top-grossing artists, the most visible artists, as "smarter," more "successful, more "relevant", and more "valuable" than their "dumber," "lazier," less "attuned" counterparts. This hierarchy creates divisions between artists who "make it," and those who choose a different path and "fail". That old adage of those who can't do, teach comes from this kind of thinking. I know a number of artists who are always asking their friends, "When are you going to quit your job and be a real artist?" There is little room for diversity here in terms of what defines an artist. This conception of an art practice mirrors the corporate model of Capitalist production, where the most profitable company (artist) wins, no matter what their business practices are. Instead we should be paying attention to reworking the very idea of success in the art world. Artists should be choosing their own criteria for success.

A horizontal artist looks at things a little differently. They often also have art school backgrounds, but look at their practice in a way that is not only about climbing the art ladder in

the traditional sense, but developing innovative concepts and ideas about how to combine and recombine the ingredients of their practice in order to create their own careers. They tend to work more in communities, be more activist oriented, have hybrid careers in which their "day job" is an active part of their practice. They may be entrepreneurs and self employed. They may make objects one day, and curate the next. They may guest edit a journal, or teach a workshop. Or they may do all of these things in a single day. They tend to be multi-centric instead of seeing a center. They often look at temporary strategies, instead of ones they must adhere to for life. What I mean by this is that if each artist looked at what they wanted to accomplish and chose the best strategy to get there, as opposed to the strategy they have been taught, some really interesting possibilities are brought to the forefront.

They often blur the distinction between making art and doing something else that they find important. They blend careers and ideas as if there were no distinction between artists and the rest of the world. These artists often have more impact on the world than the vertical artist who has an influence on the art world, as the art world is very small in comparison to the rest of the world.

Horizontal career-oriented artists often have a participatory or socially engaged practice, and tend to plow through formidable barriers to feed their own artistic exploration or expression. They infiltrate institutions instead of showing in them. They do not rely on the ideologically convenient museum or art fair celebrations of socially relational forms, but deliver their work to new audiences who may benefit from their politics and practices, and therefore create more change within culture.

They often confound traditional modes of critique. By it's very nature, creativity involves a departure from what has come before. Why not consider this in our own choices?

A vertical artist may hide their strategy in order to keep it to themselves in hopes that the novelty of their materials and process will garner them notoriety. Or they may keep secrets from their peers about a great grant or exhibition opportunity, choosing to apply for it themselves even if their work doesn't make sense for the project. A horizontal artist might broadcast their strategy to the world in order to include others, or ask others to adopt their strategy, much like open source is used in software. They don't necessarily follow the well-trodden path of the traditional artist.

My own practice can be defined this way, as I tend to fit in the 45-degree slant, but straddle this line on the side of a hybrid career. I created a nonprofit organization with the help of my partner Joe as a part of my art practice. Curating shows was always an extension of my own ideas and work as an artist. Teaching workshops and teaching full time at an art school is a part of what I do. Starting a for-profit company by artists, and for artists is my latest and largest artwork to date. I started a Hybrid Career Site for Artists in order to begin to study this phenomenon and get other ideas from artists around the globe. I have invited artists who see themselves having a hybrid career to post information and ideas about those practices.

Our thoughts should go out to all those forgotten creative heroes who tried and failed. We should hail them, because the innermost mechanism of human progress is called failure. It is were not for the fools trying to do the impossible over and over and over, we would still be living in caves.

62: Pricing Your Work

 Objectives

Understand how to price one's work.

Understand how different institutions deal with pricing work.

 Things To Do

Work on pricing some of your own work. There is not a right or wrong way to do this. This is an exercise to get you to think about how much you consider your work to be worth realistically.

 Pricing Your Work

Pricing work can be one of the strangest, most nebulous areas of an art practice to navigate. After all, the monetary value of art, unlike car repair, or say, furniture manufacturing, can't really be quantified by any set standard. There is no perfect formula for pricing your work, but here are a few helpful hints:

• Plan ahead. Don't price things at the last minute. This can lead to outrageously high or low prices depending on your mood, current economic situation, or desire for attention.

• Err on the high side. Low pricing often signifies that the artist doesn't have confidence in their work. On the other hand, if you are an emerging artist, asking for $25,000 for a painting might be over the top. Prices can go up, but they should never go down. Getting your work to start selling might be more important than pricing things too high. Use common sense.

• You should compensate yourself fairly for your time and materials. Most artists undervalue their work; often make less money on sales than they spent making work. It is a good idea to keep track of your expenses and the time spent creating the work. Create a spreadsheet for this or use your GYST software.

• Defend your prices. If you have kept track of your time and expenses you can defend the price of your work should your dealer or collector insist they are too high. Be realistic here, but also include your direct expenses for materials, as well as your overhead expenses such as studio rent, utilities, phone, etc.

• Use an hourly wage to calculate how much your art is worth. You are a professional artist and you deserve a professional living wage. Don't go with minimum wage numbers here. The US Department of Labor Occupational Labor Statistics lists the mean hourly wage of Fine Artists as $23.22. Use this as a starting point for figuring out your hourly wage.

• Letting dealers and consultants price your work is not always the best way to go. Often a dealer will set the price of your work, but you should be a part of this discussion and it should be a joint decision. If you have your expenses calculated, you have a better chance of getting your share of the total price of the work. But remember that gallery dealers calculate things like rent, salaries for employees, and marketing costs into valuing your work.

• Some excuses you will hear from dealers about pricing the work low is that you are an

emerging artist, your résumé does not have the right venues, the work is small or derivative, or the dealer needs to spend more time and spend more to promote the work of emerging artists. Defend your work, show them how much it costs to make your work, refer to your hourly rate. Be negotiable, but don't undervalue your work.

• Artists with gallery experience and consistent sales histories should already have base prices set for their works. If you do not already have a track record of sales, your base price should approximate what artists in your locale (with comparable experience and sales records) charge for similar works of art. Keep in mind that even though your art is unique, experienced art professionals, like dealers, advanced collectors, consultants and agents, make price comparisons from artist to artist all the time. Being able to evaluate your art from a detached standpoint, by comparing it to that of other artists in your area, is necessary in order for your price structure to make sense in the marketplace.

• Keep work that holds special meaning for you or represents critical moments in your life or career off the market. Make sure this work is not drastically different from your other art in terms of physical criteria. You may want this work as part of your own private collection. Also, often times, the tendency is to overprice such work.

• When calculating your studio expenses, maintain records of the time you spend, and the cost of materials. Include overhead such as rent, utilities, professional fees, fabrication costs, assistants' wages, transportation, postage, and shipping. Divide the total by the number of works you make a year, and average the cost per work. Then, add the sales

commission. Make sure you build in a profit margin and room for a discount to notable collectors or collecting institutions.

• Visit galleries, rental spaces and exhibitions, and do some research on comparable artists and artwork. Look at the exhibition checklist for these details.

• If you are selling work in your studio or at a studio sale, you might want to price the work a few hundred dollars over the set price so you have space to negotiate.

• You should not price your work according to what region of the country or city it is shown, or what gallery sells it. Consistent pricing is a cornerstone of a sound practice and eventually leads to successful sales.

• Always have a price list available that states the full retail price. If you are selling the work yourself, always include the discount policy in writing on the price sheet. This will get you out of a bind if a buyer brings it up.

Commission Splits

Usually galleries and art consultants take a 50% commission of all sales. Anything above that is highway robbery. If the commission is less than 50%, do not lower the price. Have a heart-to-heart talk with anyone who wants a higher commission. Often there will be a wide range of excuses for this, including that you are an emerging artist, your work costs more to sell, etc. Do not buy it! Many nonprofit galleries take from 0-30% commission and many leave the negotiation up to the artist.

There are special circumstances in which you may need to receive more than the 50% commission. If your work is very expensive to

produce, and the fabrication is very costly (such as foundry work) or you use a specialized process, you will need to negotiate this up front, before the commission split.

Prices Too High?

If people like your art enough to ask how much it costs, but do not buy, it may be because your price structure is too high. First, conduct an informal survey by asking dealers, experienced collectors, consultants, fellow artists, and agents what they think. Never arbitrarily cut prices or adjust them on the spur of the moment. Reduce your prices according to the consensus of knowledgeable people. Use your concerned judgment. Avoid having to reduce prices again by making sure your reductions are in line with or even slightly greater than the consensus opinion. Never make your art so inexpensive that people will not take it, or you, seriously.

Price Increases

A price increase is in order when demand for your art regularly outstrips demand for your contemporaries' work. The best time to increase prices is when you are experiencing a consistent degree of success and have established a proven track record of sales that has lasted for at least six months and preferably longer. Depending on what you make, and the quantity of your output, you should also be selling at least half of everything that you produce within a six-month time period. As long as sales continue and demand remains high, price increases of 10-25% per year are in order. As with any other price-setting circumstances, be able to justify all increases with facts. Never raise prices based on whimsy, personal feelings or because you feel that they have remained the same for long enough.

Your prices should remain stabilized until you have one or more of the following: increased sales, increases in the number of exhibitions you participate in, increase in the number galleries that represent you, or inflation.

Online Sales

When pricing and selling your work online, you should keep the big picture in mind. Continually compare your prices to available art in your area, as well as on the Internet, and not just among your circle. Have a good selection of reasonably priced works available for purchase. Give the buyer the option of starting small, without having to risk too much money. Remember, people are just beginning to get used to the idea of shopping online for art. Hosting your work on the Internet opens the doors to a different market, which is not necessarily driven by region. Many collectors and patrons visit web sites to see new artists who are outside of their area.

Discounts

You should not be required to split discounts with the gallery. It is a public relations expense for the dealer and you should not be paying that expense. The gallery is usually awarding the buyer for previous patronage. Exceptions might be when the buyer purchased your work before or they are buying more than one work by you. Always get a Bill of Sale as a purchase contract between the artist and the collector. Often, a dealer will issue you a purchase order, which states both commissions and the collector who bought your work. Always maintain records of who has purchased you work, including name, mailing address, and email and phone number if possible. Beware of dealers who will not give you the information on a collector, as by law, you are entitled to a

copy of the bill of sale and information on who bought the work.

Market fluctuation

No matter how old you are or how long you have been making art, know that art prices fluctuate over time as a result of a variety of factors. Set your initial price structure according to the initial value of your work, your local or regional art market, but be ready to revise those prices at any time (assuming adequate justification). The more you are aware of market forces in general, and how people respond to your art in particular, the better prepared you are to maintain sensible selling prices and to maximize your sales.

For additional information, read Caroll Michels' book How to Survive and Prosper as an Artist, Chapter 4, "Pricing Your Work, How Much is it Worth?" Henry Holt and Company, LLC. See Resource Section. "Art For All" (Wallace-Homestead, Radnor, PA, 1994)

Resources:

http://www.bls.gov/oes/2008/may/oes271013.html

63: Printing

Objectives

Understand basic printing issues for artists and things to consider, including green printing.

Things to Consider

You may consider taking some time to research 5 of the closest printers and make some cost/quality comparisons.

Printing

Contemporary artists are becoming less reliant on printed materials to get the word out about their projects. But printing is still an important component of ongoing marketing campaigns. It is useful to know the basics about printing, and this guide will give you a short overview of things to know before out-sourcing print jobs. There are many more print options coming on to the market, so do some research, figure out what you can afford, and print wisely.

Studies have found that, while many people use email as a primary way of getting the word out, emails tend to be forgotten. Sending a postcard in the mail, which can be tacked up as a visual reminder, remains a best practice. Printing postcard announcements are also a good idea because sometimes this is the only printed documentation of an exhibition.

Here are a few basic processes for printing.

Digital Offset – this process puts ink on paper as does "conventional" printing, but it does away with film, plates and separate proofing

systems. With no minimum quantity, it has a fast turnaround and great quality.

Offset Litho – this process is the conventional route. It produces a wonderful result but has a lot of up front costs and usually involves a minimum quantity in the hundreds. It is not a fast process and color proofs are sometimes produced using a different process than the final print job, which can lead to inaccuracy.

The above processes can be used to produce postcards, announcements, brochures, portfolios, greeting cards etc.

Giclee- The most recent addition to the artists' choices for reproduction is called Giclee (pronounced Jee-Clay). This is basically high quality ink jet printing.

Giclee prints are widely regarded as the highest quality reproduction currently available. There is no minimum quantity, proofing is done "on-press" so you get perfect color matching. You can print on canvas as well as paper, and it will have the look and feel of the original artwork. It is light fast, has no up front costs, and can be ordered as needed. (Be sure to read the section on Editions if you are printing in batches)

Ink-Jet – The easiest do-it-yourself method of printing is ink-jet. It can be expensive due to the high cost of printer ink. If you do not have many documents to print, this might be an option.

Finding a Printer

One of the best things you can do is find a

printer who understands the demands of fine art reproduction. Always ask to see their samples and shop around. Using the web to do research is a good place to start.

Ask a lot of questions and discuss your requirements with a printer before committing.

How to Save Money

• Send a digital file if possible, either through email or on a CD. This will skip the scanning step, which costs more money.

• While there is usually no minimum order for Giclee and Digital Offset prints, the cost per copy will change based on quantity.

• Ask for help and advice before you start the process of designing for your print job. You should only work with a helpful, patient printer.

• Sometimes schools post jobs for students in the graphic design department, and they may be cheaper than a professional designer. You might also bring up the idea of a barter or trade. (See Bartering and Trading section for details)

Scanning

Scanning can be a very important part of the process. If you do not know how to scan an image properly, have the printer do it for you. Scanning is usually a one-time charge. Once scanned, you can reproduce an image, use it on the web, send in an Email, etc. GYST also offers an affordable scanning service to artists. For more information email info@gyst-ink.com

Green Printing

The Recycled Products Cooperative estimates that over 100 million trees are cut each year to supply fiber for writing and printing papers in the United States. This is not only detrimental to forests, but to air quality and water reserves as well.

Green Printing: How to make your print job more environmentally friendly:

• Choose recycled paper whenever possible. Check out the recycled content percentage on items you buy, and find those with the most recycled content. However, remember that most recycled materials are not archival.

• Do you know where to dispose of used printer inks? Petroleum-based inks leach VOC's (volatile organic compounds), which cause cancer and birth defects into the soil when printed materials end up in landfills. They can also be released into the air while inks dry.

• Soy ink is an excellent alternative to petroleum-based inks. Soy ink uses soybean oil that's naturally low in VOC's. This smart substitute is sustainable, efficient, and cost competitive. Many newspapers and magazines are now printed with soy ink.

• Do it digitally. Digital printing is ideal for short-run, four-color work for business cards, stationery, promotional pieces, and most print work that is less than 1,000 sheet of 14 x 20 inches. This printing method even has advantages over soy inks. While soy is comprised of 86 percent oil, which isn't biodegradable, digital printing uses 100 percent nontoxic toner. Toner-based inks also produce less chemical waste.

• Use tree-free paper such as Denim Blues (100 percent reclaimed blue jean cotton), and synthetic papers by Yupo because of their environmental attributes and durability.

Consider using papers made of hemp and Knaf or a new paper called TerraSkin, which is made from ground stone.

• Bleaching processes have changed over the years, but look for those products that are acceptable by the Chlorine Free Products Association are granted PCF and TCF emblems. Look for the symbols when purchasing recycled paper.

Additional resources can be found on the web under green printing.

64: Self-Employment

 Objectives

Gain a better perspective on being a self employed artist and things to consider when becoming self-employed.

Self-Employment

There are basically six types of business folks:
• The self-employed
• The builder of businesses
• The inventor
• The franchise owner
• The marketer and the speculator.

Most artists fit into the self-employment category, addressed herein. The legal term for this is sole proprietorship. You and you alone own all the assets and assume all the liabilities of a sole proprietorship.

Things To Consider

• A place to live. Do you want your studio separate from your living space? Do you use toxic media in your work? Do you have other tenants/ housemates to think about in this equation?

• A place to do business. Do you have space for a home office? A home office allows you to deduct part of your rent or mortgage from your taxes. A home office is a place where you take care of the business side of your practice, where you generate work that you get paid for, send out packets and proposals, keep records, expense files, marketing tools, etc.

• Communication Devices. Do you need a telephone, a cell phone, email and computer? Do you need or want a business listing in your local phone book? Do you need an answering service or call waiting?

• Transportation. Will you need a car, or can you get by on public transportation, renting a car or truck when needed?

• Health Insurance. Do you have adequate health insurance? Can you afford NOT to have health insurance? (See the Health Insurance in the Resource section for options.) A number of organizations provide health insurance for artists. For instance, if you are an alumni of an art school, you maybe able to get your health insurance through their alumni association. Fractured Atlas is a nonprofit that provides many artists with affordable health insurance. Also, keep up with what materials are toxic and take precautions so as to avoid health problems down the road.

• The self-employed are required to pay unemployment insurance for themselves and their employees. The money is collected through the Employment Development Department (EDD).

• The self-employed artist needs to begin considering retirement accounts from the beginning. Do not wait until you are older to worry about this. Even a small amount per month adds up.

• Balancing your checkbook is a necessary part of being self-employed. Mind banking (keeping

it all in your head) does not work. Consider investing in an accounting program like Quickbooks, which will help keep your accounts in order and help you out when taxes are due.

• It is a good idea to create a spending plan or budget for your business. Keeping track of how and when money goes in and out of your account is vital.

• Keep records. Know how your business is doing and be able to report it accurately to the Internal Revenue Service (IRS). Whether you do your taxes yourself or not, you need to set up a good system for keeping receipts and payment records. A shoebox in the bottom drawer or your desk is okay for the short-term, but do not let them sit there until the end of the year. Organize your receipts at least every quarter-year. Group them into business expenses that correlate with your expenses on your taxes. A computer program like Quickbooks will help you do this.

• Most cities require a business license for any income you may receive.

(See Business License section)

65: Unemployment

 Objectives

To understand the basics of how unemployment works in case you find yourself unemployed.

 Things To Do

Find unemployment documents online so you can build familiarity. Hopefully, you will never need them.

 Unemployment

Artists often wonder if they qualify for unemployment benefits. Unemployment insurance provides an income to workers who have been laid off or terminated without cause by an employer. Employers pay a separate tax, which the State Department of Labor uses to pay such benefits. Unemployment insurance is a universal entitlement to those who qualify— even for artists who work seasonally or part-time. However, many artists who are self-employed or work freelance may not qualify for unemployment benefits.

One of the most common exclusions for artists pertains to the Schedule C tax form. An artist who operates a business or profession as a sole proprietor, partner in a partnership, independent contractor, or consultant may need to report resulting income on a Schedule C tax form. Many artists file these forms for sales of their artwork, for commissions, and workshops, just to name a few examples. The tax deductions artists take as businesses or sole proprietors may preclude them from unemployment benefits because they are deemed "not totally unemployed", as indicated by reported income. Unfortunately, it is possible that an artist who brings in a modest amount of additional, untaxed income on a Schedule C may be treated as if her or his entire living is made as a freelance sole proprietor.

Another serious problem artists may have with unemployment benefits is the possibility of "recoverable overpayments." The Department of Labor may determine at any time during a recipient's collection of benefits that she or he was not entitled to them because of other earnings. This is where things get complicated for artists. Certain types of promotion of artwork, such as a web site encouraging sales, may be perceived as possible sources of income and could lead to potential exclusions for unemployment benefits. Before artists panic, however, it should be noted that if the agency is responsible for overpayment due to a fault in its system or incorrect computing of benefits, the agency deems these "non-recoverable," and the claimant is not liable for return of the payment. In any event, it is best to give all the information the unemployment board asks for, and give it honestly. Return of benefits may take place if the Department of Labor believes that the individual lied or withheld information in her or his unemployment insurance application. It is extremely important to do your homework before you apply so that you do not end up in this situation.

Resources

United States Department of Labor
www.dol.gov/dol/topic/index.htm

The web site contains descriptions of unemployment benefits, as well as links to state pages.

NELA: National Employment Lawyers Association
NELA offers a referral service online or by phone.
212.302.0718
www.nela.org

Unemployment Action Center
The Unemployment Action Center offers legal representation services.
www.law.nyu.edu/studentorgs/uac

Workers Defense League
The Workers Defense League offers counseling on how to apply for benefits and free representation to appeal denials of benefits, in addition to providing information and referrals on other workplace issues. 212.627.1931

66: The Web

 ## Objectives

Understand the basics of what goes into an effective artist's web page.

Understand basic web information and what you need to know as an artist to establish a web presence.

Understand why a web presence is so important.

Understand blogs and other web based resources.

 ## Things To Do

Make a brief sketch of your website, like a story board of what a user will see and experience when they go to your site, including basic information architecture.

Developing Your Art Website

Introduction

Having and maintaining your own artist website is of the utmost importance, as the web is becoming more and more the place where curators, collectors, funders, and critics go to find out about new artists. A web site is also an indispensable marketing tool and will showcase your work to the broadest audience possible. It is extremely important that your website is easy to use, works for you, showcases your work in the most positive light possible, and makes you accessible to the people you want to reach.

A Disclaimer

While the intro to the GYST software states very clearly that every bit of information provided in this program is a suggestion, not a rule, it is important to restate this word of advice again when addressing websites. So remember THIS IS ONLY ADVICE. It is up to you to do your research, plan and make decisions regarding what kind of web presence you want to have, and what sort of website will serve you best. The web is constantly changing with new programming languages, browser requirements, and accepted rules of "good design," shifting each year. It is important to remember that your site should keep up with the times too.

First Things First

Buy your domain name ASAP. Your domain name will be the URL you give to people directing them to your site. It should be memorable, easily pronounceable, and hopefully easy to spell. If your full name is available, it's a good idea to buy that no matter what so that you wont have someone owning www.yourname.com in the future. Check right now to see if your name is available by visiting any of the hundreds of sites that provide this search capability, like http://www.checkdomain.com.

The price to register a domain ranges from $10 to $30 a year. You will want to buy yourdomainname.com AND .org. you might also consider buying .net. Anything else is really just gravy and you don't have to worry

about people confusing it with your own website name.

Buy only your domain name. Don't bother buying any hosting services right now. That comes later and can get a little complicated. You can use any number of companies to buy your domain name. There are dozens of services out there so remember to do your research!

Godaddy.com is the most popular option. http://www.thinkhost.com/ is a green company committed to Progressive causes http://www.supergreenhosting.com/ is another green company

Your Website and You

As it is with your artist statement or portfolio, your website is all about understanding your audience, the way you want others to see your work, and what they want to get out of that experience.

Consider your practice and how you want to come across to people who visit your site.

You may want to appear commercial. You may want to only show work that is available for sale. You may want to include prices, or even an auction feature. Realize how this will impact how your work is viewed, as some people in the art world might find this tacky or distracting, while others might be surfing the web looking for a bargain.

You might want to appear experimental. Does your practice demand an extremely unconventional website, with lots of innovative features? These kinds of sites usually work for artists who make interactive, web-based work. Also artists with more established careers tend to employ these sorts of unique, but sometimes

frustrating, designs. Consider if you are willing to sacrifice usability for uniqueness.

You may want your site to mimic the look of a "white cube" gallery, with a white background, sans-serif font text, and minimal distractions. This is the most popular design for artist websites, especially the kind of sites offered by online services providing boilerplate designs. While your site might look like everyone else's, think about how the ease of use will benefit or hinder how people see your work.

You may decide you don't want or need a website. Some artists, especially those who built their careers during a time before the internet, often rely on their gallery to maintain their web presence. Other artists believe a website provides a false contextualization for their work. And some artists just don't want to go through the hassle of having and maintaining a website. Before you decide to chuck the idea of a website entirely, think about the people you won't be able to reach and the opportunities that will fall by the wayside if you don't keep a web presence. Consider maintaining a limited artist website with just a few images, or just a statement and resume and contact information. In the end it's up to you how much of your practice you make available on the web.

Do Your Homework

The first thing to do is to RESEARCH RESEARCH RESEARCH. You should look at dozens, if not hundreds of artists' websites before you even begin to think about your own site. You will want to bookmark the ones you like and the ones you really dislike. Taking notes on what works and what doesn't will help you when you start to shop around for your own site. Some great places to start are:

Artslant

http://www.artslant.com/

Artslant is a site where artists can post their profile and samples of work so that they can network with other artists both locally and internationally. It's linked to galleries, museums, and nonprofits and is a great way to find out what is happening in some of the art world's major capitals like New York, Berlin, L.A., etc. Browse artists profiles by visiting http://www.artslant.com/global/artists/profilelist?allcities=1. If someone has listed their own personal web site, click on it and take notes on what works and doesn't work.

Saatchi Online Gallery

http://www.saatchi-gallery.co.uk/yourgallery/A2ZArtists/

Like Artslant, Saatchi's online gallery lets artists from all over the world post a profile with some examples of their work. It's a huge listing, but worth browsing through to find artists who've linked to their personal web sites.

It's up to you whether you want to register with these sites and open your own profile, but it's a good idea to launch your own website before you register with these services.

Basic Guidelines

Some basic advice and guidelines to think about when judging websites:

• Make it ACCESSIBLE. When you go to an artist's web site you should immediately see work and understand where you need to click to see more work, as well as the artist statement, resume, contact info, and any other information vital to their practice.

• KEEP YOUR VISITOR. You don't want your web site's design to encourage your visitor to leave, ever. You want your visitor to stay as long as possible. Avoid splash pages, where, when you go to the main website link, all you see is one big image and you have to click on it to see more work. Even though it might seem obvious that this is what you need to do to access the rest of the site, you risk confusing your visitor or having them simply leave your site because they don't like the one particular work on the splash page. Avoid designs requiring your visitor to download special plug-ins to view video or images. Anything like this could cause them to leave your site.

• Make it FAST. There is nothing more infuriating than surfing the web and having to wait for something to load, be it a horizontal bar, a swirling arrow, or a cute animal chasing its tail. This means that, in general, gratuitous features made using Flash are not your friend. Flash is an amazing program, but don't let it get in the way of an eager visitor trying to see your work. The longer they have to wait, the more likely they are to leave your site. This rule doesn't necessarily apply once you are in the artist's site, as most people understand that it can take a moment to load video or images. But if it takes more than one or two seconds for something to load, you can bet you will loose visitors.

• A blog is not a website. You can certainly use a blog template, like a Wordpress template to design your site, but in general, you want each work to appear on its own, above the fold (which means you shouldn't have to scroll down to see the work). Blogs are a great tool, as you will see later in this tutorial. But if you want a website that is easy to navigate and makes each individual work look its best, you want to avoid a blog format where you have to scroll scroll scroll your way down to see more work.

• Your website should focus on your art, not pictures of your vacation with your family, not pretty pictures of sunsets, and not work by other artists you admire. Your website should only have your work, and in general should only include work you consider complete and ready for exhibition. You may want to post pictures of works in progress, studies, or preliminary plans, but be aware that you risk giving away the surprise that comes with seeing complete work.

• Separate your fine art from other work. If you do work for hire, contract work, or commission work as a designer or in another field that you don't consider part of your art practice, then don't mix this work up with your art on your artist website. For example, if you are a photographer but you also take wedding photographs on the weekend to pay the rent, you might want to think twice about having those wedding photos on your site next to your fine art photography. Mixing the two could risk confusing your visitors, or worse, labeling you as unprofessional.

• Do not use "cookies" (small files which attach to a visitor's hard drive to track movements around your site and collect personal data). They are an invasion of privacy and may cause you trouble.

• Make sure site looks good on different browsers, especially Safari, Firefox and Internet Explorer. Some people use older computers and older versions of these browsers so try to test your site using these aged computers as well.

• Don't use too much text. You can say as much as you like with your artist statement, bio and resume, but don't require your visitor to read tons of text at every turn (unless, of course, the work itself is text-heavy).

• Provide the right information. Just like your printed portfolio, you want your website to provide accurate and necessary information about each piece. This means providing the basic info for each work: Title, date, dimensions and medium. If the work needs more explanation provide it, especially for installations and work that might not be as accessible on the web.

• Keep your images limited to 72dpi. This is the standard pixel size for online images. You also don't want your images taking up the entire screen. Remember, some people use very small computer screens when looking at websites, and have multiple windows open at once. Depending on the constraints of your web design, you might want to limit the width of your images to 800pixels max. Also, try to limit the size of images to less than 200K, which will ensure that each page loads quickly.

• Make sure you can easily drag and drop images directly from the site onto your desktop. This may seem like a negligible feature, but it's very important. When curators, collectors, or just interested parties are searching the web for works they like, or artists to consider for a show, they will want to simply drag images off the site into a folder on their desktop. Make sure that when you do this the corresponding file name that appears on the desktop has at least your last name its title. Worried about people stealing your work or printing posters from your online images? Keep in mind that printing from a 72dpi image almost always guarantees horrible image quality. Plus, having your work on the web and copyrighted should deter anyone trying to use your work without your permission.

• Make sure visitors can contact you directly. Your site should have a contact page with your

email listed. Some people prefer not to fill out forms, so you want to have some way for them to click on your email and contact you through their computer's email program. There are ways to use html to hide your actual email address from spammers in a way that will still let visitors email you. And, of course, don't list personal information like street address or phone number, unless you want everyone in the world to have that information.

• Keep ads off your site. Your website is the best advertisement for your work. Why would you want to clutter it with ads for other people's stuff? If you want to make money from ad space, do it with a blog, not with your website.

• Share the love. Make sure your site includes a links page where you can provide a list of links to your artist friends, colleagues, institutions you support, and artists you admire. Sharing links is not only a great way to show support, it also generates web traffic and can help your site climb higher in internet search engine results.

• For a look at common design mistakes and things you should NEVER put on your site visit The World's Worst Website at http://www.angelfire.com/super/badwebs/

Ok so you have bought your domain name, done your research, gathered together many sites you like and a few you find god-awful. What do you do next?

Your Options

There are many options available to you when creating a web presence. First we should address the whole notion of "free hosting."

Free hosting on a big group website

Nothing is ever "Free." Free websites, demo websites, and websites run by online arts organizations make money by planting ad space on your site or profile page.

You can register with these sites as a way to network with other artists but you should keep a few things in mind:

• Your website will have the company's name in it. So, if you give this site out as your official website it will be forever tied to that company, leaving visitors to wonder why you are too cheap to have your own independent website.

• You will be a nobody, a small fish in a big pond with hundreds, sometimes thousands of artists competing for viewers. If you operate your own site it's all about you, and you control where your site links to.
• Ads will clutter the site's design and distract from your work.

• Some of these sites have horrible designs and can make even great work look terrible.

• The chance of actually selling work using these sites is miniscule. At the end of the day the people really making money are the people running the site.

• It can be difficult or impossible to remove yourself from these sites AND, if they have a lot of artists on their site, your name, your hosted page could come up high in Google search results. This means that even if you have your own website, this site might appear before it when google runs a search. You want people to visit YOUR site, not some company's site hosting your profile.

A few examples of big group websites are:

http://www.absolutearts.com
www.artistregister.com
http://artistresource.org

Take a few minutes to peruse the artists websites offered by these services and ask yourself if that is the ideal way you want people to view your work.

So what other options are available?

Hiring someone to do it for you

Paying a designer to create your website from the bottom up can be a fantastic experience, resulting in an amazing website, or it can be an infuriating struggle culminating in a mediocre site.

Designers can charge anywhere from $15 to over $100 an hour. As with almost everything else in the world, you get what you pay for. So if you want a site with a lot of bells and whistles, be prepared to pay for it.

Some designers can try to charge you every time you need to update your site. This can mean hundreds, if not thousands of dollars down the road. So make sure you work out the details of how you will update your site ahead of time.

If you are going to hire a designer you should make sure to do the following:

• Do your research. Look at their past work, see if it fits the look you are going for with your site. If they specialize in designing for corporations, like banks or shopping centers, make sure they have also made websites for artists. You don't want to be their first artist client. In fact, it's a good idea to go with someone who specializes in designing artist websites because they will

know how users navigate artist websites, they will know how the site should flow from page to page and the subtleties of making artwork look good on the internet.

• Understand the difference between a designer and a programmer. A designer will actually create the look of the website, where text goes, where images go, etc. A programmer actually writes code and makes the design a workable reality. Sometimes designers are also programmers, but not always. If you just work with a programmer, they will expect you to design the work and you will get exactly what you ask for, which, in the end, might not be what you want. It is always important to talk with a designer.

• Request at least three references you can contact. This means people you can actually talk to on the phone. You'll want to ask them about their experience working with the designer. Did the designer meet their expectations? Did they do what they said they were going to do? Were deadlines met? Did the designer stick to the budget?

• Never underestimate the power of references. First send the word out to your artist friends that you are looking for a designer. Ask around and see if you know any designers you can work with one-on-one. Who knows, you might be able to have them design the site for you in-trade for artwork.

• Try and find a designer that will write code allowing you to easily update your site yourself. This will save you money because you wont have to pay a programmer to do it for you.

• When you have decided on a web designer, you will need to draw up a very simple contract stating when certain steps in the project need

to be completed and when payment is due. It's a good idea to reserve your final payment (usually half of the total estimate) for when the site is entirely finished. Never pay the final payment until you have a copy of the site on a CD. This will be a single folder with many folders nested within it. The reason you want this file is because with it you can alter the code, and change and update your site yourself, should you decide to do so, or should you want to switch to another designer.

Doing it yourself

Designing your own website can be a great learning experience. When you're done you will not only have built your site on your own terms, but you will have also learned a valuable skill that you can, perhaps, turn around and use to help other artists and make a little cash.

That said, learning how to build a website can be a daunting experience depending on the kind of site you want to build and how you want your site to function.

• Before you decide to go it alone you need to ask yourself a few questions:

• How much time do I have to devote to designing my site?

• Do I trust my skills as a designer enough to believe that I will create a professional looking website?

• How much money am I willing to invest in software and classes that will help me design the site I want?

• Am I willing to learn programming languages like HTML, XHTML, CSS, PHP and programs like Photoshop, Dreamweaver, Flash, etc?

• Am I willing to keep up with changes in these programming languages and adapt my site accordingly?

• Am I willing to invest in this design for the long-run? The web changes at a rapid pace and eventually you will have to redesign your site (probably in the next two years, if you want to stay trendy). Will you be willing to put in this effort?

After answering these questions you should have a pretty good idea of your abilities and commitment to designing your own site. If you are unsure whether or not you are up to the challenge, if you doubt your ability to put in the time, money and effort, or if you have no idea what HTML, PHP, Photoshop, or 72dpi even mean, you might want to consider going with a company that specializes in pre-fab artist web sites (see below). Still on the fence? Read on and see what it takes to create your own website. Once again, please understand that this is a very rudimentary overview of how to craft your own website. Doing this yourself will take lots of time and diligence. But the payoff and the knowledge that you did it yourself can be priceless.

Planning

You should always plan a web site on paper first before you begin even gathering together your web site images and text. Look at other artists' sites and consider the features that you feel you need. Most important, consider the objective and the audience for your site. Do you want to sell work on the site? Do you want to keep your site simple so that everyone, including those who still have dial-up connections, can see it?

Good design is important and the site should be easy to use. While researching other sites,

pay attention to details such as the navigation of the site, download times, the structure of the site, how each page looks, and the accessibility of the site (i.e.. plug-ins, browser, platform and operating system). Some people go overboard with special animated flash content, and it drives visitors crazy, since they spend too much time waiting for a site to open and move on. You do NOT want your audience to move on.

Use this site map to start sketching out how your site will flow and how pages will link to one another.

Get a stack of blank note cards and draw out a very rough sketch of what you want your homepage to look like. Then draw out what the Works page will look like, the resume page, the artist statement page, etc. Next lay these pages out and connect them with lines or string, showing how each page will link to another. The layout should look quite simple when it's finished. You will want to document how this layout looks for incorporating it later into your websites' overall design.

Content of the Site

You might want to break up your site into a number of categories, which can be accessed from a contents page on the first page of your site. Some examples include: exhibitions, resume, artist statement, curatorial projects, public art, lectures and panels, or any of the other categories you may currently list on your resume. You may also have a news section for upcoming events or a place to sign up for your email list. Carefully plan out just how you want your site to work, and begin collecting content for the site.

Content for the site should include any text based files you have (artist statement, resume,

work descriptions, bio) as well as images. The two most common image file formats for the web are JPEG and GIF. Use JPEGs for images of artwork, and GIFs for buttons and other graphic elements. The resolution of these image files on the web should be no larger than 72 dpi. Any files with a larger dpi will increase the download time for your images.

After you have created your site, imported images, text and linked up all your pages, make sure to have a few other people go over the design and especially the text to spot any mistakes. You don't want to publish your site with any grammatical errors or misspelled words. And you want to make sure that your visitors can get from page to page easily.

Hosting

A site host or provider is where the files of your web site reside on the Internet. Many companies can provide you with both a domain name and web hosting for one fee. Generally, the fee for web hosting is based on the space or file size that your web site will occupy on the company's server, in addition to services such as email accounts, password protected pages, etc.

You need to decide early on if you want your site to include video, multiple email accounts, lots of images, large images, a blog, a discussion forum, or any number of functions because these capabilities will influence how much your hosting costs.

A lot of people have hosting space that they do not even know about, as many companies provide a small hosting account that comes with an email account. Most Internet Service Providers (Earthlink, GoDaddy, MSN, etc.) offer their customers limited web site space as part of

their email service package. Usually this space is adequate for a basic artist web site, although if you don't have your own domain name, often the web site addresses these companies assign are complicated. One way to get around this is to go ahead and purchase a domain name and then have the company that is providing the domain name reroute visitors to the address where your site is hosted. Otherwise your web site address might include the name of the hosting company, which is distracting to those looking for your domain name.

Make sure that when you purchase your hosting package you know what you are paying for. Many services try to sell you functions and space you simply don't need. Its worth the time and effort to call the hosting company and speak to someone directly who can walk you through the process. Also you might want to consult with a web designer, teacher, or another artist who's dealt with this process ahead of time and ask what services you should purchase.

Software you will need

If the hosting company has a do it yourself web design component, you might be able to do everything via that site. If not, and you decide to design your website yourself, you will need a software program such as Dreamweaver, or GoLive and photo editing software such as Photoshop, or Photoshop Elements (cheaper).

A web resource like thefreecountry.com has a list of free html and web editors available. If you don't have Photoshop and don't want to buy it, consider downloading Gimp, which is similar to Photoshop. Gimp is available at gimp.org. If you are going to add video clips or sound to your site, additional software will be required.

You might also decide to go with a web template that is recognized by blogging sites like Wordpress. There are literally thousands of templates out there. The trick is to find one that works for you. If you find one you are happy with you might have to pay the original designer a fee to use it. This can be much cheaper than hiring someone to design an entirely new site for you. But keep in mind that if you want to change the style of the template, meaning colors or any other design elements, you may have to learn PHP, HTML, or other programming languages. This can take time and money.

Getting Published

Once you site has been created, it needs to be uploaded/published. This will be an ongoing process in the life of your site. The main method of publishing a web site is to use a FTP (file transfer protocol) program. This type of program enables you to transfer files from your development site to a live server. There are plenty of good freeware FTP programs out there like Filezilla (http://filezilla-project.org/) and Cyberduck (http://cyberduck.ch/). Most will meet the needs and size of an artist's web site so find one that works for you. Some hosting companies will take you through the process, or provide an easy way to publish through their website.

Search Engines

Another aspect of creating a web site is making sure that web users can easily find your website. Search engines literally search a database of indexed sites by seeking keywords or phrases. However, in the case of crawler-based services such as Google, or in the case of user-powered directory-based services like Yahoo, you don't need to submit your site because they have their own site bots. Search

engine optimization is a science in itself. For more information on how search engines work, visit SearchEngineWatch.com.

Do NOT pay for services that promise to send your site to search engines or increase traffic to your site, these are scams. There is nothing they can do for you that you cannot do yourself.

Create reasons for viewers to come back to your site. Upload new work, information or projects regularly, and inform your audience that the site has new content. Always have news and events info that is up to date.

Copyright Issues

Guarding against unauthorized use of your online images is difficult if not impossible. Exercise due diligence and do what you can to make sure your images are not used without your permission, but never use concerns over copyright infringement as an excuse for not showing your art online or anywhere else, as your work is already in the public domain. Remember that your art is your business card—your single best means of advertising. The more people who see your art, whether in person or online, the greater your chances for making sales. Once your work has been published (this includes showing in a gallery or publishing to a web site), your work is then copyrighted. For additional copyright protection, see the copyright section, or do copyright research on the web.

You can choose to put watermarks in your online work, but realize that this is usually distracting and might actually be unnecessary. It's a better idea to just copyright your work. (See Copyright section)

Selling your work online

If you decide to sell your work online think long and hard about how this will influence how visitors will regard your work. If you've looked at many artists websites you'll notice that most of them do not offer their work for sale directly through their website. There are many reasons for this. First of all, many artists go through galleries or dealers or sell their work directly out of exhibitions or their studios. This establishes a collector base sprouted from face-to-face contact. But with the internet changing how people view artwork, more and more sales are happening online. It is up to you to decide if you want to sell work through the net. Most artwork is hard to experience on the web, so most collectors don't buy expensive work without seeing it first hand.

If you sell work through your site you will have to work through Paypal, Ebay or other shopping carts. These services will take a percentage of the sale or charge a fee for each transaction. Contacting these providers and setting up a payment and sales system is relatively easy. Just make sure your website can handle the programming/coding issues that come with making online sales.

If your work is for sale, you should consider how you price your work. Make sure work that is for sale is labeled accordingly and make sure that viewers can understand your pricing structure as well.

Offer approval, return and refund policies. On-line shoppers want to see art on approval first, and be able to return it for a complete refund if it does not look like what they saw on the web. Without this, you will not get many sales. Also remember that the web changes the way work looks, so someone might buy your art

and demand a refund when, say, the blue color in a painting appears different in-person vs. the web. Be prepared to receive returned work.

Once a work has sold take it off your site. Keeping sold works on your side can be confusing. It's like visiting a store, but everything is already sold, which makes for a frustrating shopping experience. Or if it is an important work, make a different section for that work.

Ok. So you have thought about designing your site and realize that you don't have the time or the resources. Also, you can't afford to hire a designer. What other options are available?

Paying a company for a pre-fabricated site and hosting

In the past few years, dozens of successful web companies have begun marketing pre-made website templates to artists. These companies have done all the work of designing artists websites and some of them look quite good, others have problems. These companies make money by charging a sign up fee and monthly or yearly fees ranging anywhere from $15 - $100 a month, depending on the kind of site you want. Usually these companies also pay for hosting fees so you don't have to, it's bundled into your fee.

There are pros and cons that come with subscribing to one of these services.

The best thing about going with one of these services is that they have done a lot of the work for you. They've designed the front end, which is how the site appears when you view it on an internet browser. They've researched what makes a successful artist website and hopefully incorporated good design into their product. They've considered how visitors navigate the site, made it compatible with all browsers, and

they work to fix bugs and solve problems. Most importantly for you, they've designed the back end, which is the program you use to upload content to your site.

Additionally, when you sign up with these services you may find yourself in excellent company with other professional artists willing to pay money for good web design. The host company might even have a list of selected clientele that link to your website, which both puts your site higher in Google searches, and also looks good to visitors trying to gauge your professionalism. Know what you are getting into. Research what other kinds of artists are on the site before you sign up.

When selecting one of these services you want to follow protocol similar to hiring a private web designer. Get referrals, research their client base, look at the sites they provide and judge them accordingly. See if you can talk with the people who actually designed the service. Test how quickly they return emails. If your having problems with your site in the future, you'll want to be dealing with someone who gets back to you quickly and fixes problems even quicker.

On top of researching the sites they make available on the web, ask to see the BACK END, the interface their subscribers use to upload new content to their sites. See if they offer a trial period where you can get used to uploading your files. When viewing and using the back end, ask yourself the following questions:

• Is the interface intuitive?
• Will I need lots of assistance to figure out how to get my information onto my site?
• Does the interface allow for me to customize my page?
• Is it easy to change font size, color, and add new content sections?

- How flexible is the layout and how much power do I have to change it?
- How much do they charge for minor customization?
- Does the upload feature shut down when I try to upload images?
- What size files will the back end allow me to upload?
- Am I limited when it comes to the orientation of images or where they appear on the page?
- Can I back up my website on my own computer or a back up drive?
- Will I be able to find and alter old files easily?
- Is there a search feature?
- How receptive is the interface to html codes, for example, this simple code used to embed pictures: ?

After navigating through the interface, you should have a pretty good idea of what it will be like to use the service.

Who should you choose?

We've looked into many of the companies offering pre-fab artist websites and have decided that we really like Artcodeinc.com. This company really has the best interests of their artist customers in mind. Their sites are well designed and easy to navigate. Their back end interface is intuitive and allows for just the right amount of customization. They are working on adding video capabilities, so their service isn't perfect. But, unlike other services, they offer a free 30-day demo you can use to see if you like what they have to offer. And, most importantly, their service is very affordably priced at only $15 a month plus a $100 sign up fee. That includes hosting. When you sign up, put GYST as your last name and they will waive the $100 set up fee (as of this publishing).

Resources

Check out the GYST master reading list. But here are some places to go for more info about building your artist website:

Building Arts Audiences and Communities on the Web by the folks at NYFA
http://spiderschool.org/1997/index.html

Using The Internet to Market Your Work by Beth Kanter
http://archive.nyfa.org/level4. asp?id=257&fid=1&sid=51&tid=201

Using the Internet To Get Your Work Noticed by NYFA
http://spiderschool.org/workshops/njsca/ index.html

AVOID COMMON ART & ARTIST WEB SITE MISTAKES by Artbusiness.com
http://www.artbusiness.com/weberrors.html

Weinman, Lynda. Designing Web Graphics: How to Prepare Images and Media for the Web. Indianapolis: New Riders Publishing, 1997. Designing Web Graphics was written from a visual designer's perspective, in an effort to teach other designers what is different about Web graphics.

Williams, Robin and John Tollett. The Non-Designers Web Book: An Easy Guide to Creating, Designing, and Posting Your Own Web Site. Berkeley: Peachpit Press, 1997. The Non-Designer's Web Book is an attractive, full-color guide for aspiring Web designers. The authors first explain how to browse and search the Web, and discuss how to plan and post a Web site. They then get you into the real work of designing Web sites, whether for business or personal purposes.

Commonly Made Mistakes When Building an Artist Website by Jodi Krangle
http://www.musesmuse.com/krangle-websitemistakes.html

Jessett.com – www.jessett.com
Good basic information on the basics of creating a web site.

Register.com - www.register.com

ReadyHosting.com - www.readyhosting.com

GoDaddy.com - www.GoDaddy.com
All register domain names and also provide hosting services.

Macromedia's Dreamweaver MX - www.macromedia.com/software/dreamweaver/

Adobe's GoLive - www.adobe.com/products/golive/

Microsoft's FrontPage - www.microsoft.com/frontpage/

Adobe's Photoshop Elements - www.adobe.com/products/photoshopel/main.html

GraphicConverter – www.lemkesoft.de/en/index.htm
GraphicConverter converts pictures to different formats. It also contains many useful features for picture manipulation.

Freeware and Shareware titles – www.versiontracker.com or www.webattack.com

Search Engine information - www.searchenginewatch.com

Artist Trust has a list of independent web designers in Washington State. Artist Trust

1835 12th Ave.
Seattle, WA 98122
206/467-8734 x10
866/218-7878
info@artisttrust.org

Submit your artist web site URL for free to these artist directories:
• Yahoo! Directory www.add.yahoo.com/fast/add?10203301
• The Pauper's Artist Directory www.thepauper.com/cafe/showpauper.asp
• The Open Directory Project www.dmoz.org/
• Published.com
• Artappeal.com
• Digitaldirectory.com
· Studioarts.co.uk

Web Search Engines

Submit your site for free to these major search engines if your web site does not appear in their results:
• Google
• Yahoo!
• MSN Search

Message Boards / Groups

Interact with other artists online to get more exposure. Here are some groups and message boards to consider joining. Be sure not to spread yourself too thin - this tactic only works if you are engaged with the other users.

• Yahoo! Groups for Entertainment & Arts
• Craiglist Forums
• eZBoard
• The Pauper Cafe Message Board
• The GYST Ink Networking Site

Online networking has revolutionized how artists connect with each other, curators,

funders, and collectors. While there are many social networking sites available to artists, it's important to register with the ones that matter.

Having a successful and productive web presence means keeping and maintaining select profiles on a handful of sites. Remember, each site will require maintenance. You will have to update your profile, comment on other people's profiles, and generally keep your profile alive. This takes effort. So choose the sites you join wisely.

 ## Email

Using proper email etiquette can mean the difference between cultivating a lifelong fan, or birthing an angry enemy. Make sure you learn to use email correctly.

First of all you might want to purchase or secure a personalized email address connected to your website. This can be mail@yourwebsite.com, your name@yourwebsite.com, etc. Having this email makes you appear professional and looks much better than yourname12345@hotmail.com

If you are going to send emails to more than twenty or so people at once consider using a mass-email system as offered by companies like Patronmail. Using this system will usually get around spam filters, and your email is less likely to end up in the trash.

Remember, it is annoying and impolite to disclose the email addresses from your contact list in the To: section of an email. Send emails to yourself in the To: section, and then add the others in the BCC (blind carbon copy) section to avoid this problem. Remember, some emails are private.

Be very careful when sending images in your emails, as they can take a long time to download. If you don't know the person you are emailing, think about warning them before you send an email with an attachment. This way, they will be sure to open your email, instead of rejecting it as virus-laden spam.

You should never send large files (more than 5–10MB) through email unless requested. For large files consider using an online service like yousendit.com, which will allow your recipient to download the file via the web.

Never send a bunch of unsolicited images to galleries or organizations.

Never send out unsolicited information about yourself to a bunch of random emails you happened to receive because they were carelessly left visible in the To: field. You don't want to receive an angry email asking, "How did you get my email?"

Use your mail program to create an email signature file that will be included in every email you send. Keep it short with your name, email address, and web site URL. Consider including one sentence summing up your art practice so they will know who you are. This little trick will work wonders!

 ## Social Networking

Here are some basic rules for these sites that you should learn and live by:

• These sites are not your portfolio or website. They are not an ideal place to look at or find work because they are cluttered with ads and extraneous information. It's up to you if you want to post pictures of your work on your profile. Given all the recent hullabaloo about

Facebook owning user's content, you might want to think about the work you upload because you could get yourself in copyright problems down the road. Instead, think about posting installation shots from your shows.

• Don't bombard your network with messages, group invitations, application invites, virtual gifts, etc. This is annoying and can make people de-friend you. If you send an invite to your show do it once, two or three weeks before the event and maybe send a reminder the day before. That's it. If you moderate a group or fan base, limit messages to a maximum of one per week. Even this can get annoying.

• Don't ask people you have never met to be your "friends." This particularly applies to curators and critics. Wait until you actually know them.

• Realize that any content or picture posted to your profile or anyone else's profile is permanent. Even if you remove it, untag yourself, or ask Facebook to get rid of your account, someone could still download your image or content and upload it later. The internet is much more permanent than you might think. Actively avoid being photographed doing things you might regret later. Employers scour sites like Facebook and Myspace for incriminating pictures of future employees. If your friends post naughty pictures of you, be efficient in asking them to remove the pictures from the web.

Generally, emerging artists find it invaluable to have active profiles on the following sites:

Facebook.com
Facebook is probably the most universally important social networking site. Here you set up a profile, upload pictures, and let people know about what you are doing. Facebook is a wonderful way to network with other artists, venues, and curators. Also the event feature on Facebook is one of the best ways to let people know about your exhibitions and events.

Myspace.com
Despite what some might say, people still use Myspace. This social networking site is quite helpful for musicians promoting their bands. Like Facebook, Myspace allows you to set up a profile, upload pictures, and network with friends, artists, networks, etc. Use the events feature to invite your friends to your events.

Artslant.com
Mentioned earlier, Artslant is one of many social networking and news sites specifically for artists. It lets you create a profile and upload some images of your work. It also lists the shows you've been in and who you've shown with. Creating a profile here is a great idea, especially if you live in one of the cities highlighted by Artslant: Chicago, Berlin, Los Angeles, New York, London, Amsterdam, Paris, San Francisco, Santa Fe, as well as other worldwide sites.

67: Works for Hire

 Objectives

Understand what works for hire means and what that means to an independent artist.

 Works for Hire

It is important to understand the difference between works for hire, and other working situations.

Legally, a work for hire is:

• A work prepared by an employee within the scope of his or her employment or

• A work specially ordered or commissioned for use as:
1. a contribution to a collective work;
2. as part of a motion picture or other audio visual work;
3. as a translation;
4. as a supplementary work;
5. as a compilation;
6. as an instructional text;
7. as a test;
8. as answer materials for a test; or
9. or as an atlas, if the parties expressly agree in a written instrument signed by them that the work shall be considered a work for hire.

Original works of authorship fixed in any tangible medium or expression, now known or later developed, from which they can be perceived, recorded, or otherwise communicated, either directly or with the aid or machine or device. Works of authorship include the following categories:

• literary works
• musical works, including any accompanying words
• dramatic works, including any accompanying music
• pantomimes and choreographic works
• pictorial, graphic and sculptural works
• motion pictures and other audio visual works; sounds recordings and architectural works.

What is not a work for hire:

Non-copyrightable matter, i.e. inventions, ideas, utilitarian works, procedures, processes, systems, models of operation, concepts, principles, discoveries, facts, U.S. Governmental works, works not lawfully obtained, works not original to employee, works in the public domain (i.e. not protected by copyright), obscene works, unoriginal works, works created by employees outside the scope of her/his employment titles, names, works, short phrases.

It may be important to investigate works for hire issues if you hire employees, or if you work for someone else.

68: Writing

 Objectives

Gain information on writing jobs for artists. Understand what to consider when starting out as a writer.

✳ Writing

Writing about your work, other people's work, and events in the art world is a great way to add your voice to the global art community. Writing is one of the most valuable skills an artist - or anyone for that matter - can have. Being able to write convincingly and understandably can lead to employment opportunities, grant awards, and respect from colleagues. Like a muscle, writing takes dedication and practice, and if you don't exercise your writing skills, you are bound to find yourself floundering and frustrated when you do have to submit a piece of writing for a publication or proposal. Often galleries rely on artists to help write press releases and marketing materials. Being prepared with a well-written artist statement can make this task easier and assure you that your work is properly contextualized and discussed.

Perhaps the most valuable reason to start writing is that when you publish your work, you can actively participate in the larger dialogue surrounding a particular set of ideas, or shift the way an artist's work is perceived.

Your writing practice can take many forms. Many artists supplement their income by writing critical essays or reviews in local/international publications. Artist writers can also simultaneously curate exhibitions and exhibit their work.

You can build your writing skills by keeping a journal or sketchbook. Use this format to clarify thoughts about your work. You can also build your writing skills by constantly updating your artist statement and applying for grants. Keeping up with these writing exercises will help you better understand your work and make you better prepared to talk with an interested curator or collector.

What Arts Writers Do

The world of arts writing is as vast as the art world itself. Arts writers can find avenues to publish their work in many places. An arts writer can:

- Write reviews of shows
- Interview artists
- Write catalog essays
- Write museum exhibition texts
- Write art theory essays
- Write informational texts for artist handbooks

Writers communicate to a variety of readers in newspapers, magazines, catalogs and publications, web sites, gallery handouts and books. Some writers freelance and keep their own schedule. Other writers are staff at large publications and write exclusively for their employer. Some writers choose what they want to write about and others get assignments from editors.

If you freelance and choose your own publications, you can usually write for a

number of different venues. This typically means you are self-employed and should develop sound business skills and have a business license. If you are employed full time as a staff writer, you may get health insurance and other benefits.

Some publications will take outside submissions from writers they have never worked with, and others will not. In order to find out which publications will accept new writers, do a bit of research. Visit their web sites and take note of their submission guidelines and deadlines. Be sure to ask your writer friends about various publications they have written for and ask for a referral.

Job Skills Needed

• Interest in art and a background in art history

• A strong point of view

• Ability to write clearly so that readers understand what you are talking about

• Ability to understand publication guidelines and writing formats

• Ability to write for target audiences

• Thorough knowledge of the subject matter at hand and the ability to research on the fly

• Ability to pay close attention to details

• Ability to write clearly for a variety of readers

• Ability to use word-processing software

• Ability to understand complex or challenging ideas and concepts

• Willingness to stand by your opinions and ideas in a public forum

• Ability to work alone much of the time

• Ability to be flexible and adjust to changes in project scheduling

• Ability to function as a self-employed writer and a willingness to always be looking for new writing jobs

How to Find a Writing Job

The first thing potential employers and editors will look for when considering a writer is a collection of writing samples. This can come in the form of published works or unpublished works. You will be in a better position to get the job if you have published some of your writings. Don't worry if you haven't published yet. The best way to get published is to keep submitting work again and again to receptive publications. Start in your local community. Consider writing a review of an exhibit for a community newspaper, a small newsletter, or community-focused web publication. Consider writing for one of the hundreds of art blogs currently in circulation on the internet. Or you can start your own art blog. You can get your start just about anywhere.

Once you have written a few pieces, select some of your best works demonstrating your personal viewpoint and your ability to write various length articles on different subjects. Assemble these work samples in a word processing document and make sure to insert page numbers. Your future editor will let you know how he or she wants to receive your work samples. Follow their instructions very carefully. Sometimes editors or educational publications want to see actual hard-copies of

published works. This is why it is very important to always save at least three copies of every work of yours appearing in print. One copy is for your archives, the other is for your immediately-available writing portfolio, and the third is a backup. You will also want to include a letter of introduction and maybe a writer's statement about your viewpoint as a writer and what you intend your writings to accomplish. Often a prospective editor will be more than happy to look at a web-based portfolio of your work, so consider publishing your writings on the web.

New writers may receive very little pay for their work. A five-hundred word review of a show which took a dozen hours to write can fetch $70 or less. Some writers are paid by the hour, some by the piece, and some by the number of words in a project. Your experience and demand as a writer will also determine your rates.

Most writers write small reviews for little pay not because it pays the bills, but because they love to write and because the more their work is published, the more they can charge down the line and the more in-demand they will be for lucrative projects, like catalog essays, curatorial gigs, and longer essays.

 Objectives

Understand basic crating and shipping information so when you call a vender, you now exactly what they are talking about.

Understand how to find shippers and craters.

 Things To Do

Research names of various shippers and crate builders in your area.

 Crating & Shipping

Introduction

Artworks that travel can be vulnerable to damage due to poor handling by untrained art handlers, bad weather, rough roads, and poor storage. You can never assume that all institutions have well trained art handlers, but accidents are preventable. It is best to do research on art handling companies and get referrals before trusting your art to shippers. Professional shippers and craters are the best guarantee you have that your precious, valuable, and fragile objects arrive safely at their destination.

Advantages of Using an Art Handler

An art handling company specializes in transporting artwork and dealing with galleries and museums. They have trained personnel and specially equipped trucks and storage areas with which to make artwork transfers. Many art handlers are artists themselves and have worked in museums and galleries. The specialists, combined with art handling tools and equipment, make up a team of people whose skills surpass those of regular movers. They are generally adept at handling and solving problems encountered with art. Although art handlers tend to cost more, they may be essential to safeguard your work. It is a good idea to interview the shipper to find out how your work will be handled.

Assessing Your Shipping Needs

Before starting to pack, you need to address your artworks' specific shipping needs. Remember that each artwork usually has specific requirements.

• Assess the artwork to be moved, determine size, materials and their fragility. The shape of the work is important.

• Consider where the work is being moved from and how far does it has to go. Shipping something across town may be very different than shipping across the country where the packaging has to be handled by many hands. Shipping work overseas is another issue altogether.

• Determine if the work can be moved by truck, by hand, in your car or by air. Research shipping possibilities before making decisions, as the costs of shipping varies greatly. You will need to match the crate or packing for the correct transport. Will you be moving the work with a bunch of your friends or hiring an art handler?

• Determine how long the work will be packed in its packaging or crate. Will it be in storage for

a long time, or will it be unpacked soon after it arrives at its destination. Work left in storage for a long time can be effected by environmental changes like humidity and heat.

• Consider the weight of the materials and objects you are shipping. You may need multiple crates instead of one large one, in order to safeguard your work and to keep the weight within shipping guidelines.

• Assess the cost of the materials you will need to build your own crate or research what it will cost to have it built for you. This may dictate the choices you make.

Crating: General Principles

Why crate artworks for transit? A custom art crate is a protective environment, designed to streamline transit from one location to another and to provide the ultimate safety for the art object that the crate contains. It must provide a barrier from water (rain, snow, condensation), soil, and shock (low-level vibration as well as a high-impact blow).

The art packed in an art crate should be inside the primary object or container, which is then floated in shock-absorbent materials within a solid outer shell. There must be no movement in any direction and the floated objects should be a safe distance from the hard surfaces of its protective container.

The size of the crate or shipping container will be determined by the size and shape of the artwork you are packaging. The amount of packing will be determined by the shape, size and weight of the object. It is a good idea to know the limitations of the receiver. If the crate does not fit through the door of the gallery, you could be in trouble. Consider if art handlers will be available on the other end to help unpack and move the crate.

How do you create safety for your artworks during transit without having excess costs or weight? Remember to never over pack an object. A crate of substantial dimension and weight can limit the possibilities of mishandling during shipping. Your safest bet is to build a crate that is too great for movement by one handler, but too small to require the use of a forklift.

The Object: Sustainable for Travel?

Before determining the crate size, analyze if the artwork is suitable for travel by determining its physical condition and medium. If an artwork is fragile or in poor condition it will only get further damaged or possibly destroyed in transit. It is better to send a piece that is less fragile and durable. The medium and physical condition of an artwork will affect all crating preparations. The condition of the artwork may require an unusual orientation within the crate: a painting that shows signs of flaking or is still wet will need to be placed horizontally, with the fragile or wet surface up, inside the crate.

To avoid possible crating problems or surprises follow the steps below:

• Schedule a visit by the crate preparatory so that they may inspect the artwork size, depth, and medium, and fragility. This meeting will give the crater a first hand look at your particular shipping needs and you can get an estimate of how much it will cost to crate and ship your work.

• Schedule a visit by all lenders before artwork is crated so they are prepared for installation. Also provide a drawing with the exact measurements of the piece. This drawing should include: height, width, depth, length, medium, and weight. Provide the host venue with shipping estimates and get the payment agreement in writing, especially if operating on a reimbursable plan.

• In the crate, provide detailed installation instructions for shipped artwork, and send these via email and regular mail as well. The last thing you want is the people installing the work to make assumptions about how to handle the work.

• It may be a good idea to provide unpacking and repacking instructions. You may need to number packing pieces and provide detailed instructions. These instructions should be in the top of the crate once it is opened or outside the crate. Sending a second by mail or email is often a good idea.

• Coordinate the return shipment of your artwork with the registrar or gallery director well in advance of the close of the exhibition. Make sure you cover the following information:

Where the return shipment should be shipped to (gallery, studio, collector, home address)?
Who pays for the return shipment?
Who pays for insurance for the work both to and from the exhibition space?

Make sure there is an inventory list that travels with the art shipment listing the contents of the shipment and number of packages, method of shipping with tracking numbers, proof of insurance during transit and estimated time of arrival.

Supplies for Shipping & Crating

Below is a list of packing materials that will assist you in selecting the best material for a given job and for durable shipping containers. Not only will you need scissors, a box cutter, a matt knife, basic shop tools (hammer, drill), but also a clean and adequate space for crating.

Use archival (non-acidic) materials whenever possible, particularly when the art will have direct contact with the surface of your work. Archival materials are generally more expensive than non-archival ones, but they will not harm your work. Additionally, you should always try to purchase materials that are environmentally friendly.

BUBBLE WRAP: A waterproof, double polyethylene sheet with circles of injected air that is great for cushioning. Often available in various thicknesses; re-useable, and transparent. Always keep the bubbles facing out because pressure or prolonged contact with the bubbles can leave impressions on work.

CELLULOSE WADDING: A soft, shock-absorbent crepe paper wrapping best used with solid objects without delicate protrusions; opaque; not recommended for reuse.

CORRUGATED CARDBOARD: Cardboard comes in all sizes and thicknesses. Though it has a high acid content, it is fairly strong and makes an excellent protective layer.

ETHAFOAM: ETHAFOAM (trademark of The Dow Chemical Company) brand polyethylene foam products are semi-rigid foams whose flexibility, resilience, and light weight make it particularly useful as shock absorbers for solid three-dimensional objects. ETHAFOAM can also be used as interior packing in crates where a secondary package is "floated." Chemically stable, ETHAFOAM's tough, closed-cell structure is capable of high load bearing. It is not adversely affected by moisture.

FELT: Used as a covering material for foam pads or corrugated dividing sheets. It can be glued directly to interior crate surfaces to provide nonabrasive surfaces but does not absorb shock. Felt does soak up moisture, which is a major drawback.

FOAM: Polyethylene foam is waterproof and comes in sheets and rolls of varying thickness'. It is excellent for cushioning and does not break down over time.

FOAM CORE: Foam core is made up of a layer of foam sandwiched between 2 layers of paperboard. It comes both archival and non-archival, and is available in various thicknesses.

FOAM POPCORN, CHIPS OR PEANUTS: Made of polystyrene, they come in different shapes and sizes and are excellent for filling empty spaces around work.

GATORFOAM: Gatorfoam is a series of unique, lightweight structural panels consisting of a rigid Polystyrene foam core faced on both sides by smooth, moisture resistant man-made wood fiber veneers. The foam and veneers are permanently bonded together in a sandwich construction. The face laminates have been specially developed to provide an excellent surface for painting, silk screening, laminating and photo mounting. It comes in various thicknesses and is much stronger than foam core.

GLASSINE: Glassine, a glazed, semi transparent paper, is an archival product used for the initial cover of artworks. Glassine can also be layered between multiple drawings, prints and other flat works on paper that are unframed. It is not water-repellent, thus not suitable for exterior wrapping.

PLASTIC SHEETING OR BAGS: Plastic sheeting or bags will form the moisture barrier around your work. If you can afford it, try to use an archival brand. Use plastic sheeting for paintings. They are reusable but electrostatic qualities attract and hold dirt, making onetime use more likely. To avoid condensation build up, use ventilation holes and 4-mil thickness.

PLYWOOD & MASONITE: Plywood and Masonite are available in various thickness. Plywood should be used to construct crates. Masonite should be used to protect unframed works.

MASKING TAPE or BLUE PAINTERS' TAPE: Used to secure work inside the package/crate and to protect glass in frames from shattering. Painter's tape is easily removed, while some masking tape can be quite sticky and harder to remove.

PACKING TAPE: Used to seal your cardboard packages. Best used with a tape gun for efficiency.

SCREWS, BOLTS AND NUTS: Used to assemble wooden crates.

TISSUE PAPER: Available in both archival and non-archival forms; used as initial wrapping for three-dimensional objects. Non-archival tissue paper is very cheap and when crumpled up, it provides excellent cushioning for your work

VOLARA: VOLARA (Trademark of Voltek, Inc.) brand closed-cell polyethylene foam can be laminated (with heat gun or contact cement) to

ETHAFOAM blocks to provide resilient, smooth surface to cushion artworks. Bonding by use of heat gun is permanent and safe.

Suppliers

All the above materials can be found at one of the following suppliers. Call them for a free catalog. Check the web or your local phone book for shippers and suppliers, and be sure to ask a lot of questions before you make a decision.

AIRFLOAT SYSTEMS
1 (800) 445-2580
www.airfloatsys.com

MASTERPAK
1 (800) 922-5522
www.masterpak-usa.com

VALENTINE PACKING CORP.
1 (718) 545-6300

BOX CITY
1 (800) 992-6924
www.boxcity.com

LA PACKING & CRATING (ASHLEY
DISTRIBUTORS)
1 (323) 937-2669
www.lapacking.com
www.ashleydistributors.com

HOME DEPOT
www.homedepot.com

LOEWS
www.lowes.com
LIGHT IMPRESSIONS
1 (800) 828-6216
www.lightimpressionsdirect.com

ULINE
1(800) 958-5463
www.uline.com

To learn how to create 2- Dimensional objects,
single- object, multiple- object, or 3-
Dimensional objects refer to:

Way to Go! Crating Artwork for Travel by
Stephen Horne. Hamilton, NY: Gallery
Association of New York State, 1985. Tel: (315)
824-2510. Cost: $10

Caring for Your Art by Jill Snyder. Allworth
Press, 1996. Available from Americans for the
Arts. Tel: (202) 371-2830. Cost $16.95

**Packing Unframed Photographs and Work
on Paper**

When your work is in transport from your
studio, or between shows, there are several
threats including water, temperature changes,
humidity, rough handling or dropping. Proper
packaging should protect the artwork against
all of the above. Consider these suggestions:

• A layer of archival tissue or glassine should be
placed between each work, including a sheet
on the top and bottom of the stack.

• Wrap the works in plastic or enclose them in a
plastic bag to keep out any moisture. Plastic
should be archival if possible. Remove excess
air and then seal it shut with tape.

• Place the package in the center of a piece of
Masonite (1/8" or thicker) with at least a two-
inch margin around each side so that the work
does not get crinkled or bent on the edges or
corners. Masonite or any other hard board will
protect your work from being punctured.

• Tape the package at all four corners to the
Masonite board to prevent shifting during
handling. In some instances you may want to
wrap the board and the work. Make sure you
do not harm the work.

• Place your consignment agreement or artwork
checklist on top of the bag. Make sure that there
are no staples or paper clips that will damage
the work. It is a good idea to send a separate
agreement or checklist through the mail or
Email in addition to including it in the crate.

• Take a second piece of Masonite and place it
on top of the first one making a sandwich with
your work in the middle.

• Take two sheets of cardboard (same size as the Masonite) and place the Masonite sandwich between them.

• Completely seal all four sides of the sandwich with shipping tape.

• This sandwich may or may not need to be packed within a crate with additional packing.

Packing Paintings, Framed Works, and Sculpture

• Framed pieces and sculpture should be packed in a reinforced cardboard box or a wooden crate especially if being shipped any distance.

• Cardboard boxes specially designed for transporting art are available in all sizes from several companies (listed above).

• Crates are generally made of plywood and fastened with screws to allow for easy opening and closing. Crates should always be sealed with several coats of polyurethane to be water-repellent. Label the crates with fragile or keep dry stickers or signage.

• The box or crate should be at least two inches larger than the work on each side to allow plenty of room for cushioning. You should always fill in the extra space around the work with cushioning materials like layers of foam or peanuts.

• Multiple works should be crated standing vertically with a layer of cardboard and cushioning between each work.

• Framed works, paintings or sculpture should be wrapped with glassine or archival tissue paper, and then sealed in plastic sheeting or bags. Never tape anything directly to the work.

Also, use additional padding on all four corners of paintings and frames. You can make your own or order corner padding from a supplier.

• The glass in framed works should be replaced with Plexiglas, or it should be removed from the frame and wrapped separately. If this is not possible, make a grid of masking tape directly on the glass to hold it together in case it breaks during transit.

• Sculpture should be wrapped in glassine or archival tissue paper, sealed in plastic sheeting or bags and then floated within the crate to allow for plenty of cushioning on all sides.

Wrapping: General Principles

By wrapping artwork for shipping you are keeping the art clean and dry from airborne dirt. Always use clean materials and a clean work area to prevent dirt from accumulating on artwork. Keep wrapping simple so that there is no damage to the artwork in the process of unpacking. Wrapping should be taped only to itself; tape should never touch artwork, including the back of a painting or its frame. Avoid excessive taping for it will only be more difficult for the preparator to safely unpack the artwork. Excessive taping can also damage the packing and render is unusable for repacking. To waterproof work, use plastic sheeting.

Parcel Services:

UPS
1(800) 742-5877
Limitations: 130" total height/width/length, and/or 150 pounds

FEDERAL EXPRESS
1(800) 238-5355
Limitations: 10' in length, 165" girth, and/or 150 pounds

DHL
1(800) 225-5345
Limitations: none

U.S. POSTAL SERVICE
Limitations: 108" total height/width/length, and/or 70 pounds

Some Art Handlers Start With:

Cook's Crating and Fine Art Transportation, Inc.
3124 East 11th Street
Los Angeles, CA 90023
1 (323) 268-5101

LA Packing
1 (323) 937-2669
www.lapacking.com

Atelier 4, Inc.
177 Water Street
Brooklyn, NY 11201-111
Office: 1 (718) 875-5050
Fax: 1 (718) 852-5723
www.atelier4.com

Fine Arts Service Inc.
222 S Figueroa St.
Los Angeles, CA 90012
1 (213) 617-2217

Crate 88
4091 Redwood Ave.
Los Angeles, CA 90066 USA
Office: 1 (310) 821-8558
Fax: 1 (310) 306-3572
www.crate88.com
info@crate88.com

Precautionary Measures

• When shipping, always insure the work for the maximum retail price.

• Packages/crates should always be clearly labeled with handling instruction on the exterior using these symbols: a broken stem glass indicating that the package is fragile; an umbrella indicating that the package needs to remain dry; and a upward arrow indicating the top side; write 'face' on the exterior of the package to indicate the face of the artwork inside.

• You should also write a condition report listing any prior damage or potential vulnerabilities. This should be included inside the package to be sent. You should include photographs of previous damage or diagrams of the work if it needs to be reassembled once unpacked.

• You should make a detailed diagram of installation instructions for the crated piece, which should be placed inside the crate, as well as sent separately to the exhibition site.

Who Should Pay For Shipping?

The answer depends on the exhibition venue. Make no assumptions.

Gallery Exhibitions (both non and for profit)
It is standard practice for the artist to pay the cost of shipping to the show and for the gallery to pay the return cost. You need to make sure that it is clearly addressed in your consignment agreement.

Juried Exhibitions
The artist is expected to pay the cost of shipping to and from the exhibition.

Museum Exhibitions
The museum usually pays for shipping in both directions.

70: Estate Planning & Aging

 Objectives

Gain understanding of the issues of aging in the art world, and how to go about planning your estate.

 Things to Consider

Do you know where all of your artwork is? Do you have a will that explains where this work will go, or to whom?

 Aging

As the graying of America progresses and the baby boomers begin to enter their twilight years, the US government and other agencies are deep in discussion over issues of physical and mental health care; social security, retirement and pension benefits, and attitudes and policies on aging. Traditional solutions to the challenges listed above are not sufficient. A plethora of programs from 'lifelong education' to more user-friendly assisted-living facilities have been created to help Americans cope with aging. It is important to understand how issues pertaining to aging affect artists and shape opinions about artistic production.

As artists age, they face a variety of issues that may effect their personal lives as well as their artistic practice. Matisse worked from his wheelchair with a severe illness until the age of 81. Monet painted into his 80's despite the fact that he was losing his eyesight and becoming blind. Louise Bourgeois continued to make art well into her 90s and had a very successful traveling retrospective in 2008 at the youthful age of 97.

These examples, and many more, underline the fact that as artists age they don't stop making work or lose creative impulses. On the contrary, the wisdom, and maturity that comes with age might in fact produce the best work of an artist's career. The key is to develop ways to circumvent some of the negative aspects of aging and the stereotypes that come with it.

A wise artist and curator whose career had spanned decades once quipped that "In the early 21st century being an older artist (and by this I mean being over 50) seems to generate the kind of repulsive response from curators and galleries that being a woman, a homosexual, a person of color generated in the past. Ageism, it seems, is the new bigoted response to what's not selling, right up there with the racism, sexism, xenophobia, and homophobia that have marked art world snobbery and greed for so many decades." It should be the goal of any concerned artist to rid the world of prejudiced responses to individual artists, and especially to carve out a space where older artists have a voice and a space to exhibit work.

If you are an older artist, if you have found yourself emerging for longer than you'd like, there are some steps you can take to build a supportive community and get your work out there:

• Be visible. Get together with friends, colleagues, other artists and attend gallery openings, lectures and events together. Being a presence and a force, will change people's ideas about what it means to be an aging artist.

• Familiarize yourself with the Americans with Disabilities Act of 1990 and laws prohibiting age discrimination in the workplace. Check out the section on Artists with Disabilities in this manual. It is the responsibility of all artists, young and old, to ensure that our cultural institutions are open and welcoming to everyone.

• Find and join local arts organizations and nonprofits where you can develop contacts and share your work with like-minded people in your community. If you have any extra time, consider volunteering for one of these organizations. Not only will this give you access to the people running the space, it will also help you to network with other artists in your community.

• Start your own network of late-career artists. Meet up at museums, galleries, or each other's houses to talk about work. Invite some of your colleagues over for a potluck, or go out to dinner if cooking is too much trouble.

• Consider having an exhibition in your own studio and invite everyone you know. You might even sell some work. Do not wait to be validated by the art world, get out there and do it yourself.

Your Estate

It is important to know how you want others to handle your estate and the artwork that you will leave behind. Organizing the work and the information about the work will ensure that it is not lost or destroyed. Some organizations work with older artists specifically, and provide important information. Consider hiring a young artist or student to help you enter art data into a computer, and scan older slides and photos. Contact local service organizations to see if they have a service near you.

Resources

The National Endowment for the Art's Creativity and Aging Study:
The Impact of Professionally Conducted Cultural Programs on Older Adults: Final Report: April 2006
http://www.nea.gov/resources/Accessibility/CnA-Rep4-30-06.pdf

The National Endowment for the Art's Mini-Conference on Creativity and Aging in America -- May 18-19, 2005
http://www.nea.gov/resources/Accessibility/aa/contents.html

The National Endowment for the Art's Creativity and Aging: Best Practices Report
http://www.nea.gov/resources/Accessibility/BestPractices.pdf

Arts for the Aging provides artistic outreach to the elderly in Washington, D.C.
http://www.aftaarts.org/
Elder Hostel is a nonprofit providing learning and travel programs to senior citizens.
http://www.elderhostel.org/

Grace Art promotes the artwork of the elderly in Vermont.
http://www.graceart.org/index2.php

Ithaca College's Linden Center for Creativity and Aging
http://www.ithaca.edu/lindencenter/

The Huffington Center on Aging
http://www.hcoa.org/newsite/index.asp

Life Extension Foundation reviews a book about old Great Masters:
http://www.acfnewsource.org/art/aging_artists.html

The National Center for Creative Aging has a resources for arts and aging: http://www.creativeaging.org/

The Marie Walsh Sharpe Art Foundation offers a comprehensive visual artist's guide to Estate Planning via their web site and in book form. Sections of the following have been published on their web site. The book is a must if you are serious about estate planning.

www.sharpeartfdn.org/estateplnbook/estateplanning.htm

 Estate Planning

Introduction

Typically, working artists produce a large amount of work over the course of their career and lifetime. As you get older, your chances of passing on are greater, and at some point you should begin to consider just what to do with your artwork. Consider what would happen to your work if you did not plan ahead. All artists should consider their legacy. How you treat your artwork can affect its value and marketability for the rest of your life and beyond.

Lots of artists do not consider this important aspect of their careers until much later in their lives. The idea of making a will can be off-putting, but if you value your work, you should read this segment and perhaps begin to think about your long-term plans.

Your Estate Planning

Creating a good estate and financial plan is an excellent way to start. Your financial security and the preservation of your assets for future generations should be in place by the time you reach 50 years of age.

• Do you have a will?

• Is your will up to date or less than five years old?

• Are there any changes in your life that would change the circumstances of your will?

• Do you know your financial status?

Keep a list where all of your important financial information and documents are stored and tell someone you trust.

How to Start

• Document and inventory all of your work and enter it into your Artwork Inventory. This includes art at home, in your studio, in storage areas, at galleries, and on display at outside locations. In case you will ever have a retrospective, you should include all artwork you have ever made, including work owned by collectors so it will be easy to find your work in the future.

• Artists often amass a collection of artwork by other artists, friends and colleagues. You should treat this collection with the same professionalism as your own work. Archive this work, maintain accurate records, and have a plan in place for this work should something happen to you at a later date.

• Organize all information related to your art and your career as an artist, including notes, show reviews, photographs, invoices, personal journals, and correspondences from artists, friends, dealers and collectors.

• Sign, date and title all your artwork, legibly.

• Price your work or get an appraisal.

• Have a marketing plan for your work after your gone.

Additional points to keep in mind when planning your estate:

• When planning your estate, you need to assign an executor. Find someone you trust and make sure they are willing to take on this role. Talking with them upfront is a good idea, and you can make plans together.

• Make sure the executor knows where things are stored and how to find complete contact information for your dealers, representatives and agents. It is crucial to explain to the executor how to work with these people. If you have not found someone with art business experience to represent or handle your art, now is a good time to start looking.

• Make sure your executor, heirs, dealers, agents and representatives understand what you want done with your art (without trying to micro manage). Never assume that people automatically know what to do. Put your preferences in writing.

• Give all concerned parties opportunities to ask questions, offer opinions, and make suggestions regarding the future of your art and your legacy as an artist.

• Leave clear instructions on how your art is to be divided among family members, institutions, galleries, and other relevant parties. Make sure that everyone understands what they are going to get and, if necessary, why they are getting it.

71: Resources & Further Reading

 ## Objectives

Understand what resources are available to you as an artist.

Things To Do

Use these resources to answer any questions not answered in this manual

 ## Resources and Further Reading

MAKING ARTWORK

"The Artwork is Most Important", Chapter 1, The Practical Handbook for the Emerging Artist, Margaret Lazzari, Harcourt College Publishers, second edition, 2002.

"The Art World is Bursting Apart: An Art Consultant's Insight into the Myths and Realities of the Artist's Life", by Geoffrey Gorman, www.nyfa.org.

"Choosing the Artist's Life", Chapter 1, Art That Pays, Adele Slaughter and Jeff Kober, National Network for Artist Placement, 2004.

"Launching or Relaunching Your Career: Overcoming Career Blocks", Chapter 1, How to Survive and Prosper as an Artist, Caroll Michels, Henry Holt and Co., 2001.

"Making Time for Art: I Wanted to Be an Artist, So I Quit My Job and Became One", Christopher Fife, www.nyfa.org

"Ten Habits of Successful Artists", Geoffrey Gorman, www.nyfa.org

YOUR PORTFOLIO

"Creating a Professional Portfolio", by Geoffrey Gorman, www.nyfa.org

"Dr. Art on Developing Your Artist Portfolio", by Matthew Deleget, www.nyfa.org
"Portfolio Development for Artists Working in All Disciplines", Susan Myers, www.nyfa.org

"Presentation Tools and Packages", Chapter 3, How to Survive and Prosper as an Artist, Caroll Michels, Henry Holt and Co., 2001.

"Presenting Your Work to Art Professionals or Clients", Chapter 6, The Practical Handbook for the Emerging Artist, Margaret Lazzari, Harcourt College Publishers, second edition, 2002.

YOUR STUDIO

"The Gentrification Game: Are Artists Pawns or Players in the Gentrification of Low-Income Urban Neighborhoods?", by Ilana Stanger, www.nyfa.org

"Lofts and Leases", Legal Guide for the Visual Artist., Tad Crawford, Allworth Press, revised 1999.

PLANNING

"Career Self-Assessment and Setting Goals", by Susan Koblin Schear, www.nyfa.org

"Setting Clear Goals: The First Steps on the Runway to Success", by Geoffrey Gorman, www.nyfa.org

"Ten Principles of Successful Artists", by Geoffrey Gorman, www.nyfa.org

"Ten Tips for Success in the Art World", by Geoffrey Gorman, www.nyfa.org

ARTIST'S STATEMENTS

"The Artwork is Most Important", Chapter 1, The Practical Handbook for the Emerging Artist, Margaret Lazzari, Harcourt College Publishers, second edition, 2002. (See Describing Your Art Section)

"Writing the Artist's Statement", Adriane Goodwin, www.artist-statement.com

"How to Write an Artist's Statement", Marion Boddy-Evans, http://painting.about.com/cs/careerdevelopment/a/statementartist.htm

"Writing Your Artist Statement", Molly Gordon, www.mollygordon.com/resources/marketingresources/artstatemt/

"Your Artist Statement: Explaining the Unexplainable", www.artbusiness.com/artstate.html

TEACHING STATEMENTS

Strategies: Resume Preparation. http://www.students.vcu.edu/careers/

MAKING CONNECTIONS

"Dr. Art on Conducting Studio Visits", by Matthew Deleget, www.nyfa.org

"Making Connections", Chapter 2, The Practical Handbook for the Emerging Artist, Margaret Lazzari, Harcourt College Publishers, 2002.

"Making the Most of Professional Organizations", by Susan Ball, www.nyfa.org

"Finding a Community", Chapter 8, Art That Pays, Adele Slaughter and Jeff Kober, National Network for Artist Placement, 2004.

GETTING YOUR WORK OUT IN PUBLIC

"Art Auction Fundraiser Tips for Everyone", www.artbusiness.com/auctips.html

"Dr. Art on Donating Your Work to Charity", by Matthew Deleget and Gail Rosen, www.nyfa.org

"Exhibitions and Sales Opportunities: Using Those That Exist and Creating Your Own", Chapter 6, How to Survive and Prosper as an Artist, Caroll Michels, Henry Holt and Co., 2001.

"Launching or Relaunching Your Career: Entering the Marketplace", by Caroll Michels, Chapter 2, How to Survive and Prosper as an Artist, Caroll Michels, Henry Holt and Co., 2001.

High Art Down Home: An Economic Ethnography of a Local Art Market, Stuart Plattner, University of Chicago Press, 1997.

"Taking Control of Showing Your Work", Chapter 3, The Practical Handbook for the Emerging Artist, Margaret Lazzari, Harcourt College Publishers, 2002.

"Presenting Your Work to Art Professionals or Clients", Chapter 6, The Practical Handbook for the Emerging Artist, Margaret Lazzari, Harcourt College Publishers, 2002.

"Researching Galleries, Museums and Other Art Venues", Chapter 7, The Practical Handbook for the Emerging Artist, Margaret Lazzari, Harcourt College Publishers, 2002.

The Skinny on Slide Registries, by Ilana Stanger, www.nyfa.org

ART VENUES

Art in American Annual Guide to Galleries, Museums, Artists, Art in America, annually.

The National Resource Guide for the Placement of Artists, Cheryl Slean, The National Network for Artist Placement.

Organizing Artists, Directory of the National Association of Artists' Organizations, NAAO, 1998.

SELF GENERATED PROJECTS

The Artist's Guide to New Markets: Opportunities to Show and Sell Art Beyond Galleries, Peggy Hadden, editor, Allworth Press, 1998.

"Exhibitions and Sales Opportunities: Using Those That Exist and Creating Your Own", Chapter 6, How to Survive and Prosper as an Artist, Caroll Michels, Henry Holt and Co., 2001.

On Your Own, Alternative Exhibition Strategies, Visual Arts Ontario, 1995.

PUBLIC ART

Artist's Guide to Public Art: How to Find and Win Commissions, Lynn Basa, Allworth Press, 2008. www.allworth.com

Art in Other Places, William Cleveland, University of Massachusetts, 2000.

Critical Issues in Public Art. Content, Context, and Controversy, Harriet F. Senie and Sally Webster, Smithsonian Institution Press, 1998.

Dialogues in Public Art, Tom Finkelpearl, M.I.T. Press, 2000.

International Directory of Sculpture Parks, www.artnut.com/intl.html

Mapping the Terrain: New Genre Public Art, Suzanne Lacy, editor, Bay Press, 1994.

"Other Financial Support", Chapter 14, The Practical Handbook for the Emerging Artist, Margaret Lazzari, Harcourt College Publishers, 2002.

GALLERIES, CONSULTANTS AND OTHER SALES OF WORK

"Art Consultants: The Hidden Resource", by Geoffrey Gorman, www.nyfa.org

The Art Biz: The Covert World of Collectors, Dealers, Auction Houses, Museums, and Critics, Alice Goldfarb Marquis, Contemporary Books, 1991.

"Artist Gallery Relations", Chapter 8, The Practical Handbook for the Emerging Artist, Margaret Lazzari, Harcourt College Publishers, 2002.

"Corporate Art Collections", by Ilana Stanger, www.nyfa.org

"Dealing With Dealers and Psyching Them Out", Chapter 7, How to Survive and Prosper as an Artist, Caroll Michels, Henry Holt and Co., 2001.

"Dr. Art on Contracts with Galleries and Collectors", by Matthew Deleget, www.nyfa.org

"Exhibitions and Sales Opportunities: Using Those That Exist and Creating Your Own", Chapter 6, How to Survive and Prosper as an Artist, Caroll Michels, Henry Holt and Co., 2001.

Framed. Tales of the Art Underworld, Ted Volpe, Klayman/Branchcomb, 1996.

"If People Say Your Art is Too Expensive, it Just Might Be", www.artbusiness.com/expensiveart.html

"Pricing Your Art: Making Fine Line Price Distinctions", www.artbusiness.com/pricepoints.html and www.artbusiness.com/pricetipscont.html

"Pricing Your Work", Chapter 4, How to Survive and Prosper as an Artist, Caroll Michels, Henry Holt and Co., 2001.

"The Skinny on Online Galleries", by Ilana Stanger, www.nyfa.org

"Tips for Successful Art Openings", www.artbusiness.com/openingtips.html

"When an Artist Acts Without a Gallery's Consent", ww.artbusiness.com/artsurp.html

"Where Will an Agent Take You?", by Amy Holman, www.nyfa.org

EXHIBITIONS

"Art and Coffee Shops: An Investigation into the Coffee Shop/Gallery Business," by Ilana Stanger, www.nyfa.org

"Artist in the Community", by Bill Rauch, www.nyfa.org.

"Dr. Art on Paying to Exhibit Your Work", by Matthew Deleget and Renée Phillips, www.nyfa.org

"Exhibitions and Sales Opportunities: Using Those That Exist and Creating Your Own", Chapter 6, How to Survive and Prosper as an Artist, Caroll Michels, Henry Holt and Co., 2001.

"Investing in Your Career: A Worthwhile Risk?", by Daniel Grant, www.nyfa.org

"Your Show," Chapter 4, The Practical Handbook for the Emerging Artist, Margaret Lazzari, Harcourt College Publishers, 2002.

PERFORMANCE

Booking and Tour Management for the Performing Arts, Rena Shagan, Allworth Press, 2001.

Presenting Performances, Thomas Wolf, American Council for the Arts, 1991.

KEEPING ORGANIZED

Art Office, Constance Smith and Sue Viders, editors, ArtNetwork, 1998.

Organizing for the Creative Person, Dorothy Lehmkuhl with Delores Cotter Lamping, Crown Publishing, 1994.

Time Management for the Creative Person, Lee Silber, Three Rivers Press, 1998.

PRESS AND PUBLICITY

Don't Waste Money Buying An Art Gallery Or Dealer Mailing List, www.artbusiness.com/maillist.html

"Marketing Your Work" , by Betsy Kelso, www.nyfa.org

"Public Relations: Keep Those Cards and Letters Coming", Chapter 5, How to Survive and Prosper as an Artist, Caroll Michels, Henry Holt and Co., 2001.

"Using the Internet to Get Your Work Noticed", www.nyfa.org

"Using the Internet to Market Your Work", by Beth Kanter, www.nyfa.org

"What Makes Your Art Different: The Art of Self-Promotion", by Diane Rapaport, www.nyfa.org

DOCUMENTING YOUR WORK

"Documenting Your Work," Chapter 5, The Practical Handbook for the Emerging Artist, Margaret Lazzari, Harcourt College Publishers, 2002.

REJECTION

"Dr. Art on Dealing with Rejection", by Mathew Deleget and Sandra Indig, www.nyfa.org

"Rationalization, Paranoia, Competition and Rejection", Chapter 10, How to Survive and Prosper as an Artist, Caroll Michels, Henry Holt and Co., 2001.

ETHICS

"Rationalization, Paranoia, Competition and Rejection", Chapter 10, How to Survive and Prosper as an Artist, Caroll Michels, Henry Holt and Co., 2001.

Naming a Practice: Curatorial Strategies for the Future, Peter White, coordinator, Banff Centre Press, press@banffcentre.ca

CURATING

"Curating", Chapter 10, The Practical Handbook for the Emerging Artist, Margaret Lazzari, Harcourt College Publishers, 2002.

"Dr. Art on Museum Curating", by Matthew Deleget and Marysol Nieves, www.nyfa.org

"Dr. Art on Nonprofit Curating", by Matthew Deleget and Jenelle Porter, www.nyfa.org

Naming a Practice: Curatorial Strategies for the Future, Peter White, coordinator, Banff Centre Press, press@banffcentre.ca

WRITING

"Writing For Art Publications", Chapter 9, The Practical Handbook for the Emerging Artist, Margaret Lazzari, Harcourt College Publishers, 2002.

STARTING AN ART SPACE

"Creating a New Art Space", Chapter 11, The Practical Handbook for the Emerging Artist, Margaret Lazzari, Harcourt College Publishers, 2002.

"Dr. Art on Incorporation", by Matthew Deleget, www.nyfa.org

COMMISSIONS

"Making Art on Commission: Tips for Artists", www.artbusiness.com/privcom.html

"Assure Positive Outcome When Working on Commission", www.artbusiness.com/commission.html

TEACHING

"Developing a Teaching Portfolio", Center for Instructional Development and Research, http://depts.washington.edu/cidrweb/PortfolioTools.htm

GRADUATE SCHOOL and EDUCATION

Finding Foundation Support for Your Education, The Foundation Center, http://foundationcenter.org

"Ten Tips for Those Considering MFA Programs: So You Want to Be an Artist...", by Ilana Stanger, www.nyfa.org

"The Master of Fine Arts Degree", Chapter 16, The Practical Handbook for the Emerging Artist, Margaret Lazzari, Harcourt College Publishers, 2002.

"Other Educational Opportunities", Chapter 17, The Practical Handbook for the Emerging Artist, Margaret Lazzari, Harcourt College Publishers, 2002.

"Preparing Your Art School Portfolio", by Karyn Tufarolo, Admissions Counselor, The University of the Arts, www.nyfa.org

JOBS

"A' Job/ 'B' Job", Chapter 2, Art That Pays, Adele Slaughter and Jeff Kober, National Network for Artist Placement, 2004.

"Generating Income: Alternative to Driving a Cab", Chapter 9, How to Survive and Prosper as an Artist, Caroll Michels, Henry Holt and Co., 2001.

Getting Interviews, Kate Wendleton, Five O'Clock Books.

Interview Strategies. www.students.vcu.edu/careers/strategy/iview10.html

"Jobs", Chapter 12, The Practical Handbook for the Emerging Artist, Margaret Lazzari, Harcourt College Publishers, 2002.

Interviews and Salary Negotiation, Kate Wendleton, Five O'Clock Books.

NYFA Current - Jobs. www.nyfa.org/current

NYFA Source. www.nyfa.org/source

Targeting the Job You Want, Kate Wendleton, Five O'Clock Books.

The Chronicle of Higher Education: Career Network. http://chronicle.com/jobs

Art Career Network. www.artcareer.net

THE WEB

Building Arts Audiences and Communities on the Web by the folks at NYFA http://spiderschool.org/1997/index.html

Using The Internet to Market Your Work by Beth Kanter http://archive.nyfa.org/level4.asp?id=257&fid=1&sid=51&tid=201

Using the Internet To Get Your Work Noticed by NYFA http://spiderschool.org/workshops/njsca/index.html

AVOID COMMON ART & ARTIST WEB SITE MISTAKES by Artbusiness.com http://www.artbusiness.com/weberrors.html

Weinman, Lynda. Designing Web Graphics: How to Prepare Images and Media for the Web. Indianapolis: New Riders Publishing, 1997. Designing Web Graphics was written from a visual designer's perspective, in an effort to teach other designers what is different about Web graphics.

Williams, Robin and John Tollett. The Non-Designers Web Book: An Easy Guide to Creating, Designing, and Posting Your Own Web Site. Berkeley: Peachpit Press, 1997. The Non-Designer's Web Book is an attractive, full-color guide for aspiring Web designers. The authors first explain how to browse and search the Web, and discuss how to plan and post a Web site. They then get you into the real work of designing Web sites, whether for business or personal purposes.

Commonly Made Mistakes When Building an Artist Website by Jodi Kranqle
http://www.musesmuse.com/krangle-websitemistakes.html

Jessett.com – www.jessett.com
Good basic information on the basics of creating a web site.

Register.com - www.register.com
ReadyHosting.com - www.readyhosting.com

GoDaddy.com - www.GoDaddy.com
All register domain names and also provide hosting services.

Macromedia's Dreamweaver MX - www.macromedia.com/software/dreamweaver/

Adobe's GoLive - www.adobe.com/products/golive/

Microsoft's FrontPage - www.microsoft.com/frontpage/

Adobe's Photoshop Elements - www.adobe.com/products/photoshopel/main.html

GraphicConverter – www.lemkesoft.de/en/index.htm

Freeware and Shareware titles – www.versiontracker.com or www.webattack.com

Search Engine information - www.searchenginewatch.com

Artist Trust has a list of independent web designers in Washington State. Artist Trust
1835 12th Ave.
Seattle, WA 98122
206/467-8734 x10
866/218-7878
info@artisttrust.org

GRANTS AND FUNDING

"Basic Elements of Grant Writing", Corporation for Public Broadcasting, www.cpb.org/grants/grantwriting.html

"Dr. Art on Emergency Support Organizations", by Matthew Deleget and Cornelia Carey , www.nyfa.org

"The Etiquette of Getting Grants", by Shakurra Amatulla, The Grant Lady, www.nyfa.org

"Grants", Chapter 7, Art That Pays, Adele Slaughter and Jeff Kober, National Network for Artist Placement, 2004.

"Grants", Chapter 13, The Practical Handbook for the Emerging Artist, Margaret Lazzari, Harcourt College Publishers, 2002.

"Guide to Fiscal Sponsorship and Affiliation", The Foundation Center, http://foundationcenter.org

"The Mysterious World of Grants: Fact and Fiction", Chapter 8, How to Survive and Prosper as an Artist, Caroll Michels, Henry Holt and Co., 2001. "Online Orientation to Grantseeking - Individual's Path", The Foundation Center, http://foundationcenter.org

"Other Financial Support", Chapter 14, The Practical Handbook for the Emerging Artist, Margaret Lazzari, Harcourt College Publishers, 2002.

"Proposal Writing for Funding Projects", by Yedda Morrison, www.nyfa.org

ARTIST IN RESIDENCE

"Other Financial Support", Chapter 14, The Practical Handbook for the Emerging Artist, Margaret Lazzari, Harcourt College Publishers, 2002.

HEALTH AND SAFETY

Artist Beware: The Hazards of Working With All Art and Craft Materials and the Precautions Every Artist and Photographer Should Take, by Michael, Ph.D., C.I.H. McCann. The Lyons Press; (March 2001).

The Artist's Handbook of Materials and Techniques, Ralph Mayer & Steven Sheehan.

Health Hazards Manual for Artists, by Michael McCann, PhD, CIH. The Lyons Press; 1990.

Making Art Safely: Alternative Methods and Materials in Drawing, Painting, Printmaking, Graphic Design, and Photography, by Merle Spandorfer, D. Curtiss, J. Snyder, MD. John Wiley & Sons; 1995.

Overexposure: Health Hazards in Photography/ Everything You Need to Know About Photographic Materials and Processes to Make Your Workplace Safe…, by Susan D. Shaw, Monona Rossol. Allworth Press; 1991.

"Artists and Mental Health: Still Crazy After All These Years", by Ilana Stanger, www.nyfa.org

"Rationalization, Paranoia, Competition and Rejection", Chapter 10, How to Survive and Prosper as an Artist, Caroll Michels, Henry Holt and Co., 2001.

BUSINESS ASPECTS

"The Basics", Chapter 3, Art That Pays, Adele Slaughter and Jeff Kober, National Network for Artist Placement, 2004.

"The Business End", Chapter 15, The Practical Handbook for the Emerging Artist, Margaret Lazzari, Harcourt College Publishers, 2002.

The Business of Art, Lee Caplin, Prentice Hall Press, 2000.

KEEPING GOOD RECORDS

"Accounting FAQ", compiled by Andrea Mills and Steve Barry, Grant Thornton Philadelphia, www.nyfa.org
"Finances", Chapter 4, Art That Pays, Adele Slaughter and Jeff Kober, National Network for Artist Placement, 2004.

"Money Basics", www.nyfa.org

"Spending Basics", www.nyfa.org

FINANCES

Ask Artemisia
Dr. Art on Buying a Home
Part 1: How Much Can You Afford?

Matthew Deleget, Information & Research Department, NYFA
www.nyfa.org/archive_detail_q.asp?type=6&qid=57&fid=6&year=2002&s=Spring

Mini Financial Plan for Artist
Walks you through several steps on financial organization: Beginner's Financial Planning, Risk tolerance Questionnaire, Gathering Information, Income and Expenses Budget Calculator, Setting Goals, and Debt Management Calculator.
www.theartrepreneur.com/financial planning/financial_plan_for_artists.asp

Free Credit Ratings
This central site allows you to request a free credit file disclosure, commonly called a credit report, once every 12 months from each of the nationwide consumer credit reporting companies: Equifax, Experian and TransUnion. You can also request your report by phone or mail. Monitoring and periodically reviewing your credit report is an effective tool in fighting identity theft.

Be aware that checking your credit too often will result in your credit rating going down so plan accordingly.

www.annualcreditreport.com

UNEMPLOYMENT

United States Department of Labor
www.dol.gov/dol/topic/index.htm
The web site contains descriptions of unemployment benefits, as well as links to state pages.

NELA: National Employment Lawyers Association
NELA offers a referral service online or by phone.
212.302.0718
www.nela.org

Unemployment Action Center
The Unemployment Action Center offers legal representation services.
www.law.nyu.edu/studentorgs/uac

Workers Defense League
The Workers Defense League offers counseling on how to apply for benefits and free representation to appeal denials of benefits, in addition to providing information and referrals on other workplace issues. 212.627.1931

CRATING AND SHIPPING

"Dr. Art on Shipping Your Art Work", by Matthew Deleget, www.nyfa.org

"Way to Go! Crating Artwork for Travel", Stephen A. Horne, Gallery Association of New York, 1985.

LEGAL ISSUES

"Bartering Art? Don't Forget the Tax Man", www.artbusiness.com/barter.html

Business and Legal Forms for Fine Artists, Tad Crawford, Allworth Press, 1999.

"Common Legal Problems and How to Avoid Them", www.artbusiness.com/legalprobs.html

"Legal FAQ", by Craig R. Blackman, and Brian P. Rothenberg, Stradley, Ronon, Stevens, & Young, LLP, www.nyfa.org

"Plan Your Estate Before It's Too Late", www.artbusiness.com/estax.html

"The Law", Chapter 6, Art That Pays, Adele Slaughter and Jeff Kober, National Network for Artist Placement, 2004.

"When to See an Art Attorney", www.
artbusiness.com/legalprobs2.html

Starving Artist Law, www.starvingartistslaw.com

The IRS's website on Bartering:
http://www.irs.gov/businesses/small/
article/0,,id=113437,00.html

IRS Tax rules on Bartering:
http://www.irs.gov/businesses/small/
article/0,,id=188094,00.html

CONTRACTS

Business and Legal Forms for Fine Artists, Tad
Crawford, Allworth Press, 1999.

Business and Legal Forms for Photographers,
Tad Crawford, Allworth Press, 1999.

Starving Artist Law, www.starvingartistslaw.com

COPYRIGHT

"Copyright Infringement, Reproduction Rights,
and Your Career", www.artbusiness.com/
reprosuit

"Copyright Infringement and Your Creative
Health", www.artbusiness.com/copfringe.html

"Dr. Art on Copyright and Fair Use", by Matthew
Deleget and John Palattella, www.nyfa.org

"How, Who What, When of Copyright"
(including forms and applications) www.
copyright.gov

Starving Artist Law, www.starvingartistslaw.com

TRADEMARKS

Starving Artist Law, www.starvingartistslaw.com

RIGHTS OF THE ARTIST

Fear No Art, www.fearnoart.com

Starving Artist Law, www.starvingartistslaw.com

TAXES

"About.com Income Tax Resources for Self-
Employed Visual Artists"
http://arttech.about.com/library/bl_income_
tax_resources_self_employed_visual_artists.htm

"Business of Art: Taxing Artists", by Sonia
Kimble-Ellis, www.nyfa.org

Starving Artist Law, www.starvingartistslaw.com

ART AND DISABILITY

The National Arts and Disability Center
http://nadc.ucla.edu

Very Special Artists
www.artusa.org/

Art Beyond Sight
www.artbeyondsight.org/

The View From Here
www.zoot.net/theviewfromhere/

National Exhibitions for Blind Artists
http://nebaart.org/

Light House for the Blind and Visually Impaired
www.lighthouse-sf.org/

FREEDOM OF EXPRESSION

Starving Artist Law, www.starvingartistslaw.com

AGING

The National Endowment for the Art's Creativity and Aging Study:
The Impact of Professionally Conducted Cultural Programs on Older Adults: Final Report: April 2006
http://www.nea.gov/resources/Accessibility/CnA-Rep4-30-06.pdf

The National Endowment for the Art's Mini-Conference on Creativity and Aging in America -- May 18-19, 2005
http://www.nea.gov/resources/Accessibility/aa/contents.html

The National Endowment for the Art's Creativity and Aging: Best Practices Report
http://www.nea.gov/resources/Accessibility/BestPractices.pdf

Arts for the Aging provides artistic outreach to the elderly in Washington, D.C.
http://www.aftaarts.org/

Elder Hostel is a nonprofit providing learning and travel programs to senior citizens.
http://www.elderhostel.org/

Grace Art promotes the artwork of the elderly in Vermont.
http://www.graceart.org/index2.php

Ithaca College's Linden Center for Creativity and Aging
http://www.ithaca.edu/lindencenter/

The Huffington Center on Aging
http://www.hcoa.org/newsite/index.asp

Life Extension Foundation reviews a book about old Great Masters:
http://www.acfnewsource.org/art/aging_artists.html

The National Center for Creative Aging has a resources for arts and aging:
http://www.creativeaging.org/

GYST-Ink is an artist-run company providing information, technology and solutions created by artists for artists. Our mission is to support artists and arts organizations with an integrated mix of software, services and information in order to keep artists working. GYST–Ink is dedicated to empowering and educating artists so that they can develop sustainable and successful careers on their own terms.

Spearheaded by Karen Atkinson, GYST-Ink has been the leading resource for professional practice, art advice and art business services in Southern California for over ten years, helping thousands of artists from all over America get on the road to career success. Founded in 2000 by Karen Atkinson as a software company, GYST's products and services now include professional practices software, a blog, a newsletter, career development workshops, artist resume and statement reviewing, document and artwork documentation and archiving, a Skills Bank, web development, and consulting services.

GYST got its start in the late 1990's. Karen Atkinson used her knowledge as a media, installation, public artist, independent curator, CalArts professor, grant writer and collaborator to create one of the first professional practices courses for artists in the country called Getting Your Sh*t Together. Artists came from as far away as San Diego to attend the ten-week workshop taught at both CalArts (Valencia, CA) and Side Street Projects (Pasadena, CA). At this time each student received an eight hundred-page binder containing resources about the business of being an artist Karen had collected over twenty years. In response to the success of the course, GYST was founded. Karen soon created GYST v1.0, for MAC & PC, which included over five hundred pages of professional practices resources culled from over twenty years of lectures and teaching experience.

Since 2006, GYST has rapidly expanded. We have brought on new team members, updated our computer software to v.2.8 for MAC & PC. We have redesigned our website, and we now offer a selection of new products and services that are a direct response to the needs of the artist community at large. GYST Ink also publishes the ARTISTs* AT WORK blog (gyst-ink. com/blog), providing readers with valuable, up-to-date information about the business of being a professional artist.

Our team now consists of Karen Atkinson, President/Founder, Tucker Neel, Vice President, Chris Bassett, Internet Technology Manager, Monica Hicks, Operations Manager, Ari Kletzky, Business Advisor, Freddy Bustillos, Programmer, Calvin Lee, Archive Technician, Elleni Sclavenitis, Video Editor, April Totten, Video Editor, Michael Grodsky, Financial and Health Insurance Specialist, Bernard Brunon, writer. There is also a range of other arts professionals, from grant writing and gallery management experts, to lawyers that are part of the GYST extended network. This dynamic team of professional artists enables GYST to expand our national mission to provide tangible professional practices information and resources to contemporary artists through various support services in order to keep artists working.

All kinds of artists, including students and art school graduates, self-taught artists, young and older artists, emerging and established artists, benefit creatively, personally and monetarily from having an organized and directed professional life. We are here to help artists of all kinds on the road to personal and professional success.

 ## GYST Ink Services

GYST Software: Created by practicing visual artists as a teaching tool for navigating all parts of a challenging art world, GYST 3.0 is the most comprehensive professional practices software solution available to artists today. The dynamic new GYST v3.0 software manages all the business-related paperwork for your art career, and comes complete with tons of educational and information resources, too. Available for both MAC and PC, the software easily keeps track of your art, exhibition history, prices, sales, invoices, budgets, and your artist statements, resumes, proposals and research notes. It also has a powerful inventory management system integrated with your contacts and mailing lists. With all this great information in one place you can easily keep your sh*t together.

But the software doesn't stop there - it also includes the ability to create exhibition checklists, budgets, to-do lists and will guide you through writing a grant or proposal with detailed instructions. Finally, there are over 300 pages of information artists need to know including how to secure exhibition spaces, negotiate contracts, file taxes, and plan for retirement. GYST 3.0 is also packed with hundreds of helpful web links, suggested readings, and more. GYST 3.0 is available online at www.gyst-ink.com/products.

Free Demo Download: Try GYST 3.0 for free for 30 days by visit our website and downloading the fully functional demo. **www.gyst-ink.com.**

Software Includes:
Artwork Inventory System
Image, Audio, & Video Archive
Grant Writing Tutorials
Long & Short-Term Planning Tools
Exhibition Checklists & Guides
Presentation & Exhibition Tools
Legal Advice & Contracts
Artist's Statement & Resume Tutorials
Mailing List with Email capabilities
Research Archive with hundreds of web links

Over 300 Pages of Information About: Aging, Billing & Collection, Business Licenses, Charitable Contributions, Commissions, Community Service, Curating, Disabilities, Ethics, Experimental Materials, Fame, Finances, Finding a Job, Fiscal Sponsorship, Galleries & Selling, Health & Safety Issues, Housing, Insurance, Inventory, Keeping Records, Loans, Networking, Nonprofits, Presenting Yourself, Pricing Your Work, Printing, Renting & Leasing a Studio, Self-Employment, Studio Visits & Open Studios, Taxes, Teaching, Unemployment, Websites, Works for Hire, Writing, Estate Planning, Teaching, and Shipping & Crating.

ARTISTs* AT WORK: www.gyst-ink.com/blog
A dynamic blog dedicated to providing readers with up-todate information on issues important to working artists today.

Custom Databases:
GYST works with artists and galleries to create custom databases to suit their needs.

Notable Custom Database Clients Include:
Mike Kelley
John Baldessari
Cheech Marin

Skills Bank: For just $25 a year you can sign up with our skills bank, post your job skills and have other artists and employers hire you. Browsing and responding to listings is free. Sign up now at http://gyst-ink.com/gyst/skills-bank-list.

Artist Statement & Resume Reviews: You can now have your artist statement and resume reviewed by a GYST professional who will suggest improvements and work with you throughout the process. This is a great resource if you are applying to graduate school or writing a grant. For more information visit gyst-ink.com.

Scanning, Documenting & Archiving Services: In today's art world a digital archive is a must. Our professional staff will help you document your work, scan slides, digitize video, and enter all your info into our unbeatable GYST software. Scanning starts at just $2 per slide.

GYST Affiliate Program: Are you a member of an organization or nonprofit catering to artists? If your organization or institution signs up to become an affiliate then all members receive a $20 discount on GYST software through our website: http://www.gyst-ink.com/buy/buyonline.php. We also offer huge discounts for bulk software sales. For more information on the affiliate program email Tucker Neel at tucker@gyst-ink.com

Notable Affiliates Include:
The Women's Caucus for Art
Otis College of Art and Design
Cal Arts
Outpost of Contemporary Art
Chicano Art of Aztlan
Side Street Projects
Center for Creative Inquiry
New York Artists Circle
The School of The Art Institute of Chicago
Alliance Of Artist Communities

Chicago Art Resources
National Association of Artists' Organizations
Center for Creative innovation
Fractured Atlas

Workshops: GYST teaches custom designed workshops on all aspects of developing a successful art career for artists and nonprofit organizations all over the country. Workshops range from two hours, one day or up to 10 weeks. GYST will customize workshops for your city or organization. 10 week workshops are held in Los Angeles each Fall and Spring. To schedule a workshop email Tucker Neel, GYST Vice President, at tucker@gyst-ink.com.

 Getting Your Sh*t Together Workshop Alumni Testimonials

"The value is worth WAY MORE than the tuition."
- John B.

"I was blown away... I never really had my art eyes opened up from so many directions."
- Joel T.

"This class was personally useful for me as a "re-emerging" artist. This class has helped motivate me tremendously to reclaim my career as an artist. I also made a few friends and contacts that I hope to spend time with discussing work as practicing artists."
- Michael Y.

"I thought the class offered extremely relevant information on the business of being an artist (that you wouldn't otherwise get on your own) in such a clear, well-covered way. There was information presented that I hadn't even considered."
- Kathleen B.

"Excellent class! Karen is my super-hero, too! It is no longer a mystery as to how the art world works. With some hard work on my behalf, I will be able to find a place to exhibit my work, and present it on my own terms."
- Nancy W.

"I was surprised at how many students were people that had been in the art world for quite some time! I was expecting more recent MFA grads like myself. My expectations about Karen were more than fulfilled. She is an incredibly generous (and gregarious) teacher. I was expecting her to be a 'pro,' and boy... is she ever! I can't say enough positive things about this class and all its practical, business knowledge that every artist needs to know. Karen just RULES! She is funny, approachable, immensely knowledgeable, and a great artist in her own right."
- Alexandria C.

"I came for an introduction & overview of the business of art and I got it, which has helped diminish my fears a lot. The openness and enthusiasm of Side Street's facilitators were very helpful,. The guest lecturers were terrific. It was a down-to-earth approach with great sense of humor all the way!"
- Francesca H.

"I really appreciated the frankness of how Karen Atkinson 'cuts to the chase.' After listening to my fellow classmates, it was clear that the average artist doesn't know much about the business side of art. All in all, I'm a smarter artist and now, I'm mentoring my mentor – go figure!"
- Natalie H.

"My expectations were totally surpassed! Overall, I think GYST really boosted my confidence levels and directed me towards figuring out what is best for me. Glad I did this, because I think I'll be a better artists because of it."
- Jorge F.

"I expected to be presented with a lot of resources and to have these resources contextualized. My expectations were met and exceeded."
- Jalal P.

www.gyst-ink.com

7450633R0

Made in the USA
Charleston, SC
05 March 2011